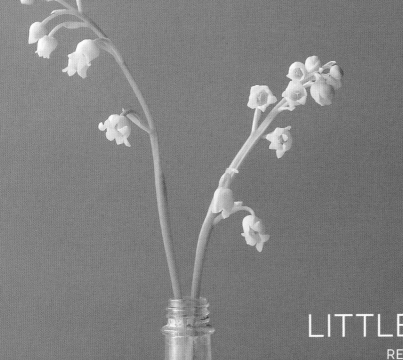

THE
LITTLE FLOWER
RECIPE BOOK

ALSO AVAILABLE

The Flower Recipe Book
by Alethea Harampolis and Jill Rizzo

Branches & Blooms
by Alethea Harampolis and Jill Rizzo

THE
LITTLE FLOWER
RECIPE BOOK

148 Tiny Arrangements for Every Season & Occasion

JILL RIZZO

PHOTOGRAPHS BY MAAIKE BERNSTROM

ARTISAN | NEW YORK

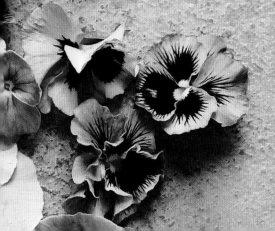

A note about the front cover arrangement: This design combines all of my favorite tiny spring blooms, arranged in a miniature vase by Object and Totem. I created a bunch in hand with a cluster of forget-me-nots, muscari, and lily of the valley (clipped from my garden) and added them to the vase with the lowest level of blooms resting at the rim. Then I tucked in two perfect violas and a sweet pea grown by Little State Flower Company, and finished by adding two exquisite petite ranunculus from Pistil and Stamen, one nestled in at the front and the other reaching up tall on the left side.

Library of Congress Cataloging-in-Publication Data.
Names: Rizzo, Jill, author.
Title: The little flower recipe book / Jill Rizzo ; photographs by Maaike Bernstrom.
Description: New York : Artisan, a division of Workman Publishing Co., Inc. [2022]
Identifiers: LCCN 2021044281 | ISBN 9781648290534 (hardback)
Subjects: LCSH: Miniature flower arrangement.
Classification: LCC SB449.5.M56 R59 2022 | DDC 745.92—dc23/eng/20211013
LC record available at https://lccn.loc.gov/2021044281

Design by Nina Simoneaux

Artisan books are available at special discounts when purchased in bulk for premiums and sales promotions as well as for fund-raising or educational use. Special editions or book excerpts also can be created to specification. For details, contact the Special Sales Director at the address below, or send an e-mail to specialmarkets@workman.com.

For speaking engagements, contact speakersbureau@workman.com.

Published by Artisan
A division of Workman Publishing Co., Inc.
225 Varick Street
New York, NY 10014-4381
artisanbooks.com

Artisan is a registered trademark of Workman Publishing Co., Inc.

Published simultaneously in Canada by Thomas Allen & Son, Limited

Printed in China on responsibly sourced paper

First printing, March 2022

10 9 8 7 6 5 4 3 2 1

*To my amazing father, who
has supported my love of tiny
things since I was a tiny thing*

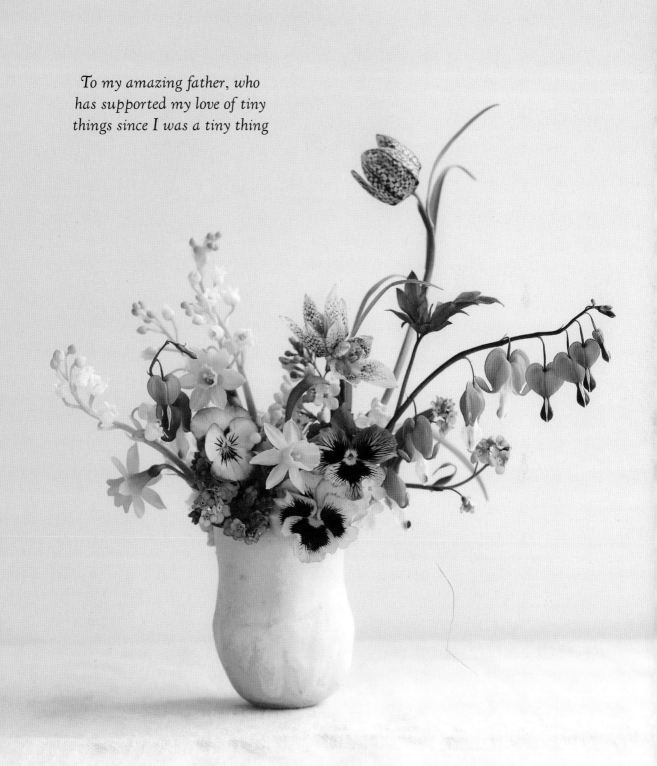

CONTENTS

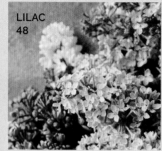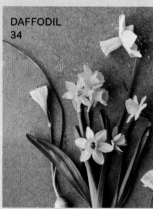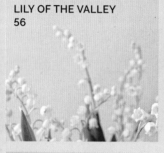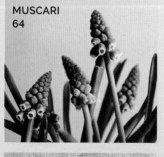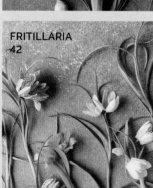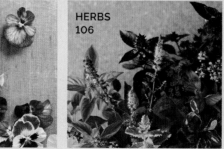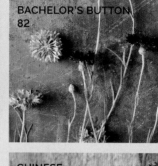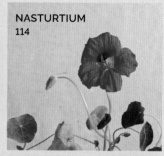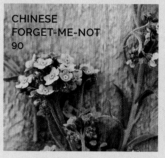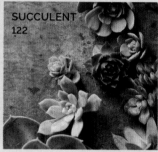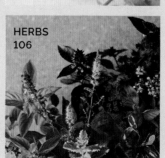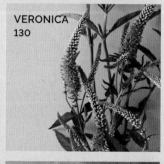

Autumn

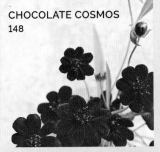
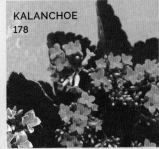
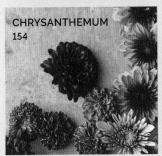
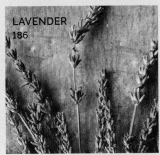

Winter

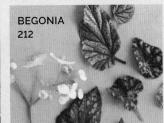
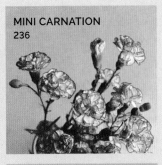
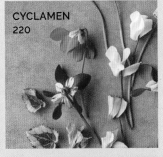
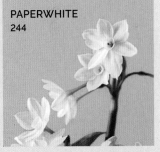

INTRODUCTION

I appreciate flowers of all sizes, but the tiny ones have always been nearest and dearest to my heart. As the daughter of a florist, I have happy childhood memories of fashioning little bouquets from scrap flowers in my mother's shop. There was a small section of the display cooler reserved for my creations, which customers would sweetly "purchase," to my extreme delight. There were also foraging trips to the park across the street for lily of the valley, and Johnny-jump-up bouquets made from the purple and yellow invaders that took over the cracks in my grandmother's patio.

Making a little arrangement is an act that is just for you. The tiniest ones may seem impractical, but their purpose is in the pleasure of slowing down and marveling at their intricate detail. They may last for a week or just an evening, inspiring you to create a new treasure tomorrow. I work with big, beautiful flowers every day, but the ones that most often end up on my windowsill at home are these little gems. They are everywhere—and once you start looking, you won't be able to unsee them.

HOW TO USE THIS BOOK

The recipes that follow are organized loosely by season and showcase dozens of little flowers, each arranged first on their own, then in combination with a collection of complementary ingredients. This book doesn't delve into specific plant varieties or use botanical terminology but instead provides an inspirational road map for seasonal combinations. Don't hesitate to make substitutions depending on what is available to you. Whether you want to replicate a recipe as closely as possible or re-create a color palette with entirely different blooms, the arranging techniques demonstrated throughout the book will help you design beautiful miniature arrangements with the flowers you have.

You'll see that individual recipes are often identified as either a "Micro Arrangement" or a "Mini Arrangement." Micro arrangements are pared down to the smallest form of each ingredient, typically in a vase that is less than 2 inches (5 cm) in size. Mini arrangements are slightly larger, using more stems and larger sprigs. There are also wreaths, garlands, place settings, gift toppers, floating displays (compositions created by floating ingredients in water in a low dish, intended to be viewed from above), and more!

A few additional notes:

- The colors listed in the descriptions are the ones most commonly available, but there may be more out there!

- Bloom size will vary depending on what stage of growth the flowers are harvested in and the health of the plant; struggling plants often produce smaller flowers.

- Proper harvesting techniques can make a big difference for a flower's vase life. Generally, try to cut blossoms early in the day before the temperature gets hot. Use sharp, clean tools. Immediately place the stems into a clean bucket of cold water and keep in a cool place for a few hours or overnight before using them in designs. Some materials, like weeds and tender new growth, just don't like to be cut, so no matter how well they are processed, they will wilt quickly.

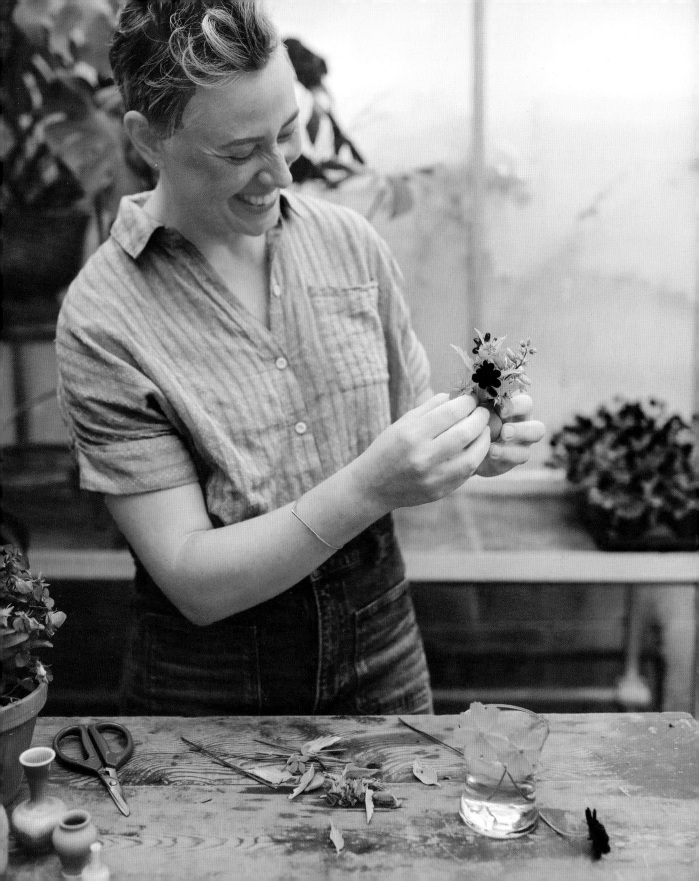

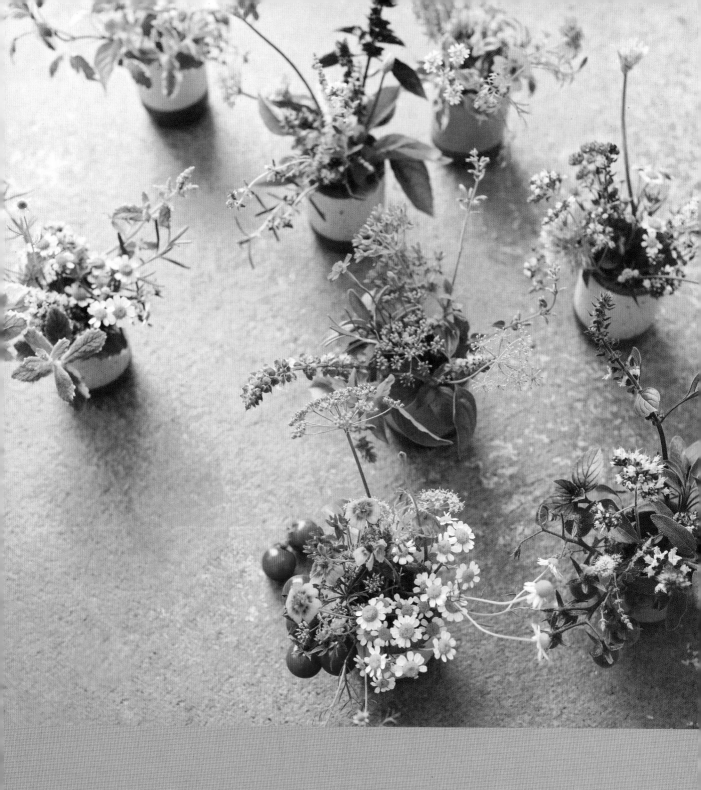

Herbs are prolific producers of some of the tiniest flowers. Just a few plants can yield a miniature summer bounty.

THE INGREDIENTS

SOURCING LITTLE FLOWERS

My favorite way to source all kinds of plant materials is to purchase them right from the growers: the most direct route from the field into your vase is ideal. This may mean ordering from a local flower farmer, visiting your neighborhood farmers' market, or having stems shipped from a nearby grower. I also enjoy visiting nurseries to look for unusual varieties that I can plant in my garden for future harvesting, and with an eye on the roadside, I'm constantly culling material from the ever-changing landscape around me. Here are my go-to spots to find flowers:

CUTTING GARDENS. Whether you have an acre of land or a few pots on your fire escape, your home garden is the best place to cherry-pick the tiniest materials.

FLORISTS. With access to national wholesale farms and the international market, your local florist can be an invaluable resource for seasonal and special-order cut flowers as well as unique plants.

FLOWER FARMS. Many new farms have popped up across the country over the past ten years, and some specialize in unique flower varieties.

GARDEN CENTERS. Seasonal plant selections and houseplants provide a wide array of flowers and foliage that aren't available as cut stems.

GROCERY STORES. Stocked with durable blooms and small plants and produce, some specialty grocers offer selections rivaling that of a florist.

NATURE. Keep your eyes peeled for interesting weeds, grasses, twigs, and shrubs—but never clip anything from someone else's property without permission.

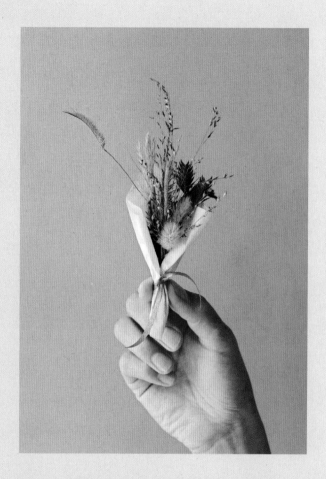

This autumnal posy combines several specialty grasses sourced from a local nursery along with tiny feathery blooms plucked from the lawn.

HARVESTING LITTLE FLOWERS

Several different types of little flowers are used in these recipes:

TINY BLOOMS. Flowers whose mature size is naturally diminutive.

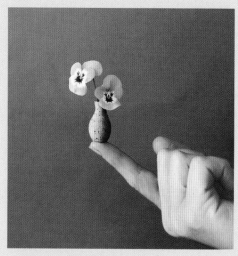

Less than an inch (2.5 cm) tall when full size, violas are big on character.

FLORETS. Individual blooms clipped from a larger flower.

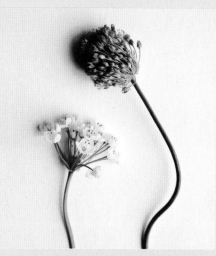

Alliums grow in an umbel formation, with a single floret at the end of each tiny stem.

SECONDARY BLOOMS. Smaller versions of the main flower on a stem.

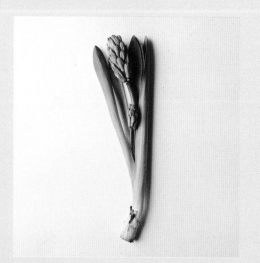

Though a full-size hyacinth stem is too large for a little arrangement, these bulbs sometimes send up a miniature secondary bloom.

RUNTS. Mature blooms that have not grown to the average size.

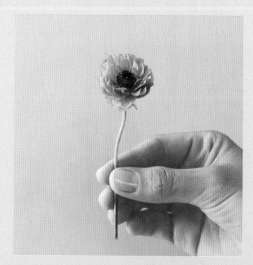

A delicate ruffled ranunculus bloom was the runt of the bunch but perfect in its own way.

SPRIGS. Sections pruned from a larger flower or branch.

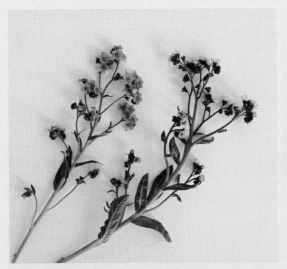
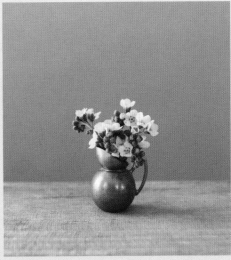

Chinese forget-me-nots grow in branched clusters with one stem yielding several sprigs. Cluster the sprigs at a similar height to create tiny lush compositions.

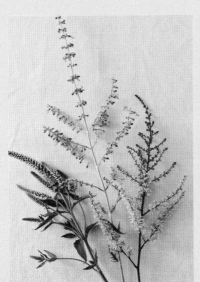
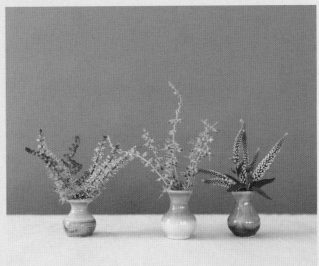

Veronica, sage, and astilbe are tall, pointed flowers made up of smaller spikes that can be trimmed apart to create delicate, wispy arrangements.

SPECIAL INGREDIENTS

EDIBLES. Petite edibles like strawberries and mushrooms combine beautifully with flowers, whether in arrangements or displayed alongside them in a seasonal tablescape.

BULBS. Most bulb flowers can be removed from the soil and displayed out of water if the roots are kept moist. Flowers on the bulb last longer than cut stems because their food source is still attached.

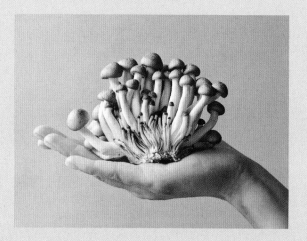

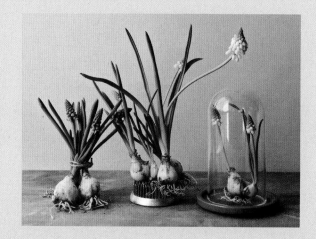

HOUSEPLANTS. Houseplants are a great resource for unique, long-lasting foliage when fresh materials are scarce. Clip just a few leaves at a time to keep the plant looking full for display.

SUCCULENTS. Succulents are easy to propagate to create ingredients for the tiniest of pots. When set on dry soil, a baby plant will appear at the end of a detached leaf after a few weeks!

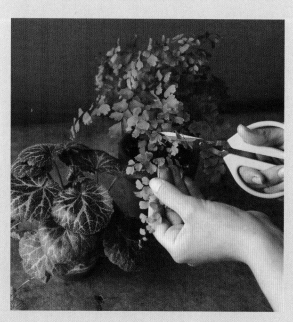

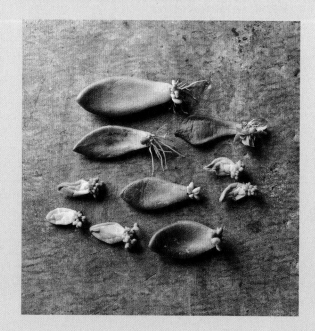

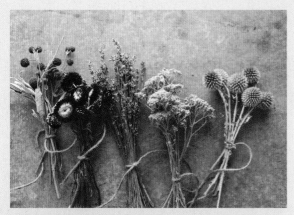

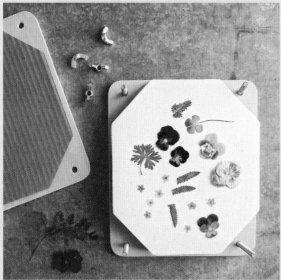

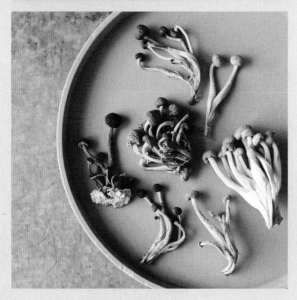

DRYING AND PRESSING

When flowers are plentiful, set aside an assortment to dry for use in fall and winter. Use freshly harvested open flowers for best color and sturdiness. Plants known as everlastings are ideal for this purpose. Composed of papery bracts, everlastings retain their color well and have a similar look whether fresh or dry. Strawflower, gomphrena, celosia, and ammobium fall into this category, as do a variety of grasses and pods. Experiment with different materials using the drying techniques below to see what you like best.

HANGING

Prepare flowers (shown above left, from left to right: buddleia, strawflower, lavender, yarrow, and echinops) for drying by removing the foliage from the stems and loosely bunching the blooms to allow for airflow. If the flowers are packed together too tightly, the petals can get moldy. Hang the bunches upside down in a dark, dry area for a few weeks or until they are stiff.

PRESSING

A flower press, or a heavy book with a weight on top, can preserve delicate materials for future use in framed projects, cards, and place settings. Use freshly opened, undamaged flowers and make sure they are dry before adding to a press. Thin blooms like violas and forget-me-nots can be pressed in their entirety, while thicker blooms need to be disassembled and the individual petals pressed. Layer your press by stacking sheets of cardboard and paper between your flowers, in this order: cardboard, paper, flowers, paper, cardboard. The hardest part is waiting a month before opening to see the results!

DRYING EDIBLES

Incorporate unexpected materials like mushrooms and citrus fruit into your dried repertoire. The mushrooms shown here were left to air-dry on a tray for several weeks. Fruit can be thinly sliced and dried in a very-low-temperature oven for a few hours, then glued onto wreaths or other projects.

STOCKING YOUR TOOLBOX

Keep your supplies organized so you are always ready to arrange when you come across a little treasure. Most of these supplies can be purchased at your local craft store or floral shop.

1. **CHICKEN WIRE.** Bendable coated wire useful for stabilizing stems and creating mounded sculptural pieces.

2. **PIN FROG (KENZAN).** Small flower holder with spikes in various sizes; handy for quick and airy designs.

3. **WATERPROOF TAPE.** Used to secure bunches, hold down a chicken wire structure, or create a tape grid.

4. **RUBBER BANDS.** Good for binding bunches of stems to keep them clustered in an arrangement.

5. **TWEEZERS AND ANGLED TWEEZERS.** Useful for placing tiny florets in vases or creating floating compositions.

6. **FLORAL SNIPS.** Your number one tool for trimming stems and removing foliage; keep clean and sharp to avoid crushing stems.

7. **RIBBON.** Decorative element used for finishing flair or hanging.

8. **TWINE.** Natural fiber string for garlands, gift toppers, and wrapping stems.

9. **SPOOL WIRE.** Available in different gauges; used to continuously wrap ingredients onto a wreath form.

10. **EMBROIDERY FLOSS.** Colorful thick string for creating garlands and gift toppers and for wrapping stems.

11. **NEEDLES.** Used with thread or embroidery floss to string flower heads into garlands.

12. **THREAD.** Colorful thin string for creating garlands and wrapping stems.

13. **FLORAL WIRE.** Available in different gauges and lengths; used in wreath making and to create stems on succulents and fruit.

14. **SKEWERS.** Used to create artificial stems for fruit and other ingredients, so they can easily be added to projects.

15. **FLORAL GLUE.** Gel-like adhesive used to attach flowers and leaves to almost any surface.

16. **BIND WIRE.** Paper-coated wire that doesn't pinch delicate stems as much as regular wire; useful for securing bunches and for wreath and garland making.

CELLOPHANE TAPE (NOT PICTURED). Can be used to create an "invisible" grid on top of a vase to hold stems in place.

DOUBLE-SIDED GLUE TABS (NOT PICTURED). Sometimes placed on the bottom of a micro vase to stabilize it and keep it from tipping after completion.

A NOTE ON FLORAL FOAM

Green bricks of floral foam have been used by florists for hydration and structure in arrangements for many years, but the material's negative impact on the environment (microplastic pollution) and health (inhalation of fragments can cause respiratory harm) have spurred many in the industry to seek alternative arranging methods. All the projects in my books are made without foam, and I encourage you to try using earth-friendlier options, such as chicken wire or pin frogs, for your arrangements of all sizes.

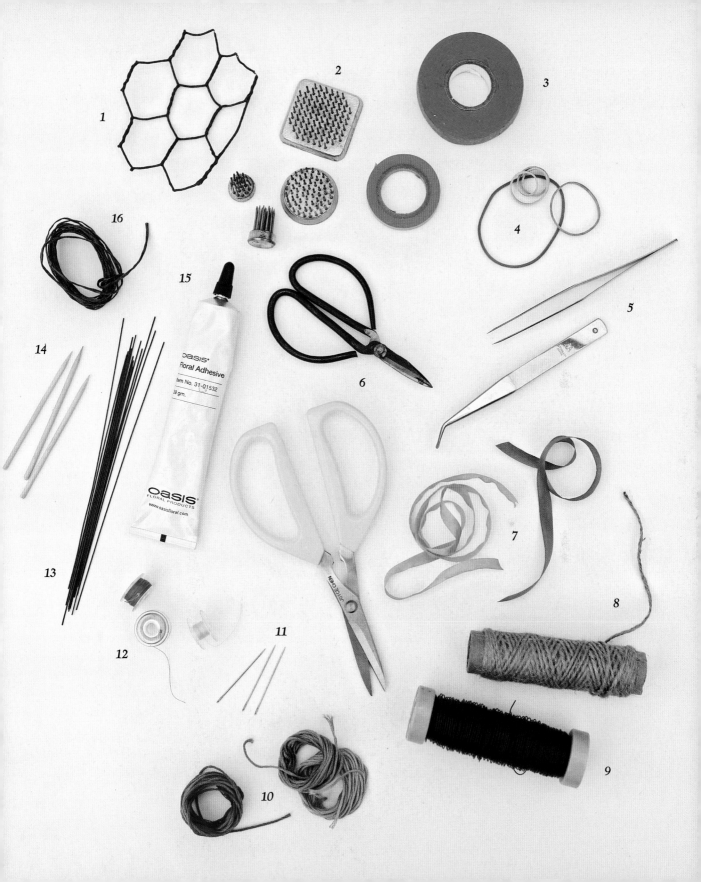

CHOOSING YOUR VESSEL

Just as delightful as the blooms that they hold, tiny vases celebrate smallness and give weight to the most diminutive materials. Among the littlest are dollhouse-scale vessels and beautifully handmade ceramic micro vases designed to hold just a few wire-thin blooms. (Use caution when searching for miniature vessels online: you might lose a night's sleep falling down a tiny-vase rabbit hole on Etsy. I certainly have.)

Flower size, shape, and quantity should guide you in determining the vase you choose for an arrangement, so keep on hand a few different vessels with various heights and diameters (for some of the sources featured in this book, see page 271). Before you begin arranging, decide what you like about your flower and how you can accentuate that feature. A narrow-mouth bottle will highlight tall, delicate stems, while a low cup with a pin frog showcases chunky blooms with thick stems. A set of five or more small cups or similarly shaped bud vases are useful to create tablescapes.

In addition to all the vases designed to hold flowers, tiny vessels come in many other forms, including:

PERSONALITY PIECES. Antiques shops are a great place to score special little containers like pitchers, creamers, candy tins, perfume bottles, laboratory glass, and wooden boxes that can be used as vases if they are watertight or lined.

TRAVEL-SIZE CONTAINERS. Honey, jam, condiments, and toiletries are often packaged in cute travel-size bottles; save a special one from your next trip and relive the vacation every time you arrange in it.

BOTTLES. They are manufactured in a wide variety of sizes and materials, and their narrow openings are ideal for displaying just a few stems.

KITCHENWARE. Food and drink containers come in many specialty shapes and sizes. Cups and glasses for shots, shooters, aperitifs, espresso, sake, punch, and cordials all make sweet vases, as do ramekins and condiment bowls.

TECHNIQUES

STEM PREPARATION & CUTTING

ANGLED CUTS

Trim the stem of each flower right before you add it to the vase. Use an angled cut when trimming individual stems to create a longer surface area and increase water absorption. The cut stem should be exposed to the air for as little time as possible.

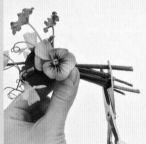

CUTTING STEMS FOR A BOUQUET

Cut bouquet stems straight across together for a clean look.

TRIMMING STEMS

When working with sprigs, remove some of the lower florets or leaflets to expose more of the stem, which is useful for design work. Because small stems are delicate and can be easily torn, use snips to trim off the lower leaves as close to the stem as possible.

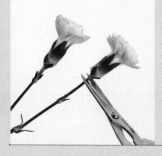

TRIMMING HEADS

Some blooms, like this mini carnation, have a receptacle that holds the petals together; be careful not to trim the stem too short or the petals will fall apart.

ARRANGING & STABILIZING

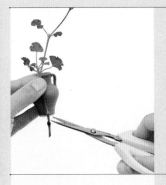

MEASURING STEMS TO CUT
To determine where to trim a stem, hold it next to the vase and decide where you want the blooms and foliage to rest. Remove the lower leaves that will fall below the rim, then trim and add to the vase.

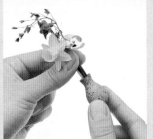

ARRANGEMENT IN HAND
Because small vases can be easily tipped, try designing your arrangement "in hand" and adding it to the vase at once: Hold your flowers just below the base of the blooms, then measure and trim the stems so that the blooms will rest at the rim.

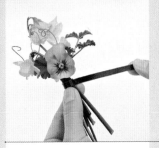

BOUQUET IN HAND
Follow the steps above to create an arrangement in hand, but rather than inserting into the vase, use floral tape to secure the stems just below the blooms. This technique is useful for boutonnieres, gift toppers, and wrapped bouquets.

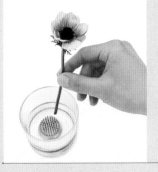

PIN FROG
A pin frog, or kenzan, is a floral arranging tool with small spikes poking up from a sturdy metal base. Pin frogs are available in many shapes and sizes and are extremely useful for creating small, airy compositions by pushing the stems of your flowers into the pins. When you are working at this scale, affixing the pin frog to the vase with floral putty is not usually necessary; this allows you to easily transfer the pin frog to other containers.

CARING FOR LITTLE FLOWERS

WATER & LONGEVITY

Unless otherwise noted in a recipe, always fill your vessel with fresh cold water. Tiny vases don't hold much water, so they need to be filled more frequently than larger ones. A small squirt bottle is ideal to add a few drops of water to the vase. Regular water changes and occasional stem recutting are the best ways to prolong the life of an arrangement. Bacteria from dirty water will clog the flowers' stems and prevent them from drinking. And just like us, when flowers can't drink, they become dehydrated and wilt. Keep arrangements cool and out of direct sunlight; both heat and sunlight cause wilting and encourage bacteria growth in the water. Scrub buckets and vases well after use to avoid yucky buildup. A petite bottle brush with a soft end is helpful in cleaning smaller vases with narrow openings.

BAGGING

Bagging is a way to keep small bunches of delicate ingredients hydrated for a prolonged period outside a vase. Wrap the bottom of the stems together in a wet paper towel and place the wrapped stems in a small plastic bag with a small amount of water. Seal the top of the bag with a piece of floral tape and add the bag to your project.

TOXICITY & SAP

Many flowers contain some level of toxicity. If you have small children or pets that like to munch on leaves, keep all arrangements out of reach. Some flowers, like hyacinth and narcissus, ooze a clear sap from the stems when cut. Use caution when handling them, because the sap can irritate skin and may be poisonous to other flowers. If possible, trim the stems and place them in a bucket of water for a few hours, until the sap stops flowing, before using them. When you add the flowers to the arrangement, do not retrim the stems.

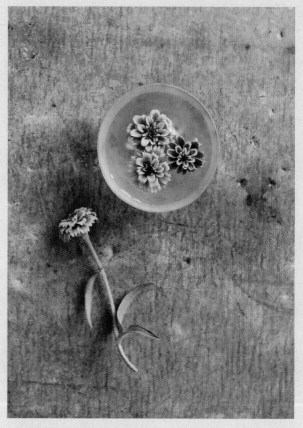

Floating the heads of broken or wilted flowers in a low bowl is a great way to extend the life of blooms otherwise destined for the compost bin.

DESIGN TIPS

The recipes that follow offer precise instructions for bloom selection and placement, but don't be discouraged if you can't replicate a design exactly. Feel free to use shape, variety, or palette as a starting point for your own arrangements. Here are a few general guidelines to keep in mind as you do.

- To make your design appear to grow from the center of the vase, place stems at a slight angle through an imaginary X in the center of the vessel rather than inserting them straight down.

- Varying the size and shape of blooms, clustering similar ingredients, and using directional elements like spires and vines help move the eye around an arrangement.

- Pay close attention to which direction your blooms are facing in the composition: whether pointed toward each other in an intimate conversation or looking away and ignoring one another. A simple twist can change the entire attitude of an arrangement.

- Empty space is just as impactful as the flowers—arrangements don't always need to be packed full.

- Choose what you like about a flower and emphasize it. If it has a beautiful bloom with an uninteresting stem, chop it short and place it front and center. If a stem has particularly graceful curves, let it rise above the other ingredients and show off.

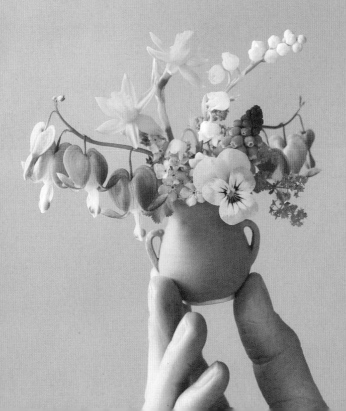

SPRING

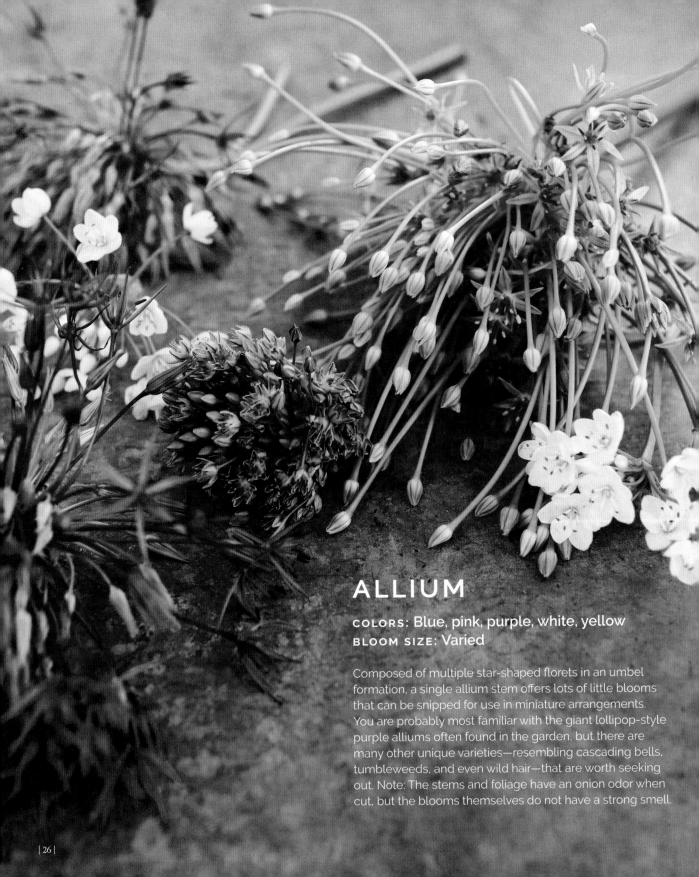

ALLIUM

COLORS: Blue, pink, purple, white, yellow
BLOOM SIZE: Varied

Composed of multiple star-shaped florets in an umbel
formation, a single allium stem offers lots of little blooms
that can be snipped for use in miniature arrangements.
You are probably most familiar with the giant lollipop-style
purple alliums often found in the garden, but there are
many other unique varieties—resembling cascading bells,
tumbleweeds, and even wild hair—that are worth seeking
out. Note: The stems and foliage have an onion odor when
cut, but the blooms themselves do not have a strong smell.

ALLIUM

RECIPE 1
ON ITS OWN

INGREDIENTS

10 allium florets, assorted
varieties, with buds and blooms

VESSEL

1-inch-tall (2.5 cm) ceramic
bud vase

When working with larger allium varieties, you'll want to snip off
the individual florets, each with its own long stem. Incorporate
both buds and open blooms so the composition feels varied,
even in an extremely diminutive vase.

1. Place three allium florets leaning out the left side of the vase
at varying heights.

2. Set four more florets at similar heights to the first three, with
two leaning right and two faceup in the center.

3. Nestle the remaining three florets on the center rim so their
stems are not visible.

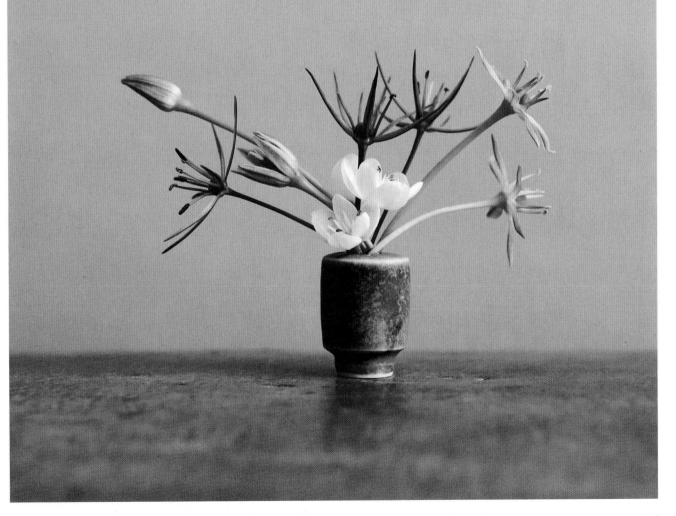

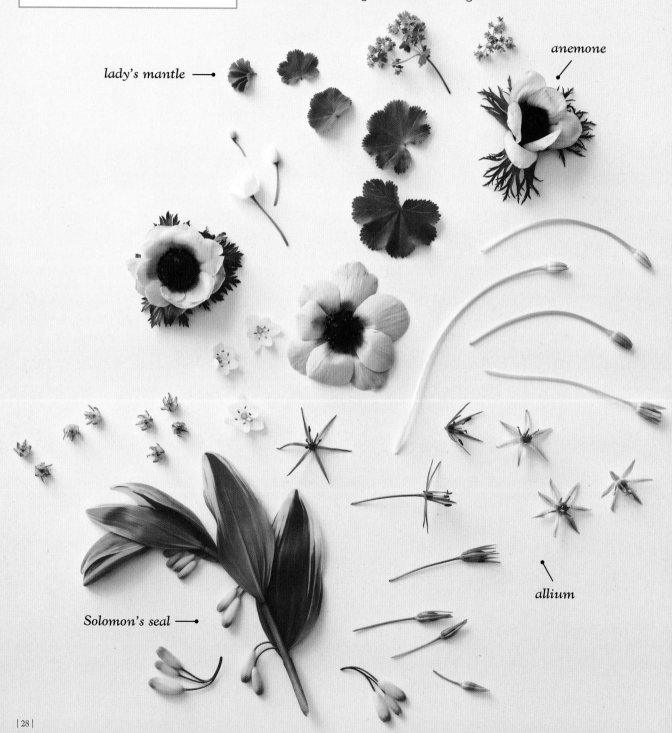

ALLIUM

RECIPES 2–4
INGREDIENTS

When grouped together, the star-shaped florets of allium and lady's mantle evoke a tiny fireworks display. Seek out petite anemones from your local flower farmer and clip the dangling bell-shaped blooms from Solomon's seal to scale down materials that are traditionally valued for their larger blooms and longer stems.

lady's mantle ⟶

anemone

allium

Solomon's seal ⟶

ALLIUM

RECIPE 2
MICRO ARRANGEMENT

INGREDIENTS

12 allium florets, assorted
varieties

3 allium floret buds

1 white allium stem

3 lady's mantle sprigs

6 Solomon's seal florets

1 anemone bloom

VESSEL

1½-inch-tall (4 cm) ceramic vase

For a spring palette that feels bright yet soothing, pair chartreuse foliage with cool-toned flowers in a pale blue vase.

1. Cluster the allium florets, at slightly varying heights, along the vase rim. Place the three allium buds curving up on the left side and the white allium stem leaning right.

2. Nestle two lady's mantle sprigs at the back and let the third curve down on the left. Carefully feed the delicate Solomon's seal floret stems through the allium cluster so the blooms dangle on both sides of the vase.

3. Place the anemone bloom at the highest point in the composition, with a slight curve to the left.

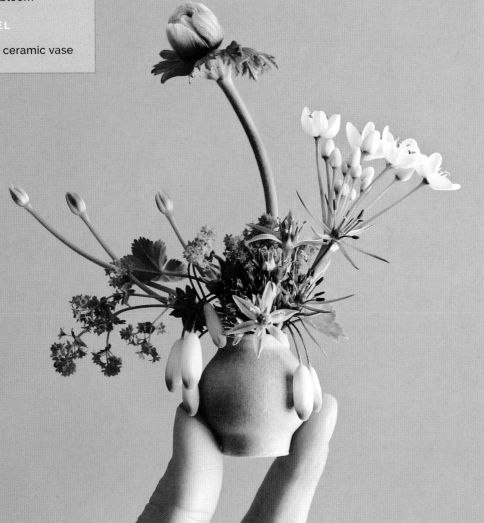

ALLIUM

RECIPE 3
MINI ARRANGEMENT

INGREDIENTS

6 lady's mantle sprigs

1 allium stem

40 allium florets, assorted varieties

2 Solomon's seal sprigs

2 anemone blooms

VESSEL

2¼-inch-tall (5.5 cm) ceramic cup

1 Create a bunch in hand with five lady's mantle sprigs, lining up the lowest level of blooms. Trim and place in the cup in a cluster leaning to the left.

2 Place the allium stem leaning right. Create a bunch in hand with ten allium florets; trim and add together at the rim next to the allium stem. Repeat with ten more florets, adding these upright at the center. One at a time, nestle in ten more florets to rest on the lady's mantle. Create a bunch in hand with the remaining allium florets, trim, and lean it out the left side.

3 Add one Solomon's seal sprig curving down on the left and the other curving up and inward over the center. Place the remaining lady's mantle sprig high on the right. Finish by nestling one anemone bloom in the center front and the other on the left, mirroring the height of the lady's mantle.

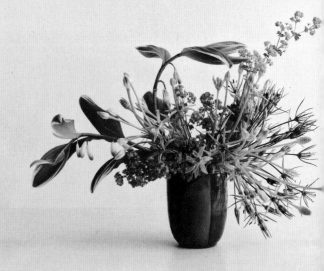

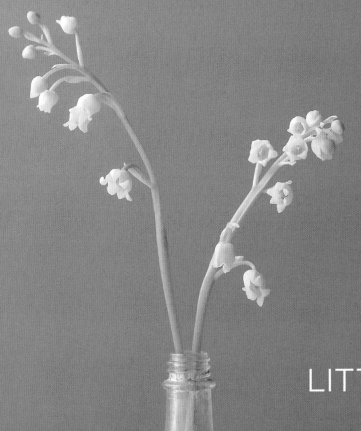

THE
LITTLE FLOWER
RECIPE BOOK

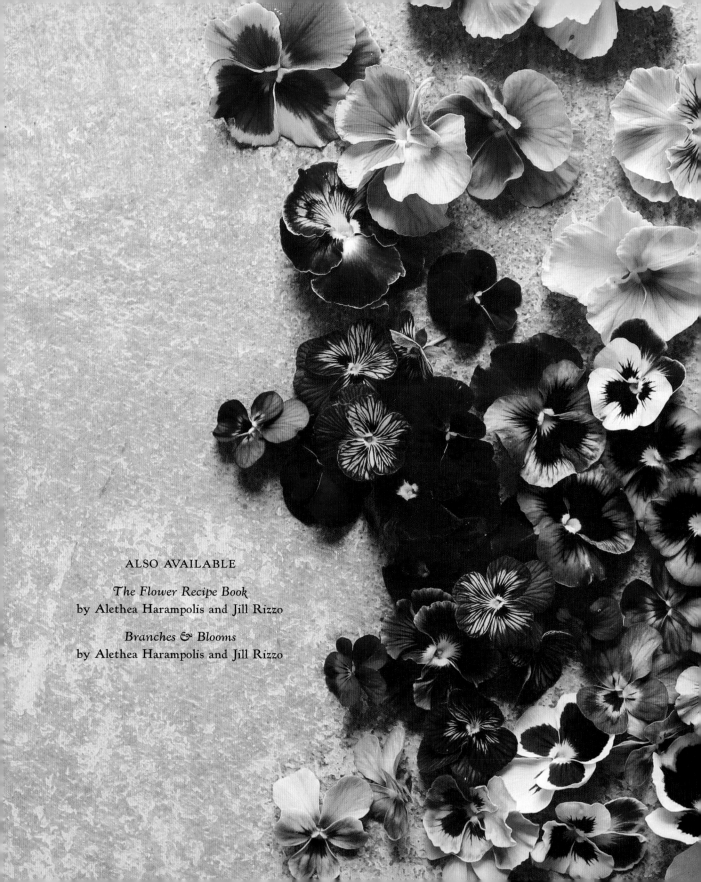

ALSO AVAILABLE

The Flower Recipe Book
by Alethea Harampolis and Jill Rizzo

Branches & Blooms
by Alethea Harampolis and Jill Rizzo

THE
LITTLE FLOWER
RECIPE BOOK

148 Tiny Arrangements for Every Season & Occasion

JILL RIZZO
PHOTOGRAPHS BY MAAIKE BERNSTROM

ARTISAN | NEW YORK

A note about the front cover arrangement: This design combines all of my favorite tiny spring blooms, arranged in a miniature vase by Object and Totem. I created a bunch in hand with a cluster of forget-me-nots, muscari, and lily of the valley (clipped from my garden) and added them to the vase with the lowest level of blooms resting at the rim. Then I tucked in two perfect violas and a sweet pea grown by Little State Flower Company, and finished by adding two exquisite petite ranunculus from Pistil and Stamen, one nestled in at the front and the other reaching up tall on the left side.

Library of Congress Cataloging-in-Publication Data.
Names: Rizzo, Jill, author.
Title: The little flower recipe book / Jill Rizzo ; photographs by Maaike Bernstrom.
Description: New York : Artisan, a division of Workman Publishing Co., Inc. [2022]
Identifiers: LCCN 2021044281 | ISBN 9781648290534 (hardback)
Subjects: LCSH: Miniature flower arrangement.
Classification: LCC SB449.5.M56 R59 2022 | DDC 745.92—dc23/eng/20211013
LC record available at https://lccn.loc.gov/2021044281

Design by Nina Simoneaux

Artisan books are available at special discounts when purchased in bulk for premiums and sales promotions as well as for fund-raising or educational use. Special editions or book excerpts also can be created to specification. For details, contact the Special Sales Director at the address below, or send an e-mail to specialmarkets@workman.com.

For speaking engagements, contact speakersbureau@workman.com.

Published by Artisan
A division of Workman Publishing Co., Inc.
225 Varick Street
New York, NY 10014-4381
artisanbooks.com

Artisan is a registered trademark of Workman Publishing Co., Inc.

Published simultaneously in Canada by Thomas Allen & Son, Limited

Printed in China on responsibly sourced paper

First printing, March 2022

10 9 8 7 6 5 4 3 2 1

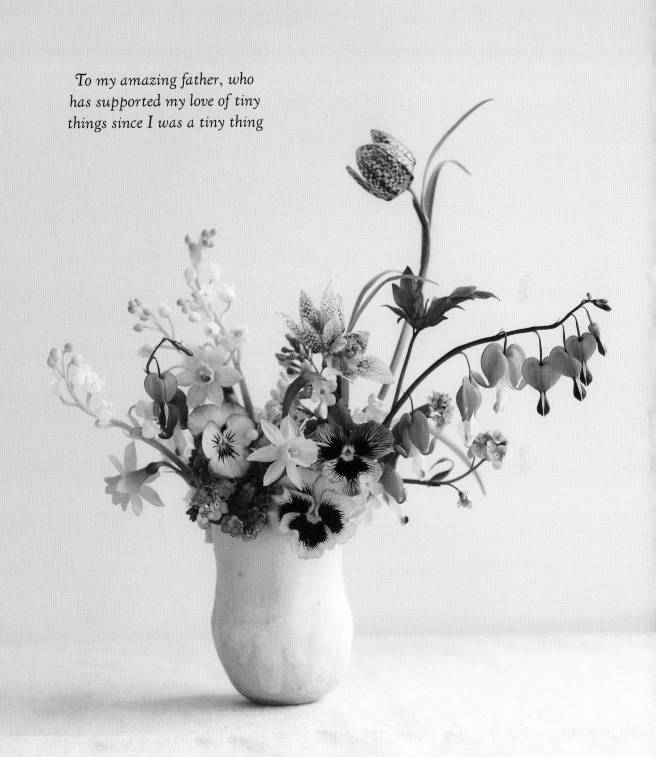

To my amazing father, who
has supported my love of tiny
things since I was a tiny thing

CONTENTS

Spring

ALLIUM
26
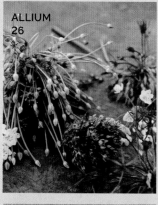

LILAC
48
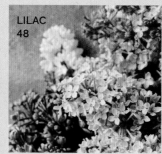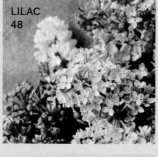

LILY OF THE VALLEY
56
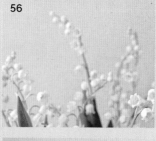

DAFFODIL
34
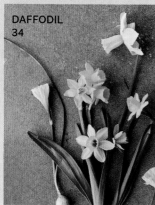

MUSCARI
64
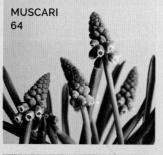

FRITILLARIA
42
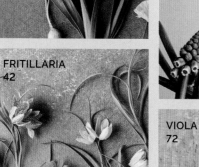

VIOLA
72

Summer

BACHELOR'S BUTTON
82
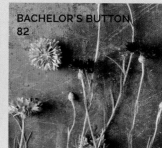

NASTURTIUM
114
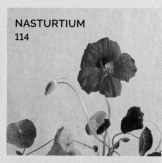

CHINESE FORGET-ME-NOT
90
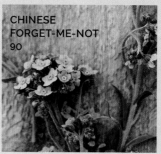

SUCCULENT
122
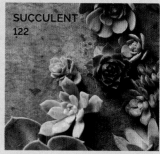

GOMPHRENA
98
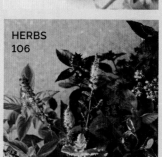

VERONICA
130
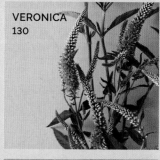

HERBS
106
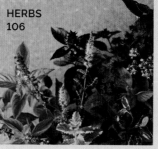

WEEDS
138
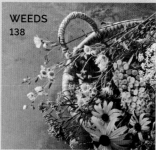

Autumn

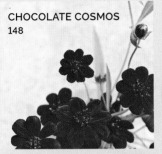

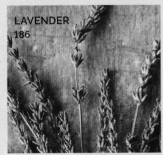
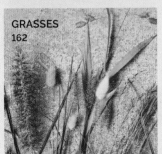
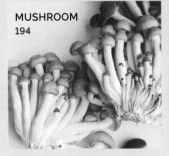

Winter

INTRODUCTION

I appreciate flowers of all sizes, but the tiny ones have always been nearest and dearest to my heart. As the daughter of a florist, I have happy childhood memories of fashioning little bouquets from scrap flowers in my mother's shop. There was a small section of the display cooler reserved for my creations, which customers would sweetly "purchase," to my extreme delight. There were also foraging trips to the park across the street for lily of the valley, and Johnny-jump-up bouquets made from the purple and yellow invaders that took over the cracks in my grandmother's patio.

Making a little arrangement is an act that is just for you. The tiniest ones may seem impractical, but their purpose is in the pleasure of slowing down and marveling at their intricate detail. They may last for a week or just an evening, inspiring you to create a new treasure tomorrow. I work with big, beautiful flowers every day, but the ones that most often end up on my windowsill at home are these little gems. They are everywhere—and once you start looking, you won't be able to unsee them.

HOW TO USE THIS BOOK

The recipes that follow are organized loosely by season and showcase dozens of little flowers, each arranged first on their own, then in combination with a collection of complementary ingredients. This book doesn't delve into specific plant varieties or use botanical terminology but instead provides an inspirational road map for seasonal combinations. Don't hesitate to make substitutions depending on what is available to you. Whether you want to replicate a recipe as closely as possible or re-create a color palette with entirely different blooms, the arranging techniques demonstrated throughout the book will help you design beautiful miniature arrangements with the flowers you have.

You'll see that individual recipes are often identified as either a "Micro Arrangement" or a "Mini Arrangement." Micro arrangements are pared down to the smallest form of each ingredient, typically in a vase that is less than 2 inches (5 cm) in size. Mini arrangements are slightly larger, using more stems and larger sprigs. There are also wreaths, garlands, place settings, gift toppers, floating displays (compositions created by floating ingredients in water in a low dish, intended to be viewed from above), and more!

A few additional notes:

- The colors listed in the descriptions are the ones most commonly available, but there may be more out there!

- Bloom size will vary depending on what stage of growth the flowers are harvested in and the health of the plant; struggling plants often produce smaller flowers.

- Proper harvesting techniques can make a big difference for a flower's vase life. Generally, try to cut blossoms early in the day before the temperature gets hot. Use sharp, clean tools. Immediately place the stems into a clean bucket of cold water and keep in a cool place for a few hours or overnight before using them in designs. Some materials, like weeds and tender new growth, just don't like to be cut, so no matter how well they are processed, they will wilt quickly.

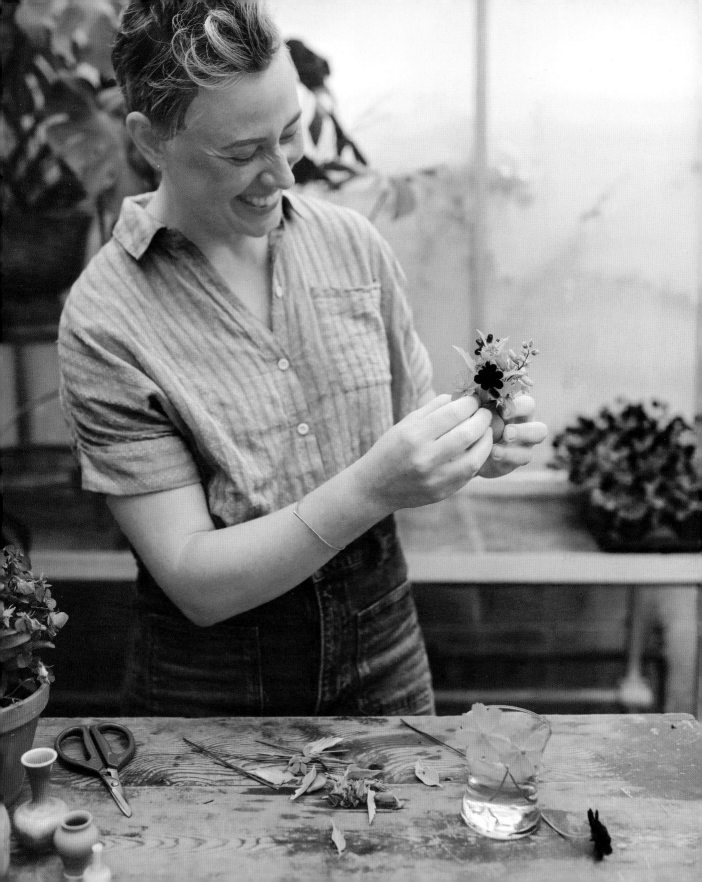

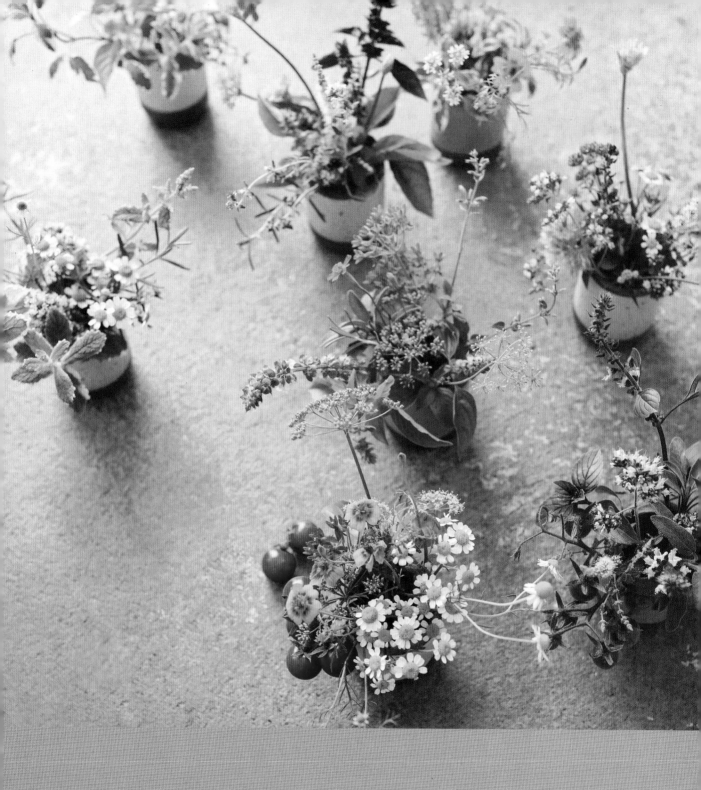

Herbs are prolific producers of some of the tiniest flowers; just a few plants can yield a miniature summer bounty.

THE INGREDIENTS

SOURCING LITTLE FLOWERS

My favorite way to source all kinds of plant materials is to purchase them right from the growers: the most direct route from the field into your vase is ideal. This may mean ordering from a local flower farmer, visiting your neighborhood farmers' market, or having stems shipped from a nearby grower. I also enjoy visiting nurseries to look for unusual varieties that I can plant in my garden for future harvesting, and with an eye on the roadside, I'm constantly culling material from the ever-changing landscape around me. Here are my go-to spots to find flowers:

CUTTING GARDENS. Whether you have an acre of land or a few pots on your fire escape, your home garden is the best place to cherry-pick the tiniest materials.

FLORISTS. With access to national wholesale farms and the international market, your local florist can be an invaluable resource for seasonal and special-order cut flowers as well as unique plants.

FLOWER FARMS. Many new farms have popped up across the country over the past ten years, and some specialize in unique flower varieties.

GARDEN CENTERS. Seasonal plant selections and houseplants provide a wide array of flowers and foliage that aren't available as cut stems.

GROCERY STORES. Stocked with durable blooms and small plants and produce, some specialty grocers offer selections rivaling that of a florist.

NATURE. Keep your eyes peeled for interesting weeds, grasses, twigs, and shrubs—but never clip anything from someone else's property without permission.

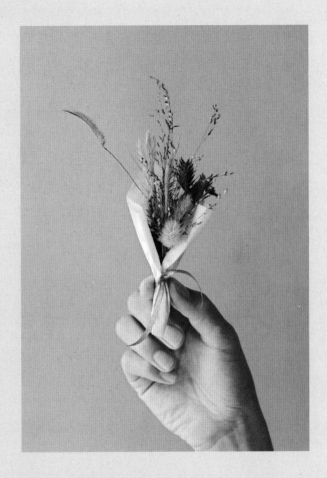

This autumnal posy combines several specialty grasses sourced from a local nursery along with tiny feathery blooms plucked from the lawn.

HARVESTING LITTLE FLOWERS

Several different types of little flowers are used in these recipes:

TINY BLOOMS. Flowers whose mature size is naturally diminutive.

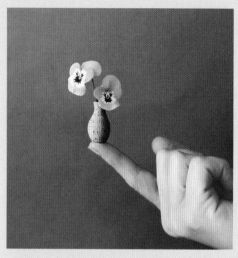

Less than an inch (2.5 cm) tall when full size, violas are big on character.

FLORETS. Individual blooms clipped from a larger flower.

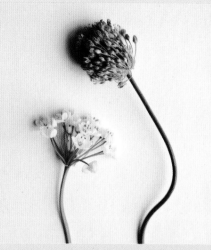

Alliums grow in an umbel formation, with a single floret at the end of each tiny stem.

SECONDARY BLOOMS. Smaller versions of the main flower on a stem.

Though a full-size hyacinth stem is too large for a little arrangement, these bulbs sometimes send up a miniature secondary bloom.

RUNTS. Mature blooms that have not grown to the average size.

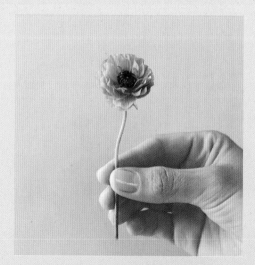

A delicate ruffled ranunculus bloom was the runt of the bunch but perfect in its own way.

SPRIGS. Sections pruned from a larger flower or branch.

Chinese forget-me-nots grow in branched clusters with one stem yielding several sprigs. Cluster the sprigs at a similar height to create tiny lush compositions.

Veronica, sage, and astilbe are tall, pointed flowers made up of smaller spikes that can be trimmed apart to create delicate, wispy arrangements.

SPECIAL INGREDIENTS

EDIBLES. Petite edibles like strawberries and mushrooms combine beautifully with flowers, whether in arrangements or displayed alongside them in a seasonal tablescape.

BULBS. Most bulb flowers can be removed from the soil and displayed out of water if the roots are kept moist. Flowers on the bulb last longer than cut stems because their food source is still attached.

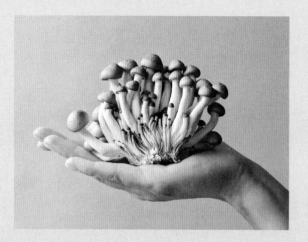

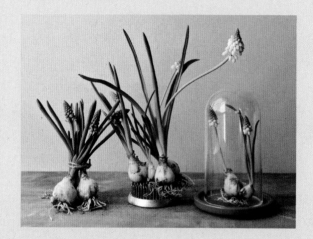

HOUSEPLANTS. Houseplants are a great resource for unique, long-lasting foliage when fresh materials are scarce. Clip just a few leaves at a time to keep the plant looking full for display.

SUCCULENTS. Succulents are easy to propagate to create ingredients for the tiniest of pots. When set on dry soil, a baby plant will appear at the end of a detached leaf after a few weeks!

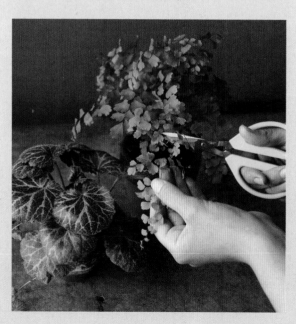

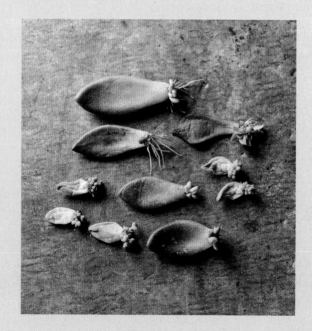

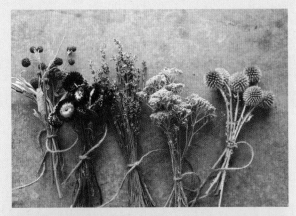

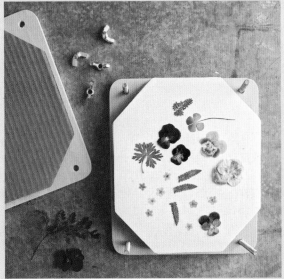

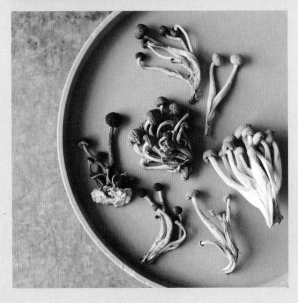

DRYING AND PRESSING

When flowers are plentiful, set aside an assortment to dry for use in fall and winter. Use freshly harvested open flowers for best color and sturdiness. Plants known as everlastings are ideal for this purpose. Composed of papery bracts, everlastings retain their color well and have a similar look whether fresh or dry. Strawflower, gomphrena, celosia, and ammobium fall into this category, as do a variety of grasses and pods. Experiment with different materials using the drying techniques below to see what you like best.

HANGING

Prepare flowers (shown above left, from left to right: buddleia, strawflower, lavender, yarrow, and echinops) for drying by removing the foliage from the stems and loosely bunching the blooms to allow for airflow. If the flowers are packed together too tightly, the petals can get moldy. Hang the bunches upside down in a dark, dry area for a few weeks or until they are stiff.

PRESSING

A flower press, or a heavy book with a weight on top, can preserve delicate materials for future use in framed projects, cards, and place settings. Use freshly opened, undamaged flowers and make sure they are dry before adding to a press. Thin blooms like violas and forget-me-nots can be pressed in their entirety, while thicker blooms need to be disassembled and the individual petals pressed. Layer your press by stacking sheets of cardboard and paper between your flowers, in this order: cardboard, paper, flowers, paper, cardboard. The hardest part is waiting a month before opening to see the results!

DRYING EDIBLES

Incorporate unexpected materials like mushrooms and citrus fruit into your dried repertoire. The mushrooms shown here were left to air-dry on a tray for several weeks. Fruit can be thinly sliced and dried in a very-low-temperature oven for a few hours, then glued onto wreaths or other projects.

STOCKING YOUR TOOLBOX

Keep your supplies organized so you are always ready to arrange when you come across a little treasure. Most of these supplies can be purchased at your local craft store or floral shop.

1. **CHICKEN WIRE.** Bendable coated wire useful for stabilizing stems and creating mounded sculptural pieces.

2. **PIN FROG (KENZAN).** Small flower holder with spikes in various sizes; handy for quick and airy designs.

3. **WATERPROOF TAPE.** Used to secure bunches, hold down a chicken wire structure, or create a tape grid.

4. **RUBBER BANDS.** Good for binding bunches of stems to keep them clustered in an arrangement.

5. **TWEEZERS AND ANGLED TWEEZERS.** Useful for placing tiny florets in vases or creating floating compositions.

6. **FLORAL SNIPS.** Your number one tool for trimming stems and removing foliage; keep clean and sharp to avoid crushing stems.

7. **RIBBON.** Decorative element used for finishing flair or hanging.

8. **TWINE.** Natural fiber string for garlands, gift toppers, and wrapping stems.

9. **SPOOL WIRE.** Available in different gauges; used to continuously wrap ingredients onto a wreath form.

10. **EMBROIDERY FLOSS.** Colorful thick string for creating garlands and gift toppers and for wrapping stems.

11. **NEEDLES.** Used with thread or embroidery floss to string flower heads into garlands.

12. **THREAD.** Colorful thin string for creating garlands and wrapping stems.

13. **FLORAL WIRE.** Available in different gauges and lengths; used in wreath making and to create stems on succulents and fruit.

14. **SKEWERS.** Used to create artificial stems for fruit and other ingredients, so they can easily be added to projects.

15. **FLORAL GLUE.** Gel-like adhesive used to attach flowers and leaves to almost any surface.

16. **BIND WIRE.** Paper-coated wire that doesn't pinch delicate stems as much as regular wire; useful for securing bunches and for wreath and garland making.

CELLOPHANE TAPE (NOT PICTURED). Can be used to create an "invisible" grid on top of a vase to hold stems in place.

DOUBLE-SIDED GLUE TABS (NOT PICTURED). Sometimes placed on the bottom of a micro vase to stabilize it and keep it from tipping after completion.

A NOTE ON FLORAL FOAM

Green bricks of floral foam have been used by florists for hydration and structure in arrangements for many years, but the material's negative impact on the environment (microplastic pollution) and health (inhalation of fragments can cause respiratory harm) have spurred many in the industry to seek alternative arranging methods. All the projects in my books are made without foam, and I encourage you to try using earth-friendlier options, such as chicken wire or pin frogs, for your arrangements of all sizes.

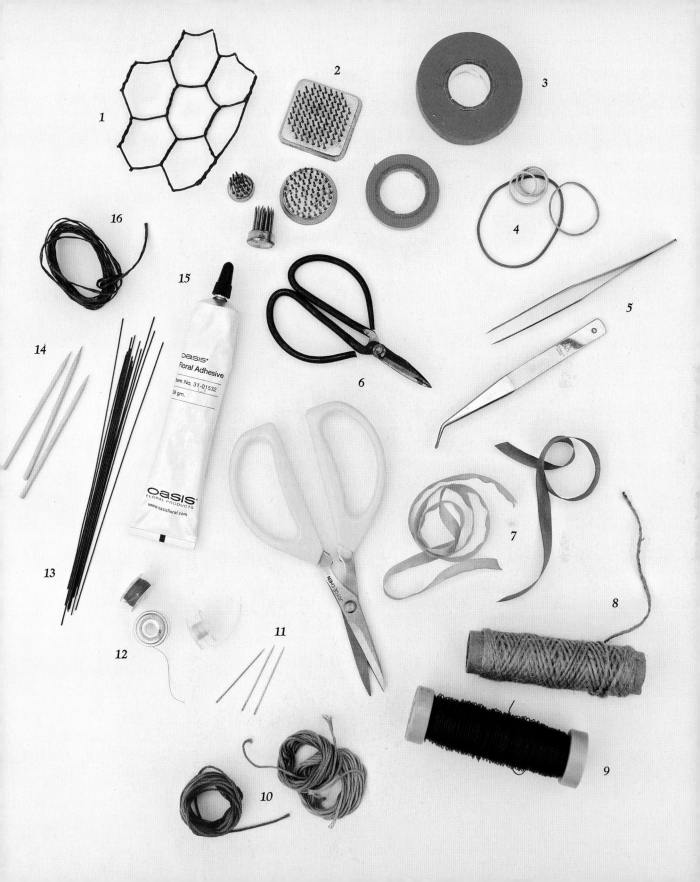

CHOOSING YOUR VESSEL

Just as delightful as the blooms that they hold, tiny vases celebrate smallness and give weight to the most diminutive materials. Among the littlest are dollhouse-scale vessels and beautifully handmade ceramic micro vases designed to hold just a few wire-thin blooms. (Use caution when searching for miniature vessels online: you might lose a night's sleep falling down a tiny-vase rabbit hole on Etsy. I certainly have.)

Flower size, shape, and quantity should guide you in determining the vase you choose for an arrangement, so keep on hand a few different vessels with various heights and diameters (for some of the sources featured in this book, see page 271). Before you begin arranging, decide what you like about your flower and how you can accentuate that feature. A narrow-mouth bottle will highlight tall, delicate stems, while a low cup with a pin frog showcases chunky blooms with thick stems. A set of five or more small cups or similarly shaped bud vases are useful to create tablescapes.

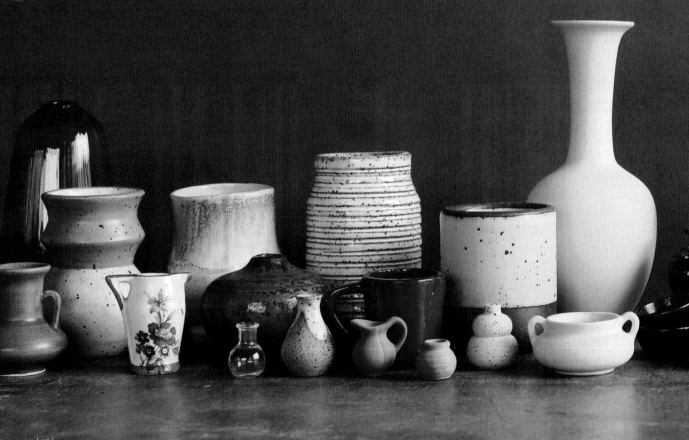

In addition to all the vases designed to hold flowers, tiny vessels come in many other forms, including:

PERSONALITY PIECES. Antiques shops are a great place to score special little containers like pitchers, creamers, candy tins, perfume bottles, laboratory glass, and wooden boxes that can be used as vases if they are watertight or lined.

TRAVEL-SIZE CONTAINERS. Honey, jam, condiments, and toiletries are often packaged in cute travel-size bottles; save a special one from your next trip and relive the vacation every time you arrange in it.

BOTTLES. They are manufactured in a wide variety of sizes and materials, and their narrow openings are ideal for displaying just a few stems.

KITCHENWARE. Food and drink containers come in many specialty shapes and sizes. Cups and glasses for shots, shooters, aperitifs, espresso, sake, punch, and cordials all make sweet vases, as do ramekins and condiment bowls.

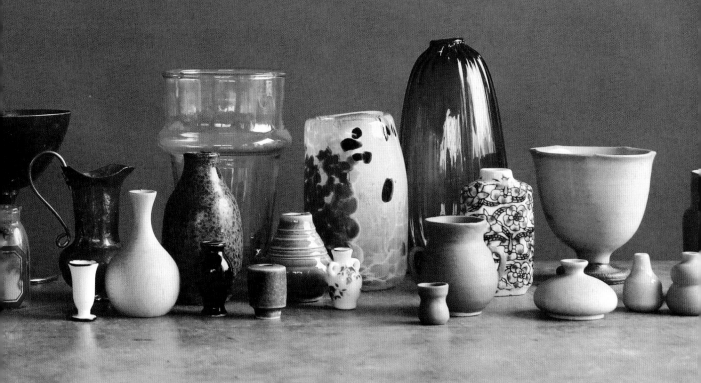

TECHNIQUES

STEM PREPARATION & CUTTING

ANGLED CUTS

Trim the stem of each flower right before you add it to the vase. Use an angled cut when trimming individual stems to create a longer surface area and increase water absorption. The cut stem should be exposed to the air for as little time as possible.

CUTTING STEMS FOR A BOUQUET

Cut bouquet stems straight across together for a clean look.

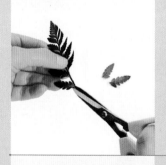

TRIMMING STEMS

When working with sprigs, remove some of the lower florets or leaflets to expose more of the stem, which is useful for design work. Because small stems are delicate and can be easily torn, use snips to trim off the lower leaves as close to the stem as possible.

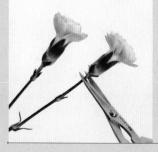

TRIMMING HEADS

Some blooms, like this mini carnation, have a receptacle that holds the petals together; be careful not to trim the stem too short or the petals will fall apart.

ARRANGING & STABILIZING

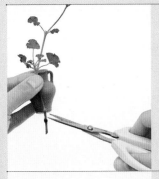

MEASURING STEMS TO CUT
To determine where to trim a stem, hold it next to the vase and decide where you want the blooms and foliage to rest. Remove the lower leaves that will fall below the rim, then trim and add to the vase.

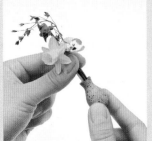

ARRANGEMENT IN HAND
Because small vases can be easily tipped, try designing your arrangement "in hand" and adding it to the vase at once: Hold your flowers just below the base of the blooms, then measure and trim the stems so that the blooms will rest at the rim.

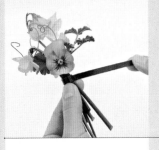

BOUQUET IN HAND
Follow the steps above to create an arrangement in hand, but rather than inserting into the vase, use floral tape to secure the stems just below the blooms. This technique is useful for boutonnieres, gift toppers, and wrapped bouquets.

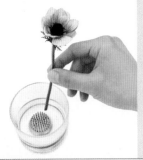

PIN FROG
A pin frog, or kenzan, is a floral arranging tool with small spikes poking up from a sturdy metal base. Pin frogs are available in many shapes and sizes and are extremely useful for creating small, airy compositions by pushing the stems of your flowers into the pins. When you are working at this scale, affixing the pin frog to the vase with floral putty is not usually necessary; this allows you to easily transfer the pin frog to other containers.

CARING FOR LITTLE FLOWERS

WATER & LONGEVITY

Unless otherwise noted in a recipe, always fill your vessel with fresh cold water. Tiny vases don't hold much water, so they need to be filled more frequently than larger ones. A small squirt bottle is ideal to add a few drops of water to the vase. Regular water changes and occasional stem recutting are the best ways to prolong the life of an arrangement. Bacteria from dirty water will clog the flowers' stems and prevent them from drinking. And just like us, when flowers can't drink, they become dehydrated and wilt. Keep arrangements cool and out of direct sunlight; both heat and sunlight cause wilting and encourage bacteria growth in the water. Scrub buckets and vases well after use to avoid yucky buildup. A petite bottle brush with a soft end is helpful in cleaning smaller vases with narrow openings.

BAGGING

Bagging is a way to keep small bunches of delicate ingredients hydrated for a prolonged period outside a vase. Wrap the bottom of the stems together in a wet paper towel and place the wrapped stems in a small plastic bag with a small amount of water. Seal the top of the bag with a piece of floral tape and add the bag to your project.

TOXICITY & SAP

Many flowers contain some level of toxicity. If you have small children or pets that like to munch on leaves, keep all arrangements out of reach. Some flowers, like hyacinth and narcissus, ooze a clear sap from the stems when cut. Use caution when handling them, because the sap can irritate skin and may be poisonous to other flowers. If possible, trim the stems and place them in a bucket of water for a few hours, until the sap stops flowing, before using them. When you add the flowers to the arrangement, do not retrim the stems.

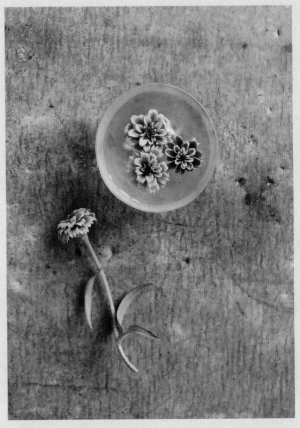

Floating the heads of broken or wilted flowers in a low bowl is a great way to extend the life of blooms otherwise destined for the compost bin.

DESIGN TIPS

The recipes that follow offer precise instructions for bloom selection and placement, but don't be discouraged if you can't replicate a design exactly. Feel free to use shape, variety, or palette as a starting point for your own arrangements. Here are a few general guidelines to keep in mind as you do.

- To make your design appear to grow from the center of the vase, place stems at a slight angle through an imaginary X in the center of the vessel rather than inserting them straight down.

- Varying the size and shape of blooms, clustering similar ingredients, and using directional elements like spires and vines help move the eye around an arrangement.

- Pay close attention to which direction your blooms are facing in the composition: whether pointed toward each other in an intimate conversation or looking away and ignoring one another. A simple twist can change the entire attitude of an arrangement.

- Empty space is just as impactful as the flowers—arrangements don't always need to be packed full.

- Choose what you like about a flower and emphasize it. If it has a beautiful bloom with an uninteresting stem, chop it short and place it front and center. If a stem has particularly graceful curves, let it rise above the other ingredients and show off.

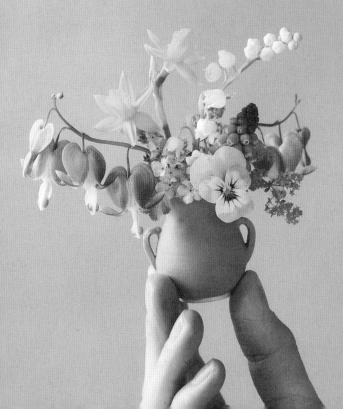

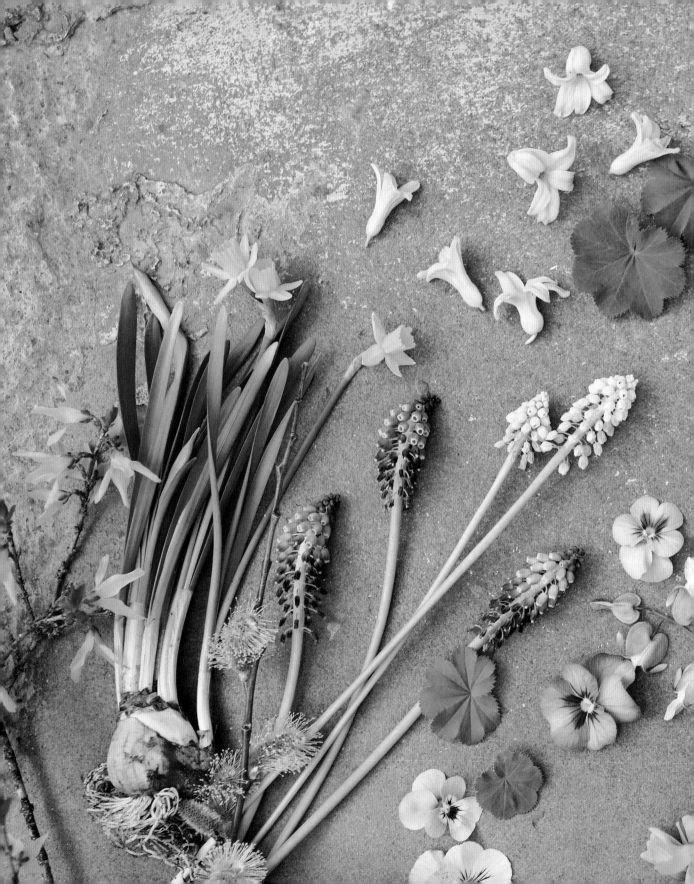

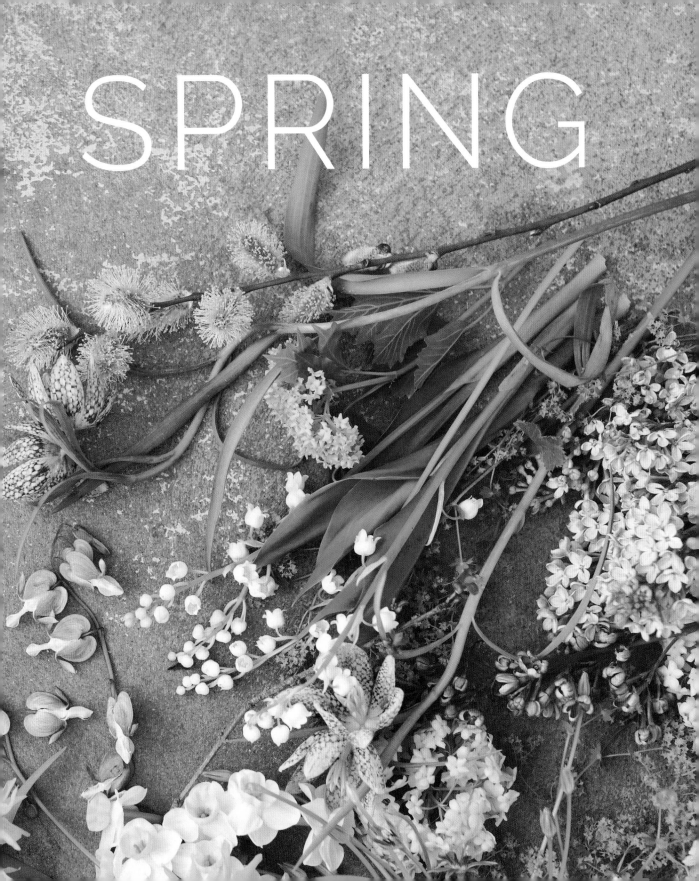

SPRING

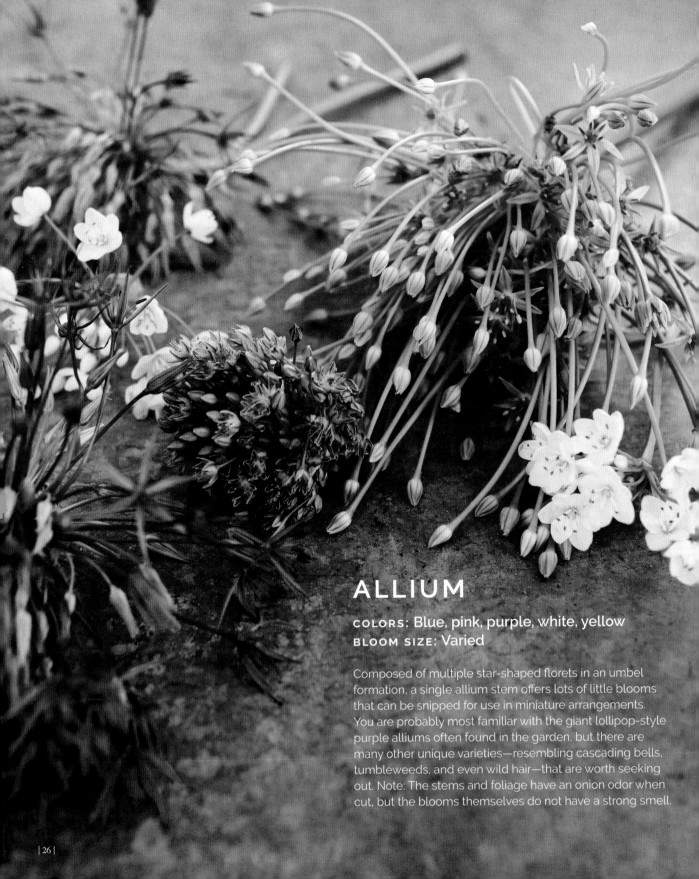

ALLIUM

COLORS: Blue, pink, purple, white, yellow
BLOOM SIZE: Varied

Composed of multiple star-shaped florets in an umbel formation, a single allium stem offers lots of little blooms that can be snipped for use in miniature arrangements. You are probably most familiar with the giant lollipop-style purple alliums often found in the garden, but there are many other unique varieties—resembling cascading bells, tumbleweeds, and even wild hair—that are worth seeking out. Note: The stems and foliage have an onion odor when cut, but the blooms themselves do not have a strong smell.

ALLIUM

RECIPE 1
ON ITS OWN

INGREDIENTS

10 allium florets, assorted
varieties, with buds and blooms

VESSEL

1-inch-tall (2.5 cm) ceramic
bud vase

When working with larger allium varieties, you'll want to snip off the individual florets, each with its own long stem. Incorporate both buds and open blooms so the composition feels varied, even in an extremely diminutive vase.

1. Place three allium florets leaning out the left side of the vase at varying heights.

2. Set four more florets at similar heights to the first three, with two leaning right and two faceup in the center.

3. Nestle the remaining three florets on the center rim so their stems are not visible.

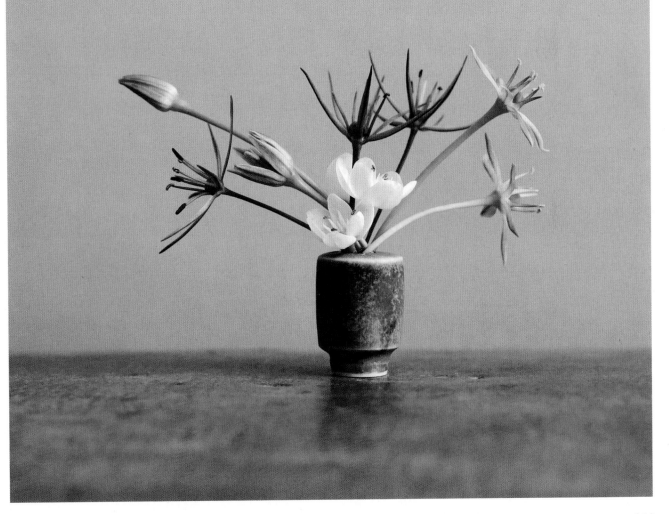

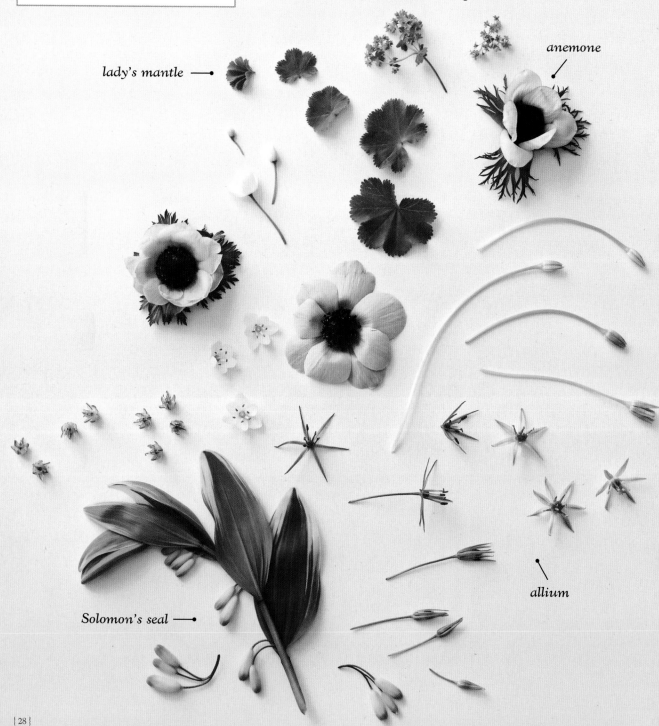

ALLIUM

RECIPES 2-4
INGREDIENTS

When grouped together, the star-shaped florets of allium and lady's mantle evoke a tiny fireworks display. Seek out petite anemones from your local flower farmer and clip the dangling bell-shaped blooms from Solomon's seal to scale down materials that are traditionally valued for their larger blooms and longer stems.

lady's mantle →

anemone

Solomon's seal →

allium

ALLIUM

RECIPE 2
MICRO ARRANGEMENT

INGREDIENTS

12 allium florets, assorted
varieties

3 allium floret buds

1 white allium stem

3 lady's mantle sprigs

6 Solomon's seal florets

1 anemone bloom

VESSEL

1½-inch-tall (4 cm) ceramic vase

For a spring palette that feels bright yet soothing, pair chartreuse foliage with cool-toned flowers in a pale blue vase.

1. Cluster the allium florets, at slightly varying heights, along the vase rim. Place the three allium buds curving up on the left side and the white allium stem leaning right.

2. Nestle two lady's mantle sprigs at the back and let the third curve down on the left. Carefully feed the delicate Solomon's seal floret stems through the allium cluster so the blooms dangle on both sides of the vase.

3. Place the anemone bloom at the highest point in the composition, with a slight curve to the left.

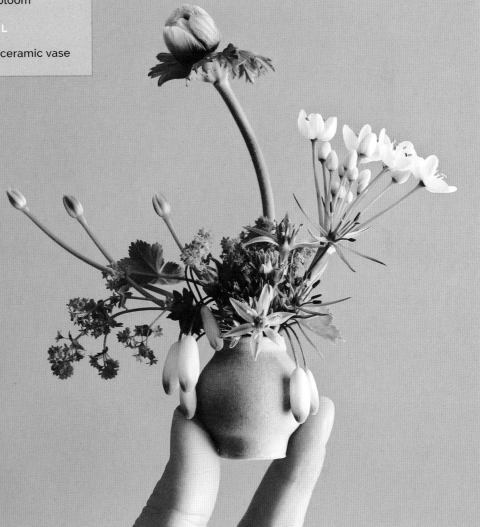

RECIPE 3
MINI ARRANGEMENT

INGREDIENTS

6 lady's mantle sprigs

1 allium stem

40 allium florets, assorted varieties

2 Solomon's seal sprigs

2 anemone blooms

VESSEL

2¼-inch-tall (5.5 cm) ceramic cup

1 Create a bunch in hand with five lady's mantle sprigs, lining up the lowest level of blooms. Trim and place in the cup in a cluster leaning to the left.

2 Place the allium stem leaning right. Create a bunch in hand with ten allium florets; trim and add together at the rim next to the allium stem. Repeat with ten more florets, adding these upright at the center. One at a time, nestle in ten more florets to rest on the lady's mantle. Create a bunch in hand with the remaining allium florets, trim, and lean it out the left side.

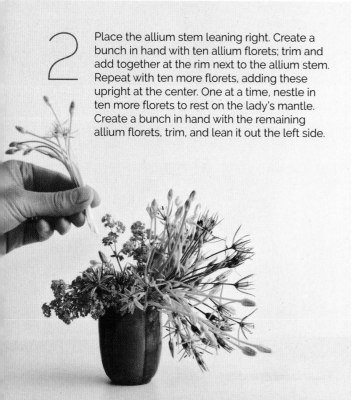

3 Add one Solomon's seal sprig curving down on the left and the other curving up and inward over the center. Place the remaining lady's mantle sprig high on the right. Finish by nestling one anemone bloom in the center front and the other on the left, mirroring the height of the lady's mantle.

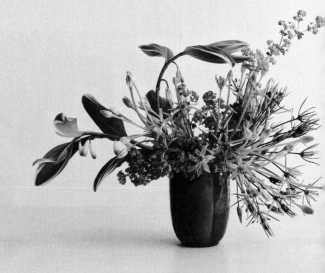

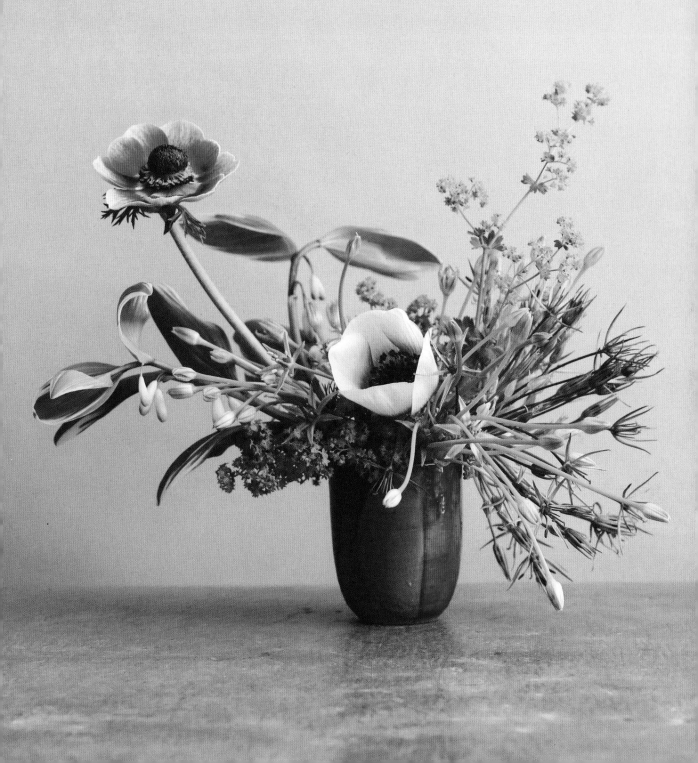

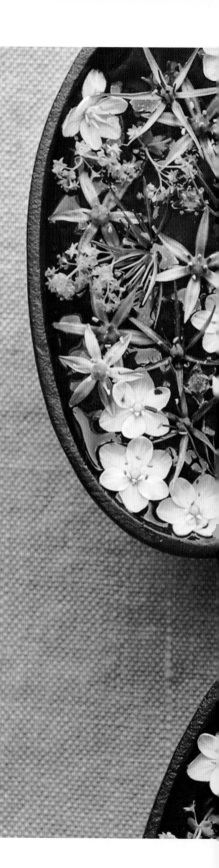

ALLIUM

RECIPE 4
FLOATING

INGREDIENTS

90 allium florets,
assorted varieties

2 lady's mantle sprigs with
leaves and blooms

VESSELS

3 oval ceramic bowls,
5¼ inches (13.5 cm) long

The intricate details of the allium and lady's mantle bloom and
leaf shapes are highlighted when placed faceup on the same
plane and silhouetted against the dark background of these low
ceramic dishes. Long, angled tweezers are useful for moving
the florets to adjust the design.

1. Fill the bowls to the top with water.

2. Gently set each ingredient to float on the surface. Create
small clusters to vary the composition by placing multiple
florets of the same variety next to one another.

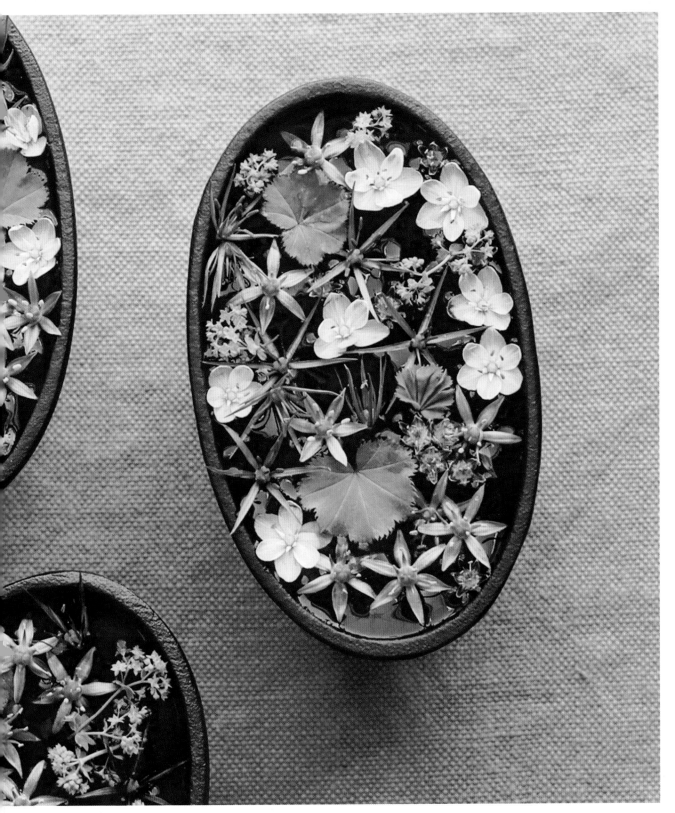

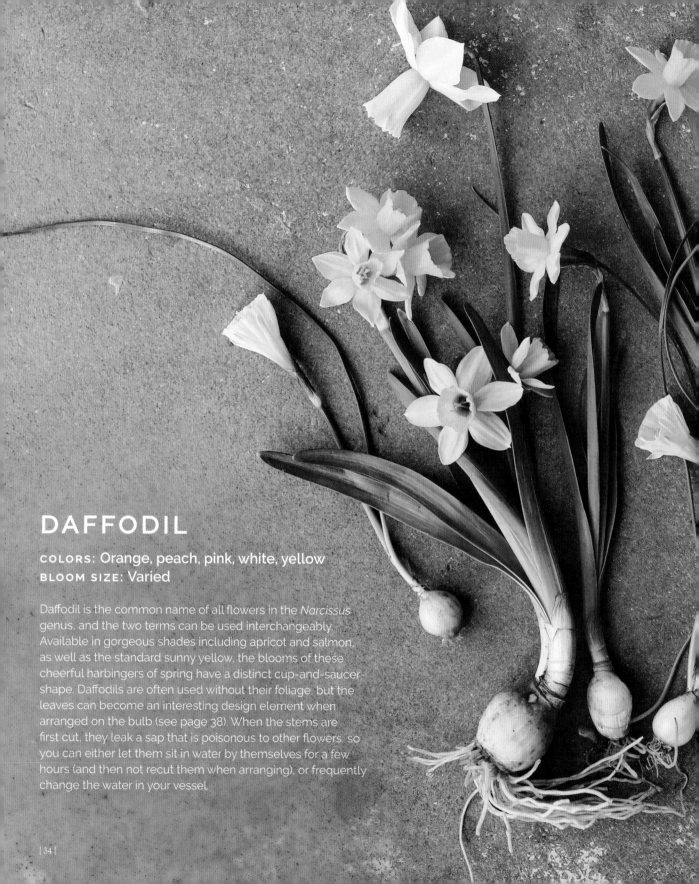

DAFFODIL

COLORS: Orange, peach, pink, white, yellow
BLOOM SIZE: Varied

Daffodil is the common name of all flowers in the *Narcissus* genus, and the two terms can be used interchangeably. Available in gorgeous shades including apricot and salmon, as well as the standard sunny yellow, the blooms of these cheerful harbingers of spring have a distinct cup-and-saucer shape. Daffodils are often used without their foliage, but the leaves can become an interesting design element when arranged on the bulb (see page 38). When the stems are first cut, they leak a sap that is poisonous to other flowers, so you can either let them sit in water by themselves for a few hours (and then not recut them when arranging), or frequently change the water in your vessel.

DAFFODIL

RECIPE 1
ON ITS OWN

INGREDIENTS

7 daffodil blooms,
assorted varieties

VESSEL

2¾-inch-tall (7 cm)
glass bud vase

A bud vase with a narrow opening perfectly anchors straight-stemmed daffodils into position.

1. Place the daffodils in the vase to lean out at various heights.

2. Gently turn the stems so their expressive blooms face in different directions, with some seemingly engaged in conversation and others minding their own business.

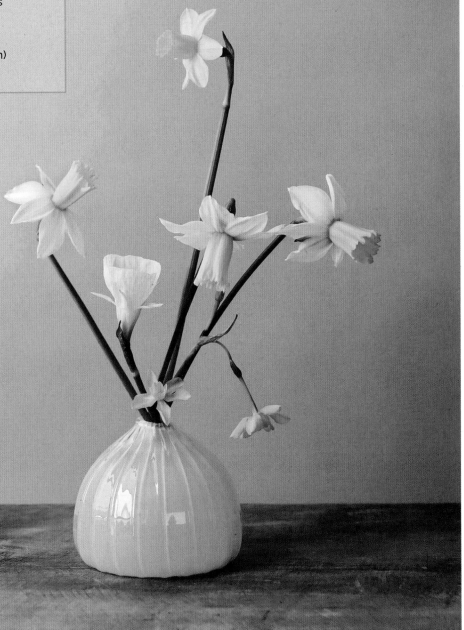

RECIPES 2–5
INGREDIENTS

This collection features an array of distinctly spring blooms with playful shapes and variation in scale. Tiny branches of pinhead-size spirea blossoms contrast nicely with chunkier hyacinth and daffodil florets. Bleeding heart stems can be used whole to showcase a gradation of bloom sizes or trimmed apart into individual hearts.

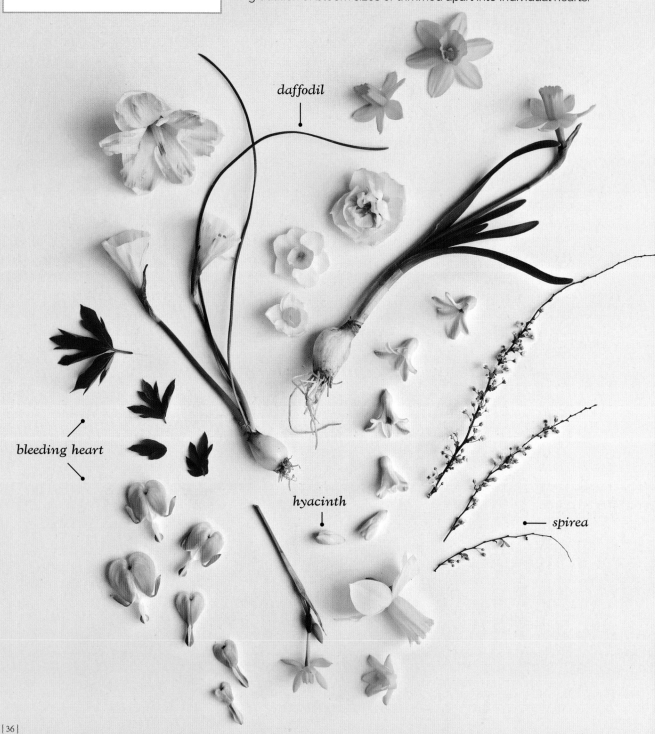

daffodil

bleeding heart

hyacinth

spirea

DAFFODIL

RECIPE 2
MICRO ARRANGEMENT

INGREDIENTS

1 bleeding heart sprig

1 hyacinth floret

2 daffodil blooms

1 spirea sprig

VESSEL & SUPPLIES

¾-inch-tall (2 cm) ceramic vase

Double-sided glue tab (optional)

This arrangement shouts spring love, with a joyful palette of pink and yellow and a prominent heart-shaped bloom.

1. Place the bleeding heart sprig so the largest bloom dangles at the front of the vase. Nestle the hyacinth floret next to it.

2. Set one daffodil bloom on the left side and the second one faceup in the center of the composition. Finish by placing the spirea curving upward on the right. If desired, add a glue tab to the surface where you wish to place the vase, to help stabilize the arrangement.

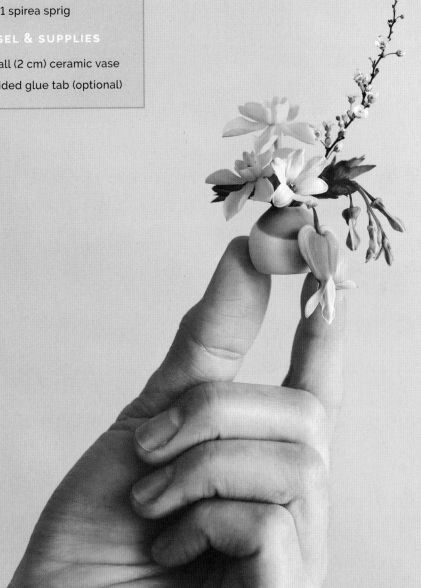

DAFFODIL

RECIPE 3
MINI ARRANGEMENT

INGREDIENTS

5 daffodils on the bulb, assorted varieties

8 daffodil blooms, assorted varieties

2 hyacinth sprigs

1 bleeding heart stem

2 spirea sprigs

VESSEL & SUPPLIES

Pin frog

4-inch-diameter (10 cm) low ceramic dish

1 Place the pin frog in the dish and add the daffodil bulbs in the center, with the blooms facing in different directions and the roots touching the water.

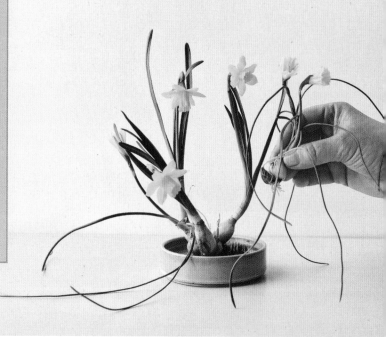

2 Place five daffodil blooms in a cluster at the right rim and the remaining three among the bulb blooms.

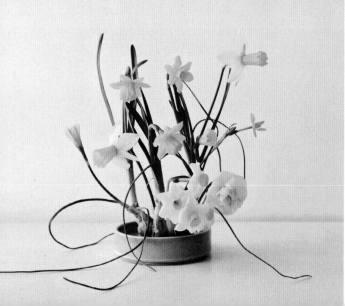

3 Add the hyacinth sprigs at the front and back, with the lowest blooms resting at the rim. Place the bleeding heart curving inward above the daffodils on the left. Place one spirea sprig curving upward on the left and the other at the highest point in the composition, curving inward on the right.

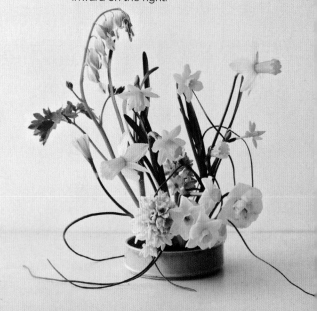

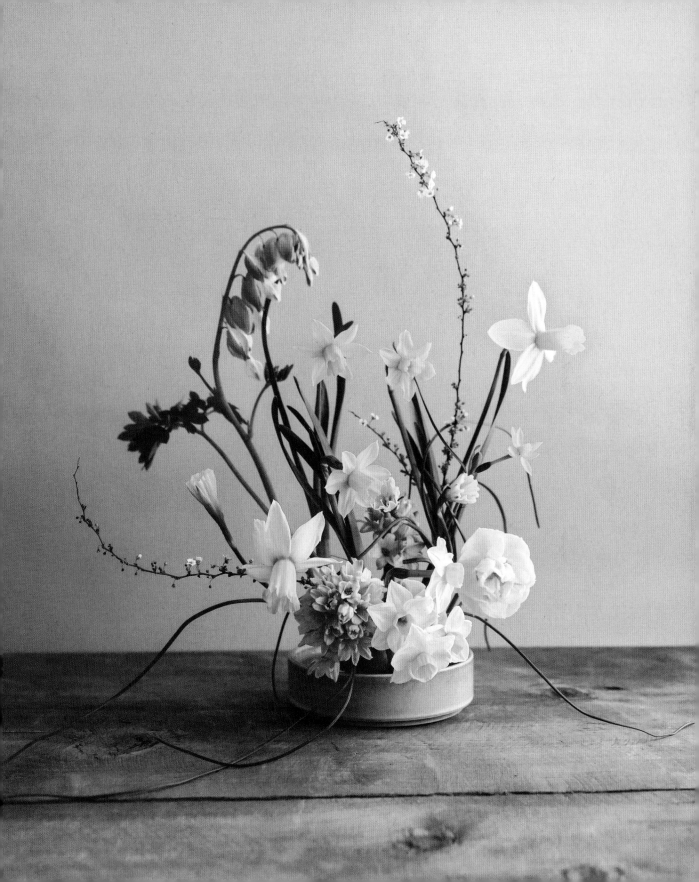

DAFFODIL

RECIPE 4
CONES

INGREDIENTS

18 daffodils, assorted varieties

2 hyacinth sprigs

5 spirea sprigs

2 bleeding heart sprigs

VESSELS & SUPPLIES

Floral tape

5 paper cones with ribbon (see page 269)

5 plastic bags

Paper towel

Twine

1 Create a posy in hand with assorted blooms, and secure with floral tape below the blooms. Trim the stems so the blooms will dangle over the rim of the cone when inserted. Create four more posies with the remaining materials.

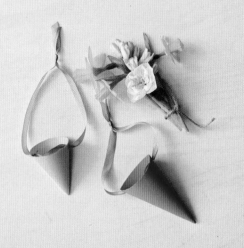

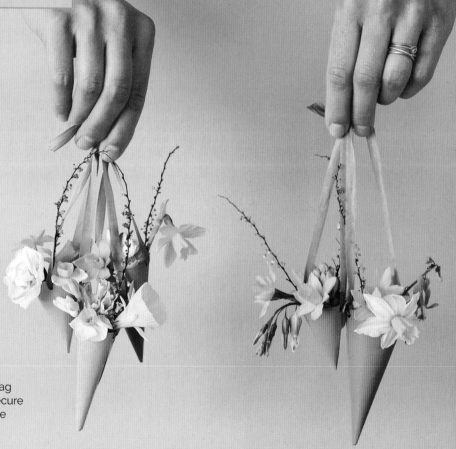

2 Place each posy in a plastic bag with a wet paper towel and secure with twine before resting in the cone.

DAFFODIL

RECIPE 5
BONUS: HYACINTH

INGREDIENTS

50 hyacinth florets

SUPPLIES

Three 12-inch (30.5 cm) pieces of medium-gauge wire

Three 6-inch (15 cm) pieces of ribbon

These architectural wreaths are made with individual hyacinth florets. Older hyacinth stems, with more open florets, will work better than tightly budded ones for this nested look. These wreaths will hold up well out of water for an evening.

1. Make a small loop in the end of a piece of wire. Insert the other end through the face of a hyacinth floret and out the other side. Pull the floret down the wire to the loop. Thread another floret onto the wire facing in the same direction and pull down close to the first one so they nest slightly. Repeat until the desired length is reached, using around fifteen more florets.

2. Gently bend the piece into a round shape and thread the end of the wire through the loop, making a twist to secure. Trim off the excess wire and adjust the florets to conceal the closure, then attach a ribbon to hang. Repeat the entire process to make two additional wreaths.

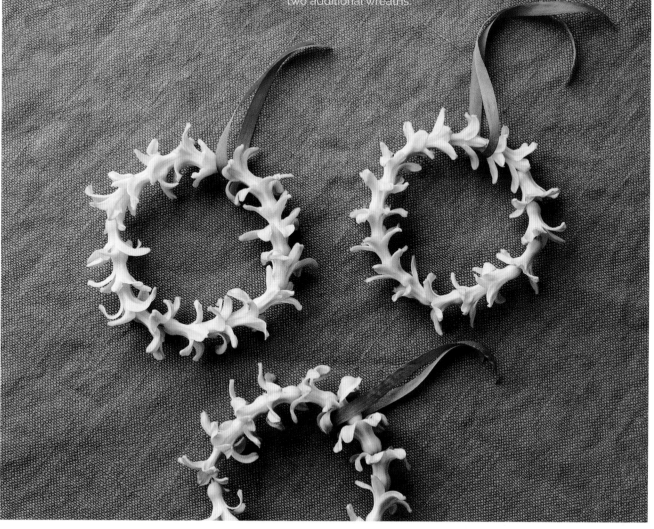

FRITILLARIA

COLORS: Green, orange, purple, red, white, yellow
BLOOM SIZE: Varied

With nodding bell-shaped blooms, narrow leaves, and delicate curved stems, fritillaria have a slightly exotic look compared with other spring bulb flowers. The *meleagris* species, also called snake's head, looks unreal with its distinct, high-contrast checkerboard pattern. The larger *persica* species has tall, thick stems, but the blooms are composed of many small florets that can be snipped for mini arrangements. Try planting the bulbs in your garden, or special order them as cut flowers from your local florist.

FRITILLARIA

RECIPE 1
ON ITS OWN

INGREDIENTS

9 fritillaria stems,
assorted varieties

VESSELS

5 vintage glass bottles
in assorted sizes
from 2½ inches (6.5 cm) to
4½ inches (11.5 cm) tall

Create an impactful fritillaria display to highlight their graphic
bell-shaped blooms and distinct slender leaves by separating
the varieties into individual bottles.

1. Trim and add the fritillaria stems to the bottles, keeping each
variety in its own vessel, so the lowest level of leaves curves out
at the rim.

2. Line up the bottles, clustering two on the left and three
on the right, and adjust the blooms so they face in different
directions without overlapping.

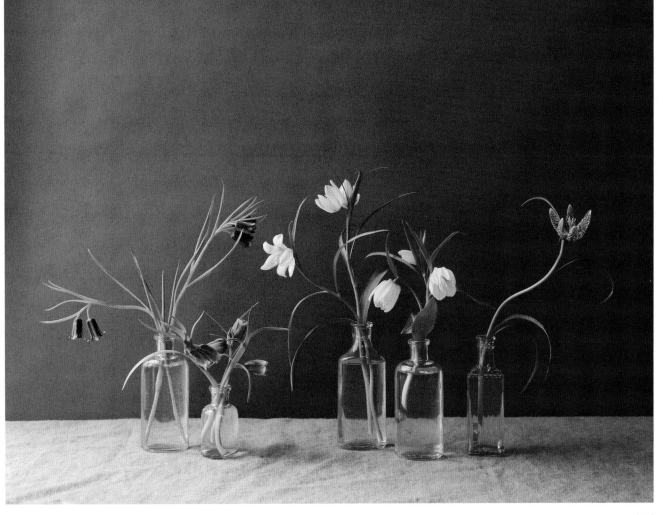

This moody spring collection takes a complementary color palette of yellow and purple to the dark side with almost-black accents. The ranunculus, fritillaria, and crocus petals all have high-contrast detailing that makes them look as though they were painted by hand.

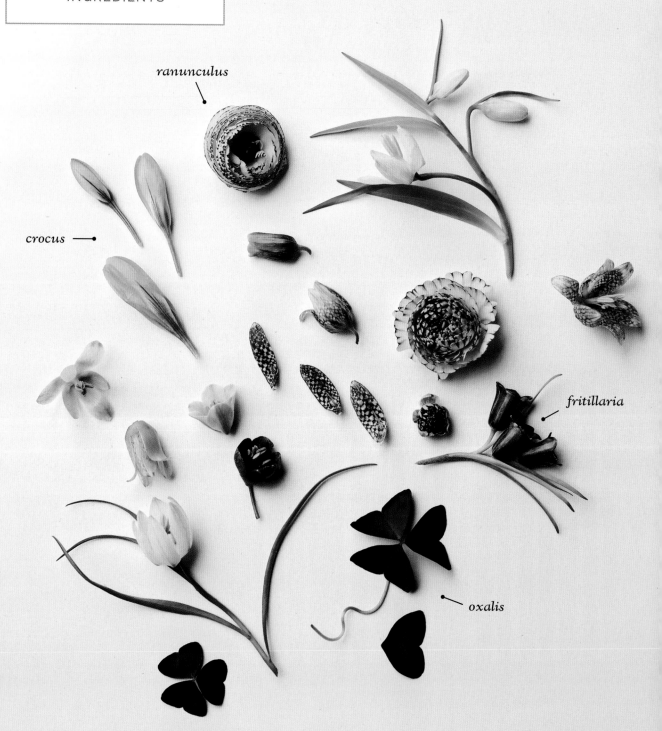

ranunculus

crocus

fritillaria

oxalis

RECIPE 2
TOWER

INGREDIENTS

14 fritillaria stems,
assorted varieties

6 fritillaria florets, assorted colors

5 oxalis leaves

4 crocus blooms

3 ranunculus blooms

VESSELS & SUPPLIES

18 glass vials in assorted sizes
from 1 inch (2.5 cm) to 3 inches
(7.5 cm) tall

Three-tiered tray

Double-sided glue tabs

Squirt bottle

Composed of glass vials with just one or two ingredients in each, this tiered tray arrangement is a great way to get vertical with short stems. Use glue tabs to hold the vials in place, and vary the stem heights for a richly layered display.

1. Arrange the vials in a pleasing composition on the three shelves: five on top, six in the middle, and seven on the bottom. Pick up the vials one at a time and stick a glue tab to the bottom, return to the shelf, and press gently to secure. Add water to each vial using a squirt bottle.

2. Place one or two ingredients in each vial, varying the heights so some rest at the rim and others curve outward on longer stems.

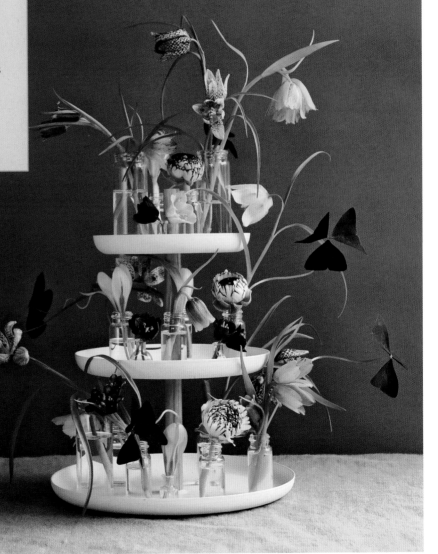

RECIPE 3
MINI ARRANGEMENT

INGREDIENTS

2 crocus blooms

2 ranunculus blooms

1 ranunculus bud

6 fritillaria stems, assorted varieties

2 oxalis leaves

VESSEL & SUPPLIES

Pin frog

2-inch-tall (5 cm) round porcelain vase

1 Place the pin frog in the vase and press the crocus blooms into it, one at the front rim and one facing upright in the center. Lean the ranunculus blooms out on the left side behind the crocus, one at the rim and the other a few inches (7.5 cm) higher. Lean the ranunculus bud out over the right rim.

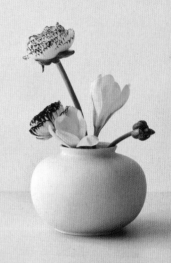

2 Nestle one fritillaria stem at the front left rim under the ranunculus and another leaning right.

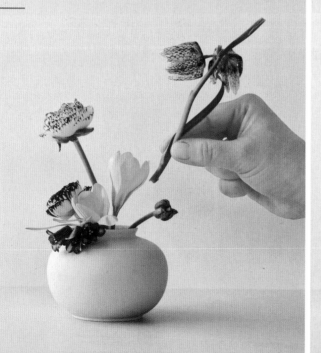

3 Add the remaining fritillaria stems at varying heights with the blooms facing different directions. Finish by nestling one oxalis leaf under the crocus at the rim and the other on the left side to balance the height of the fritillaria.

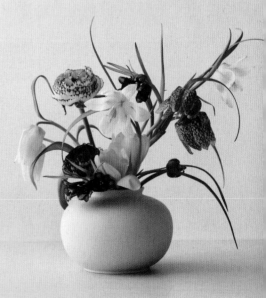

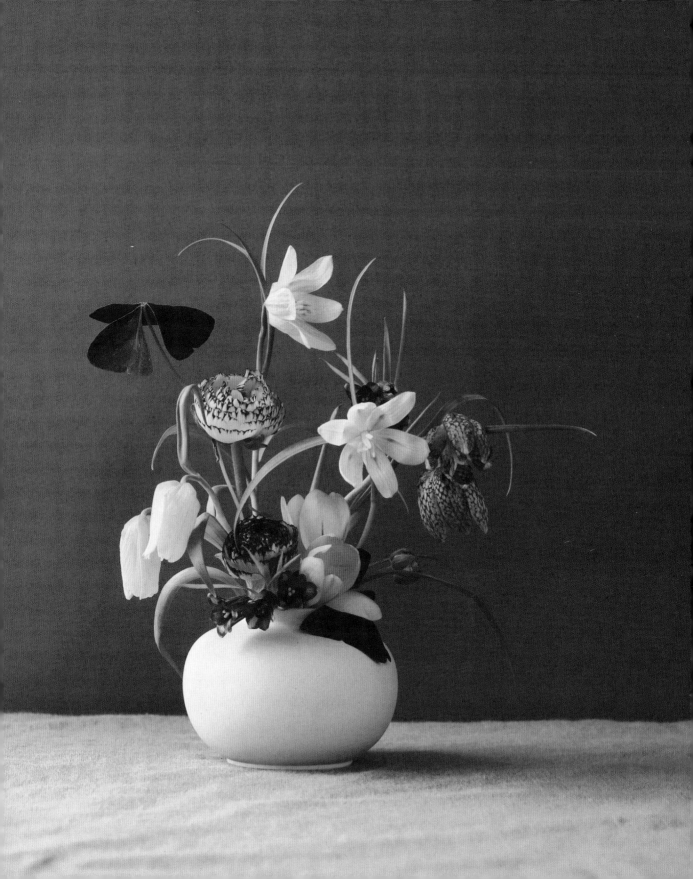

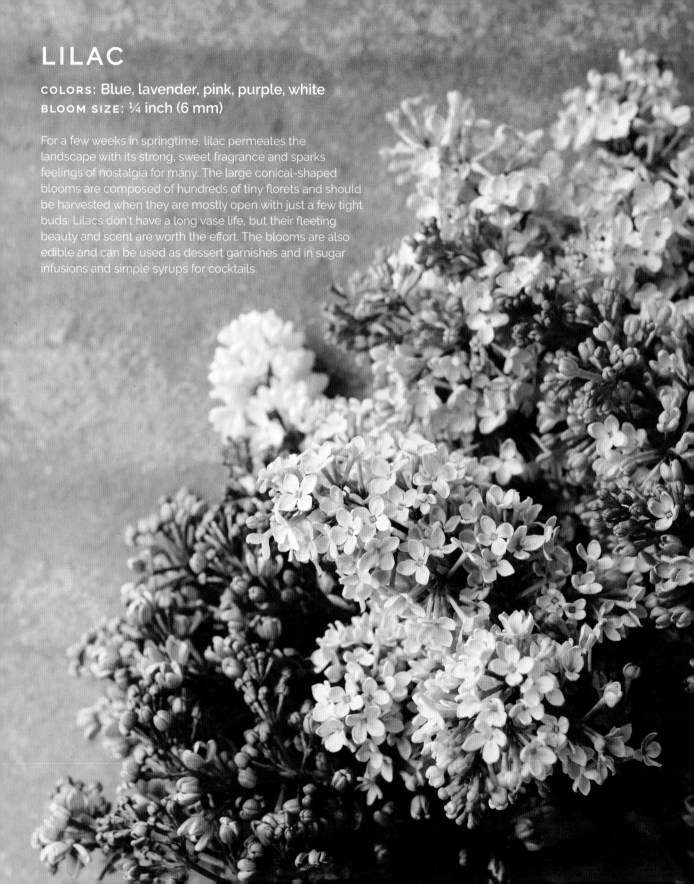

LILAC

COLORS: Blue, lavender, pink, purple, white
BLOOM SIZE: ¼ inch (6 mm)

For a few weeks in springtime, lilac permeates the landscape with its strong, sweet fragrance and sparks feelings of nostalgia for many. The large conical-shaped blooms are composed of hundreds of tiny florets and should be harvested when they are mostly open with just a few tight buds. Lilacs don't have a long vase life, but their fleeting beauty and scent are worth the effort. The blooms are also edible and can be used as dessert garnishes and in sugar infusions and simple syrups for cocktails.

LILAC

RECIPE 1
ON ITS OWN

INGREDIENTS

6 lilac sprigs, assorted colors

VESSEL & SUPPLIES

Rubber band

3½-inch-tall (9 cm) candy tin

This casual cluster of lilac sprigs placed in an antique-looking candy tin is an effortless treat for the bedside table.

1. Remove the florets from the bottom of each sprig to create a short stem about 1 inch (2.5 cm) long.

2. Create a bunch in hand, arranging the sprigs from dark to light, and secure with a rubber band. Slide the bunch into the tin, wedging the lowest level of florets just inside the rim to prevent the arrangement from popping out.

RECIPES 2–5
INGREDIENTS

The charm of this quirky collection of garden clippings comes from the varied shapes and sizes of the flowers. Most of the ingredients display buds alongside open blooms, evoking a feeling of fresh new growth. Experiment with snipping flowers from annual plants not typically used as cuts, like this hot coral spur-shaped diascia.

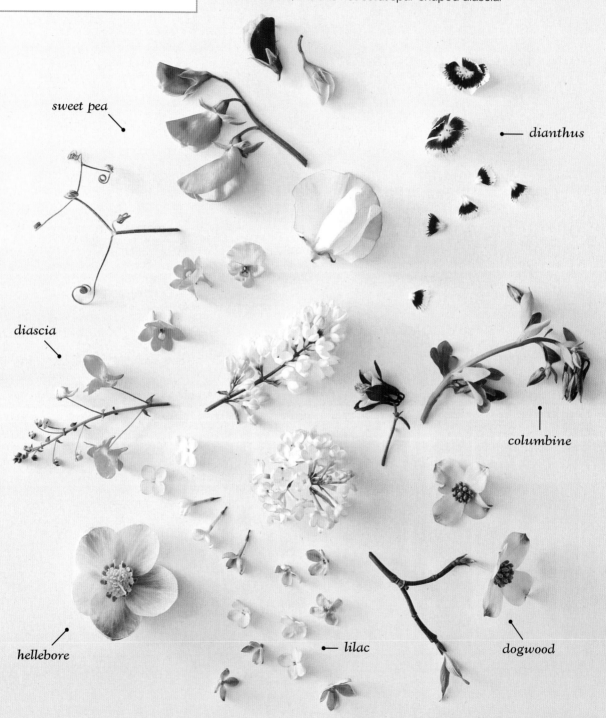

sweet pea

dianthus

diascia

columbine

hellebore

lilac

dogwood

LILAC

RECIPE 2
MICRO ARRANGEMENT

INGREDIENTS

1 lilac sprig

1 hellebore bud

1 dianthus floret

1 columbine bloom

1 dogwood bloom

1 diascia sprig

1 sweet pea tendril

VESSEL & SUPPLIES

1-inch-tall (2.5 cm)
dollhouse vase

Double-sided glue tab (optional)

Use a sprig of lilac to anchor the other ingredients in place, feeding their skinny stems through the flower cluster. These thirsty spring flowers will quickly drink up the water in this tiny vase, so be prepared to frequently refill with a squirt bottle.

1. Position the lilac sprig in the vase center with the florets hanging over the rim.

2. Place the hellebore bud leaning out the left rim and layer the dianthus floret into the lilac on the right.

3. Add the columbine, dogwood, diascia, and sweet pea tendril above the lilac at slightly varying heights. If desired, apply a glue tab to the surface where you wish to place the vase, to help stabilize the arrangement.

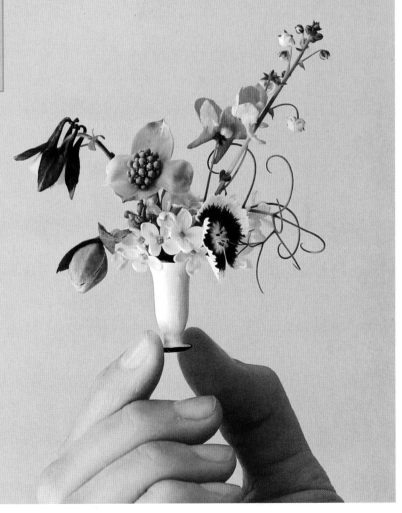

RECIPE 3
MINI ARRANGEMENT

INGREDIENTS

2 lilac sprigs

1 hellebore bloom

1 dogwood sprig

1 dianthus sprig

1 sweet pea stem

1 columbine sprig

2 diascia sprigs

VESSEL

2½-inch-tall (6.5 cm) ceramic vase

1 Position one lilac sprig in the vase center with the florets hanging over the rim. Lean the other lilac sprig out the right, and mirror it by adding the hellebore bloom on the left.

2 Layer the dogwood sprig into the center lilac at a similar height and the dianthus sprig just below it on the right.

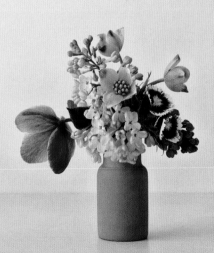

3 Trim a tendril from the sweet pea stem and add it to the right side. Then layer the remaining sprig on the left. Position the columbine high on the right with the bloom facing inward. Finish by curving one diascia sprig up on the right and leaning the other out on the left to balance the columbine.

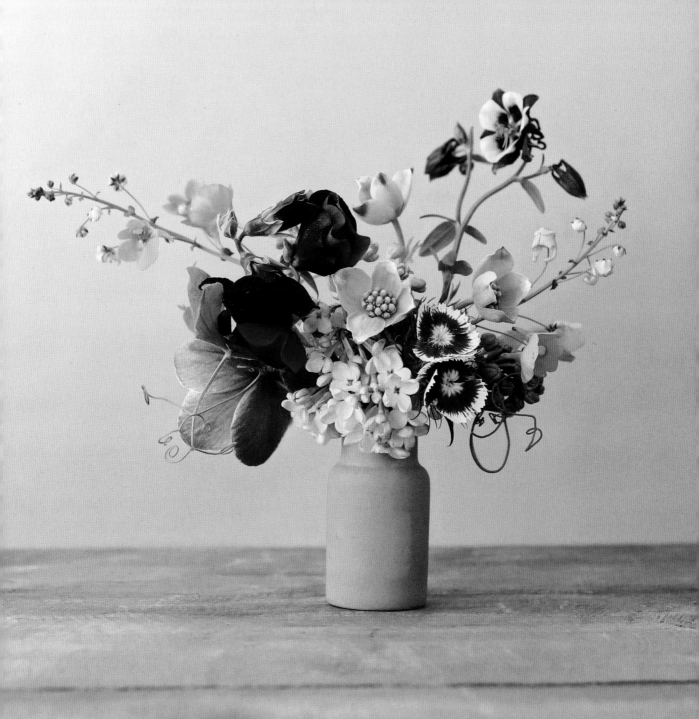

LILAC

RECIPE 4
MINI ARRANGEMENTS

INGREDIENTS

3 lilac stems, purple, pink, and white

3 sweet pea stems, purple, pink,
and white

VESSELS

Three 2½-inch-tall (6.5 cm) ceramic cups

1 Thanks to their branching form, multiple sprigs of lilac can be cut from one larger woody stem. Trim the sprigs from each stem and add them to the cups, keeping the colors separated.

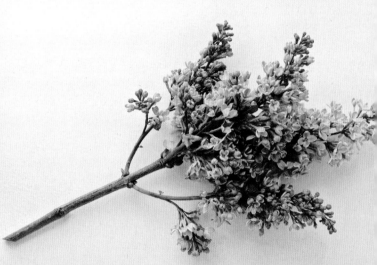

2 Trim the curly tendrils from the sweet pea stems to use as delicate finishing touches. Insert the purple sweet pea through the purple lilac florets to anchor it in place. Repeat with the pink and white sweet peas. Finish by tucking the pea tendrils into each cup.

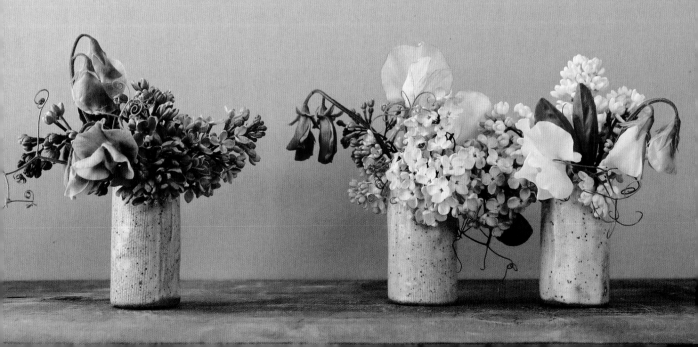

LILAC

RECIPE 5
FLOATING

INGREDIENTS

45 purple lilac florets

15 dianthus florets

1 hellebore head

40 pink lilac florets

VESSEL

5-inch-diameter (13 cm) low
glass bowl

Lilacs have a reputation for wilting quickly in the vase; the individual florets last longer when used in this floating mandala-inspired arrangement. Using tweezers, carefully line up trimmed heads on the water surface to create concentric rings radiating from a center flower.

1. Fill the bowl with water, and float a layer of purple lilac florets faceup, lining them along the bowl's edge. Repeat with the dianthus, creating a second, smaller ring inside the lilac.

2. Place the hellebore head in the center of the composition and fill in around it with the pink lilac florets.

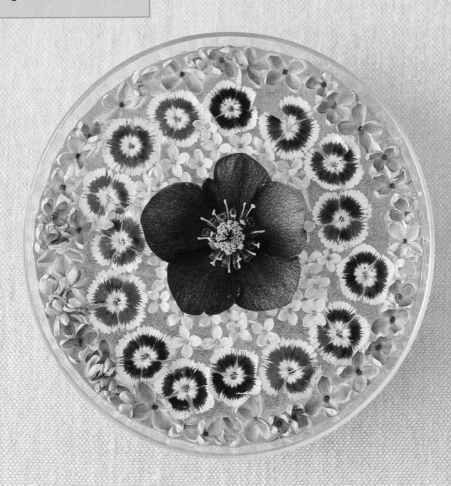

LILY OF THE VALLEY

COLORS: Pink, white
SPIKE SIZE: 3 inches (7.5 cm)

Symbolizing luck in love and thus a popular choice for wedding bouquets, lily of the valley is celebrated in many cultures and even has its own national holiday in France called La Fête du Muguet. The heavily fragranced bell-shaped florets nod on delicate stems and should be harvested when just the first few lower blooms are open. They can be dwarfed by larger flowers in arrangements, so they are most commonly used on their own for maximum visibility.

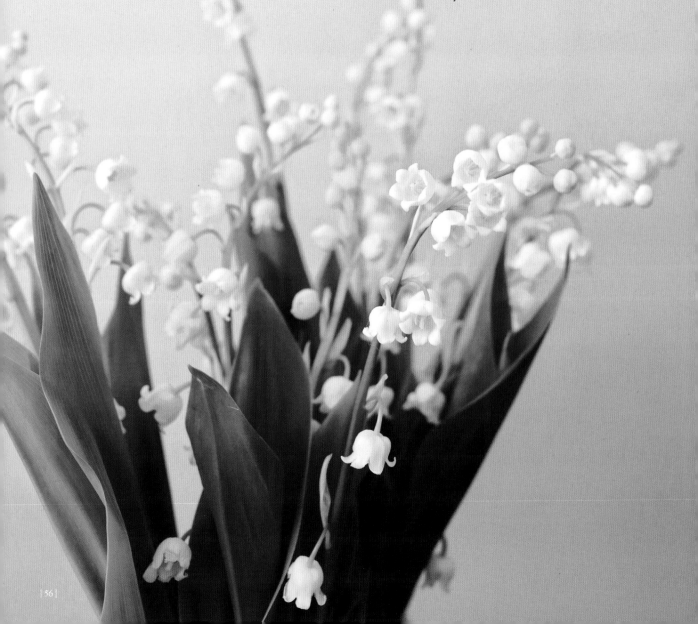

LILY OF THE VALLEY

RECIPE 1
ON ITS OWN

INGREDIENTS

10 lily of the valley stems

VESSEL

1¾-inch-tall (4.5 cm) ceramic bud vase

These aromatic blooms are the ultimate in petite elegance when arranged in a classic (though miniature) urn. Their leaves can be bulky and much larger than their blooms, so remove the foliage to highlight the exquisite bell-shaped florets.

1. Create a bunch in hand with the lily of the valley stems, lining up the bottom blooms so the tips curve out at varying heights.

2. Trim and place in the vase together.

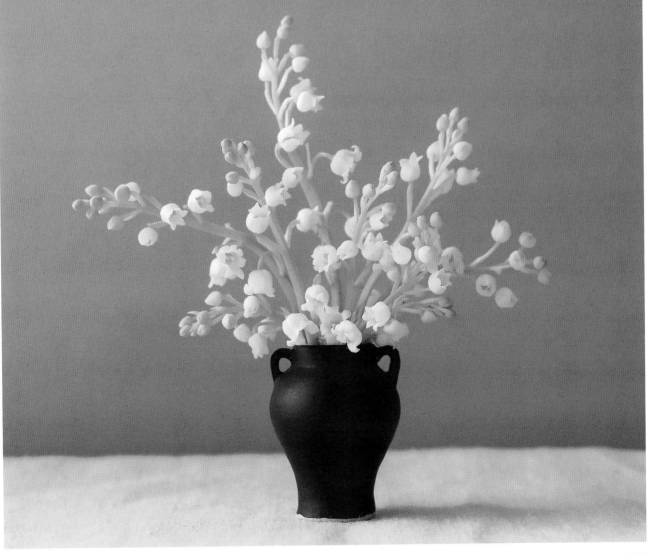

RECIPES 2–5
INGREDIENTS

Anchored by a range of bright greens and whites, this collection embodies the fresh new growth of spring. Delicate sprigs of blush-tinged crab apple and chartreuse viburnum blooms selectively clipped from larger branches partner well with the iconic diminutive lily of the valley. Nicknamed foamy bells, heucherella are often used for their colorful foliage, but as you can see in the arrangements that follow, their tiny textural flower spikes really sparkle.

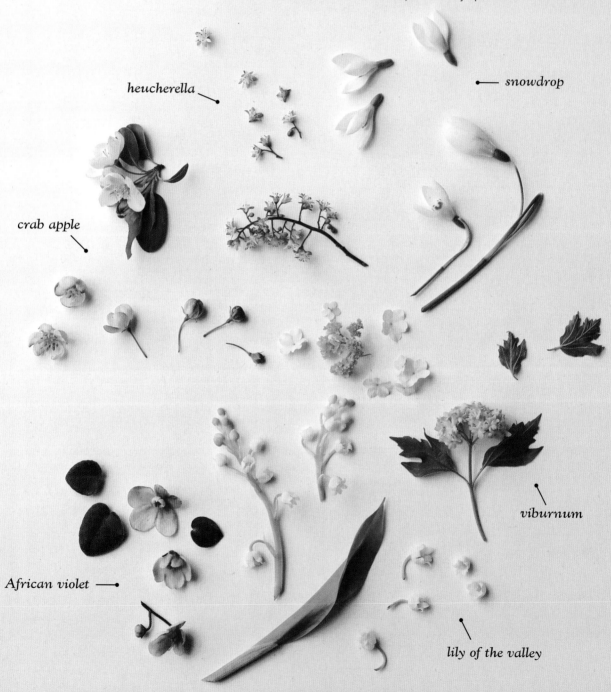

heucherella

snowdrop

crab apple

viburnum

African violet

lily of the valley

LILY OF THE VALLEY

RECIPE 2
MICRO ARRANGEMENT

INGREDIENTS

1 crab apple sprig

2 African violet blooms

1 heucherella spike

1 viburnum bloom

1 snowdrop bloom

1 lily of the valley stem

VESSEL & SUPPLIES

¾-inch-tall (2 cm) ceramic vase

Double-sided glue tab (optional)

This sweet coral vase holds an equally charming assortment of tiny spring blossoms. Add a low cluster of blooms to anchor taller curved stems and create a tiny composition with big personality.

1. Create a bunch in hand with the crab apple, African violets, heucherella, and viburnum, lining up the lowest level of blooms. Trim and slide into the vase together.

2. Place the snowdrop bloom leaning out to the left. Finish by setting the lily of the valley in the center with the tip curving to the left. If desired, add a glue tab to the surface where you wish to place the vase, to help stabilize the arrangement.

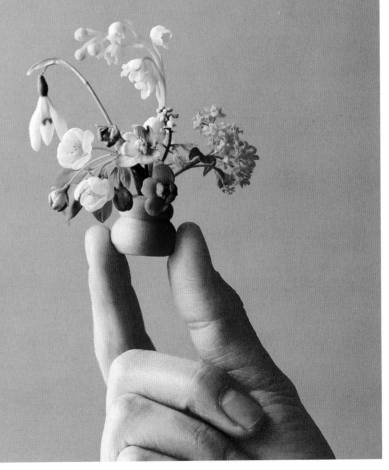

LILY OF THE VALLEY

RECIPE 3
MINI ARRANGEMENT

INGREDIENTS

2 crab apple sprigs

3 viburnum sprigs

3 African violet sprigs

6 lily of the valley stems

4 snowdrop blooms

3 heucherella spikes

VESSEL & SUPPLIES

Pin frog

2½-inch-diameter (6.5 cm) metal
pedestal cup

1 Place the pin frog in the cup and press the crab apple sprigs into it, one leaning to the left and the other more upright on the right.

2 Add the viburnum sprigs so the blooms dangle over the cup rim, one on the left and two on the right. Place the African violets in a cluster at the center and adjust the viburnum leaves to nestle around them.

3 Cluster the lily of the valley stems on the right, with the tips curving up at varying heights. Cluster the snowdrop blooms to lean out at varying heights in front. Finish by placing two heucherella spikes in the middle of the composition at a similar height, and insert the third spike at the highest point on the right.

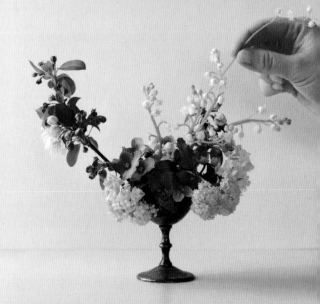

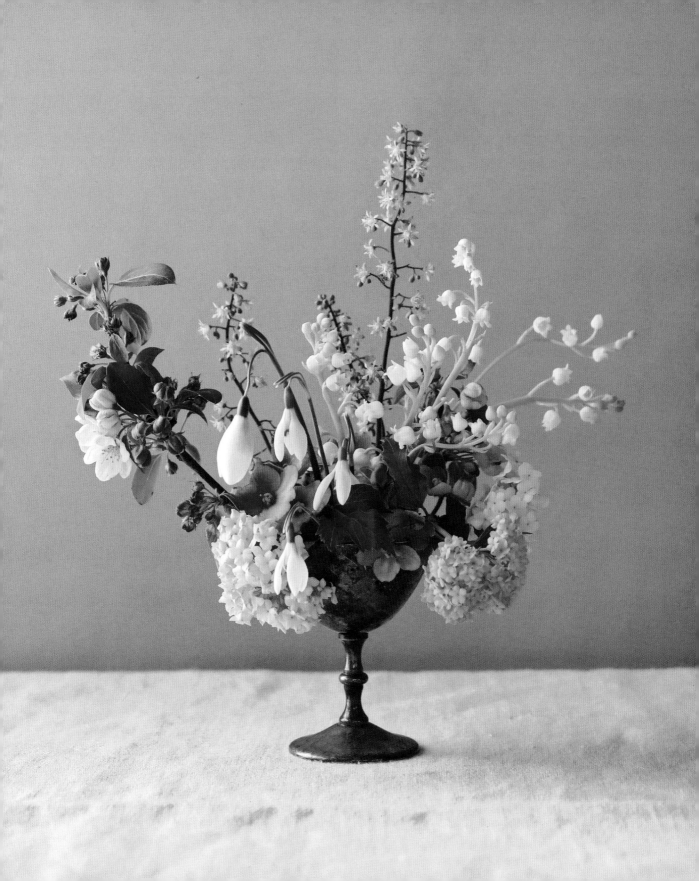

LILY OF THE VALLEY

RECIPE 4
PLANTED

INGREDIENTS

1 snowdrop plant

2 crab apple sprigs

2 viburnum sprigs

2 African violet sprigs

4 lily of the valley stems

3 heucherella spikes

VESSEL & SUPPLIES

3-inch-diameter (7.5 cm) glass cup

Potting soil

3 water tubes

1 Dig up a snowdrop plant from your garden along with foliage and soil, or use a similar plant in a 2-inch (5 cm) pot if you don't have garden access. Place the clump of snowdrops in the center of the cup and add soil around the edges so the stems sit upright. Press three water tubes into the loose soil.

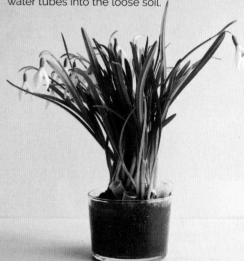

2 Add the leafy sprigs of crab apple and viburnum to the water tubes first, followed by the African violet blooms, concealing the water tubes with the lowest layer of foliage and blooms. Finish by tucking in the narrow stems of lily of the valley and heucherella at varying heights, with the tips pointing in different directions.

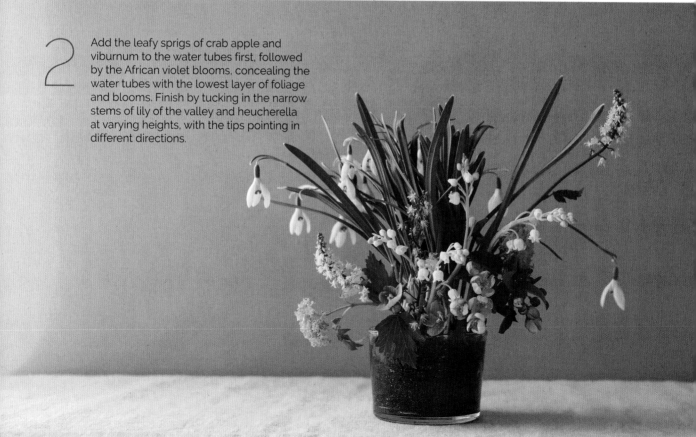

RECIPE 5
STEM WRAPS

INGREDIENTS

Lily of the valley stems,
2 per bundle

SUPPLIES

Floral tape

Embroidery floss, assorted colors

A thoughtful place setting or gift topper, these sweetly scented bundles are reminiscent of knotted friendship bracelets. Wrap stems with color-blocked sections of embroidery floss and keep bundles fresh in water until just before guests arrive.

1. Line up two lily of the valley stems in hand with the tips at slightly different heights. Use a small piece of floral tape to hold them together just under the lowest blooms.

2. Using one color of embroidery floss, tie a knot with it around the bundle just above the floral tape. Wrap the floss around the bundle several times, moving downward with each wrap and leaving no space between them to form a solid band of color. Continue wrapping until the band reaches the desired width, then secure with a knot. Repeat with two more colors of floss, creating bands of different widths.

3. Repeat this process to create as many bundles as desired.

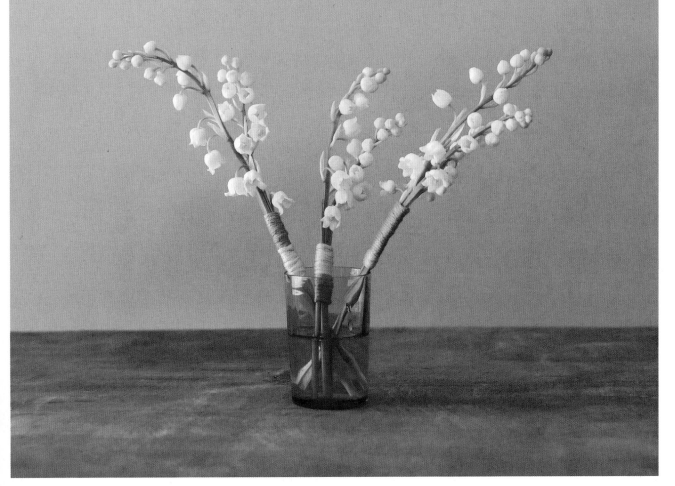

MUSCARI

COLORS: Blue, pink, purple, white
SPIKE SIZE: 2 inches (5 cm)

Muscari are nicknamed grape hyacinths (though these spring bulbs are not related to hyacinths) because their blooms resemble bunches of tightly packed miniature fruit. The florets open sequentially from the bottom up and become spaced farther apart on the stem as the blooms mature. Most commonly found in shades of blue with a tiny rim of white, muscari are also available in varieties with two-tone coloration and crested tops.

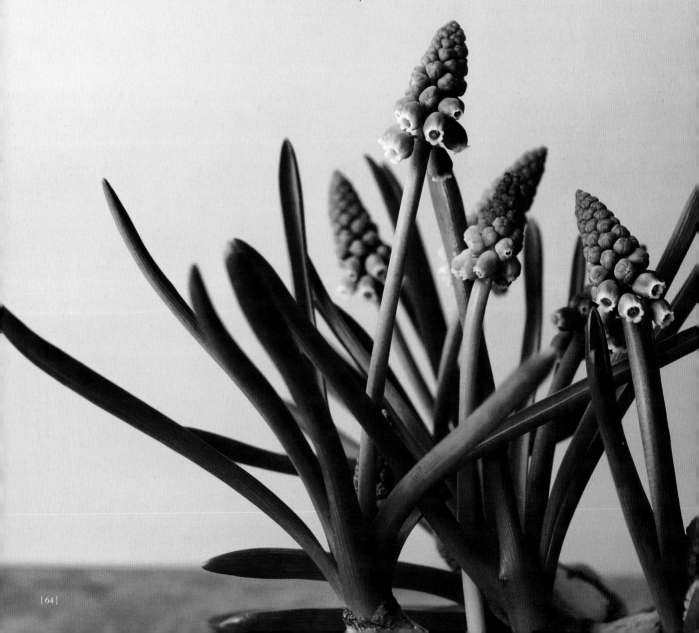

MUSCARI

RECIPE 1
ON ITS OWN

INGREDIENTS

16 muscari blooms,
assorted blues

VESSEL

1½-inch-tall (4 cm) round
ceramic vase

Cut muscari stems from outdoor plants and watch up close as the blooms continue to stretch and open. For the longest vase life, harvest muscari when the bottom few rows of florets are just starting to swell with color.

1. Create a small bunch in hand with nine muscari blooms, in assorted colors, clustering the darker ones in the center and lining up the bottoms. Trim and place in the vase together so the blooms rest at the rim. This base grouping creates structure to hold the next, longer stems in place.

2. Place three light blue blooms together on the right side at varying heights, and lean one to the left. Add the remaining four blooms to the center at varying heights, turning the stems gently in the vase so they curve up in different directions.

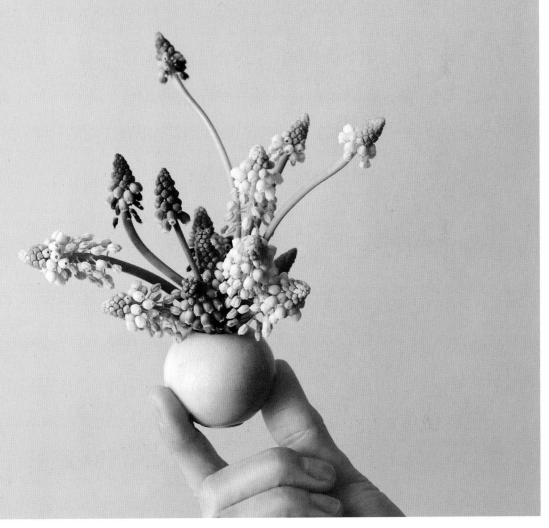

RECIPES 2–4
INGREDIENTS

This whimsical collection of blue and yellow tones combines velvety geranium and silky soft pussy willows with quail eggs that have been blown and dyed (available for purchase at quail farms or online). Muscari is used here both as a cut flower and a stem on the bulb, which allows you to include its foliage and secondary smaller blooms in your arrangement.

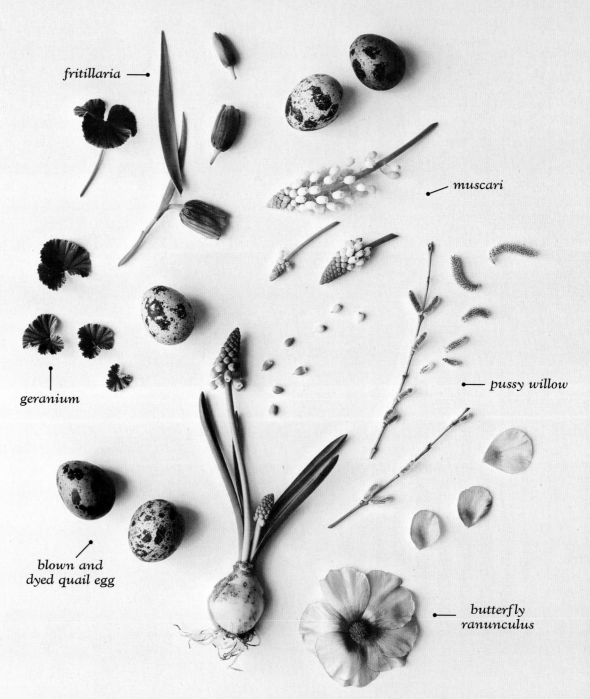

fritillaria

muscari

geranium

pussy willow

blown and dyed quail egg

butterfly ranunculus

RECIPE 2
MINI ARRANGEMENT

INGREDIENTS

8 pussy willow sprigs

4 muscari blooms

3 geranium leaves

2 butterfly ranunculus,
one bloom and one bud

2 fritillaria stems

VESSEL & SUPPLIES

Bind wire

Blown quail egg

Pin frog

2½-inch-tall (6.5 cm) antique
metal tin

Pussy willow sprigs are flexible enough to be used to form a simple nest, making a home for a tiny quail egg. Display the duo beside the flowers or use a skewer to layer the nest into the arrangement for a more "lived-in" look.

1. Twist a pussy willow sprig into a circular shape and connect the ends with a piece of bind wire. Repeat with three more sprigs, making one ring slightly smaller, to serve as the bottom of the nest. Stack the rings and connect them by looping a piece of bind wire around all rings on one side and twisting the ends together. Place the egg in the nest.

2. Place the pin frog in the tin and press three muscari blooms and two geranium leaves into it so they lean over the rim. Layer the butterfly ranunculus bloom into the center of the arrangement with the bloom facing front, then add the butterfly ranunculus bud above it on the left.

3. Lean the last muscari bloom out wide on the left and mirror it with a geranium leaf on the right. Insert both fritillaria stems so that they are leaning right, with one bloom curving down and the other facing upward.

4. Finish by centering the remaining four pussy willow sprigs at varying heights in the arrangement.

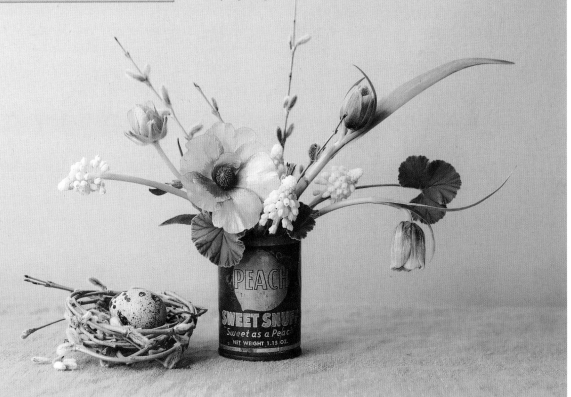

RECIPE 3
TABLESCAPE

INGREDIENTS

35 flowering muscari bulbs,
assorted colors

35 blown and dyed quail eggs

SUPPLIES

Twine

Display the roots, bulbs, leaves, and blooms of muscari alongside a gradation of quail eggs (blown and dyed with food coloring) for a tablescape that is both earthy and charming. Purchase potted muscari plants that have started to flower and prepare the bulbs by removing them from their pots and shaking off the soil.

1. Holding on to the stems, gently swirl the bulbs in a bucket of cool water to rinse. Once the majority of the dirt is removed, give them a final rinse under the faucet and pat dry.

2. Create five bundles of plants, grouped by color, and secure the stems with twine just above the bulbs, then line them up in color order from light to dark. Cluster the quail eggs around the muscari bulbs, also in color order from light to dark. A display like this will last out of water for an evening, or, for a longer-lasting centerpiece, place the bundles in shallow bowls with just enough water to cover the exposed roots.

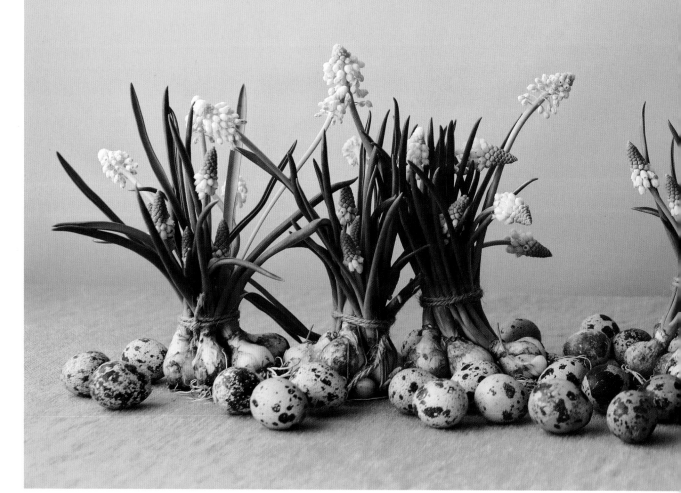

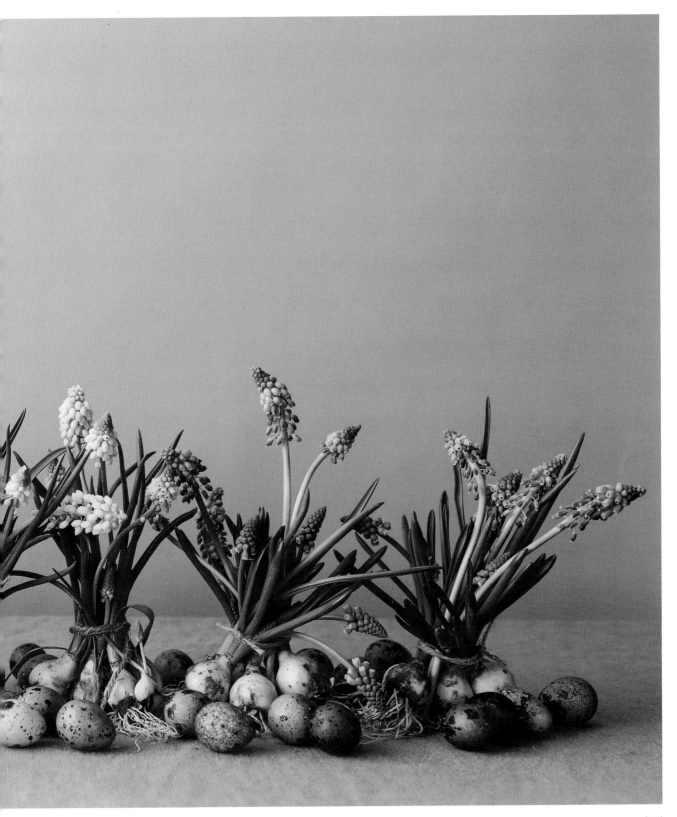

MUSCARI

RECIPE 4
MINI ARRANGEMENT

INGREDIENTS

4 butterfly ranunculus blooms

4 fritillaria stems

9 pussy willow sprigs

20 muscari blooms

4 geranium leaves

VESSEL & SUPPLIES

Pin frog

4-inch-diameter (10 cm) pedestal cup

2 rubber bands

1 Place the pin frog in the cup and press the butterfly ranunculus into it: one leaning over the right rim, one over the left, and the other two standing upright in the middle. Place two fritillaria stems on the left side at slightly varying heights, one curving down and the other facing upward. Place the other two on the right with one stem higher and curving inward.

2 Make two bunches of pussy willow at slightly varying heights, and use the rubber bands to secure them at the bottom. Insert the bunches next to each other on the left side of the cup.

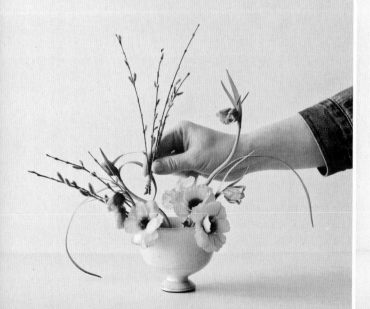

3 Nestle fifteen muscari blooms around the rim and in the center, filling the spaces between the other flowers. Add the remaining muscari higher than the others, with two curving downward on the right and three pointing up in the center. Place three geranium leaves at rim height: one tucked low in the center, one on the front right, and another leaning out at the left. Finish by adding the last leaf in the back at a similar height to the tall muscari.

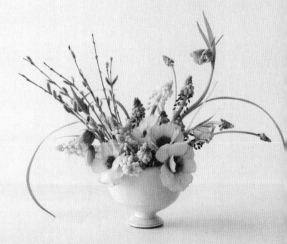

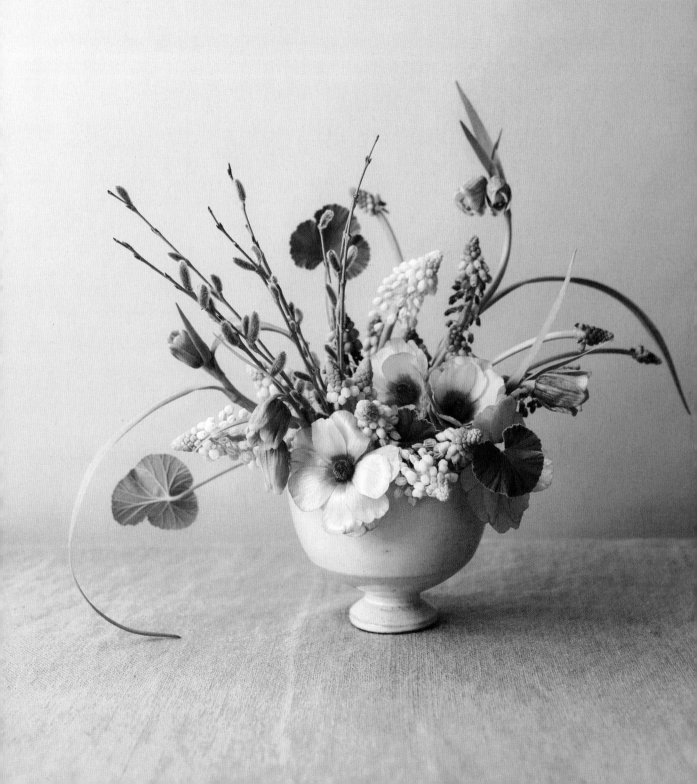

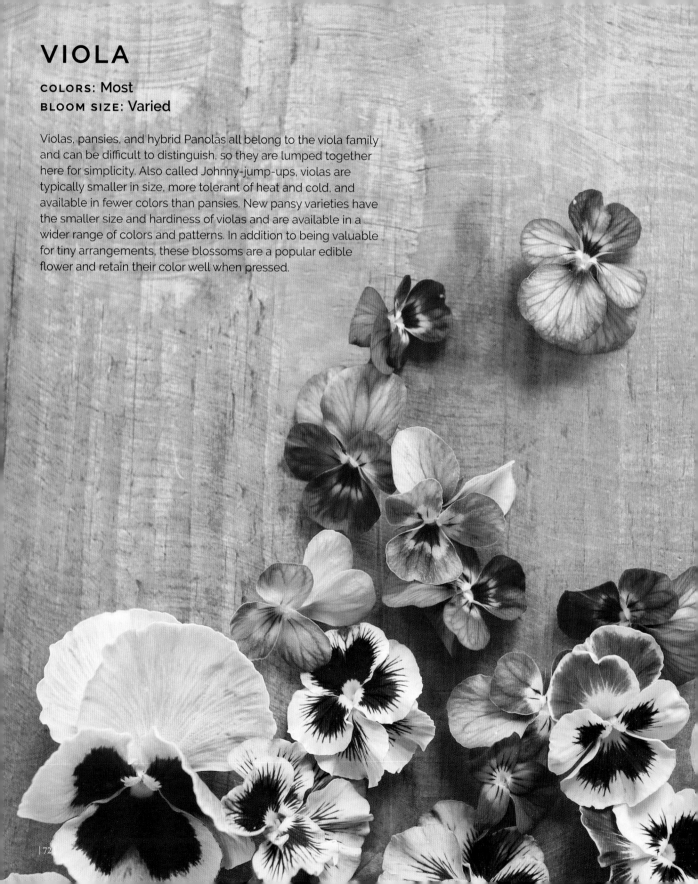

VIOLA

COLORS: Most
BLOOM SIZE: Varied

Violas, pansies, and hybrid Panolas all belong to the viola family and can be difficult to distinguish, so they are lumped together here for simplicity. Also called Johnny-jump-ups, violas are typically smaller in size, more tolerant of heat and cold, and available in fewer colors than pansies. New pansy varieties have the smaller size and hardiness of violas and are available in a wider range of colors and patterns. In addition to being valuable for tiny arrangements, these blossoms are a popular edible flower and retain their color well when pressed.

RECIPE 1
ON ITS OWN

INGREDIENTS

3 viola blooms, assorted colors

VESSEL & SUPPLIES

1-inch-tall (2.5 cm)
dollhouse vase

Double-sided glue tab (optional)

There is so much personality in this tiny grouping, thanks to the blooms and vase, which are both packed with exquisite detail. The dark veins on the petals have an unreal appearance, as if carefully drawn with a fine-tip pen.

1. Create a bunch in hand so the viola blooms sit at three different heights and face the front. Trim and insert in the vase together.

2. If desired, add a glue tab to the surface where you wish to place the vase, to help stabilize the arrangement.

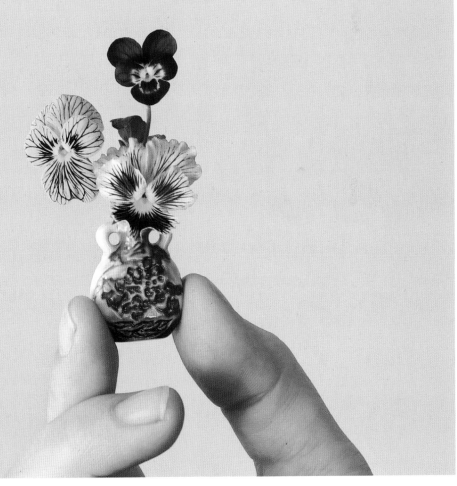

VIOLA

RECIPE 2
TABLESCAPE

INGREDIENTS

80 to 100 viola blooms,
assorted colors

VESSELS

Six 3¼-inch-tall (8.5 cm)
miniature mason jars

Trimming open and spent blooms on viola plants encourages higher flower production and longer stems, so deadhead often. The reward for keeping your plants healthy and productive is a constant flow of blooms to your bedside table.

1. Loosely organize the blooms on your work surface into six different color groupings of lavender, red/violet, blue/purple, white/peach, red/brown, and yellow.

2. Create a bunch in hand with the first grouping, adjusting the stems to achieve a round and full shape. Trim and place the bunch in a jar, letting the blooms spill out over the rim. Repeat for each color grouping.

3. Line up the jars and refine the gradation by moving blooms from neighboring jars to create smoother color transitions.

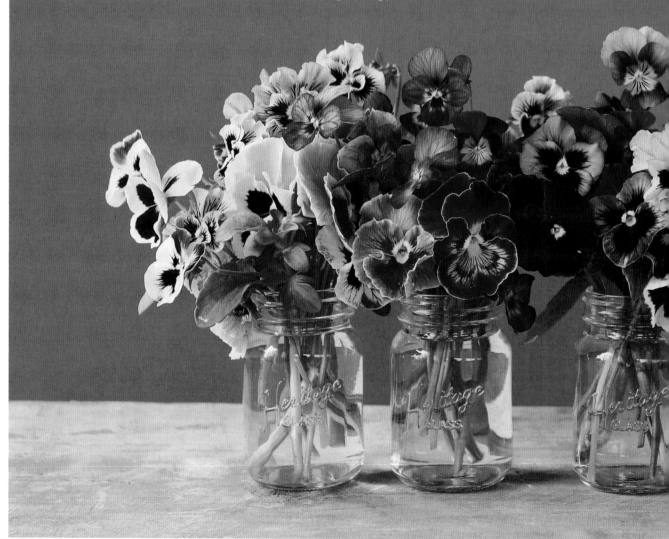

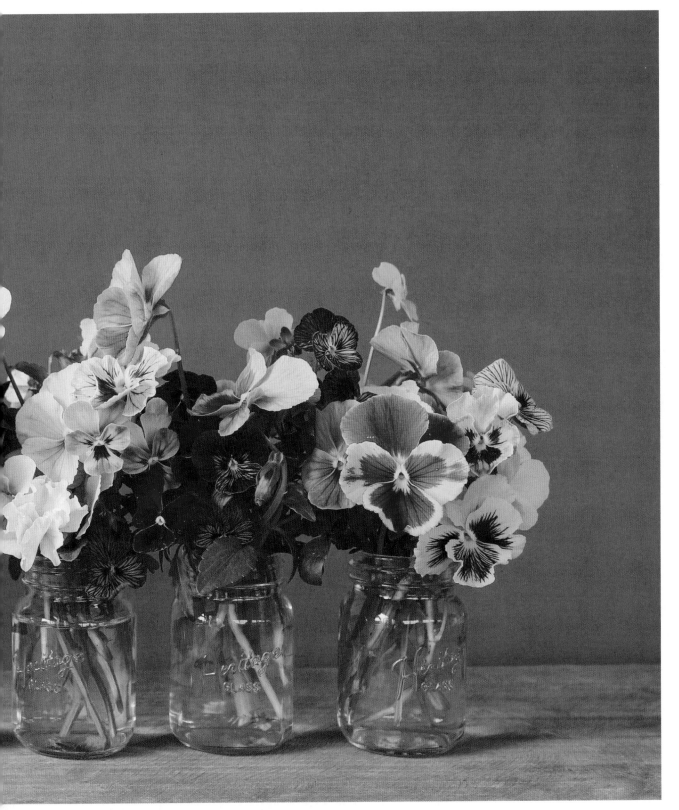

RECIPES 3 + 4
INGREDIENTS

The purple and yellow tones featured in this collection come not only from the blooms but also from the dark veins of the heuchera leaves and the striking purple pea pods. Unripened blueberry sprigs add another fun and surprising edible design element. To get this diminutive bloom size, the calendula, celosia, and angelonia should be plucked from plants early in the season.

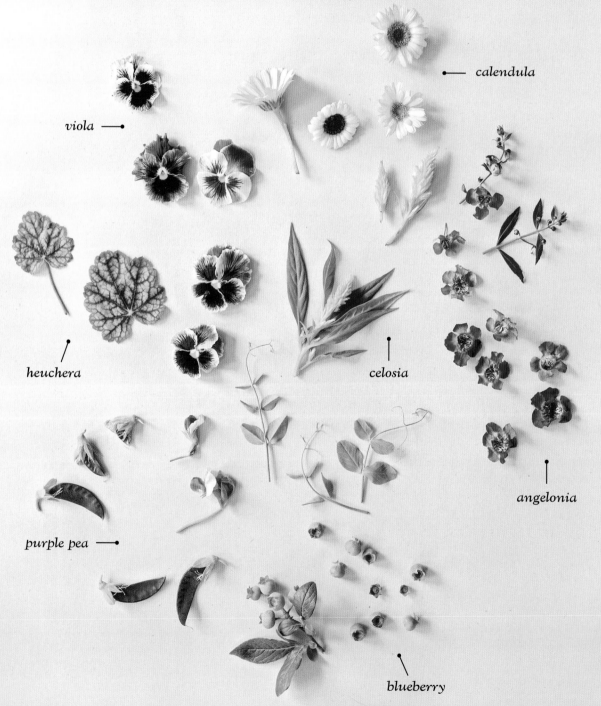

calendula

viola

heuchera

celosia

angelonia

purple pea

blueberry

VIOLA

RECIPE 3
NAPKIN DETAILS

INGREDIENTS

1 purple pea sprig

2 viola blooms

1 heuchera leaf

1 blueberry sprig

2 celosia blooms

SUPPLIES

4 napkins

Four 8-inch (20 cm)
pieces of ribbon

For a cohesive table display, select a few sprigs of the same ingredients that you have used in your centerpiece arrangement (following page) to create a napkin detail that makes every place setting special. Keep it simple and choose a ribbon in the same color family as the napkin, or select a ribbon color pulled from the flowers for higher contrast.

1. Roll the four napkins and secure each with a ribbon tied in a simple knot.

2. Tuck the stems of the ingredients under the ribbons in varied combinations just before guests arrive.

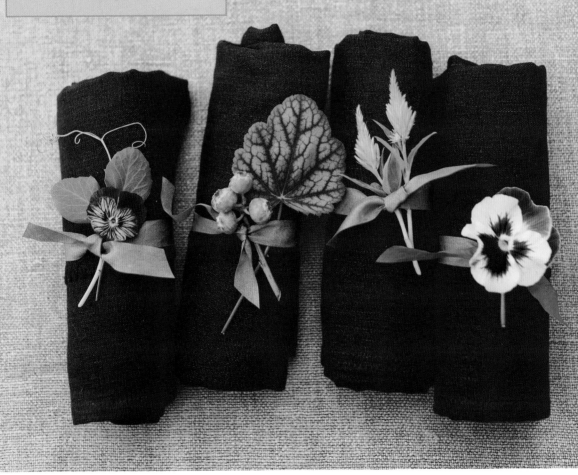

VIOLA

RECIPE 4
MINI ARRANGEMENT

INGREDIENTS

1 blueberry sprig

1 heuchera leaf

3 purple pea sprigs

3 calendula blooms

2 celosia blooms

2 angelonia stems

3 viola blooms

VESSEL

3-inch-tall (7.5 cm) glass jar

1 Lean the blueberry sprig out to the right so the lower leaves and fruit dangle over the rim.

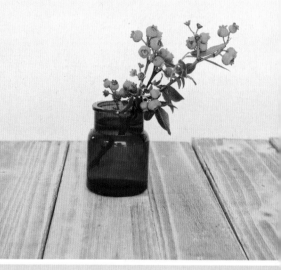

2 Place the heuchera leaf leaning out at the center of the rim in front. Position one purple pea sprig curving up above the blueberry on the right and the other two leaning out on the left.

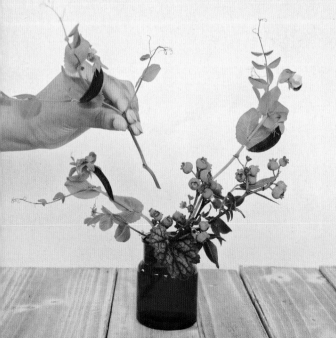

3 Layer two calendula blooms above the heuchera leaf and nestle the two celosia blooms behind them in the middle. Add the remaining calendula bloom higher up, with the bloom facing right. Tuck in the angelonia stems, one curving down on the right and the other in back. Finish by layering two viola blooms at the rim on the left and the last one in the center above the other ingredients.

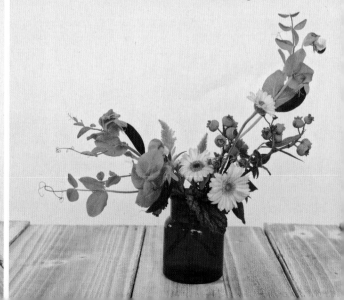

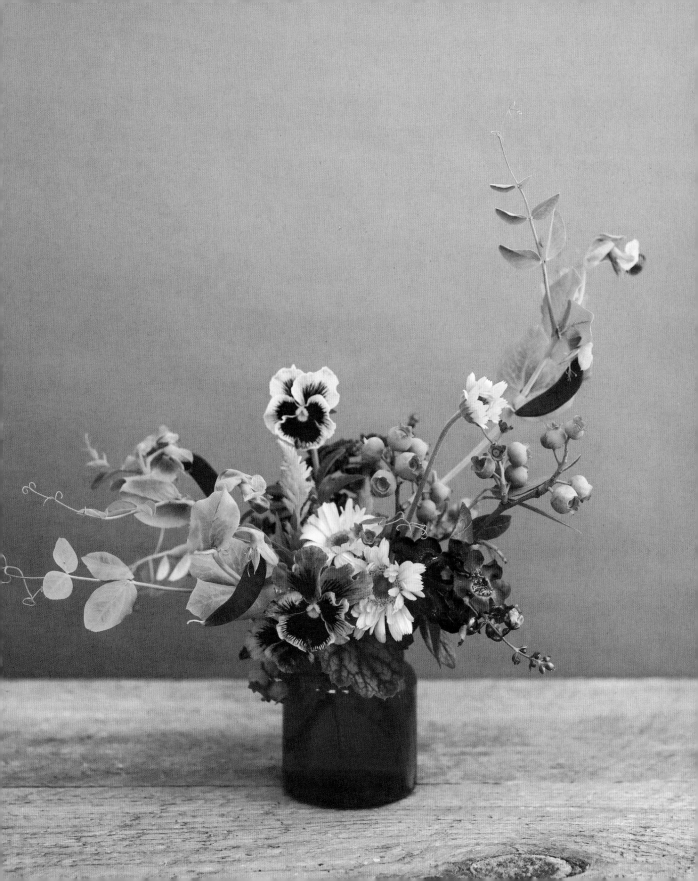

SUMMER

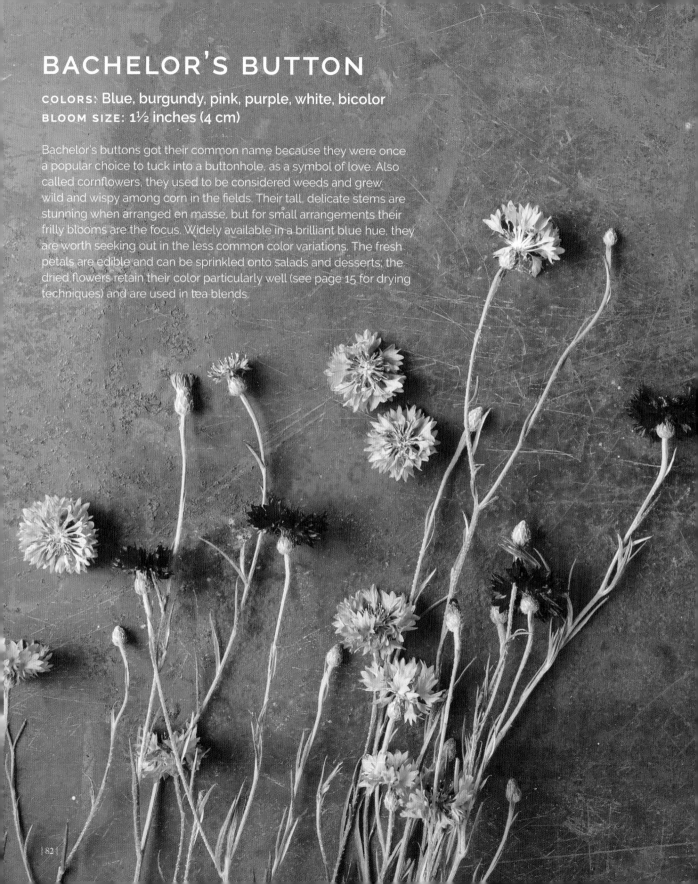

BACHELOR'S BUTTON

COLORS: Blue, burgundy, pink, purple, white, bicolor
BLOOM SIZE: 1½ inches (4 cm)

Bachelor's buttons got their common name because they were once a popular choice to tuck into a buttonhole, as a symbol of love. Also called cornflowers, they used to be considered weeds and grew wild and wispy among corn in the fields. Their tall, delicate stems are stunning when arranged en masse, but for small arrangements their frilly blooms are the focus. Widely available in a brilliant blue hue, they are worth seeking out in the less common color variations. The fresh petals are edible and can be sprinkled onto salads and desserts; the dried flowers retain their color particularly well (see page 15 for drying techniques) and are used in tea blends.

BACHELOR'S BUTTON

RECIPE 1
PRESSED

INGREDIENTS

2 bachelor's button stems, separated into blooms, buds, and leaves

SUPPLIES

3½-by-4½-inch (9 by 11.5 cm) picture frame

Cardstock cut to fit inside frame opening

Tweezers

Glue dots

This project is inspired by antique drawings of botanical anatomy. By cutting the blooms in half and removing the bulk of the petals, you're able to maintain the flower's signature silhouette while saving on pressing and drying time.

1. Cut the blooms and buds in half lengthwise so they are flat on one side.

2. Remove the glass from the picture frame. Arrange the ingredients on the cardstock in a pleasing composition, then carefully press the glass onto the paper. Lift the glass and, using tweezers if necessary, remove any petals that have altered the bloom silhouettes when pressed.

3. Affix the ingredients to the cardstock with glue dots. Put a glue dot on each corner of the paper and affix it to the glass. Insert into the frame.

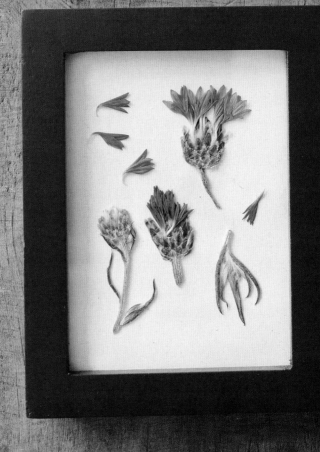

BACHELOR'S BUTTON

RECIPE 2
TABLESCAPE

INGREDIENTS

30 burgundy and white
bachelor's button blooms
and buds

VESSELS

Twelve 1¾-inch-tall (4.5 cm)
glass vials

This high-contrast display puts a modern twist on an old-fashioned wildflower.

1. Position two or three blooms and buds at varying heights in each glass vial, keeping the colors separate.

2. Arrange the vials in a line of alternating color blocks.

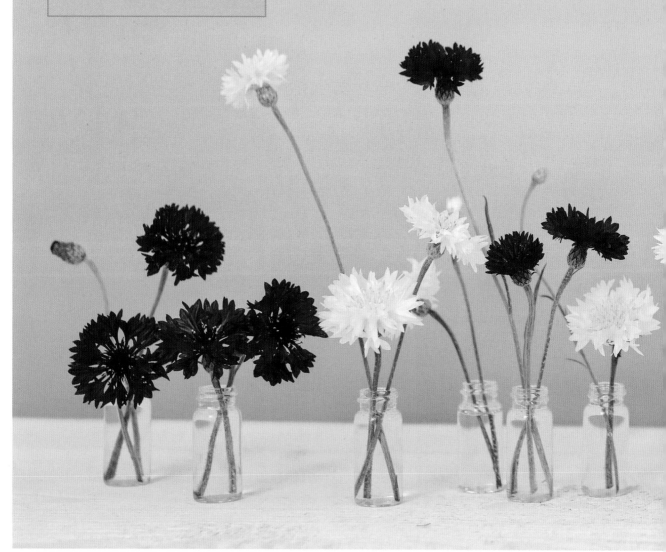

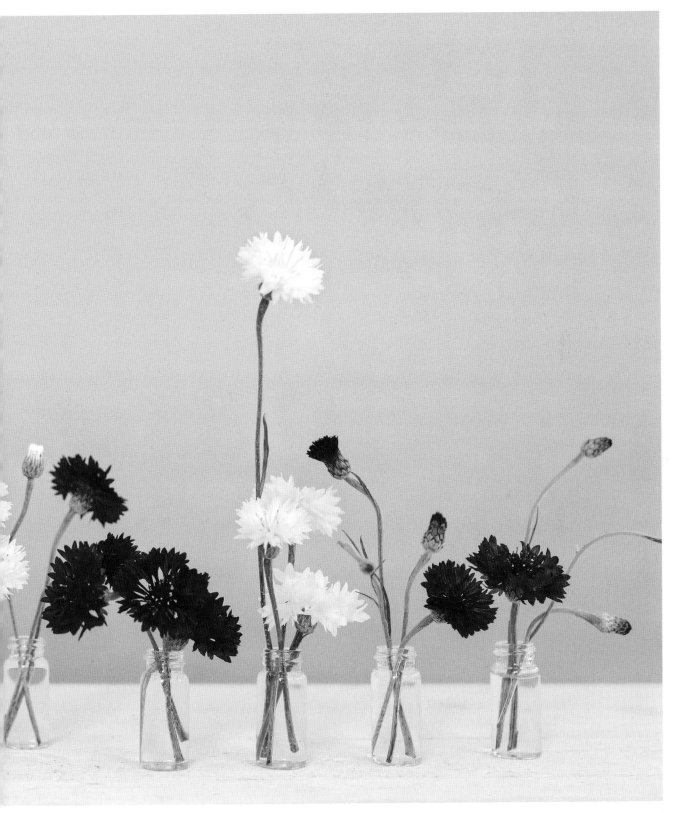

The ingredients in this collection are connected by the frilled details on the edges of their petals and leaves. Fluffy sprigs clipped from larger blooms of smoke bush are useful for adding soft layers. Alpine strawberries have unique sawtooth leaves and are the perfect fruit for small arrangements thanks to their petite berries on long stems.

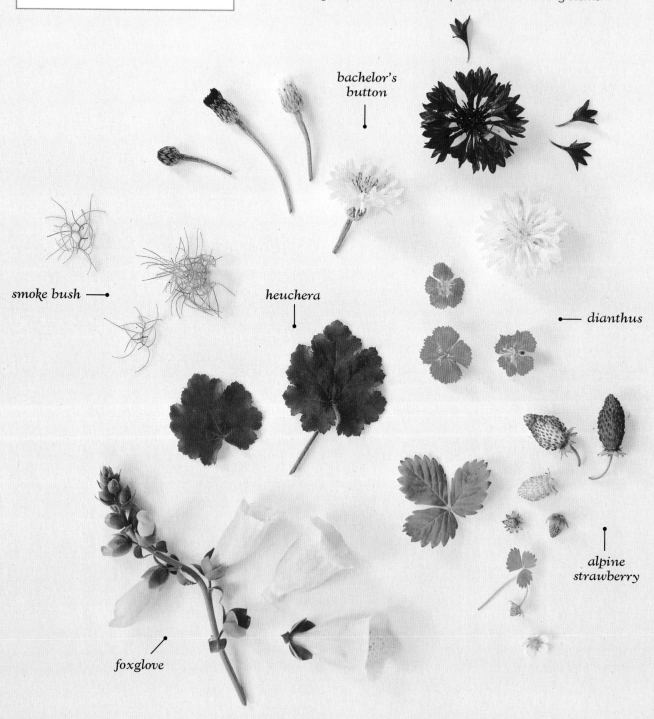

bachelor's button

smoke bush

heuchera

dianthus

alpine strawberry

foxglove

RECIPE 3
MICRO ARRANGEMENT

INGREDIENTS

1 alpine strawberry stem

2 heuchera leaves

1 smoke bush sprig

1 dianthus floret

1 foxglove spikelet

3 bachelor's button blooms

VESSEL

2¼-inch-tall (5.5 cm) ceramic
bud vase

Tiny polka-dot patterns add whimsy to this soft palette: the minuscule strawberry seeds echo the spotted throats of the foxglove bells.

1. Place the alpine strawberry stem so the lower berries dangle over the left rim.

2. Lean one heuchera leaf out at the rim on the right and the other in the center. Tuck the smoke bush sprig next to the strawberry and layer the dianthus floret in front of it.

3. Place the foxglove spikelet so the lowest bloom sits just above the heuchera leaf on the right and the tip curls inward.

4. Nestle one bachelor's button bloom at the back rim. Finish by leaning the remaining bachelor's button blooms out from the center at staggered heights so the tallest one roughly balances the height of the foxglove.

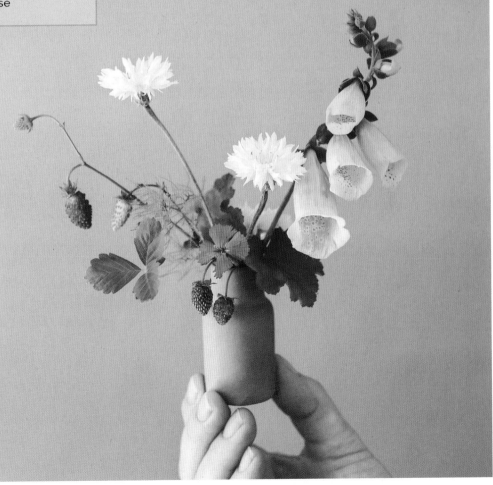

BACHELOR'S BUTTON

RECIPE 4
MINI ARRANGEMENT

INGREDIENTS

3 alpine strawberry stems

1 heuchera leaf

2 smoke bush sprigs

2 dianthus stems

9 bachelor's button blooms and buds

2 foxglove spikelets

VESSEL

4¼-inch-tall (11 cm) teapot

1 Place the alpine strawberry stems so the lower berries dangle over the rim and playfully mimic a flow from the spout.

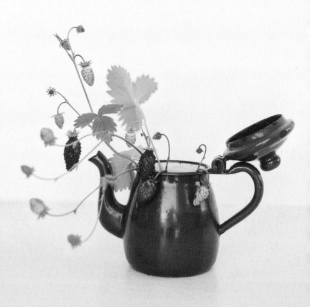

2 Add the heuchera leaf leaning out over the right rim and set the smoke bush sprigs in the middle. Layer one dianthus stem on the left above the strawberries and nestle the other dianthus higher in the center.

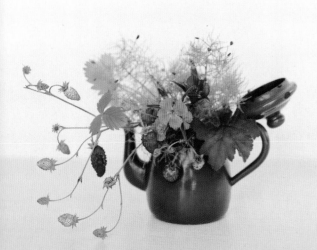

3 Layer one bachelor's button bloom above the heuchera and another above the dianthus. Lean the remaining bachelor's button blooms and buds out from the center at staggered heights. Finish by nestling the foxglove spikelets together on the right side to balance the width of the berries.

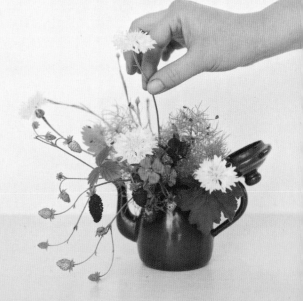

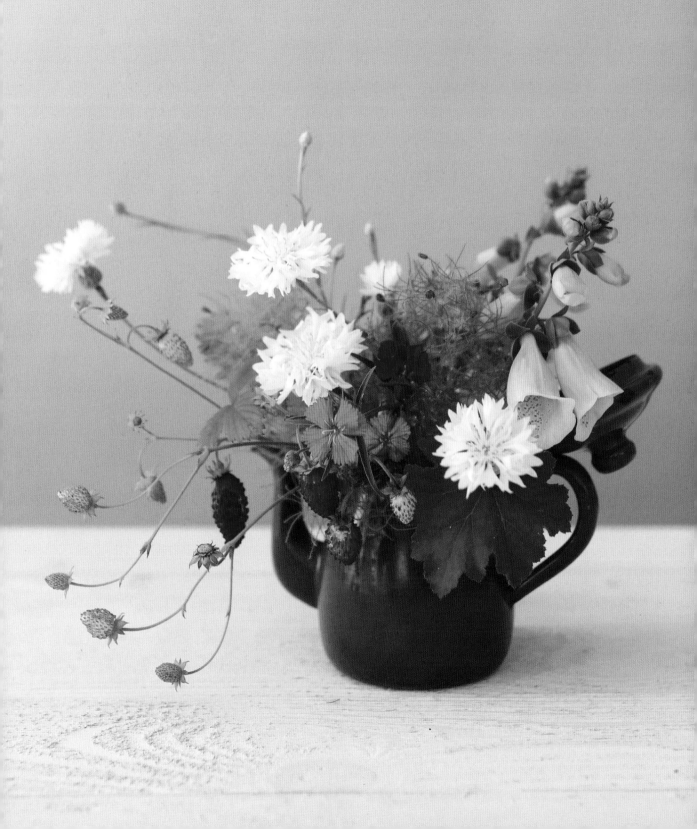

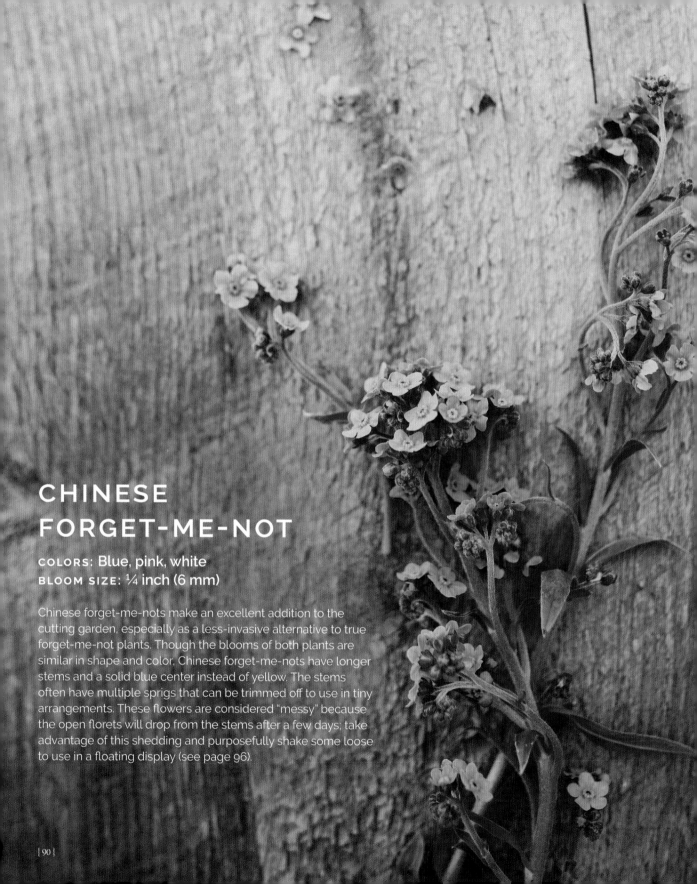

CHINESE FORGET-ME-NOT

COLORS: Blue, pink, white
BLOOM SIZE: ¼ inch (6 mm)

Chinese forget-me-nots make an excellent addition to the cutting garden, especially as a less-invasive alternative to true forget-me-not plants. Though the blooms of both plants are similar in shape and color, Chinese forget-me-nots have longer stems and a solid blue center instead of yellow. The stems often have multiple sprigs that can be trimmed off to use in tiny arrangements. These flowers are considered "messy" because the open florets will drop from the stems after a few days; take advantage of this shedding and purposefully shake some loose to use in a floating display (see page 96).

CHINESE FORGET-ME-NOT

RECIPE 1
ON ITS OWN

INGREDIENT

1 Chinese forget-me-not stem

VESSEL & SUPPLIES

1¼-inch-tall (3 cm) brass
dollhouse pitcher

Double-sided glue tab (optional)

Pink Chinese forget-me-nots can be a little trickier to source than their blue siblings, but they're worth the effort; hunt them down from a flower farm or garden center.

1. Cut four sprigs from the main stem.

2. Insert them one at a time so the lowest level of florets sits at the pitcher rim, creating an asymmetrical cluster.

3. If desired, add a glue tab to the surface where you wish to place the pitcher, to help stabilize the arrangement.

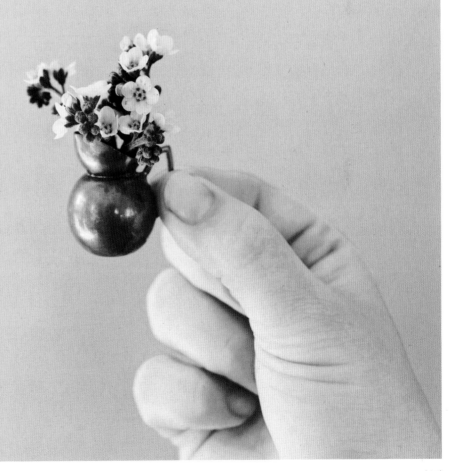

RECIPES 2–5
INGREDIENTS

A tiny explosion of pastel florets, this collection uses no foliage other than the spiny bract collars of the eryngium. Both phlox and hydrangea can have subtle color variation between florets, sometimes even on the same stem, so they are very useful for transitioning from one colorway to another. Clip the smallest side shoots you can find from a stem of delphinium, a flower typically prized for its height.

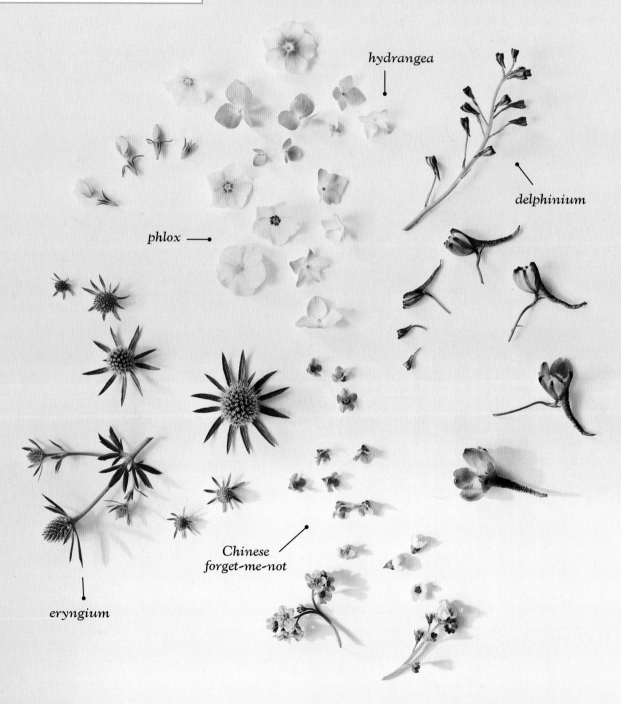

hydrangea

delphinium

phlox —

*Chinese
forget-me-not*

eryngium

CHINESE FORGET-ME-NOT

RECIPE 2
MICRO ARRANGEMENT

INGREDIENTS

3 Chinese forget-me-not sprigs

1 phlox sprig

2 eryngium blooms

1 delphinium spikelet

VESSEL

1½-inch-tall (4 cm) tapered
ceramic bud vase

Clustering blooms at the rim of the vase provides support for the taller, gestural delphinium.

1. Place the Chinese forget-me-not sprigs one at a time so the lowest level of florets are clustered at the rim to the right.

2. Add the phlox sprig on the left and nestle one eryngium bloom along the center rim. Place the second eryngium bloom leaning out on the left a little higher than the phlox.

3. Finish by feeding the delphinium spikelet through the cluster of Chinese forget-me-nots for support, with the tip curving inward.

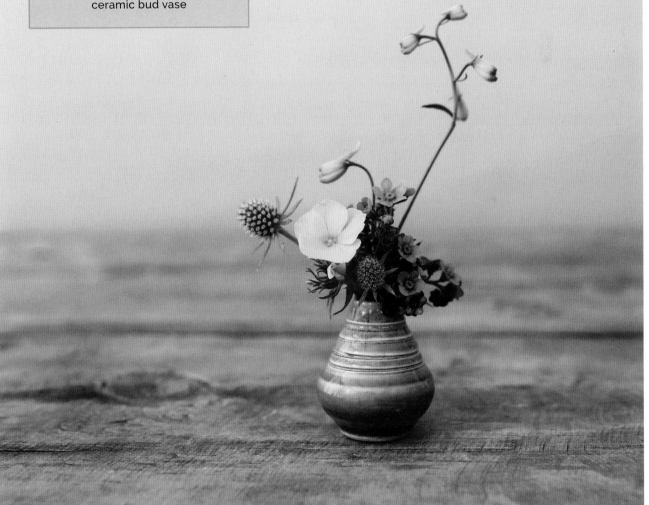

CHINESE FORGET-ME-NOT

RECIPE 3
MINI ARRANGEMENT

INGREDIENTS

3 hydrangea sprigs, 1 pink, 1 blue, and 1 purple

4 eryngium sprigs

4 phlox sprigs, 1 pink, 1 blue, and 2 purple

6 Chinese forget-me-not stems, 3 pink and 3 blue

2 delphinium spikelets

VESSEL & SUPPLIES

Pin frog

2¼-inch-diameter (5.5 cm) ceramic footed cup

1 Place the pin frog in the cup and press the hydrangea sprigs into it—pink on the left, purple in the center, blue on the right—with the florets spilling over the rim.

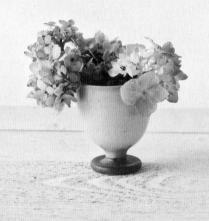

2 Nestle the eryngium sprigs between the hydrangea. Layer the pink phlox next to the pink hydrangea to create a color grouping. Repeat on the right with the blue phlox. Layer the purple phlox above the pink phlox blooms.

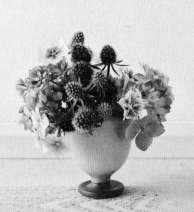

3 Cluster the pink Chinese forget-me-not stems above the purple phlox. Nestle two blue Chinese forget-me-nots in the middle, and lean the remaining stem to the right. Feed one delphinium spikelet through the center and lean the other to the right, balancing the cluster of light-colored phlox.

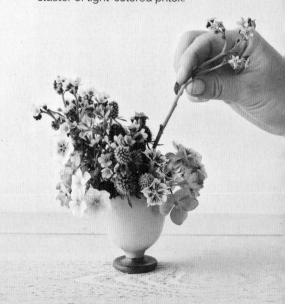

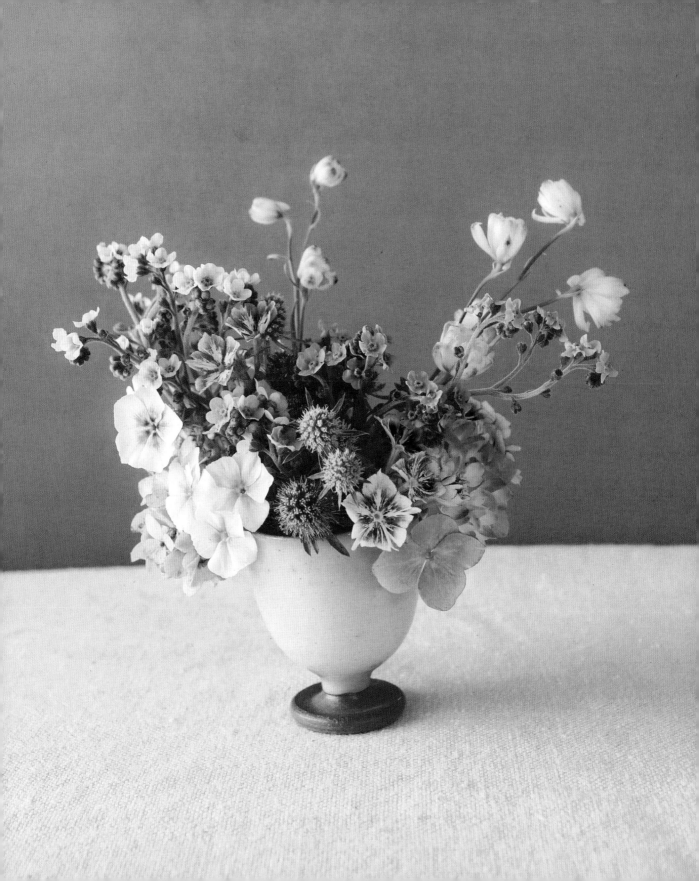

CHINESE FORGET-ME-NOT

RECIPE 4
FLOATING

INGREDIENTS

2 stems Chinese forget-me-not,
1 blue and 1 pink

2 stems phlox, 1 pink and 1 purple

3 blooms hydrangea, 1 blue, 1 pink, and
1 purple

VESSELS

Three 4-inch-diameter (10 cm) glass
petri dishes

1 Trim florets from the Chinese forget-me-not, phlox (pictured), and hydrangea blooms.

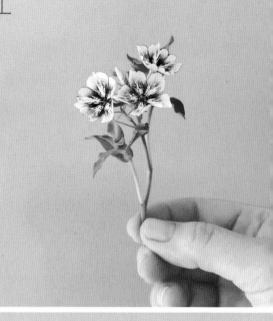

2 Place the florets randomly in shallow dishes of water; they will settle in next to each other in a quilt-like pattern as they fill the dishes. Line up the dishes along the center of the table to create a floating table runner.

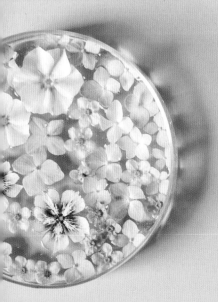
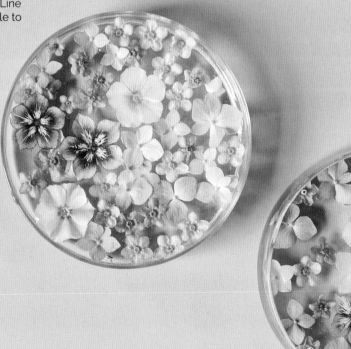

CHINESE FORGET-ME-NOT

RECIPE 5
BONUS: ERYNGIUM

INGREDIENTS

20 eryngium heads

SUPPLIES

12-inch (30.5 cm) piece of medium-gauge straight wire

10-inch (25 cm) piece of ribbon

The blooms in this sculptural wreath will maintain their shape and texture when dried, though their color will fade. If a brighter look is desired, experiment with spray paint.

1. Thread the eryngium heads onto a piece of medium-gauge wire (see page 268 for threading technique).

2. Once the desired length is reached, bend the wire to form a circle and twist the ends together. Loop the ribbon over the connection point to cover it, and secure it in a knot.

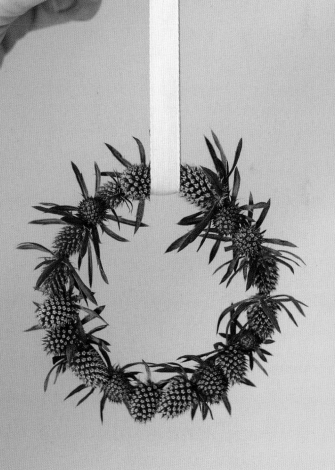

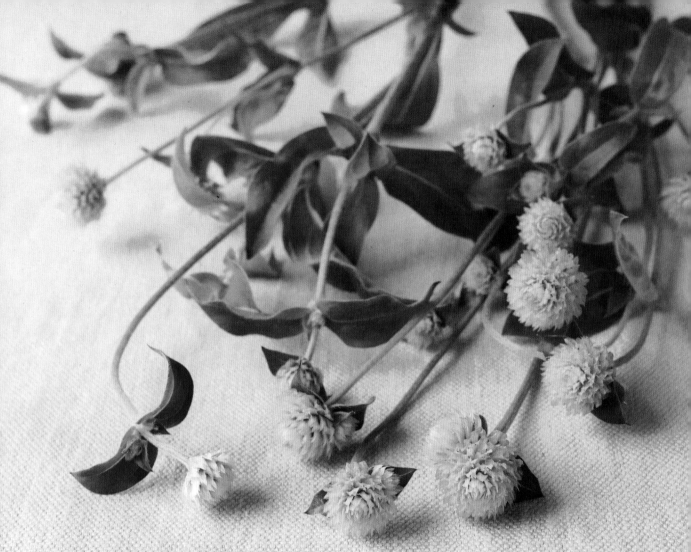

GOMPHRENA

COLORS: Lavender, magenta, orange, pink, purple, red, white
BLOOM SIZE: ½ inch (1 cm)

Also known as globe amaranth, these cheerful round "blooms"
are actually composed of papery leaf-like structures called
bracts. Upon close inspection, you can see the true flowers:
minuscule yellow or white trumpets sprouting from the ends of
these bracts. Mature gomphrena have an elongated gumdrop
shape; the developing buds, which are shown here, are more
rounded. The buds tend to wilt faster than the mature blooms,
so cut them off and nestle them among other flowers for
support. Buy extra bunches when they are in season at the
farmers' market to dry for use when fresh flowers are scarce.

RECIPE 1
CONFETTI TOSSERS

INGREDIENTS

60 gomphrena heads,
assorted colors

VESSELS

3 paper cones (see page 269)

Paper cones filled with gomphrena make sweet celebratory "natural confetti" tossers. Create a larger batch for more cones by combining gomphrena heads with the petals of other seasonal flowers.

1. Group the blooms loosely by color.

2. Add the blooms to the cones.

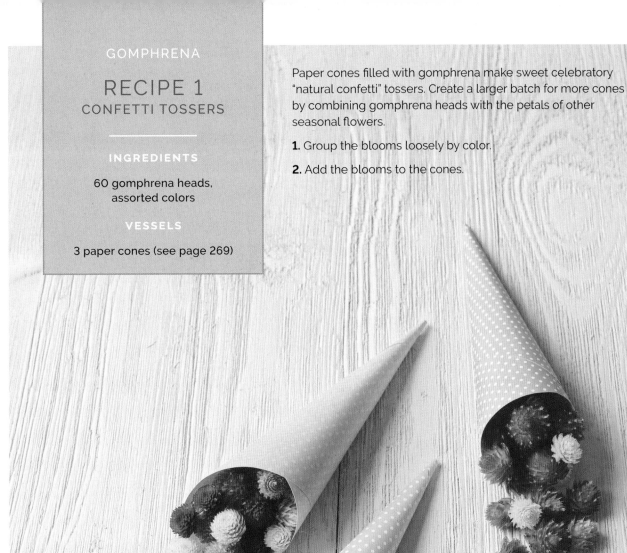

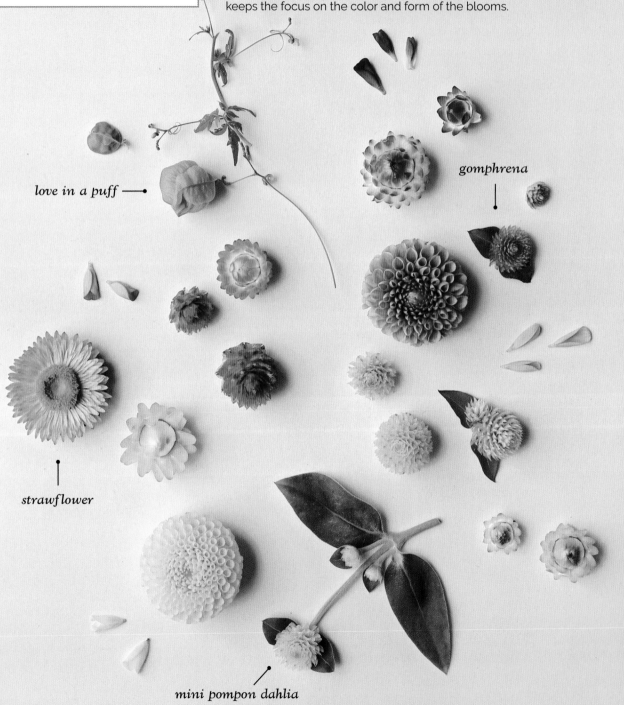

GOMPHRENA

RECIPES 2–4
INGREDIENTS

Limiting the variety of bloom shapes in a design can be a fun exercise in restraint. With a nod to the traditional pavé style of arranging, this collection uses mostly short-stemmed blooms with no foliage to create perfectly imperfect mounded compositions. Even though the flower shapes are all round, the varied sizes provide visual interest, and removing the leaves keeps the focus on the color and form of the blooms.

love in a puff ⟶

gomphrena

strawflower

mini pompon dahlia

GOMPHRENA

RECIPE 2
MICRO ARRANGEMENT

INGREDIENTS

1 mini pompon dahlia bloom

2 strawflower blooms

4 gomphrena blooms

3 love in a puff vines

VESSEL & SUPPLIES

Pin frog

1½-inch-tall (4 cm) round
ceramic vase

Take inspiration from those endearing weeds sprouting from sidewalk cracks and use love in a puff vines to transform a simple cluster of blooms into a tiny wild garden.

1. Place the pin frog in the vase and press the mini pompon dahlia stem and a strawflower stem into it, with the blooms leaning over the left rim. Add a gomphrena stem into the pin frog, with the bloom resting on the right rim.

2. Layer the remaining strawflower stem and two gomphrena blooms on top to create a mounded composition. Place the last gomphrena bloom above the others on the right, giving it a playful downward bend.

3. Finish by gently feeding the love in a puff vines between the blooms so they reach wildly in all directions.

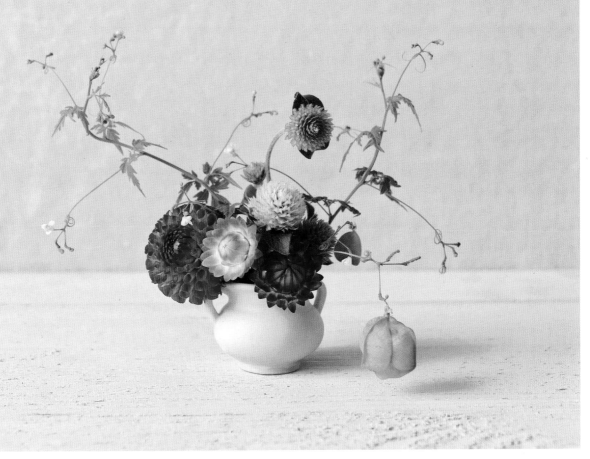

RECIPE 3
WALL HANGING

INGREDIENTS

20 gomphrena heads

15 strawflower heads

SUPPLIES

Five 10-inch (25 cm) pieces of
embroidery floss

Needle

5-inch (13 cm) wooden skewer

8-inch (20 cm) piece of ribbon

1 Line up seven gomphrena and strawflower heads in a row from large to small in a pleasing color pattern. Tie a triple knot about an inch (2.5 cm) from the end of a piece of embroidery floss to prevent the heads from slipping off, and thread the needle with the other end. Poke the needle up through the bottom of the first head in the pattern and gently pull it down the floss.

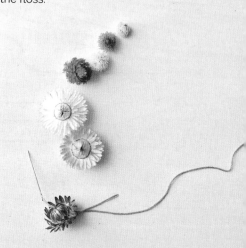

2 String the other six strawflower and gomphrena heads onto the floss, leaving a small space between them.

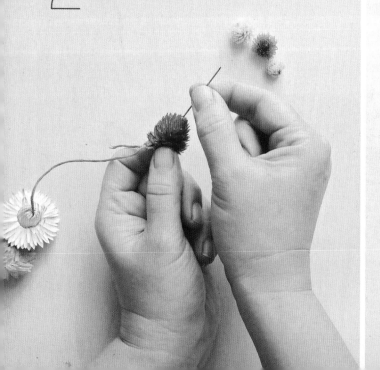

3 Repeat the process with the other four pieces of floss. Line up the completed strands and tie them onto the skewer, spacing them an inch (2.5 cm) apart. Finish by trimming off the tails of the floss and tying the ribbon to the skewer at both ends for hanging.

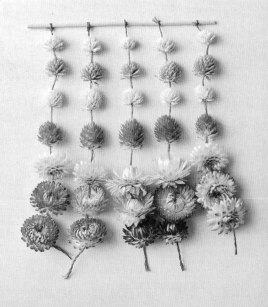

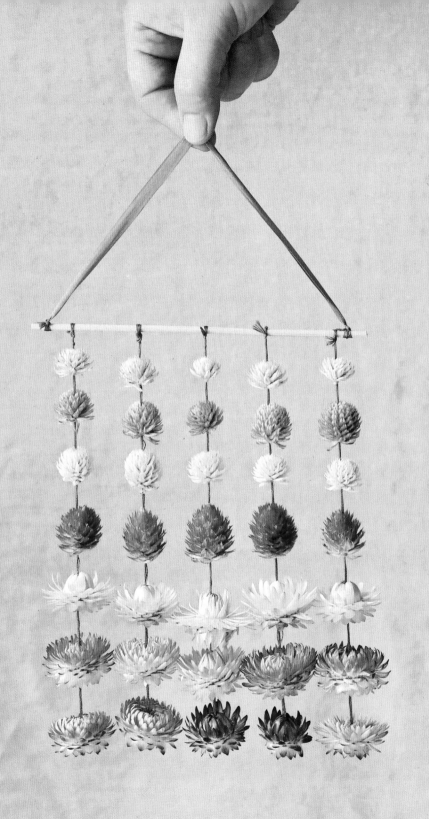

GOMPHRENA

RECIPE 4
MINI ARRANGEMENTS

Create bold, graphic arrangements by selecting flowers and vases with round shapes and in warm colors. The concept works for both mixed compositions and singular color stories; just be sure to remove all the leaves from the stems so the bloom shapes are the focus. Use a low vase with a large opening and a pin frog for support to layer assorted sizes and colors (as shown here), or create simple monochromatic mini compositions in bud vases (opposite).

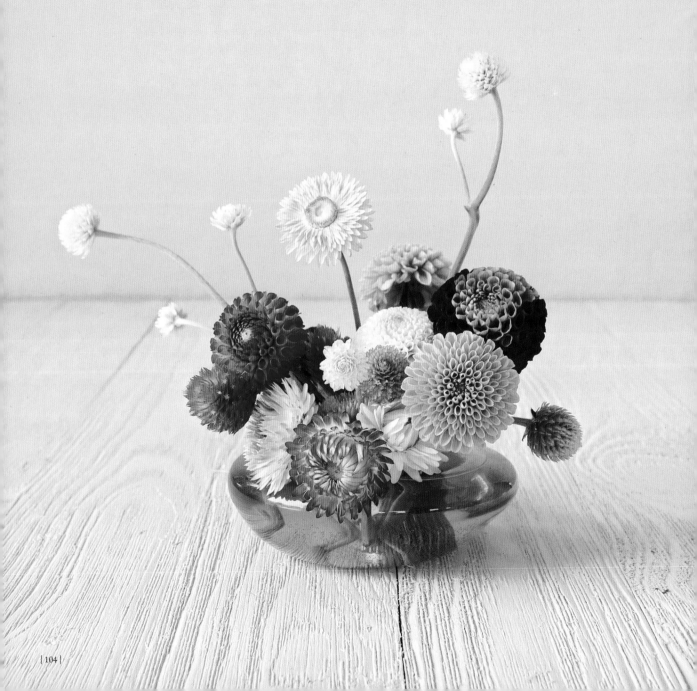

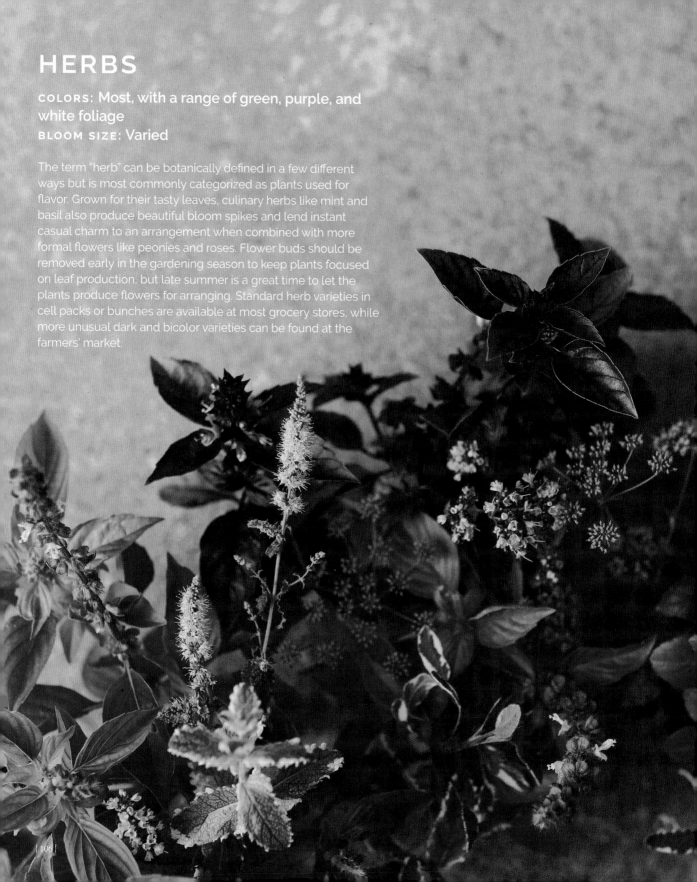

HERBS

COLORS: Most, with a range of green, purple, and white foliage
BLOOM SIZE: Varied

The term "herb" can be botanically defined in a few different ways but is most commonly categorized as plants used for flavor. Grown for their tasty leaves, culinary herbs like mint and basil also produce beautiful bloom spikes and lend instant casual charm to an arrangement when combined with more formal flowers like peonies and roses. Flower buds should be removed early in the gardening season to keep plants focused on leaf production, but late summer is a great time to let the plants produce flowers for arranging. Standard herb varieties in cell packs or bunches are available at most grocery stores, while more unusual dark and bicolor varieties can be found at the farmers' market.

HERBS

RECIPE 1
MICRO ARRANGEMENT

INGREDIENTS

1 basil spike

1 parsley umbel

1 thyme sprig

1 'Little Gem' marigold bloom

1 chamomile bloom

1 mint spike

VESSEL & SUPPLIES

1-inch-tall (2.5 cm) dollhouse
glass beaker

Double-sided glue tab (optional)

Pinching blooms from herb plants in the garden encourages production *and* creates material for the tiniest fragrant arrangements.

1. Create a tiny bunch in hand with the basil, parsley, thyme, and marigold, lining up the bottom of the blooms. Adjust the basil flower so the tip curves left. Trim and slide the bunch into the beaker all at once, with the blooms resting on the rim.

2. Finish by placing the chamomile and mint in the middle, both stems curving right to balance the basil. If desired, add a glue tab to the surface where you wish to place the beaker, to help stabilize the arrangement.

RECIPES 1–4
INGREDIENTS

This "everything but the kitchen sink" collection combines culinary herbs, pollinators (agastache, asclepias, yarrow), and edibles ('Little Gem' marigold, tomato) with florets varying in size from a pinhead to a penny. The overall palette is composed of materials mostly in the purple and orange family, with pink and blue hues purposefully omitted to avoid a rainbow effect. The muted tones of the basil and sage leaves provide a nice contrast to the brightly colored blooms.

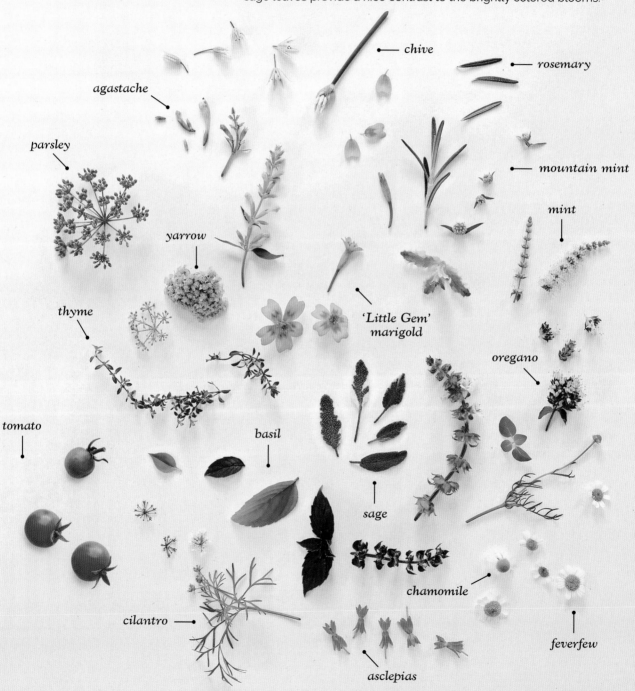

chive

rosemary

agastache

mountain mint

parsley

mint

yarrow

thyme

'Little Gem' marigold

oregano

tomato

basil

sage

chamomile

cilantro

feverfew

asclepias

HERBS

RECIPE 2
WREATH

INGREDIENTS

One 10-inch (25 cm)
rosemary stem

50 assorted
herb blooms and leaves
(see opposite for suggestions)

SUPPLIES

Twine

Thread

Combine the blooms and leaves from a variety of herbs in this fresh, fragrant wreath. Some foliage (rosemary, sage, and thyme) dries beautifully, while the textural blooms of basil and mint, for example, are hardier than their juicy leaves. For more on wreath making, see page 262.

1. Bend the rosemary stem into a circular shape to make the wreath frame. Connect the ends where they overlap with a small piece of twine.

2. Create a tiny bunch in hand with a mix of five herb stems. Wrap thread around the bunch a few times and tie tightly to secure. Repeat to make nine more bunches.

3. Lay the first bunch on top of the rosemary frame to cover the twine connection and tie it on with thread. Lay the second bunch on top of the stems of the first bunch in the same direction. Tie it on with thread. Repeat until the entire frame is covered. Finish by tucking the stems of the last bunch under the blooms of the first bunch and attach with thread.

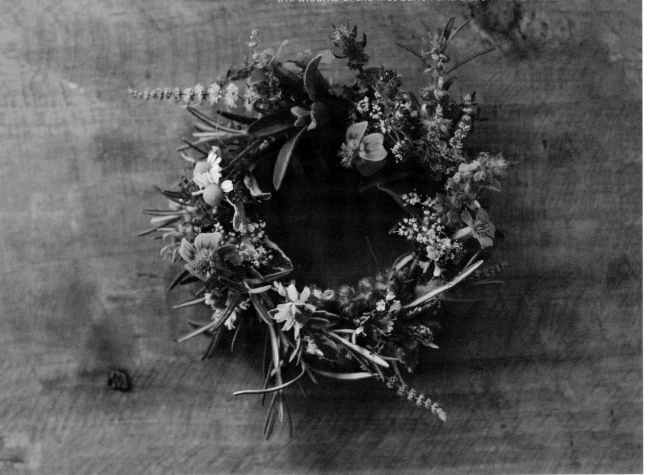

HERBS

RECIPE 3
MINI ARRANGEMENT

INGREDIENTS

1 unripe tomato stem

4 basil sprigs

5 parsley sprigs

2 feverfew sprigs

3 oregano sprigs

3 agastache spikes

VESSEL

3¼-inch-tall (8.5 cm) glass pitcher

1 Place the tomato stem so the fruit dangles over the pitcher rim and leans out to the left.

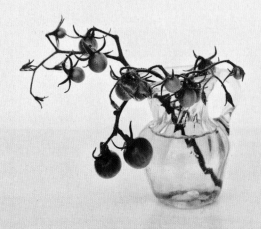

2 Lean three basil sprigs to the right with the tips curving up and the leaves hanging over the rim. Place the remaining sprig at the back.

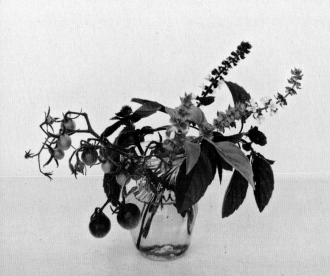

3 Nestle the parsley sprigs between the tomato and basil to fill the arrangement's center. Layer the feverfew sprigs on the left above the parsley. Nestle in the oregano sprigs to create more density in the center. Finish by feeding the agastache spikes through the base layer on the left, loosely mirroring the heights of the basil tips.

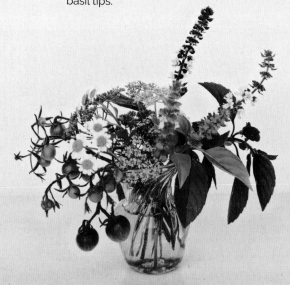

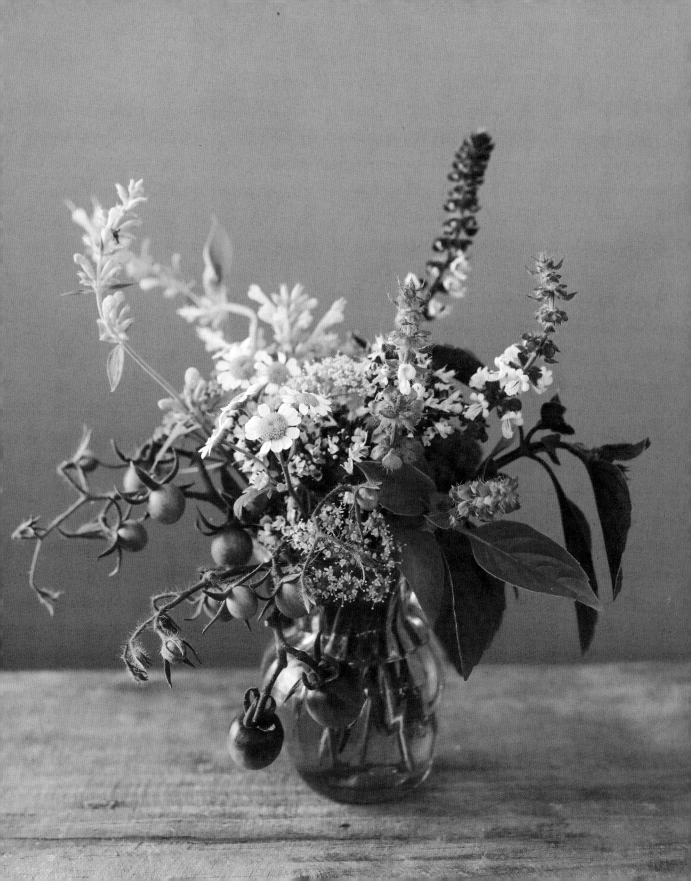

RECIPE 4
MINI ARRANGEMENTS

Nothing screams summer like a bouquet of fragrant herbs clipped fresh from the garden. Collect small sprigs from seven to ten varieties (see page 108 for suggestions) and place in petite cups with pin frogs to create airy compositions. Use multiples of the same vessel to build a cohesive but varied look for a dinner party: assemble a unique combination in each cup while repeating ingredients and varying the quantities across the collection.

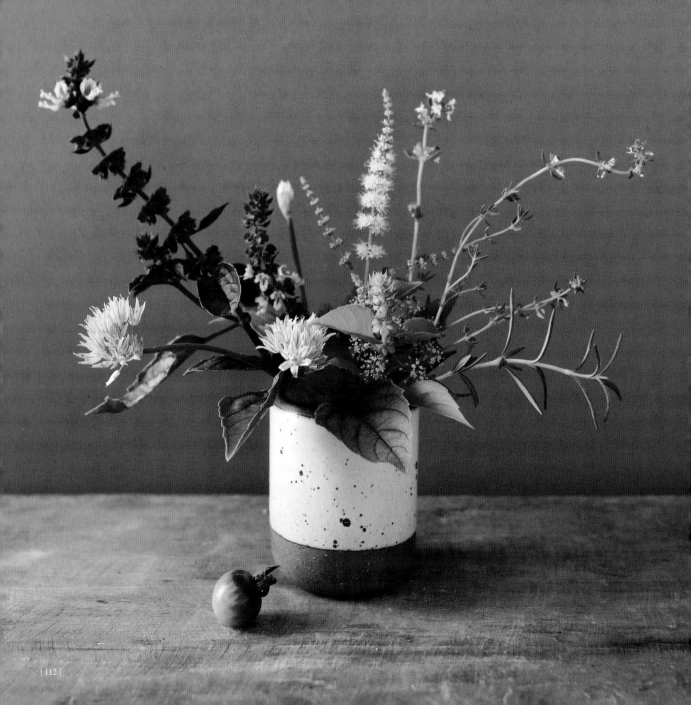

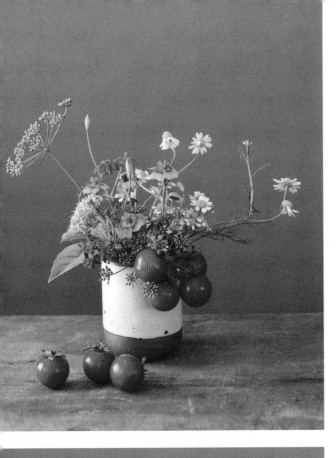
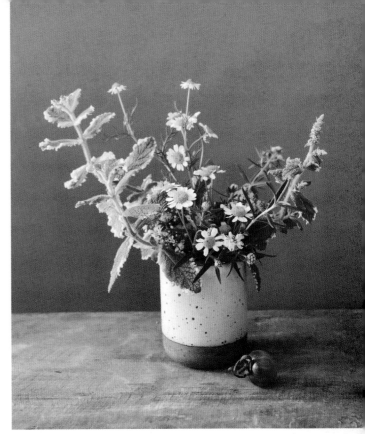
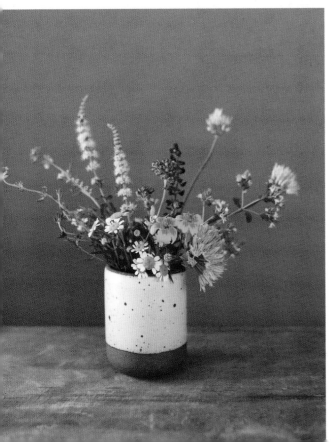
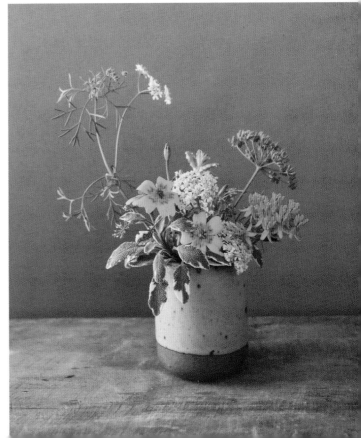

NASTURTIUM

COLORS: Most, except blue
BLOOM SIZE: 2 inches (5 cm)

Nasturtiums are commonly thought of as either colorful salad
enhancers (thanks to their edible, peppery leaves and blooms)
or gorgeous, trailing additions to hanging baskets—but they
also make fantastic cut flowers! Every part of these fast-growing
vines can be used in an arrangement, and the best way to
source them is to grow them yourself, because their fragile,
snappy stems make them too fussy for most suppliers to bother
with. There is so much variation on a single vine: leaves range in
size from a palm to a pinky nail, plus fully mature blooms, buds,
and graphic seedpods. Harvest them early in the morning to
prevent wilting and let them hydrate for several hours before
using in arrangements.

NASTURTIUM

RECIPE 1
ON ITS OWN

INGREDIENTS

1 nasturtium vine tip

9 nasturtium blooms,
assorted colors

VESSEL

4-inch-tall (10 cm) drinking glass

A simple arrangement of nasturtium flowers and vines on the kitchen windowsill adds a bright pop of citrus color to the room and makes it easy to plunk these vitamin C–rich petals onto your plate.

1. Place the nasturtium vine in the glass, leaning out on the left side.

2. Loosely add the flowers around the vine, taking care to leave a little space between the blooms so they don't get smashed.

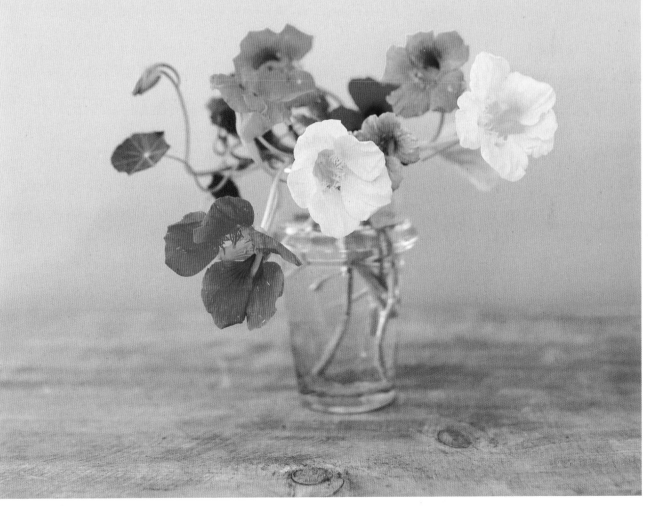

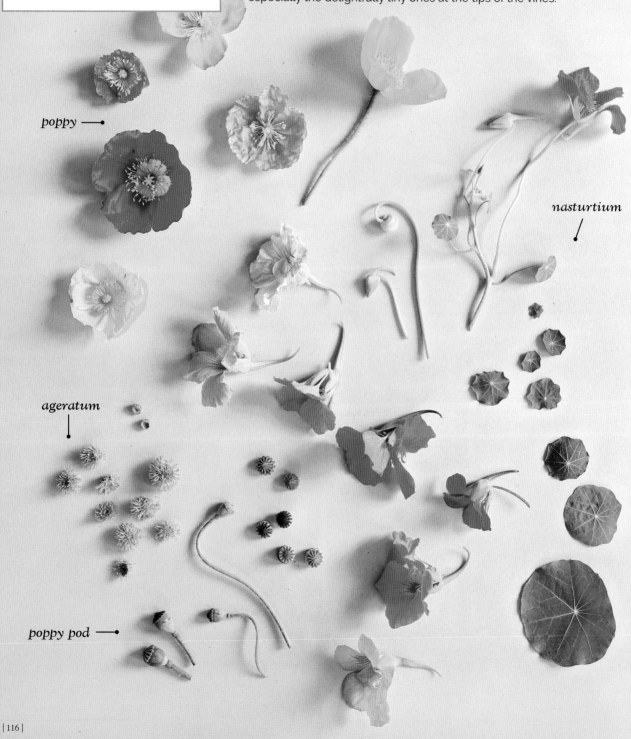

This vibrant collection is a celebration of color, featuring nasturtium and poppy blooms in warm citrus tones and fuzzy purple ageratum to add a nice contrast in both color and texture. The graphic leaves of the nasturtium are used as design elements rather than filler foliage, especially the delightfully tiny ones at the tips of the vines.

poppy ——

nasturtium

ageratum

poppy pod ——

RECIPE 2
MICRO ARRANGEMENT

INGREDIENTS

2 ageratum sprigs

2 nasturtium leaves

1 nasturtium bloom

2 poppy pods

1 poppy bloom

VESSEL & SUPPLIES

1¾-inch-tall (4.5 cm) tapered neck bud vase

Double-sided glue tab (optional)

The subtle curves of an arrangement's stems can drastically impact the composition, especially if the vase accommodates only a few. Try gently turning them in the vase until you find the perfect position.

1. Place the ageratum sprigs so the blooms rest on the right rim.

2. Lean one nasturtium leaf out above the ageratum, and add the nasturtium bloom on the left side so it faces upward and inward.

3. Tuck one poppy pod into the front of the arrangement, then place the remaining nasturtium leaf behind it.

4. Add the poppy bloom in the center and position the other poppy pod on the right at about the same height as the nasturtium. If desired, add a glue tab to the surface where you wish to place the vase, to help stabilize the arrangement.

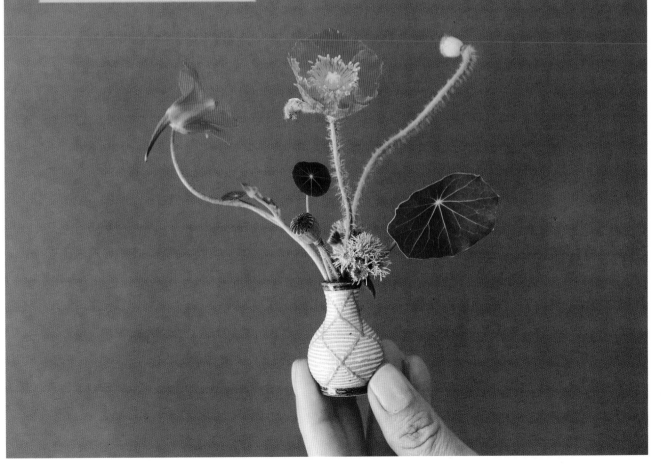

NASTURTIUM

RECIPE 3
MINI ARRANGEMENT

INGREDIENTS

3 nasturtium vines with blooms,
leaves, and buds

6 nasturtium blooms

4 ageratum sprigs

4 poppy blooms

2 poppy pods

VESSEL & SUPPLIES

Pin frog

3-inch-diameter (7.5 cm) ceramic ramekin

1 Place the pin frog in the ramekin and press two nasturtium vines into it so they lean out to the left and right. The leaves and flowers will have a loose and wild shape. Layer the nasturtium blooms around the vines, leaning over the rim.

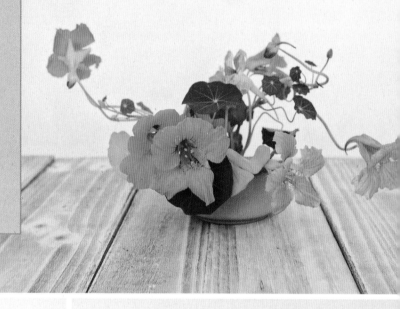

2 Nestle two ageratum sprigs between the nasturtium blooms at the rim, the third ageratum among the leaves on the right, and the fourth above the blooms on the left.

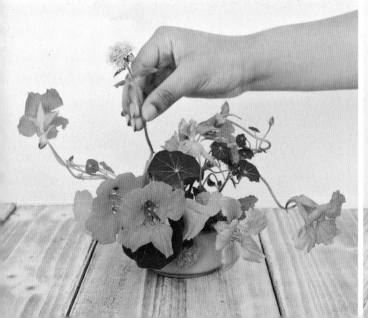

3 Press the third nasturtium vine into the pin frog so it stands upright, with a leftward lean. Lean a poppy bloom out on the right side and one facing the opposite direction at the front. Place the last two poppies facing outward at a similar height on the left and right. Finish by leaning the two gestural poppy pods to the right to balance the tall nasturtium vine.

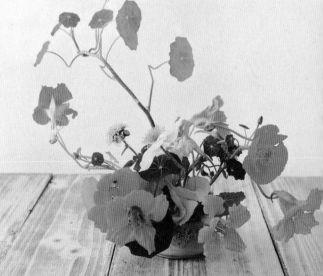

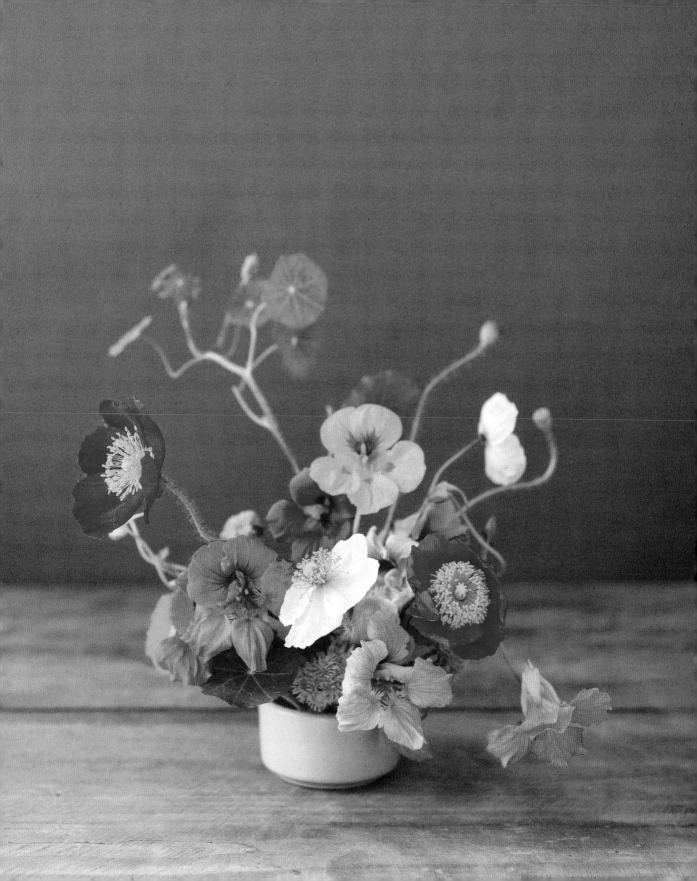

NASTURTIUM

RECIPE 4
GIFT BOX TOPPERS

INGREDIENTS

2 ageratum sprigs

6 nasturtium blooms

1 nasturtium vine tip with buds
and leaves

3 nasturtium leaves

SUPPLIES

Thin ribbon

3 kraft boxes of various sizes

Floral tape

Wide ribbon

Dress up a gift box by tucking a pretty posy under the ribbon just before it is presented. The recipient can trim the stems and pop the bouquet into water for a longer-lasting display.

1. Wrap a piece of thin ribbon around each box, trim, and secure with a simple knot.

2. Create three different-size posies in hand, lining up the bottom of the blooms, and wrap with floral tape. Using floral tape will hold the composition together more tightly than securing with only ribbon.

3. Tie a wide ribbon around each posy to conceal the floral tape and gently tuck the bundle under the ribbon on top of the box.

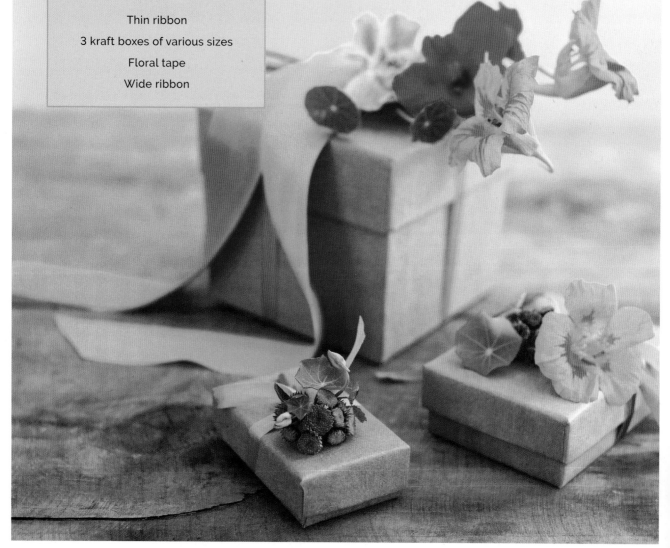

NASTURTIUM

RECIPE 5
BONUS: AGERATUM

INGREDIENTS

14 ageratum heads

SUPPLIES

15-inch (38 cm) piece of thread

Needle

Four 6-inch (15 cm) pieces of ribbon

1 Thread the needle and insert it into one of the ageratum heads. Pull the flower gently down the thread, leaving 2 inches (5 cm) of thread at the end. Repeat with the remaining heads, stringing them so they face in different directions with a small amount of space between them. Leave at least 2 inches (5 cm) of thread at the opposite end.

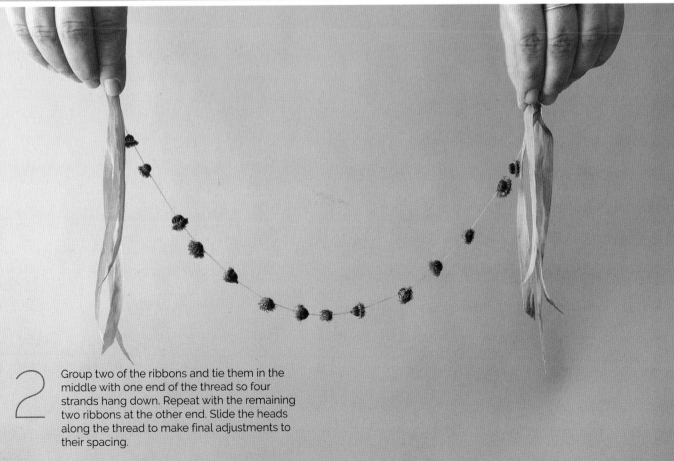

2 Group two of the ribbons and tie them in the middle with one end of the thread so four strands hang down. Repeat with the remaining two ribbons at the other end. Slide the heads along the thread to make final adjustments to their spacing.

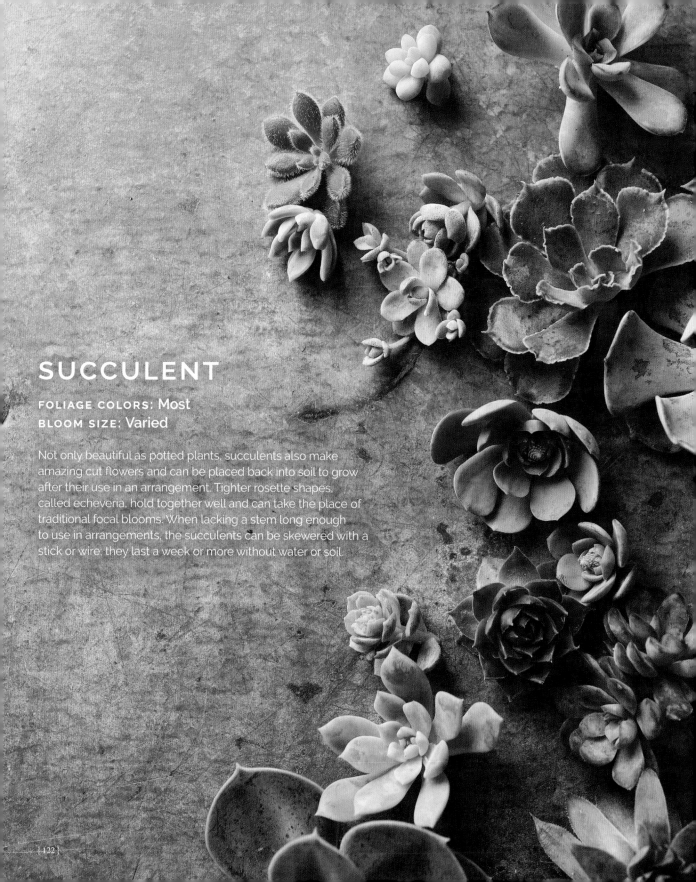

SUCCULENT

FOLIAGE COLORS: Most
BLOOM SIZE: Varied

Not only beautiful as potted plants, succulents also make amazing cut flowers and can be placed back into soil to grow after their use in an arrangement. Tighter rosette shapes, called echeveria, hold together well and can take the place of traditional focal blooms. When lacking a stem long enough to use in arrangements, the succulents can be skewered with a stick or wire; they last a week or more without water or soil.

SUCCULENT

RECIPE 1
ON ITS OWN

INGREDIENTS

50 succulent heads,
assorted varieties and sizes

VESSELS & SUPPLIES

½-inch-diameter (1 cm)
dollhouse bowl

2¼-inch-diameter (5.5 cm)
salt dish

3¼-inch-diameter (8.5 cm)
terra-cotta bowl

Sandy soil

These dense compositions, made up of tiny succulents sprouted from leaf cuttings (see page 14) or trimmed from larger plants, can be grouped as a centerpiece and later transplanted into larger containers for long-term viability.

1. Fill the vessels to about ¼ inch (6 mm) below the rims with dry, sandy soil.

2. Rest an assortment of the smallest succulents onto the soil in the dollhouse bowl, nestling them with no space between them to form a dense layer. Repeat for the two larger vessels, scaling up the size of the succulents and placing different varieties directly next to one another. Wait about ten days for the stems to callus over and sprout roots before lightly watering.

SUCCULENT

RECIPES 2–4
INGREDIENTS

This collection features an assortment of sedum, echeveria, and sempervivum that are broadly categorized as succulents and can be difficult to distinguish from each other. Along with these succulents, geometric scabiosa pods, balloon-like silene flowers, and fluffy bunny tail grasses are used in place of traditional blooms. The neutral palette of gray, beige, and green is subtle but far from boring thanks to the combo's textural playfulness.

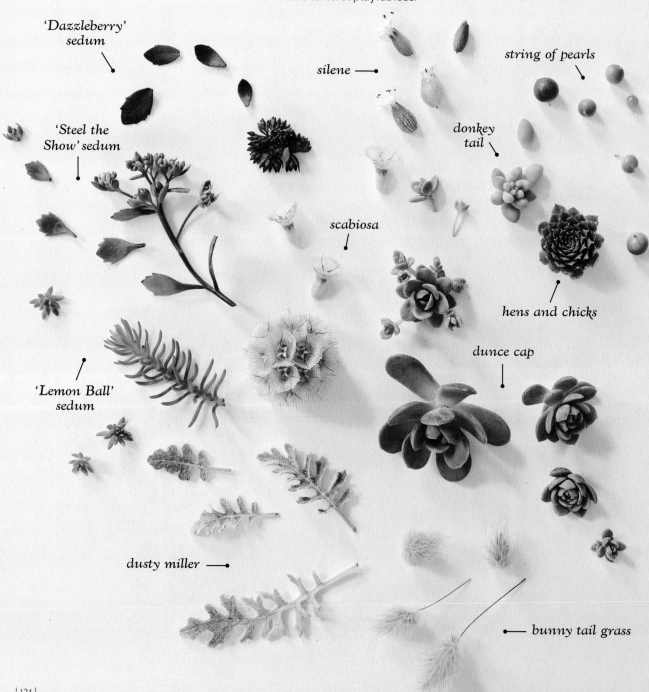

'Dazzleberry' sedum

silene

string of pearls

'Steel the Show' sedum

donkey tail

scabiosa

hens and chicks

'Lemon Ball' sedum

dunce cap

dusty miller

bunny tail grass

RECIPE 2
MICRO ARRANGEMENT

INGREDIENTS

2 succulents
(see opposite for suggestions)

1 scabiosa bloom

5 sedum sprigs
(see opposite for suggestions)

3 bunny tail grass blooms

4 dusty miller leaves

2 silene sprigs

VESSEL & SUPPLIES

Pin frog

1-inch-tall (2.5 cm) ceramic vase

The stems of succulents can be pressed into a pin frog just deep enough to hold them in place without the use of a skewer. To "reveal" a longer stem, carefully remove a few of the lower leaves (which you can set aside to propagate—see page 14).

1. Set the pin frog in the vase and press the succulents into it so they rest at the rim.

2. Place the scabiosa bloom leaning out to the left and nestle three sedum sprigs around it at a similar height. Fill in the space between the larger succulents with the last two sedum sprigs. Add the bunny tail grass blooms in the center of the arrangement at varying heights.

3. Place three dusty miller leaves at the back of the vase and lean one out on the right. Nestle one silene sprig next to the bunny tail grass and lean the other out on the left to balance the dusty miller leaf.

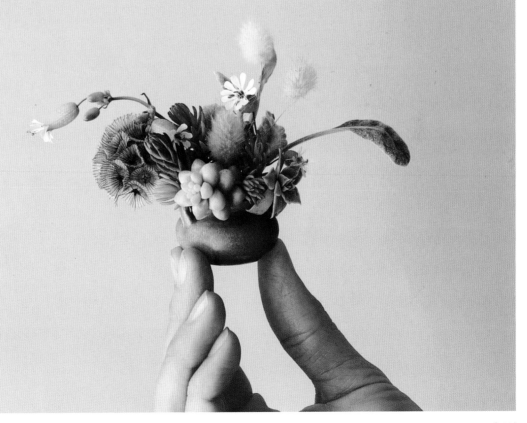

SUCCULENT

RECIPE 3
MINI ARRANGEMENT

INGREDIENTS

4 succulents
(see page 124 for suggestions)

3 sedum sprigs
(see page 124 for suggestions)

2 dusty miller leaves

2 scabiosa blooms

1 bunny tail grass bloom

1 silene sprig

VESSEL & SUPPLIES

Pin frog

2½-inch-tall (6.5 cm) ceramic bowl

1 Set the pin frog in the bowl and press three succulents into it so they rest along the center front rim. Add two sedum sprigs at the back rim and lean one out on the left, curving upward. Place the remaining succulent at the back rim.

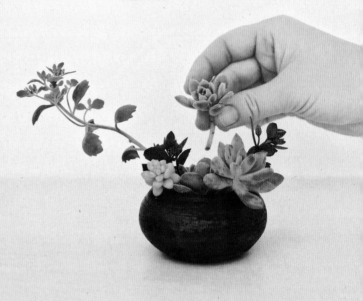

2 Tuck one dusty miller leaf under the left succulent and the other into the center, with an upward lean to the right.

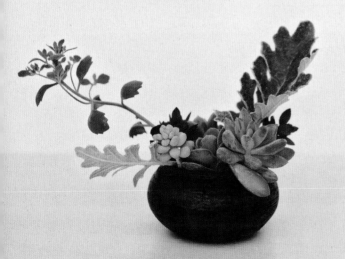

3 Nestle one scabiosa bloom along the left rim and place the other a little higher up in the center. Finish by adding the bunny tail grass bloom above the sedum on the left, balancing it with the silene sprig on the right.

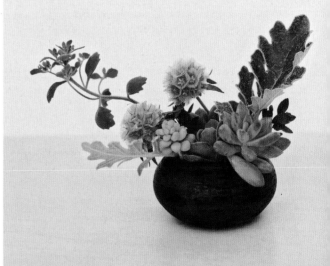

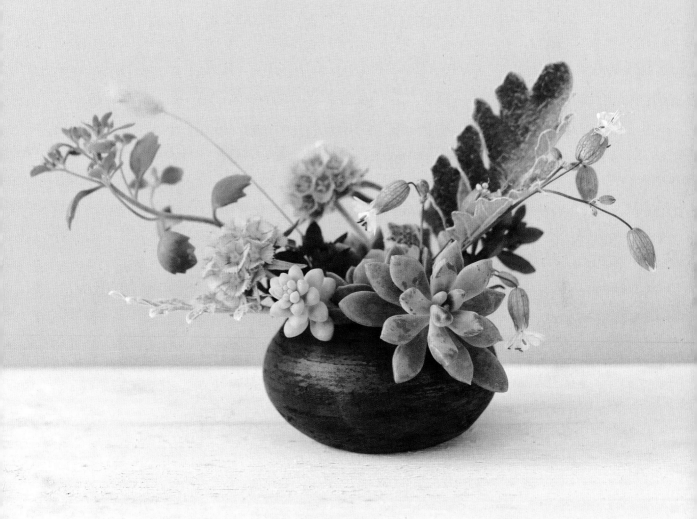

RECIPE 4
TABLESCAPE

INGREDIENTS

5 succulents
(see page 124 for suggestions)

5 silene sprigs

1 dusty miller leaf

3 sedum sprigs
(see page 124 for suggestions)

3 bunny tail grass blooms

1 scabiosa bloom

VESSELS

Glass cloches and beakers,
in assorted sizes from ¾ inch (2 cm)
to 2¾ inches (7 cm) tall

Displayed in laboratory glass, this quirky grouping feels like a beautiful floral experiment in progress.

1. Gently wedge succulent specimens upright inside cloches to invite close inspection of their unique forms. (They can be set directly onto the table, without water or dirt.)

2. Place the other ingredients in assorted groupings in the beakers (they must be in water to prevent wilting).

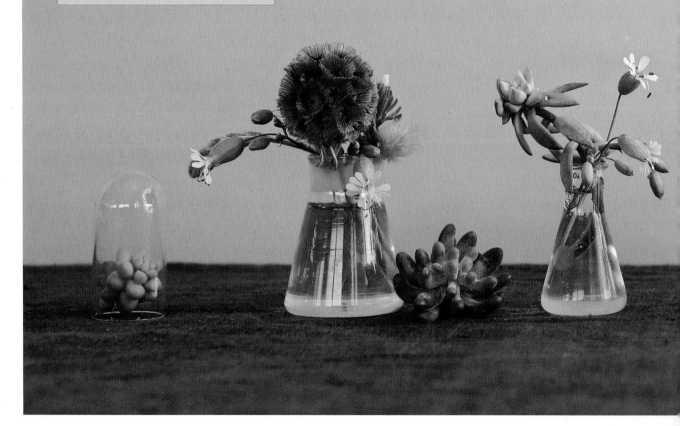

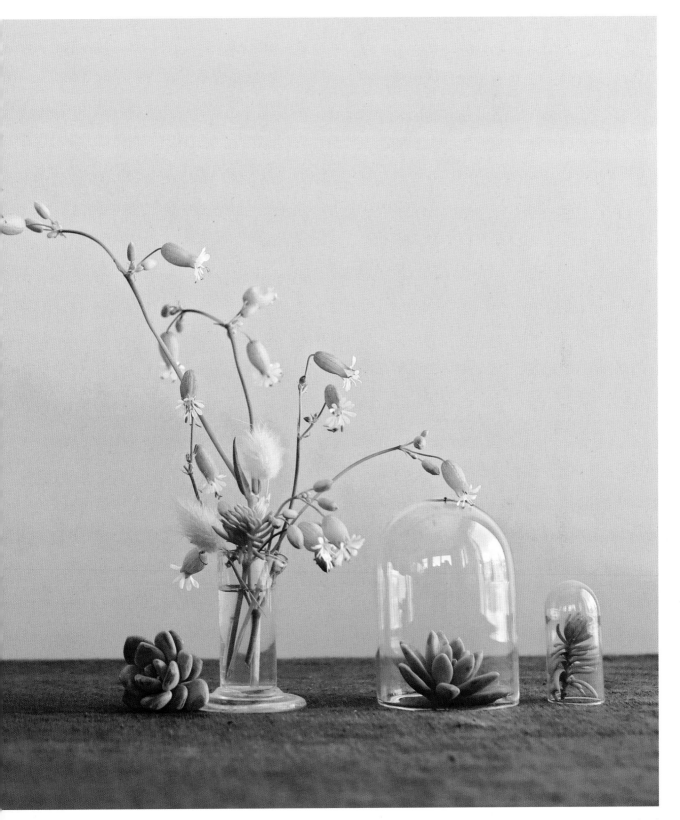

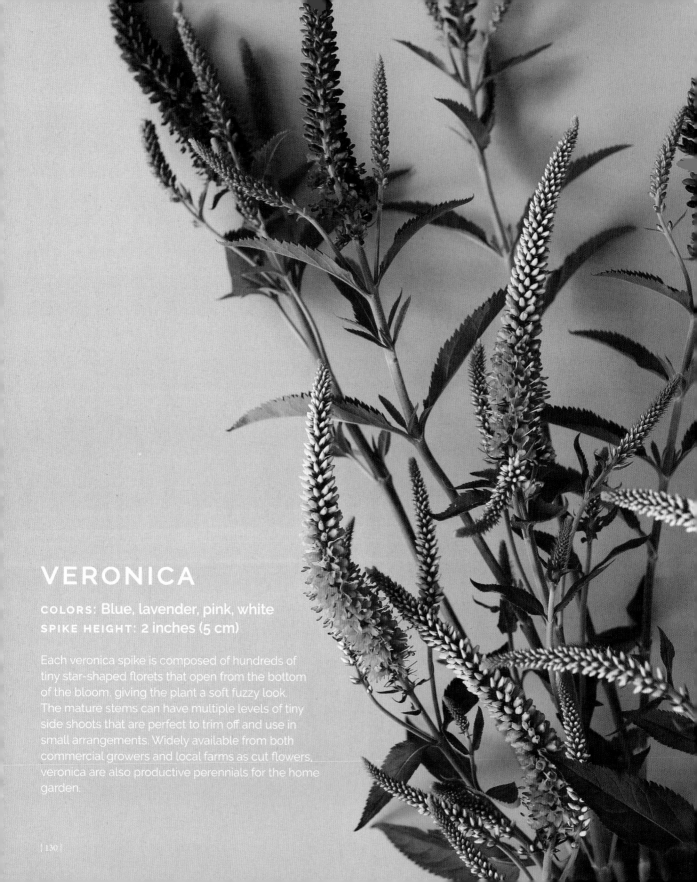

VERONICA

COLORS: Blue, lavender, pink, white
SPIKE HEIGHT: 2 inches (5 cm)

Each veronica spike is composed of hundreds of tiny star-shaped florets that open from the bottom of the bloom, giving the plant a soft fuzzy look. The mature stems can have multiple levels of tiny side shoots that are perfect to trim off and use in small arrangements. Widely available from both commercial growers and local farms as cut flowers, veronica are also productive perennials for the home garden.

RECIPE 1
ON ITS OWN

INGREDIENTS

4 veronica stems

VESSEL

2¾-inch-tall (7 cm) tapered
ceramic bud vase

Cut tall stems of veronica into smaller sections to make use of all the flower parts. You'll get more material from fewer stems when you combine the mature blooms with spikelets and leaves (see page 13).

1. Trim one of the veronica spikes above a node so the stem length is approximately the same height as the vase. Repeat with the other stems, reserving the remaining pieces to fill in around the larger blooms.

2. Place three of these spikes in the vase, curving in different directions. Add the reserved sprigs so the leaves rest on the vase rim and the spikelets fill in around the larger blooms.

3. Position the remaining veronica spike so the lowest level of blooms rests on the front rim.

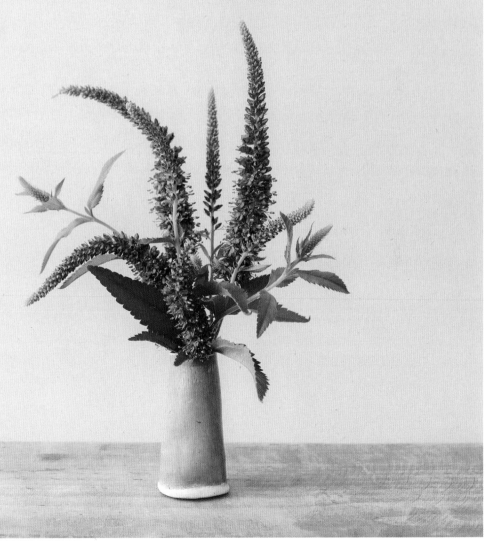

RECIPES 2–4
INGREDIENTS

Clusters of berries take the place of a round focal flower in this spiky collection of vertical blooms. The whimsical prairie coneflower, ethereal spires of thalictrum and Russian sage, and unusual color combination (red-brown mixed with pink, purple, and blue) evoke a magical fairy forest feeling. Astilbe, Russian sage, and thalictrum can be clipped apart into smaller sections, while veronica, buddleia, and foxglove typically have mini side shoots. Though the bloom formations are different, both will be called spikelets in the recipes that follow.

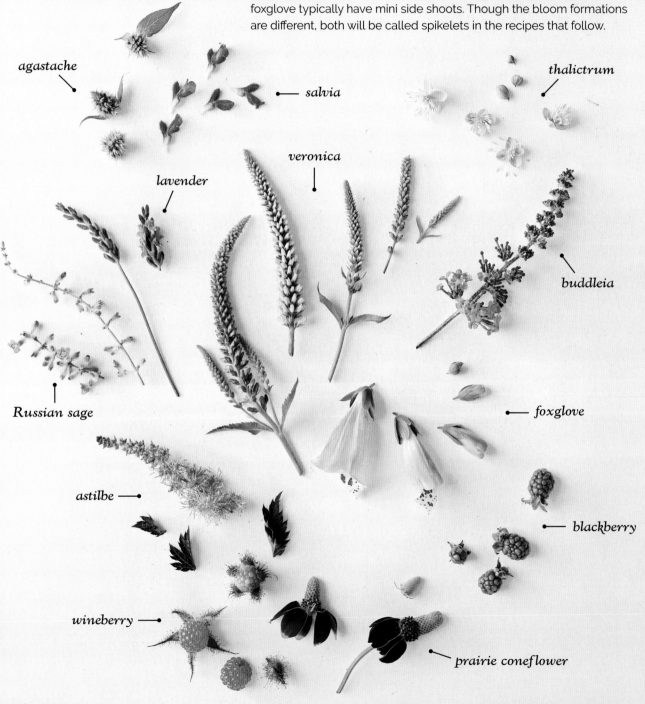

agastache

salvia

thalictrum

lavender

veronica

buddleia

Russian sage

foxglove

astilbe

blackberry

wineberry

prairie coneflower

VERONICA

RECIPE 2
MICRO ARRANGEMENT

INGREDIENTS

1 blackberry sprig

1 wineberry sprig

2 veronica spikelets

1 astilbe spikelet

1 agastache bloom

2 prairie coneflower buds

1 Russian sage spikelet

1 thalictrum spikelet

VESSEL

2-inch-tall (5 cm) ceramic vase
with handles

Clustering berries at the rim of the vase anchors these tall gestural spires into position. Each stem is given plenty of space to curve, with little overlap making for a dynamic profile. Be sure some of the tips are curved inward to keep the eye circling around the composition.

1. Place the berries so the fruit is clustered at the rim. Add a veronica and astilbe spikelet curving down on the right side so the lowest level of florets rests on the rim. Place the second veronica spikelet in the center, curving to the left, then layer the agastache bloom in front of it.

2. Add the prairie coneflower buds leaning to the left side and the Russian sage curving up and inward between them.

3. Finish by leaning the thalictrum spikelet to the right, creating the tallest point in the composition.

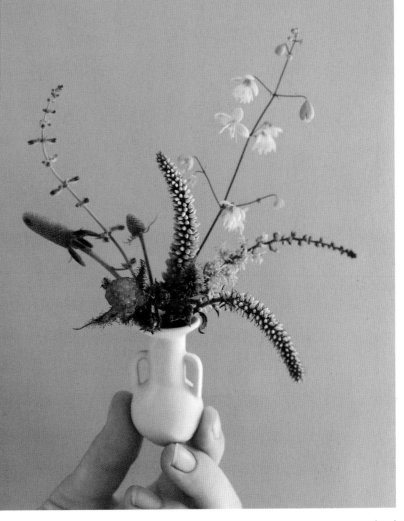

VERONICA

RECIPE 3
MINI ARRANGEMENT

INGREDIENTS

1 blackberry sprig

1 wineberry sprig

5 veronica stems

2 astilbe spikelets

2 thalictrum spikelets

2 prairie coneflower blooms

VESSEL

3¼-inch-tall (8.5 cm) ceramic pitcher

1 Place the berries so the lowest level of fruit leans out over the pitcher rim.

2 Cluster the veronica stems on the left, with the spires curving in different directions. Nestle the astilbe spikelets straight up in the middle of the arrangement.

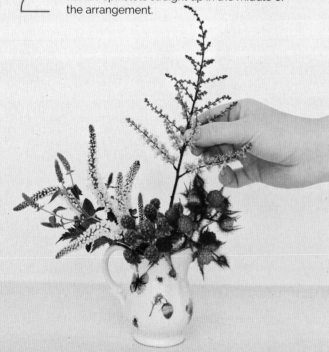

3 Insert the thalictrum spikelets between the berries to secure them in an upright position on the right side. Finish by adding one prairie coneflower bloom to the middle front and the other curving up on the left side at a similar height to the astilbe.

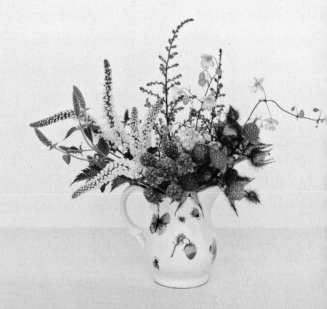

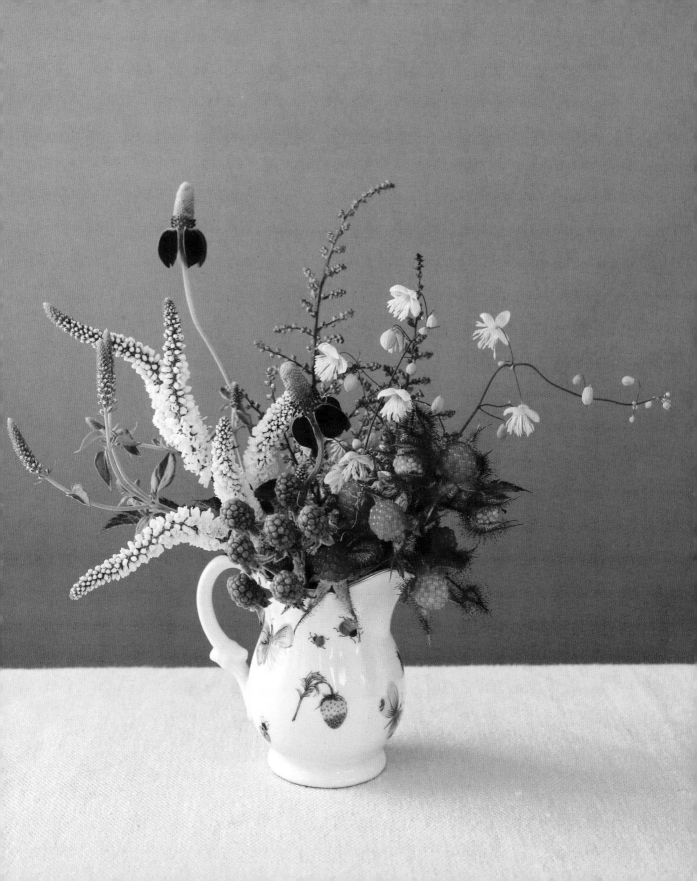

RECIPE 4

TABLESCAPE

INGREDIENTS

17 veronica stems, white, pink, and blue

30 to 40 white, pink, purple, and blue spires
(see page 132 for suggestions)

VESSELS

10 assorted 3-inch-tall (7.5 cm) glass vials

Using three different hues of veronica as a starting point, create a gradation of assorted garden clippings unified by their spike shape. Seek out blooms that come in multiple hues, like astilbe, buddleia, and foxglove, to repeat across the composition, and fill in with blooms you have only in a singular color, like thalictrum and Russian sage.

1. Add between one and four veronica spikes to each vial: white on the left, pink in the center, and blue on the right.

2. Keeping like colors with like, and subtly blending from one vial to the next, fill in around the veronica with assorted spires in white, pink, purple, and blue.

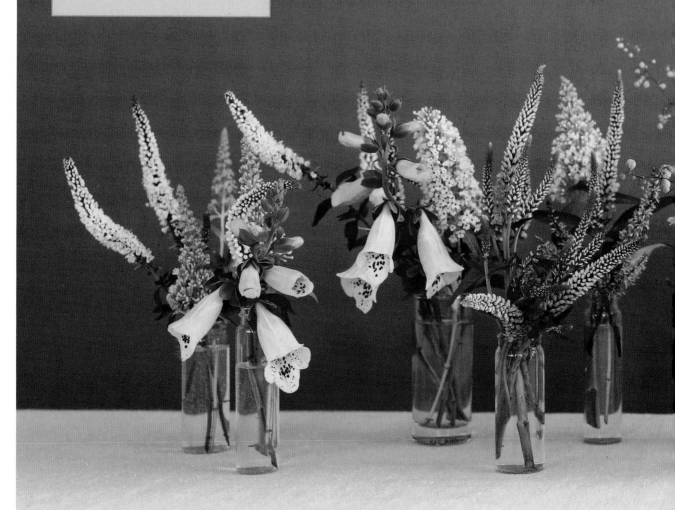

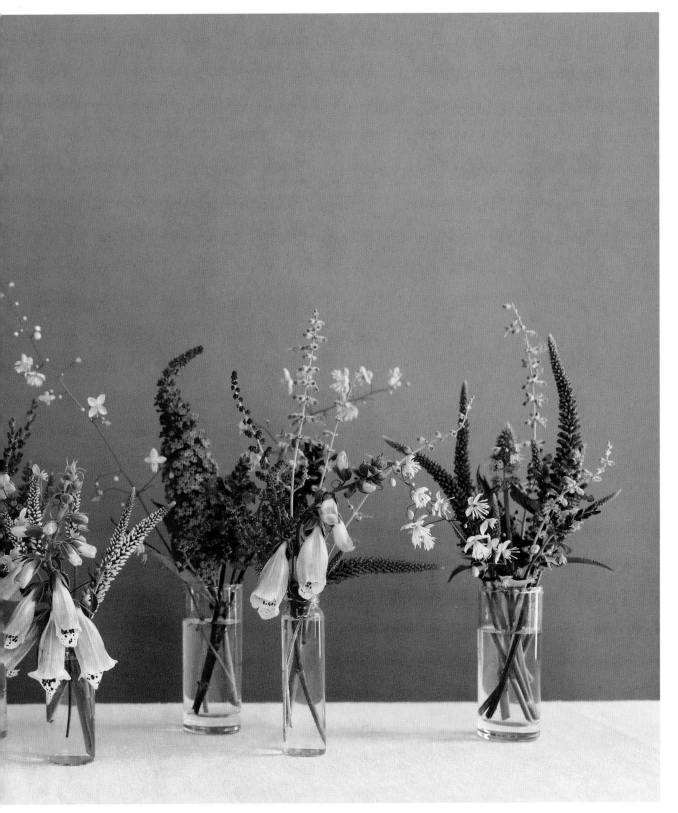

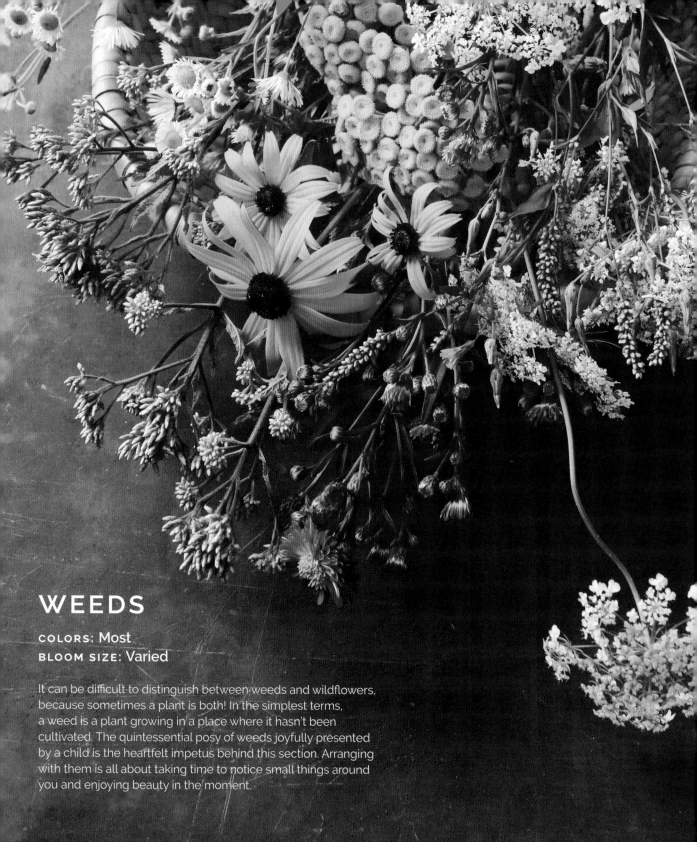

WEEDS

COLORS: Most
BLOOM SIZE: Varied

It can be difficult to distinguish between weeds and wildflowers, because sometimes a plant is both! In the simplest terms, a weed is a plant growing in a place where it hasn't been cultivated. The quintessential posy of weeds joyfully presented by a child is the heartfelt impetus behind this section. Arranging with them is all about taking time to notice small things around you and enjoying beauty in the moment.

RECIPE 1
MINI ARRANGEMENT

INGREDIENTS

2 tansy sprigs

3 goldenrod sprigs

5 rudbeckia blooms

VESSEL

2½-inch-tall (6.5 cm) ceramic
bud vase

When rudbeckia petals are bruised or damaged, pull them all off and use the remaining dark center for contrast in an otherwise sunny, monochromatic arrangement. This works for other flowers with textural centers, too, like anemones and coneflowers.

1. Place the tansy sprigs so the blooms are clustered at the front rim. Place one goldenrod sprig leaning out to the left and the other two at the back.

2. Feed four rudbeckia blooms through the tansy to anchor them in place, leaning out at staggered heights. Pull the petals off the last rudbeckia bloom and layer it on top of the tansy on the right.

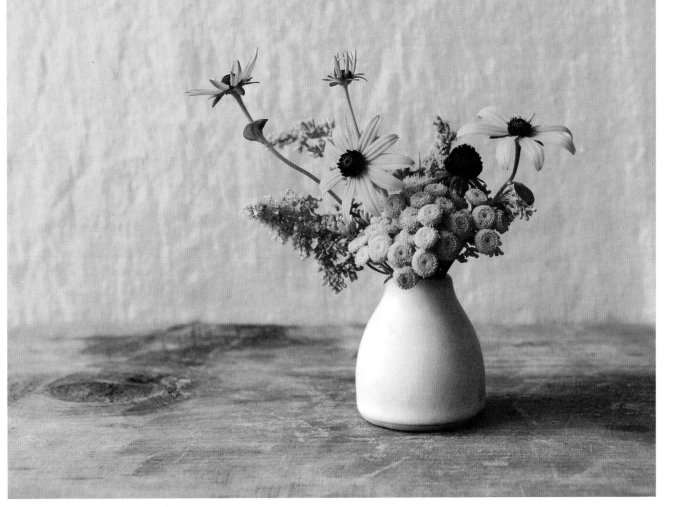

RECIPES 1–4
INGREDIENTS

This collection represents a late-summer snapshot of weeds and wildflowers in the Northeast region of the United States; available plants in your area will vary depending on climate and season. Longevity ranges from hardy (tansy, rudbeckia, goldenrod) to extremely fleeting (dandelion, bird's-foot trefoil, lady's thumb), so they will be useful for different types of arrangements. Though Queen Anne's lace, joe-pye weed, and goldenrod are large flowers, the umbel formation of their blooms makes them perfect for dividing.

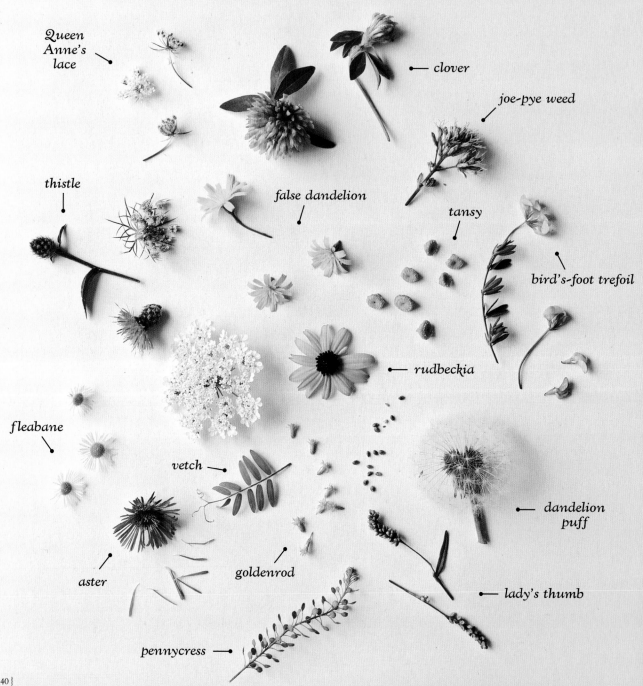

Queen Anne's lace

clover

joe-pye weed

thistle

false dandelion

tansy

bird's-foot trefoil

rudbeckia

fleabane

vetch

dandelion puff

aster

goldenrod

lady's thumb

pennycress

RECIPE 2
MICRO ARRANGEMENT

INGREDIENTS

2 false dandelion blooms

1 clover bloom

1 pennycress spikelet

1 thistle bloom

1 Queen Anne's lace umbel

VESSEL & SUPPLIES

1-inch-tall (2.5 cm) dollhouse glass bottle

Double-sided glue tab (optional)

Give each tiny weed space to shine in this pared-down composition, scaled perfectly for a dollhouse entryway.

1. Create a tiny bunch in hand with one false dandelion and the clover, pennycress, and thistle blooms, so they are spread out at varying heights with little overlap. Trim and insert them in the bottle all at once, then readjust spacing as necessary.

2. Finish by tucking the Queen Anne's lace umbel and remaining false dandelion along the rim to partially conceal the stems. If desired, add a glue tab to the surface where you wish to place the bottle, to help stabilize the arrangement.

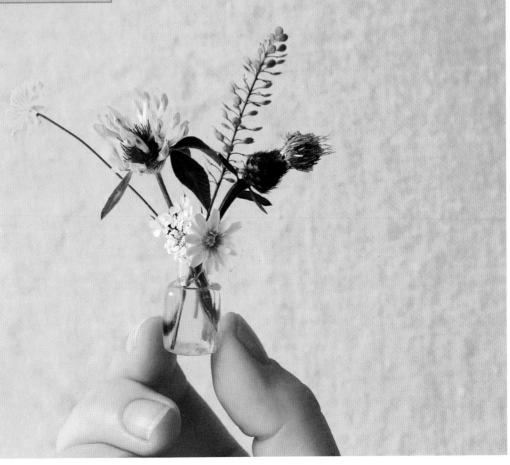

RECIPE 3
MINI ARRANGEMENT

INGREDIENTS

12 Queen Anne's lace blooms

20 to 30 sprigs of assorted weeds
(see page 140 for suggestions)

6 clover blooms

5 thistle blooms

2 lady's thumb sprigs

3 false dandelion puffs

3 rudbeckia blooms

VESSEL & SUPPLIES

Clear floral tape

7-inch-square (18 cm) low wooden box
with plastic liner

1 Create a two-by-two grid with the tape over the top of the box. Use nine Queen Anne's lace blooms to form a supporting layer over the top of the tape grid that will hold the other stems in place.

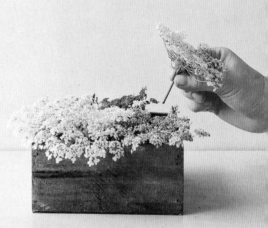

2 Feed the sprigs of assorted weeds at random through the layer of Queen Anne's lace to evoke the feeling of a field bursting with wildflowers.

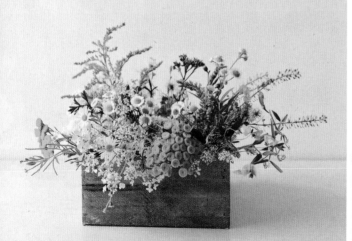

3 Insert the clover, thistle, lady's thumb, and false dandelion puffs, with these blooms sitting a little higher in the composition. Place the three rudbeckia blooms in the middle, then finish by adding the remaining Queen Anne's lace so the blooms sit at the highest point.

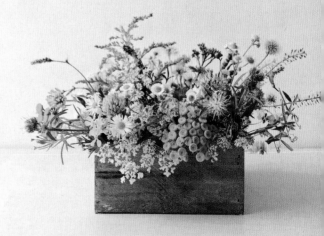

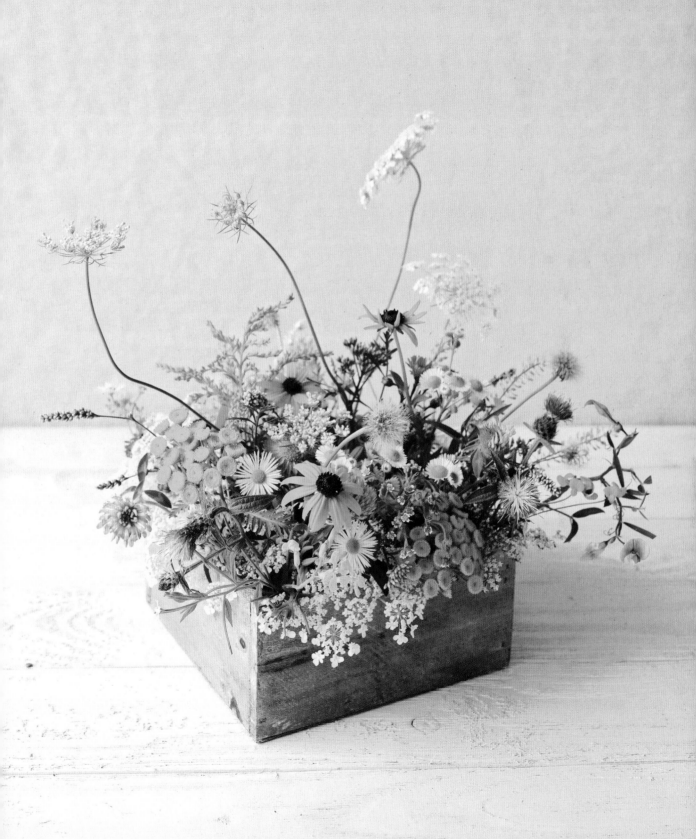

RECIPE 4
MICRO ARRANGEMENTS

When the occasion doesn't call for an entire (miniature) field of blooms (like the one on the previous page), simple groupings can be equally impactful and are easy to make. The version here uses multiples of the same vase with the same flowers to create a larger grouping, while the opposite page uses a set of vases in the same color with a singular variety in each. Fleabane, joe-pye weed, tansy, and clover (as pictured opposite, clockwise from top left) are not the showiest blooms, but when displayed as a group, they form a charming lineup. For a naturally imperfect look, cluster the blooms at the rim of the vase, then add a few longer stems that sit just above the cluster.

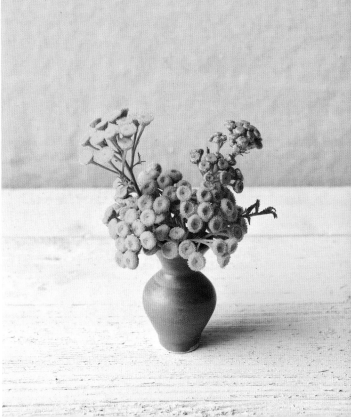

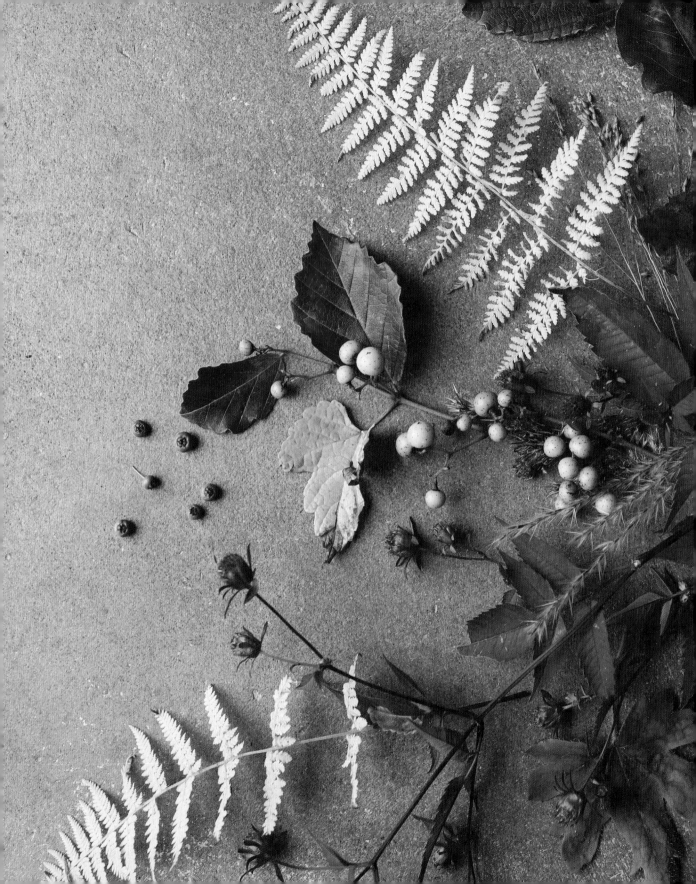

AUTUMN

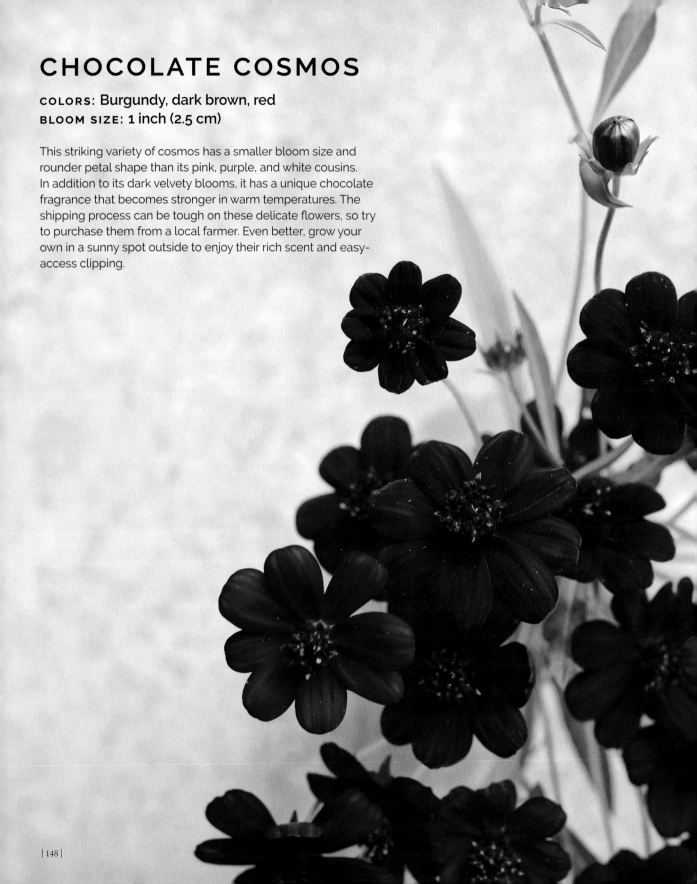

CHOCOLATE COSMOS

COLORS: Burgundy, dark brown, red
BLOOM SIZE: 1 inch (2.5 cm)

This striking variety of cosmos has a smaller bloom size and rounder petal shape than its pink, purple, and white cousins. In addition to its dark velvety blooms, it has a unique chocolate fragrance that becomes stronger in warm temperatures. The shipping process can be tough on these delicate flowers, so try to purchase them from a local farmer. Even better, grow your own in a sunny spot outside to enjoy their rich scent and easy-access clipping.

CHOCOLATE COSMOS

RECIPE 1
ON ITS OWN

INGREDIENTS

11 chocolate cosmos stems

VESSEL

1¾-inch-tall (4.5 cm) ceramic
vase with handles

When the light catches these cosmos, their petal color shifts between the most beautiful dark brown and rich burgundy. Set this little sweetie on the bedside table and don't be surprised if you wake up craving a chocolate croissant.

1. Create a bunch in hand with five stems so the blooms are lined up at a similar height. Trim the stems to approximately two times the height of the vase and add them in all at once. Adjust so they are spread evenly across the vase.

2. Add five more stems, one at a time, with the blooms layered in a cluster at the front rim.

3. Place the last stem leaning out on the back left at the highest point.

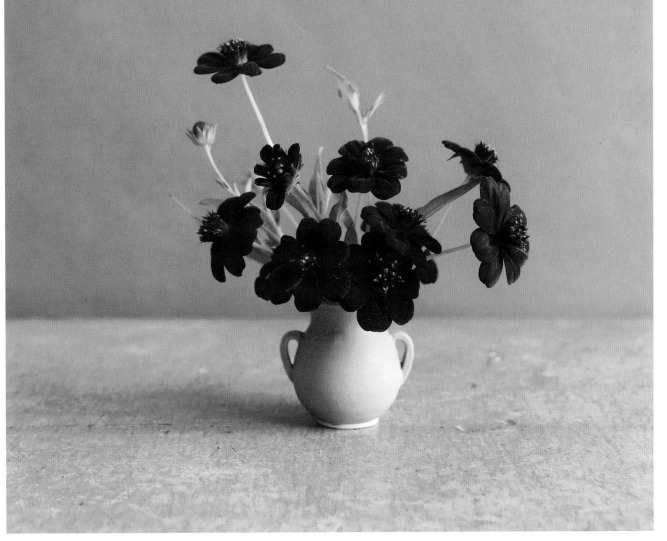

CHOCOLATE COSMOS

RECIPES 2 + 3
INGREDIENTS

Other than the chocolate cosmos, which were purchased from a local farm, this collection features materials gleaned from the landscape and plants purchased at a nursery. (Note: Both porcelain berry vine and autumn clematis can be invasive, so use caution if adding them to your garden.) An autumnal palette alternative to red and orange, the muted tones of the panicle hydrangea, abutilon, and porcelain berry blend beautifully with the chocolate cosmos and ninebark. Corydalis leaves are similar in shape and delicacy to a maidenhair fern but much more durable.

abutilon

panicle hydrangea

porcelain berry

ninebark

corydalis

autumn clematis

chocolate cosmos

CHOCOLATE COSMOS

RECIPE 2
MICRO ARRANGEMENT

INGREDIENTS

3 chocolate cosmos blooms

1 autumn clematis sprig

1 ninebark leaf

1 panicle hydrangea floret

1 porcelain berry sprig

1 abutilon bloom

1 corydalis leaf

VESSEL & SUPPLIES

1¼-inch-tall (3 cm) dollhouse ceramic vase

Double-sided glue tab (optional)

Clip a special bell-shaped abutilon bloom from the plant and add it to this garden-grown grouping. The turquoise porcelain berries pop against the dark blue vase and dark chocolate cosmos.

1. Create a bunch in hand with all the ingredients except the corydalis leaf, balancing the height of the clematis on the right with two chocolate cosmos stems on the left. Make bloom height adjustments and turn the stems until you are pleased with the composition.

2. Trim the stems and insert in the vase all at once. Tuck in the corydalis leaf so it drapes out at the front of the arrangement. If desired, add a glue tab to the surface where you wish to place the vase, to help stabilize the arrangement.

CHOCOLATE COSMOS

RECIPE 3
MINI ARRANGEMENT

INGREDIENTS

3 panicle hydrangea sprigs

2 porcelain berry sprigs

1 autumn clematis vine

1 abutilon sprig

1 corydalis leaf

2 ninebark sprigs

10 chocolate cosmos blooms

1 chocolate cosmos bud

VESSEL & SUPPLIES

Clear floral tape

4-inch-tall (10 cm) julep cup

1 Create an X grid with the floral tape across the rim of the cup. Place the panicle hydrangea sprigs so the florets spill over the rim and cover the tape.

2 Place one porcelain berry sprig curving down on the right and the other nestled at the front rim. Insert the autumn clematis vine on the left so a large cluster of florets rests on the rim and the tip curves upward, balancing the width of the berry sprig.

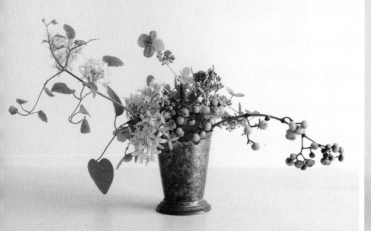

3 Nestle the abutilon sprig next to the clematis so the stems curve down and the blooms nod just above the table surface. Place the corydalis leaf leaning out on the right above the berries. Layer one ninebark sprig in the center front and set the other slightly lower than the clematis tip on the left. Add the chocolate cosmos throughout the composition at varying heights, and finish by placing the tallest bud curving forward on the right.

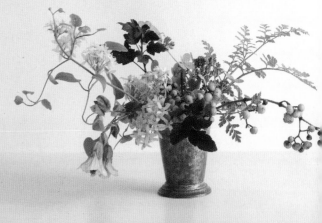

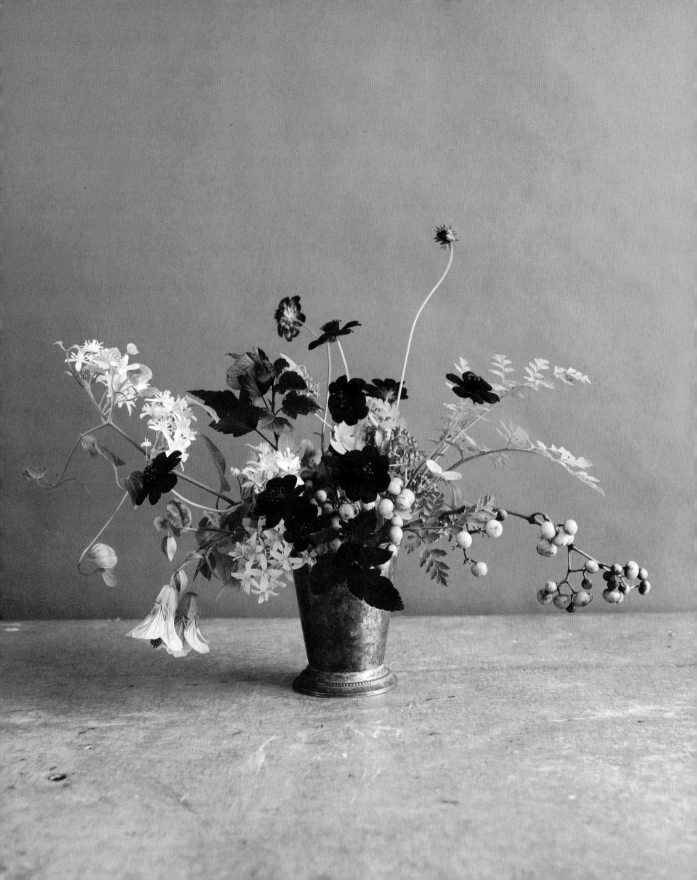

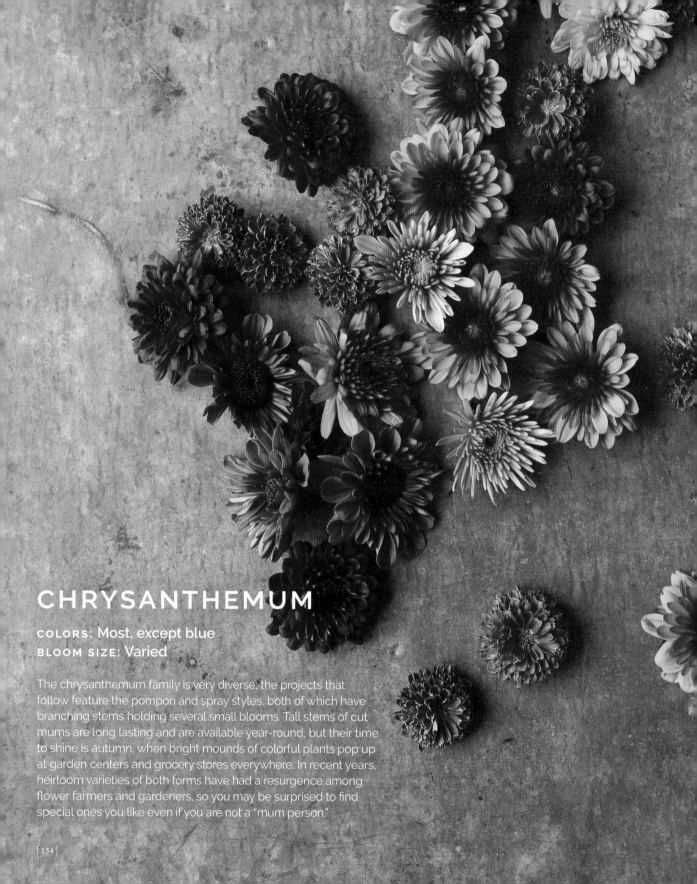

CHRYSANTHEMUM

COLORS: Most, except blue
BLOOM SIZE: Varied

The chrysanthemum family is very diverse; the projects that follow feature the pompon and spray styles, both of which have branching stems holding several small blooms. Tall stems of cut mums are long lasting and are available year-round, but their time to shine is autumn, when bright mounds of colorful plants pop up at garden centers and grocery stores everywhere. In recent years, heirloom varieties of both forms have had a resurgence among flower farmers and gardeners, so you may be surprised to find special ones you like even if you are not a "mum person."

CHRYSANTHEMUM

RECIPE 1
ON ITS OWN

INGREDIENTS

4 or 5 chrysanthemum plants,
assorted colors

VESSEL & SUPPLIES

Pin frog

4-inch-diameter (10 cm)
condiment bowl

This miniature play on big mounds of potted landscape mums combines clippings from several plants to create a delicate color gradation. Take time to search the plant for just the right sprig to clip—fully open blooms have a slightly different tone than tighter ones, so mixing both in the arrangement will help with color blending.

1. Place the pin frog in the bowl. Line up the plants to determine how the colors will blend together.

2. Clip a sprig from each plant and press them into the pin frog so the blooms drape over the rim around the front half of the bowl. Repeat for the other half of the bowl.

3. Clip another set of sprigs and add them to the pin frog so the blooms sit higher than the first row and create a rounded shape. Repeat to fill in the composition on the back side.

4. Place a tall sprig in the center and insert individual blooms where needed to round out the shape and blend the colors.

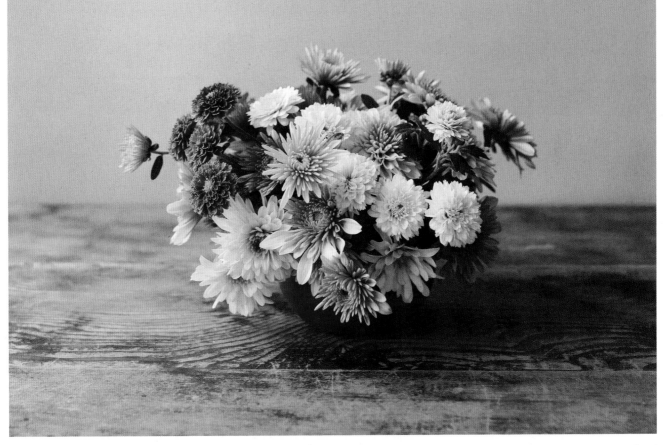

CHRYSANTHEMUM

RECIPES 2–5
INGREDIENTS

This petite autumnal harvest combines an array of button mums with the tiniest of apples and seedpods. Large celosia stems are loaded with unique side shoots for trimming. At this time of year, the foliage, fruit, and pods will have tonal variations, so seek out specific pieces to create subtle blends. Every bud counts when working at a small scale.

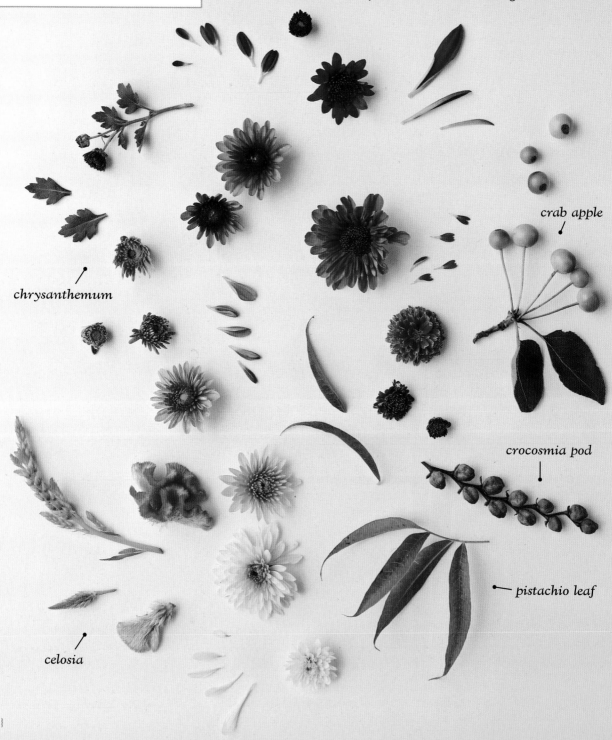

crab apple

chrysanthemum

crocosmia pod

pistachio leaf

celosia

RECIPE 2
MICRO ARRANGEMENT

INGREDIENTS

1 pistachio leaf

1 chrysanthemum bud sprig

2 celosia blooms

1 crocosmia pod

1 crab apple sprig

2 chrysanthemum blooms

VESSEL & SUPPLIES

1½-inch-tall (4 cm) ceramic pitcher

Double-sided glue tab (optional)

The warm tonal blend of this arrangement is created by choosing ingredients ranging from red to yellow, each in a slightly different hue. Pair with a vessel with graphics in similar colors for a charming matchy-matchy look.

1. Create a bunch in hand with all the ingredients except the two mum blooms, balancing the width of the pistachio leaf with the crocosmia pods on the right. Adjust the height of the blooms and turn the stems until you are pleased with the composition.

2. Trim the stems and insert in the pitcher all at once.

3. Tuck in the mum blooms along the front rim of the arrangement. If desired, add a glue tab to the surface where you wish to place the pitcher, to help stabilize the arrangement.

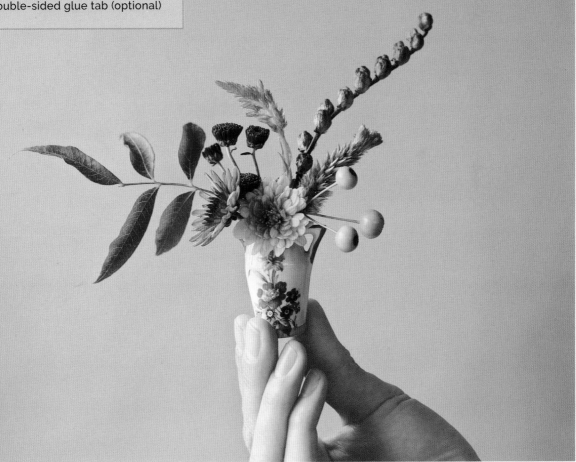

CHRYSANTHEMUM

RECIPE 3
MINI ARRANGEMENT

INGREDIENTS

1 crab apple sprig

2 pistachio leaves

5 celosia blooms, 1 large and 4 small

3 chrysanthemum sprigs

5 chrysanthemum blooms

1 crocosmia pod

VESSEL

3½-inch-tall (9 cm) ceramic vase

1 Place the crab apple sprig leaning out on the left and the pistachio leaves curving out over the rim on opposite sides.

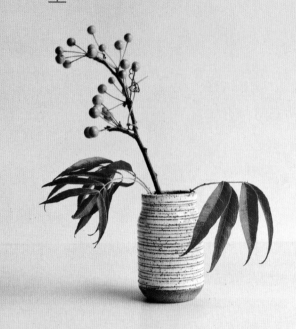

2 Add the large celosia bloom to the center of the vase with the bottom of the bloom just inside the rim to help anchor the other ingredients.

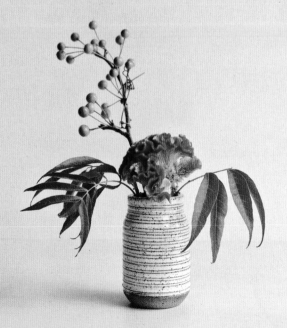

3 Fill in around the celosia with the mums, first covering the rim, then adding them in at varying heights. Position the crocosmia pod curving to the right in the center at a similar height to the crab apple. Finish by nestling two celosia blooms between the mums on the left and the others curving in opposite directions in front of the crab apple.

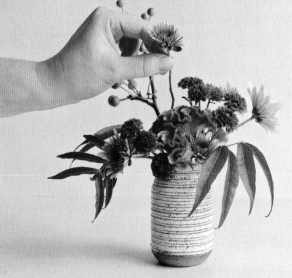

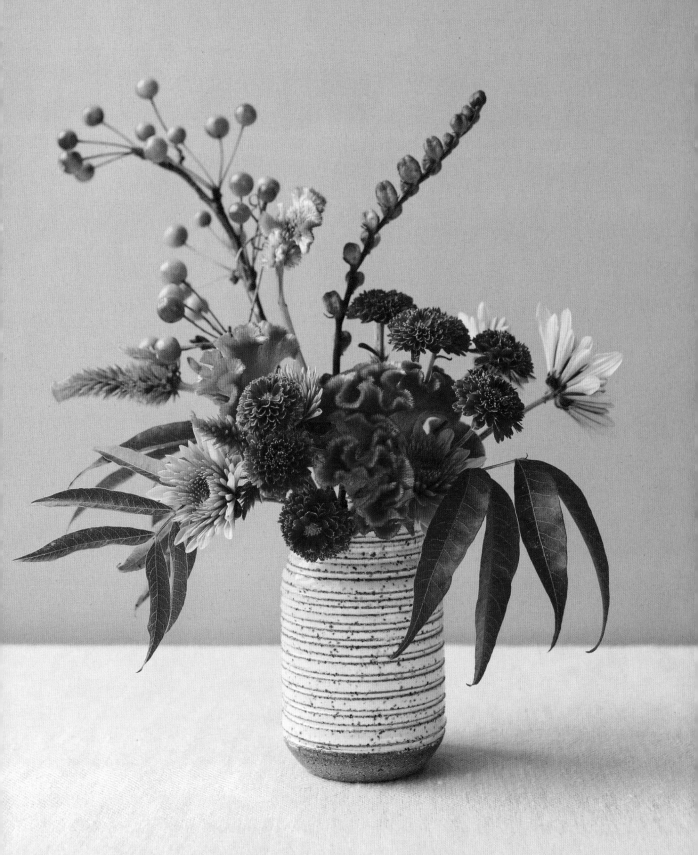

CHRYSANTHEMUM

RECIPE 4
WREATH

INGREDIENTS

10 to 15 chrysanthemum heads

SUPPLIES

5-inch (13 cm) square of cardboard

Scissors

Floral glue

6-inch (15 cm) piece of ribbon

1 Draw a 5-inch-diameter (13 cm) circle on the cardboard, then draw a 4½-inch (11.5 cm) circle inside it. Cut out the interior circle, then cut along the outer line. Place a few mum blooms facedown on the work surface and squeeze a small amount of glue on them. Stick them one at a time onto the cardboard so there is no space between them and no cardboard is visible.

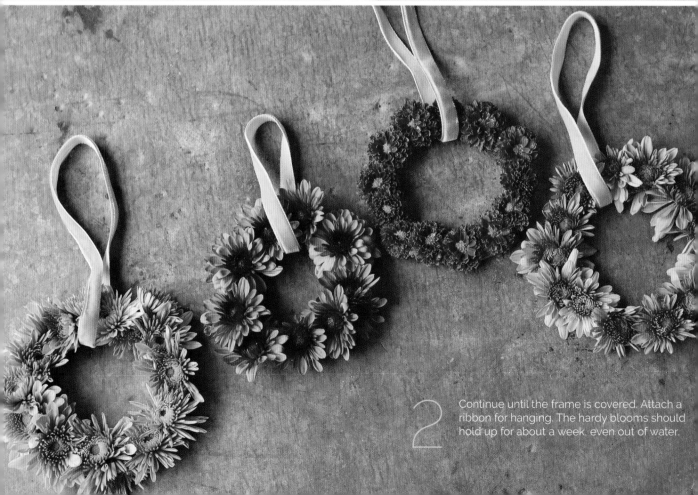

2 Continue until the frame is covered. Attach a ribbon for hanging. The hardy blooms should hold up for about a week, even out of water.

RECIPE 5
BRANCH GARLAND

INGREDIENTS

One 7-inch (18 cm) crab apple
branch tip

2 pistachio leaves

2 crocosmia pods

3 celosia blooms

8 chrysanthemum blooms

SUPPLIES

One 10-inch (25 cm)
piece of ribbon

Fabric glue

Bind wire

Floral glue

To keep this wall hanging well balanced and to find its natural resting position, hold the branch up by the ribbon before attaching other ingredients to it. Continue checking the balance as you add each posy, to ensure that the composition won't flop forward.

1. Attach the ribbon to one end of the branch by folding it onto itself and securing with a small amount of fabric glue. Repeat at the other end.

2. Create three different posies in hand with the pistachio leaves, crocosmia pods, and celosia and mum blooms, reserving three mum blooms for the final step. Line up the bottom of the blooms and secure each posy with bind wire, leaving the ends of the wire long enough to attach them to the twig.

3. Attach the posies to the branch following the garland-making instructions on page 266.

4. Trim the stems from the three remaining mum blooms, apply a small amount of floral glue to the backs of the blooms, and place them onto the garland to conceal any noticeable bind wire.

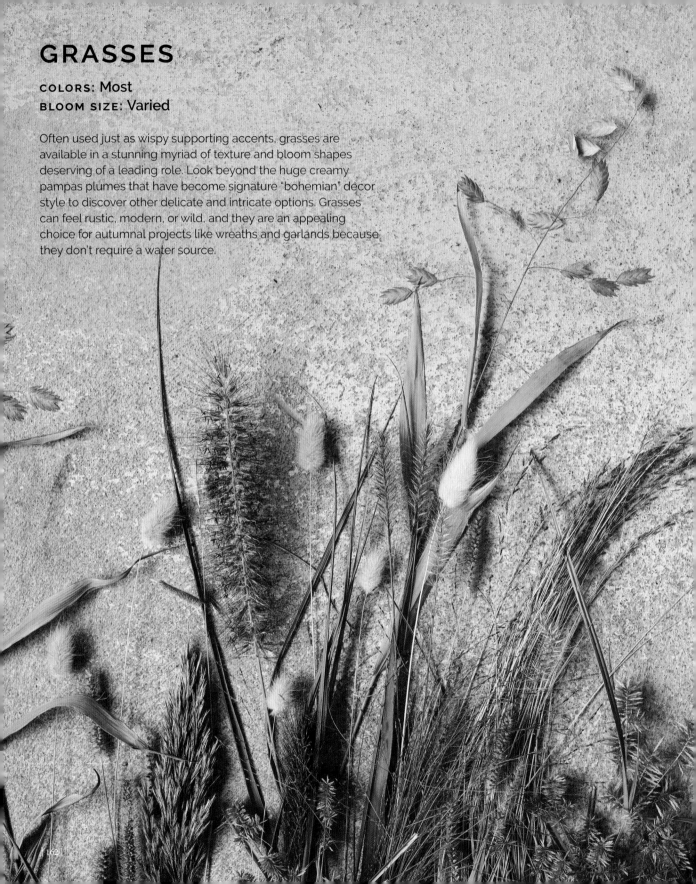

GRASSES

COLORS: Most
BLOOM SIZE: Varied

Often used just as wispy supporting accents, grasses are available in a stunning myriad of texture and bloom shapes deserving of a leading role. Look beyond the huge creamy pampas plumes that have become signature "bohemian" decor style to discover other delicate and intricate options. Grasses can feel rustic, modern, or wild, and they are an appealing choice for autumnal projects like wreaths and garlands because they don't require a water source.

RECIPE 1
MICRO ARRANGEMENTS

INGREDIENTS

5 assorted grass varieties
(see page 164 for suggestions)

VESSELS & SUPPLIES

5 terra-cotta dollhouse vases in
assorted sizes from ½ inch (1 cm)
to 1¼ inches (3 cm) tall

Double-sided glue tabs (optional)

This low-maintenance micro vase display (no water necessary) showcases individual grass varieties. Featuring plants with fun common names like eyelash (also known as blue grama, second from left) and bunny tail (far left), this dried collection can become a tiny conversation piece all season long.

1. Create a bunch in hand with each ingredient separately, lining up the bottom of the blooms and turning the stems until you are pleased with the composition.

2. Trim the stems of each bunch and insert in a vase all at once, varying the bunch height so some blooms start at the rim and others sit above on longer stems.

3. Line up the vases in a row of alternating height arrangements. If desired, add glue tabs to the surface where you wish to place the vases, to help stabilize the arrangements.

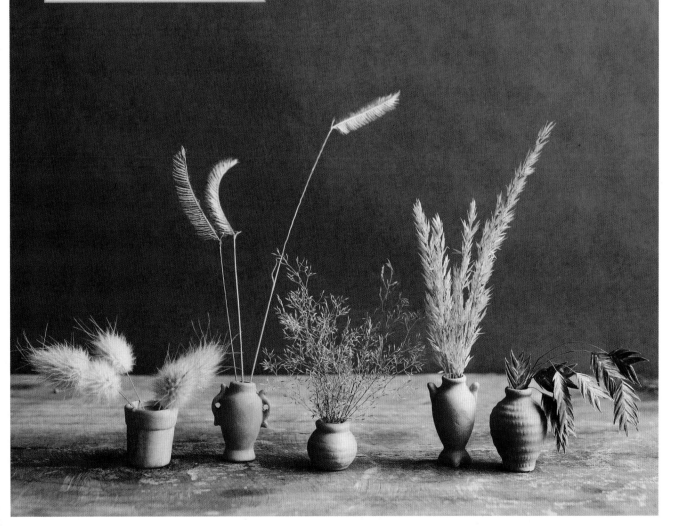

RECIPES 1–5
INGREDIENTS

There are hundreds of grasses, both wild and cultivated, sporting blooms that can be clipped and used fresh in arrangements. Plants can be purchased from garden centers, but fields and lawns are great sources as well. The smaller grass blooms are often overlooked, even though they are right underfoot, but once you begin noticing them you won't be able to stop. Feathery, prickly, puffy, and fluffy, this collection is a celebration of their texture and variety.

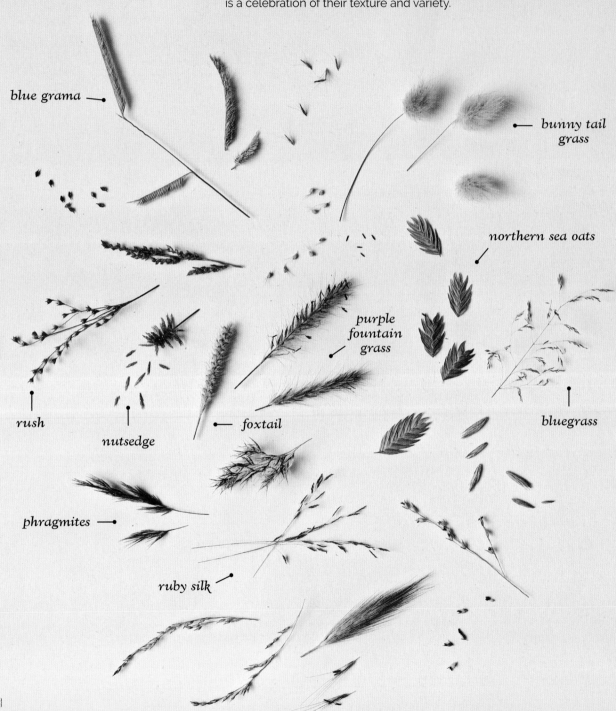

blue grama

bunny tail grass

northern sea oats

purple fountain grass

bluegrass

rush

nutsedge

foxtail

phragmites

ruby silk

RECIPE 2
MICRO ARRANGEMENT

INGREDIENTS

12 assorted grass varieties
(see opposite for suggestions)

VESSEL & SUPPLIES

2¼-inch-tall (5.5 cm) silver
tapered vase

Double-sided glue tab (optional)

The formal style of this metal vase makes wild-looking grasses feel fancy. And the arrangement's moody palette, anchored by dark phragmites with pops of cream and red, goes to show that the grass isn't *always* greener!

1. Create a bunch in hand with all the ingredients, keeping multiple stems of the same varieties grouped together and making height adjustments and turning the stems until you are pleased with the composition. Place the drapier grasses on the outer edges and the more upright stems in the center.

2. Trim the stems and insert in the vase all at once, lining up the bottom blooms so they rest at the rim. If desired, add a glue tab to the surface where you wish to place the vase, to help stabilize the arrangement.

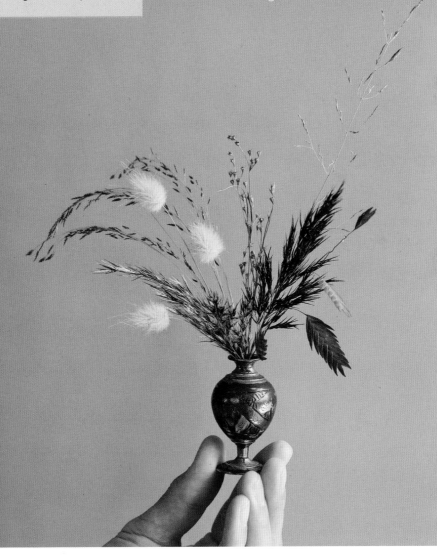

RECIPE 3
WREATH

INGREDIENTS

Assorted grass varieties
(see page 164 for suggestions),
enough to make 12 bunches and one posy

SUPPLIES

Three 4-inch (10 cm) wooden skewers

Bind wire

Thin-gauge wire

One 6-inch (15 cm) piece of ribbon

1 Separate the assorted grasses into twelve bunches of similar size. (Reserve twelve stems of grass with more graphic and airy bloom shapes for the accent posy.) They don't need to be wired together—they will be attached to the frame in loose bundles.

2 Create the frame by making a triangle with the skewers and bind wire. Starting in the lower right corner, hold a bundle against the frame with one hand so the tips cover the connection point. Use a piece of thin-gauge wire to attach the bundle stems to the frame, twisting the end around itself to secure. Without cutting the wire, hold a second bundle on top of the stems of the first in the same direction and wrap with the wire. Continue adding bundles around the frame.

3 Once all the bundles have been attached, create an accent posy in hand with the bunny tail, blue grama blooms, and wild grass sprigs. Secure with a small piece of thin wire, leaving the ends long to attach to the wreath. Attach the accent posy to the wreath and cover the wire connection with the ribbon.

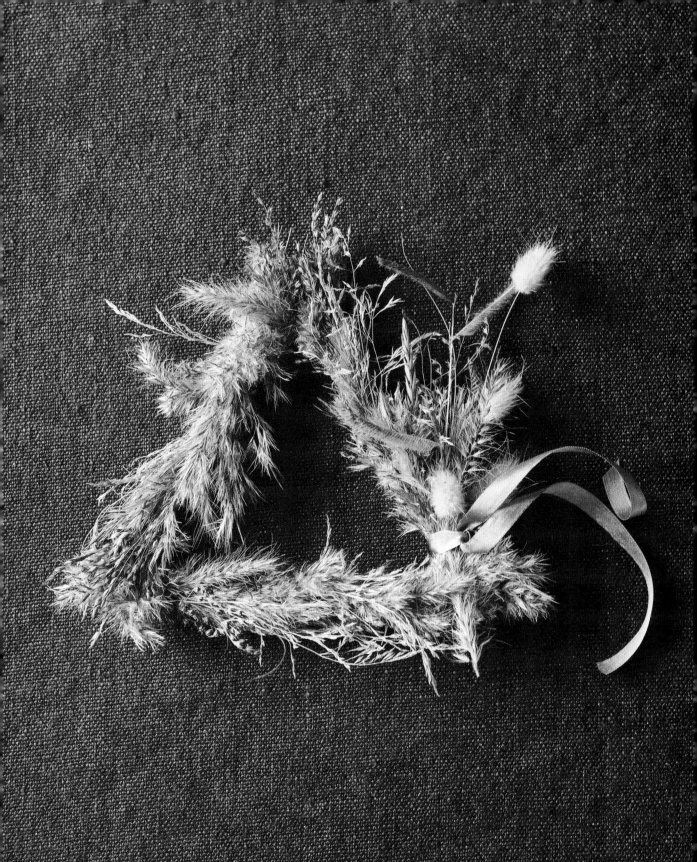

RECIPE 4

GARLAND

INGREDIENTS

Assorted grass varieties
(see page 164 for suggestions),
enough to make 5 posies

SUPPLIES

Bind wire

1 Create a posy in hand with about a fifth of the assorted grasses, lining up the bottom of the blooms. Secure with a small piece of bind wire, leaving the wire ends long to attach to the garland. Repeat to make four more posies with varied bloom shapes and colors, so that each bundle is unique.

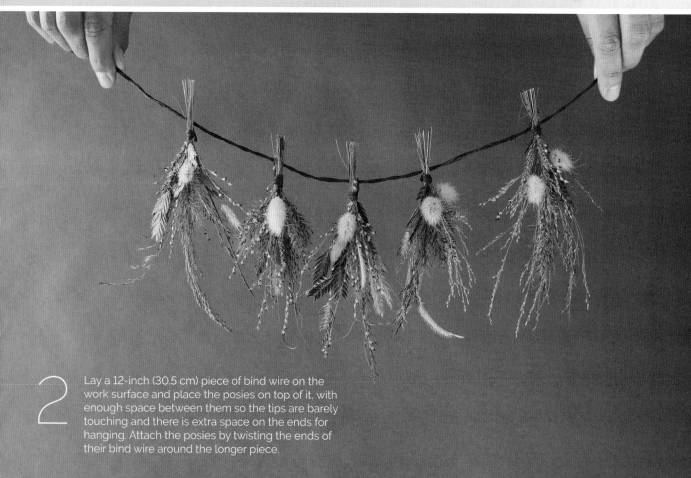

2 Lay a 12-inch (30.5 cm) piece of bind wire on the work surface and place the posies on top of it, with enough space between them so the tips are barely touching and there is extra space on the ends for hanging. Attach the posies by twisting the ends of their bind wire around the longer piece.

RECIPE 5
MINI ARRANGEMENT

INGREDIENTS

7 assorted grass varieties
(see page 164 for suggestions)

VESSEL & SUPPLIES

Small rubber bands

3-inch-tall (7.5 cm) ceramic vase

This assortment of wild grasses, grouped together in sections, takes on a contemporary feel when paired with a geometric vase. Add water to the vase if you don't want the green varieties to quickly lose their color.

1. Create a bunch in hand with each grass variety, lining up the bottom of the blooms, and secure with a rubber band a few inches (7.5 cm) below the blooms. Trim the stems of each bunch just below the rubber band.

2. Place the shortest bunch along the front so the lowest level of blooms rests at the vase rim. Position the next bunch leaning out to the left.

3. Continue adding bunches until a rounded shape is created. Once the vase is full, make small height adjustments to bunches in the composition by pulling them up or angling them as necessary.

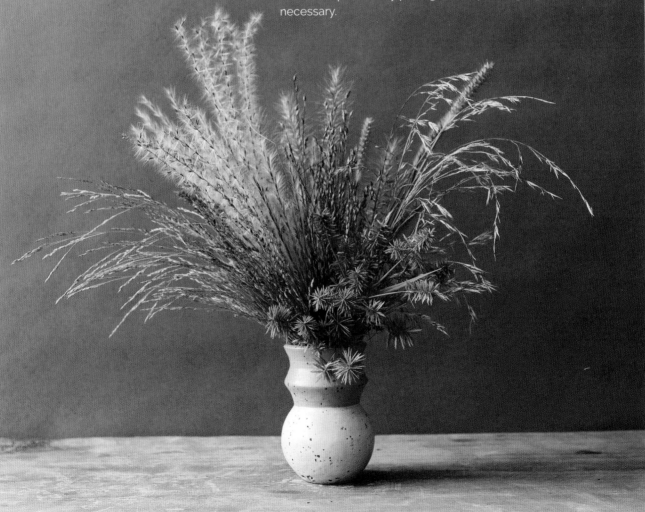

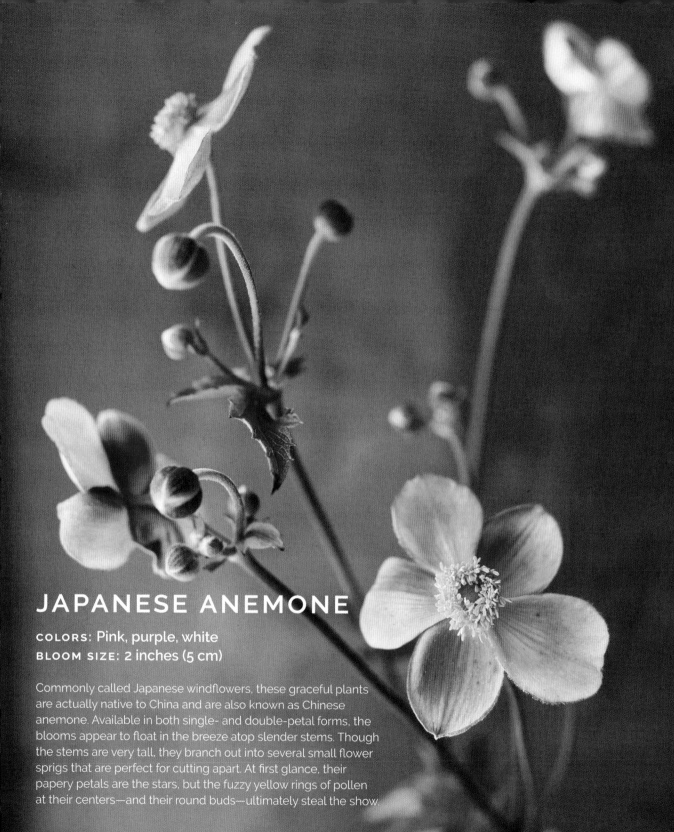

JAPANESE ANEMONE

COLORS: Pink, purple, white
BLOOM SIZE: 2 inches (5 cm)

Commonly called Japanese windflowers, these graceful plants
are actually native to China and are also known as Chinese
anemone. Available in both single- and double-petal forms, the
blooms appear to float in the breeze atop slender stems. Though
the stems are very tall, they branch out into several small flower
sprigs that are perfect for cutting apart. At first glance, their
papery petals are the stars, but the fuzzy yellow rings of pollen
at their centers—and their round buds—ultimately steal the show.

JAPANESE ANEMONE

RECIPE 1
ON ITS OWN

INGREDIENTS

1 Japanese anemone stem,
with buds and blooms

VESSEL

2-inch-tall (5 cm) ceramic
bud vase

The buds of the Japanese anemone provide a graphic contrast to the delicate crinkled bloom. Once the petals and pollen have fallen from the flower, a bright green seedpod will be revealed.

1. Insert the Japanese anemone in the vase so the branched part of the stem and leaves sits at the opening.

2. Depending on the height of the individual sprig stems, you may need to angle the main stem to adjust its balance in the vase.

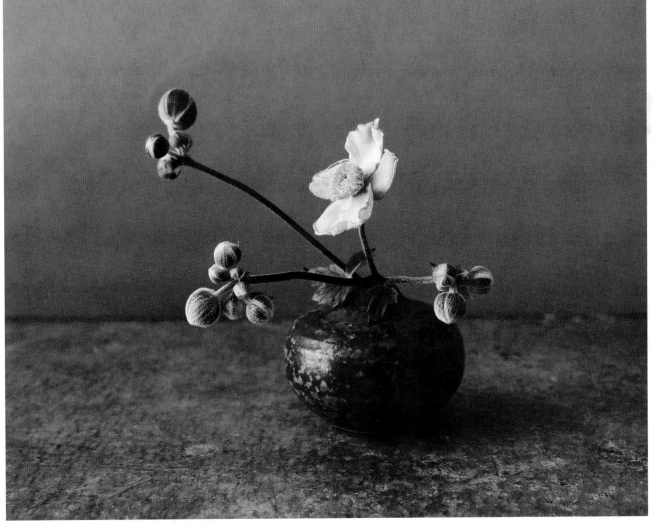

JAPANESE ANEMONE

RECIPE 2
TABLESCAPE

INGREDIENTS

12 Japanese anemone heads

VESSELS

Five 3-inch-diameter (7.5 cm) low
brass dishes

Showcase the subtle color variations of pink and lavender Japanese anemone petals and their bright yellow textural centers. Though longer stems are prone to wilting, freshly opened blooms will last for several days in this simple floating display.

1. Fill the dishes with water and place one to three Japanese anemone blooms faceup in each. Select freshly opened blooms with bright yellow centers; the color will become muddier as the blooms age.

2. Add additional petals to the dishes as desired for more color variation and to make each composition unique.

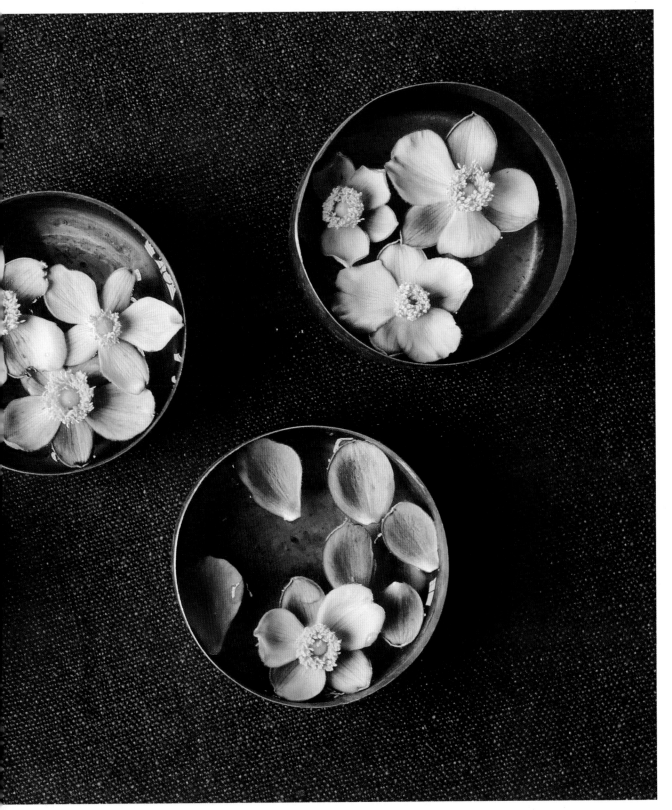

RECIPES 3 + 4
INGREDIENTS

The complementary purple and yellow palette of this moody collection combines smoky kale and sedum leaves with pops of yellow from the coreopsis and Japanese anemone centers. Pokeberry stems provide a lush fruiting element and color bridge, with stems and berries ranging in color from bright green when immature to stunning hot pink and rich black when ripe.

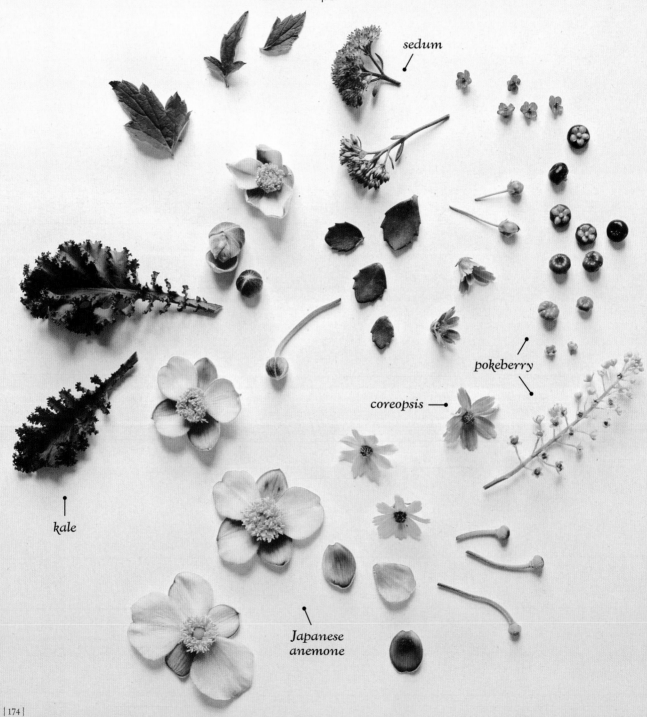

sedum

pokeberry

coreopsis

kale

Japanese anemone

RECIPE 3
MICRO ARRANGEMENT

INGREDIENTS

2 sedum sprigs

1 pokeberry sprig

1 kale leaf

1 Japanese anemone sprig

1 coreopsis bloom

VESSEL

1¼-inch-tall (3 cm) black
ceramic vase

Select a dark vase to add drama and tone down the brighter colors in this moody arrangement.

1. Position the sedum so the bloom clusters rest on the rim and help anchor the other ingredients in place. Place the pokeberry sprig to lean out on the left and nestle the kale leaf on the right.

2. Place the Japanese anemone sprig between the pokeberry and kale so the stem stands upright with a leftward lean. Finish by layering the coreopsis bloom onto the sedum sprigs at the front.

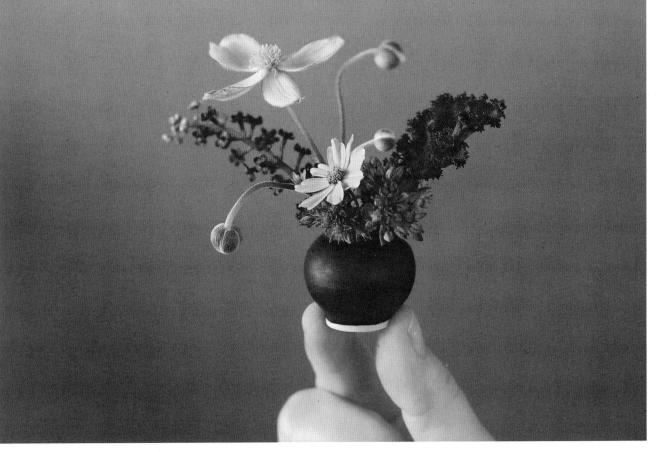

JAPANESE ANEMONE

RECIPE 4
MINI ARRANGEMENT

INGREDIENTS

2 sedum sprigs

3 pokeberry sprigs

2 kale leaves

5 coreopsis blooms

6 Japanese anemone sprigs

VESSEL & SUPPLIES

Pin frog

2½-inch-diameter (6.5 cm)
metal pedestal cup

1. Place the pin frog in the cup and add the sedum so the bloom clusters lean out over the front rim. Lean two pokeberry sprigs out on the left side, with one sprig curving down and the other curving up.

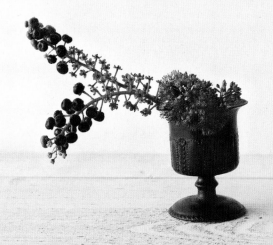

2. Nestle one kale leaf along the right rim and place the other on the left behind the sedum.

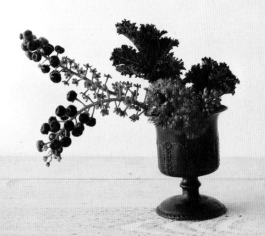

3. Tuck the remaining pokeberry sprig in front of the others to create a cluster on the left side. Add the coreopsis blooms on the right side at different lengths to balance the width of the pokeberry. Finish by leaning the Japanese anemone sprigs out from the center at varying heights so the open blooms face in different directions.

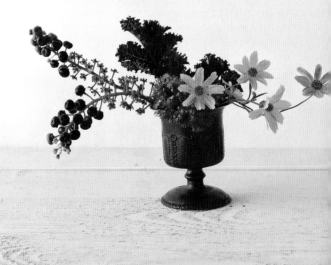

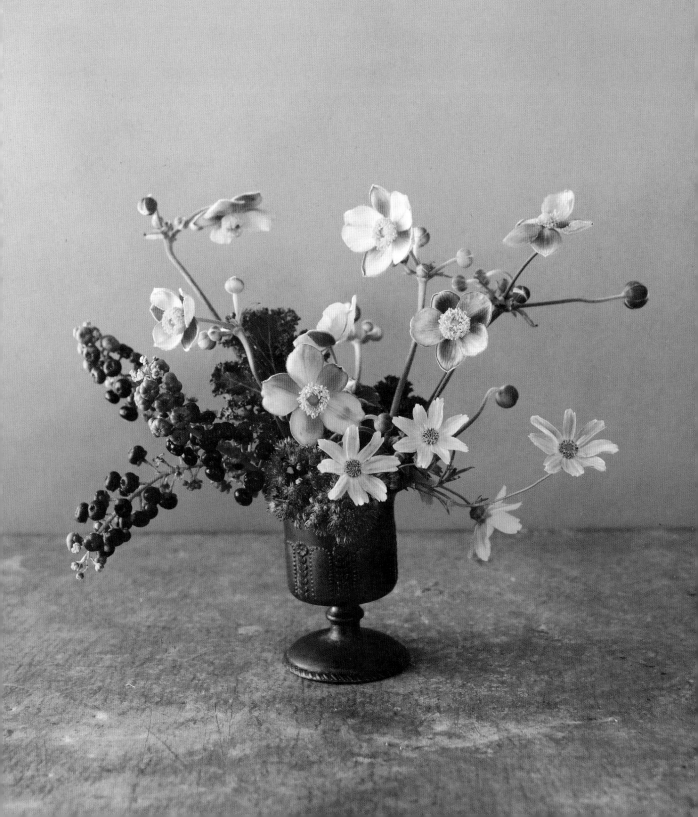

KALANCHOE

COLORS: Most except blue
BLOOM SIZE: ¼ inch (6 mm)

Widely available in grocery stores and garden centers as potted plants, kalanchoe are a light-loving, drought-tolerant family of plants. They produce dense clusters of long-lasting, brightly colored blooms that can be clipped for use in arrangements. Standard kalanchoe blooms typically have just four petals, but look out for more unusual hybrid Calandiva varieties that resemble tiny roses with several layers of overlapping petals.

KALANCHOE

RECIPE 1
WALL HANGING

INGREDIENTS

27 red kalanchoe blooms

32 pink kalanchoe blooms

SUPPLIES

Thread

Needle

4-inch (10 cm) twig

6-inch (15 cm) piece of ribbon

These sturdy little kalanchoe blooms hold up for a few days without water before they dry, which gives them a festive, crinkled look.

1. Thread the needle and insert it into one of the red blooms and out the back end. Repeat with seven more red blooms, pulling them close together on the thread so they nest slightly. Cut the thread, leaving 2 inches (5 cm) on either side of the blooms.

2. Repeat the process to make three more strands: one using eleven pink blooms, one with nineteen red blooms, and one with twenty-one pink blooms.

3. Lay the twig horizontally on your work surface and arrange the strands so they form concentric arcs underneath it. When you are pleased with the composition, tie the thread ends to the twig and trim. Finish by tying the ribbon at the ends of the twig and cut a decorative V-shape into the ends.

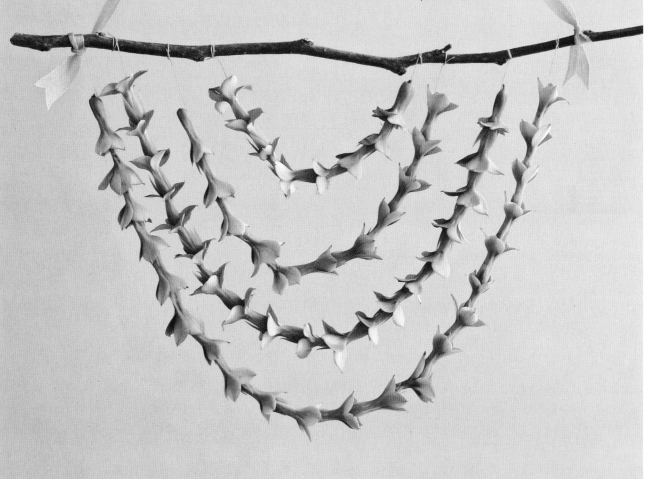

KALANCHOE

RECIPE 2
KOKEDAMA

INGREDIENTS

2-inch (5 cm) potted kalanchoe plant

SUPPLIES

6-inch (15 cm) square of sheet moss

Monofilament

Cotton twine

1 Remove the plant from the pot and soak the sheet moss in water.

2 Trim any flower sprigs and large leaves from around the base of the stem so there is a little space to wrap the moss around it.

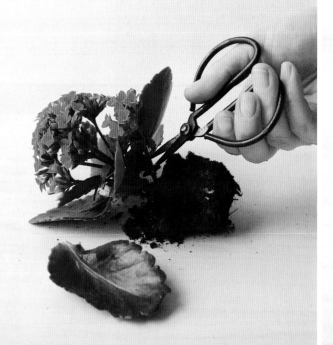

3 Wrap the moss around the dirt and gently squeeze into a rounded shape. Tie a knot with the monofilament around the moss and the stem just under the leaves to secure the moss in place. Wrap the twine around the moss ball several times to enhance the round shape and create a hanger. Remove additional leaves and flower sprigs until you achieve the desired plant shape.

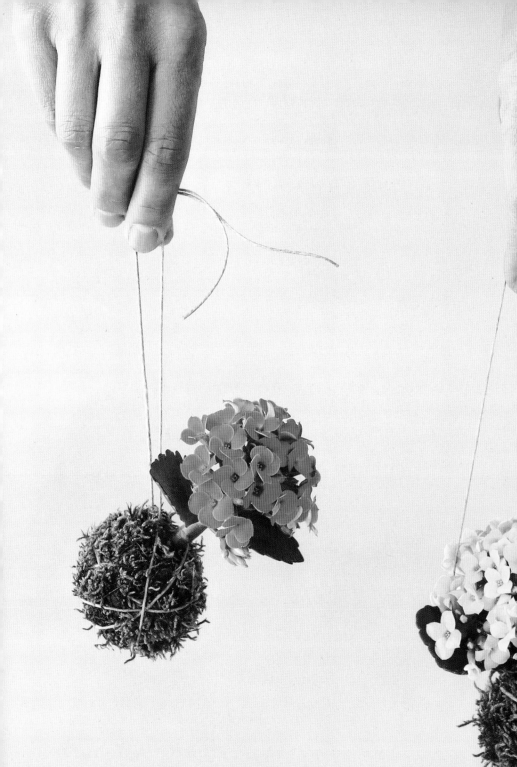

Note: Hang in a bright place and use a squirt bottle to water the ball when it feels dry or take it down and soak for several minutes in a bowl of cool water.

Autumnal clippings from burning bush shrubs and ornamental pepper plants take on a tropical feel when kalanchoe blooms are layered into the collection. Winterberry sprigs in both red and orange, as well as burning bush berries, contribute to the fruit-forward feel of this tiny bountiful harvest.

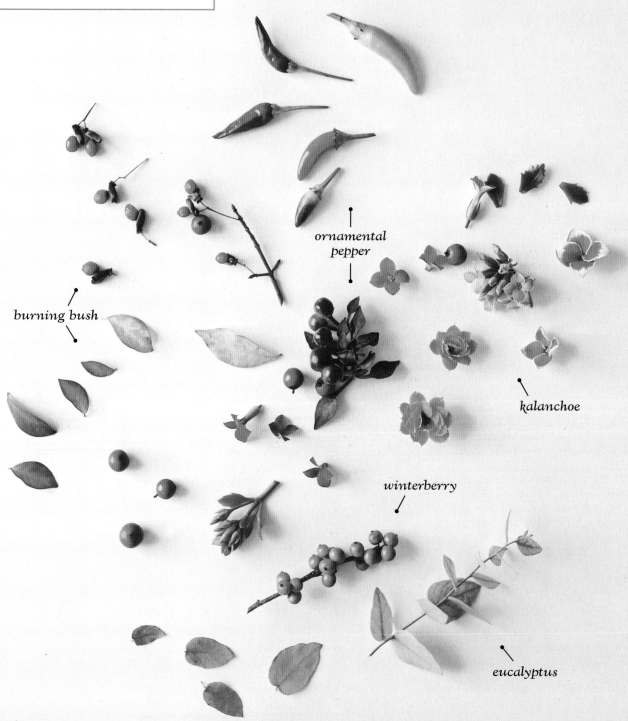

ornamental pepper

burning bush

kalanchoe

winterberry

eucalyptus

KALANCHOE

RECIPE 3
MINI ARRANGEMENT

INGREDIENTS

5 kalanchoe sprigs

2 ornamental pepper sprigs

2 winterberry sprigs

2 burning bush sprigs

2 eucalyptus sprigs

VESSEL & SUPPLIES

Pin frog

2-inch-tall (5 cm) sake cup

Orange and purple blend beautifully in this chunky mix of blooms, berries, and peppers. The kalanchoe can last a few weeks in an arrangement, and the peppers and berries dry very nicely.

1. Place the pin frog in the cup and press one kalanchoe sprig into it so the blooms lean over the front rim. Lean the ornamental pepper sprigs over the rim on both the left and right sides.

2. Layer the remaining kalanchoe sprigs in a mounded shape above the other ingredients in the cup.

3. To interrupt the mounded shape of the base ingredients, nestle the sprigs of winterberry, burning bush, and eucalyptus between the kalanchoe, leaning out from the center at varying heights.

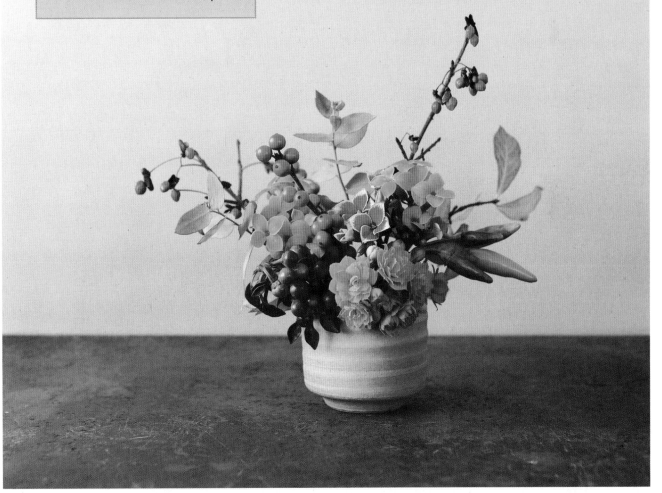

RECIPE 4
MICRO ARRANGEMENTS

These festive micro arrangements contain a little bit of this and that, forming an effortless seasonal grouping. The berries, fruit, and foliage are repeated in a similar combination across the arrangements, but the kalanchoe color is varied, giving each one a unique personality. Create a cohesive look by using multiples of similar vessels and displaying them in a row or cluster.

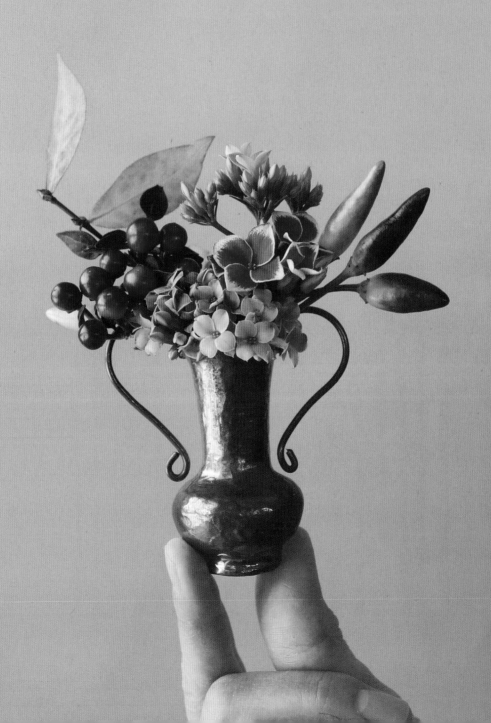

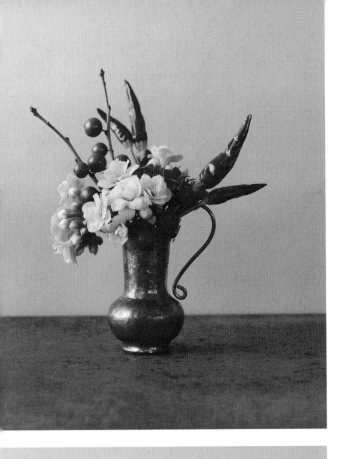
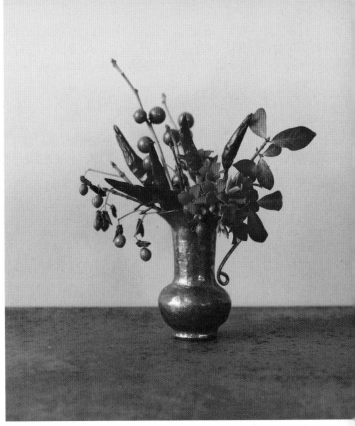
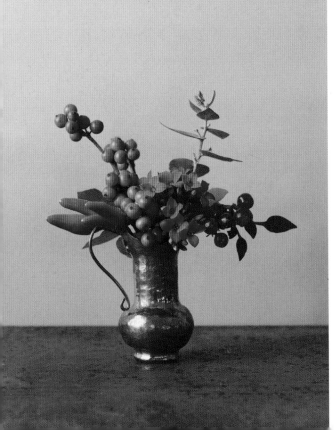
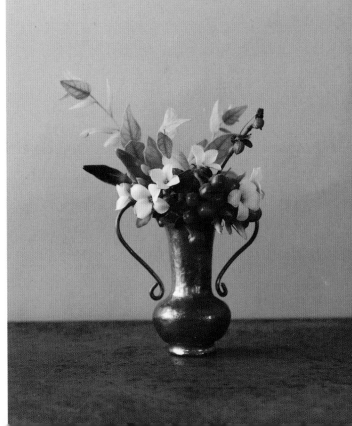

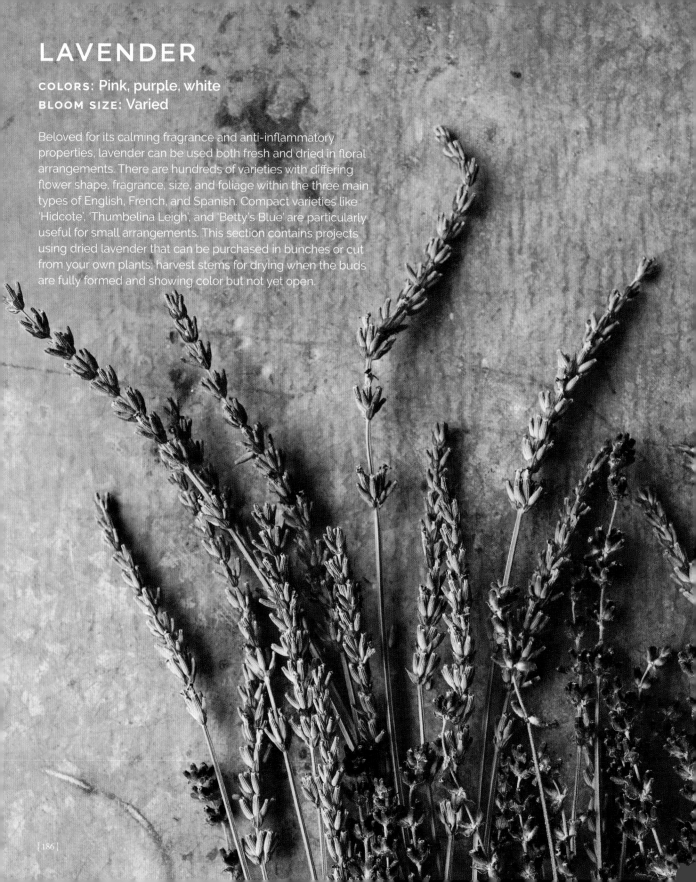

LAVENDER

COLORS: Pink, purple, white
BLOOM SIZE: Varied

Beloved for its calming fragrance and anti-inflammatory properties, lavender can be used both fresh and dried in floral arrangements. There are hundreds of varieties with differing flower shape, fragrance, size, and foliage within the three main types of English, French, and Spanish. Compact varieties like 'Hidcote', 'Thumbelina Leigh', and 'Betty's Blue' are particularly useful for small arrangements. This section contains projects using dried lavender that can be purchased in bunches or cut from your own plants; harvest stems for drying when the buds are fully formed and showing color but not yet open.

LAVENDER

RECIPE 1
ON ITS OWN

INGREDIENTS

Dried lavender blooms,
10 per bundle

SUPPLIES

Thread, assorted colors

These friendship bundles are a sweet keepsake when set atop a dinner napkin or note. The tightly wrapped bands of thread have a bright, modern look compared with the rustic twine wrap commonly seen with lavender bunches.

1. Create a bunch of ten blooms in hand, lining up the bases of the flowers. Tie a knot just below the blooms to secure the bunch with a 6-inch (15 cm) piece of thread.

2. Wrap the thread tightly around the stems several times, traveling downward with no space in between. When the desired band length is achieved, secure with a knot. Repeat with one or two more thread colors and trim the ends. Trim the stems straight across at the bottom to about an inch (2.5 cm). Repeat this process to create as many bundles as desired.

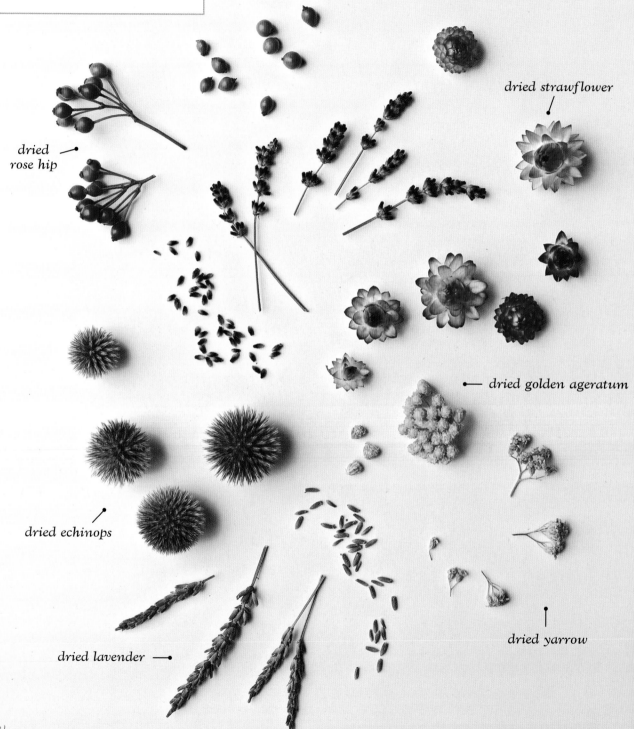

RECIPES 2–5

INGREDIENTS

This vibrant collection focuses on everlastings, which hold their color when dried. The varied textures and combination of round, clustered, and spiked bloom shapes make it possible to create compositions full of movement despite the stiffness of the dried ingredients.

dried strawflower

dried rose hip

dried golden ageratum

dried echinops

dried yarrow

dried lavender

RECIPE 2
WREATH

INGREDIENTS

25 dried lavender blooms

5 dried rose hip sprigs

5 dried golden ageratum sprigs

5 dried strawflower heads

5 dried echinops heads

3 dried yarrow sprigs

SUPPLIES

Bind wire

4-inch (10 cm) peace sign
ornament

Floral glue

12-inch (30.5 cm) piece of ribbon

You'll use a combination of attachment techniques to create this colorful, everlasting ode to flower power. You can purchase a premade brass ornament frame like the one shown here or construct your own (see page 262).

1. Divide the lavender blooms into five groups. Create bunches in hand by lining up the base of the flowers. Secure the bunches with bind wire, leaving the ends long to attach to the frame. Trim the stems to about an inch (2.5 cm), and attach equidistantly onto the ornament frame using the bind wire.

2. Layer a rose hip sprig on top of the stems of one lavender bunch and attach it to the frame with bind wire. Repeat with the remaining rose hips. Layer the golden ageratum sprig on top of one rose hip stem and attach with bind wire. Repeat with the remaining ageratum.

3. Using floral glue, attach alternating heads of strawflower and echinops to cover the stems and bind wire. Finish by gluing on small sprigs of yarrow to fill in holes. Attach the ribbon to hang.

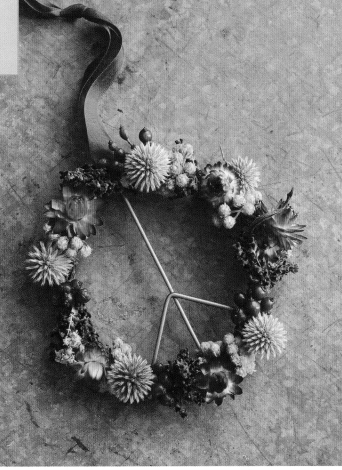

RECIPE 3
MINI ARRANGEMENT

INGREDIENTS

25 dried lavender blooms

2 dried echinops blooms

3 dried golden ageratum sprigs

2 dried yarrow sprigs

10 dried strawflower blooms

4 dried rose hip sprigs

VESSEL & SUPPLIES

Bind wire

Pin frog

3¾-inch-diameter (9.5 cm) cotton rope basket

1 Create two bunches of lavender, seven stems each. Make four different posies using a mix of the remaining ingredients, reserving eight lavender blooms, one yarrow sprig, five strawflowers, and one rose hip to tuck in at the end. Secure each bunch with bind wire just under the blooms and trim the stems to about an inch (2.5 cm).

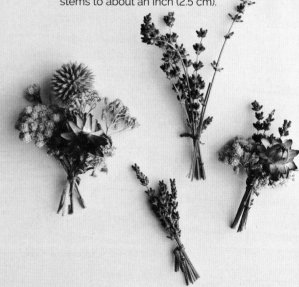

2 Place the pin frog in the basket and press the stems of the first posy into it so the bottom blooms rest along the rim.

3 Repeat with the remaining three posies, so the basket feels full and there are no large open spaces. Nestle the two lavender bunches toward the back with the tips of the blooms a few inches (7.5 cm) higher than the other ingredients. Lean the reserved rose hip sprig out the left side. Finish by clustering the remaining lavender, strawflower, and yarrow at the front of the arrangement.

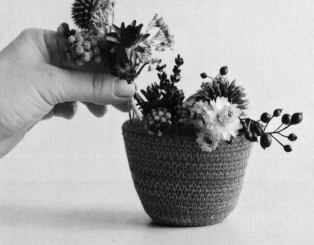

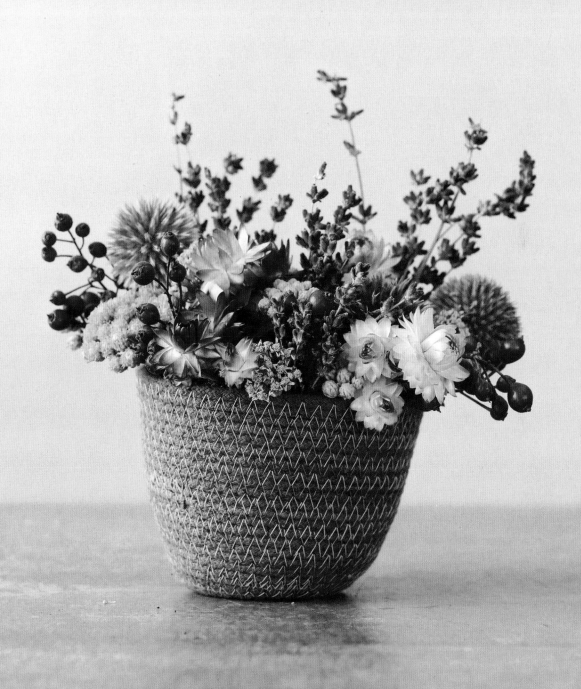

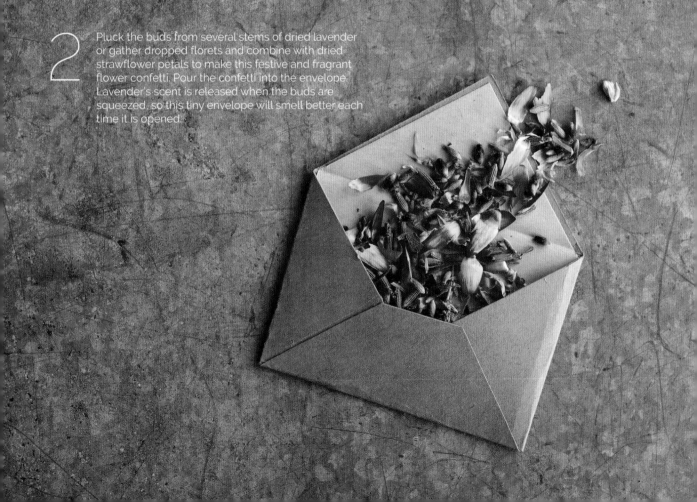

LAVENDER

RECIPE 4
STATIONERY

INGREDIENTS

20 dried lavender stems

6 dried strawflower blooms

1 dried golden ageratum stem

SUPPLIES

Floral glue

Kraft paper gift tag

Kraft paper envelope

1 Glue dried lavender tips, tiny dried strawflower heads, and dried golden ageratum buds to a gift tag to make a tiny work of art the recipient will want to save.

2 Pluck the buds from several stems of dried lavender or gather dropped florets and combine with dried strawflower petals to make this festive and fragrant flower confetti. Pour the confetti into the envelope. Lavender's scent is released when the buds are squeezed, so this tiny envelope will smell better each time it is opened.

LAVENDER

RECIPE 5
BOUTONNIERE

INGREDIENTS

5 dried lavender stems

1 dried yarrow sprig

1 dried echinops bloom

2 dried strawflower blooms

1 dried rose hip sprig

2 dried golden ageratum sprigs

SUPPLIES

Floral tape

Embroidery floss

The perfect fit for a casual autumnal wedding, this petite posy won't wilt. Use floral tape to hold the composition in place and cover it with an embroidery floss wrap, which will secure the stem positions better than thread alone.

1. Line up the bottom of the lavender blooms and create a small bunch in hand. The tips can be at varying heights. Layer the yarrow sprig and echinops and strawflower blooms on top of the lavender at the base of the bunch.

2. Holding the posy just under the blooms, tuck in the rose hip sprig and golden ageratum sprigs at varying heights. Make small adjustments in height and bloom direction until you are pleased with the composition, then secure with a piece of floral tape.

3. Tie a knot with the embroidery floss at the top of the tape, leaving about 2 inches (5 cm) at one end. Wrap the floss around the posy, moving slightly lower with each wrap to completely cover the tape. When you reach the bottom, begin wrapping back upward until you reach the middle. Pull the 2-inch (5 cm) end down to meet the wrapping end and tie a knot to secure. Leave the ends long for a decorative flourish, or trim if you prefer a neater look.

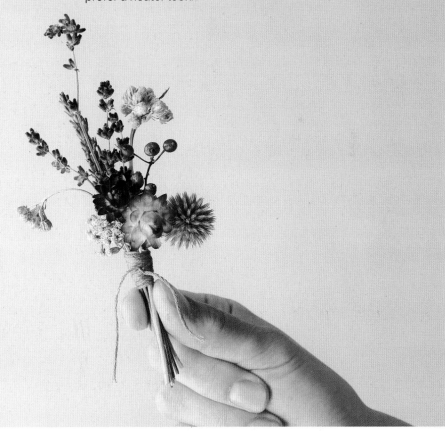

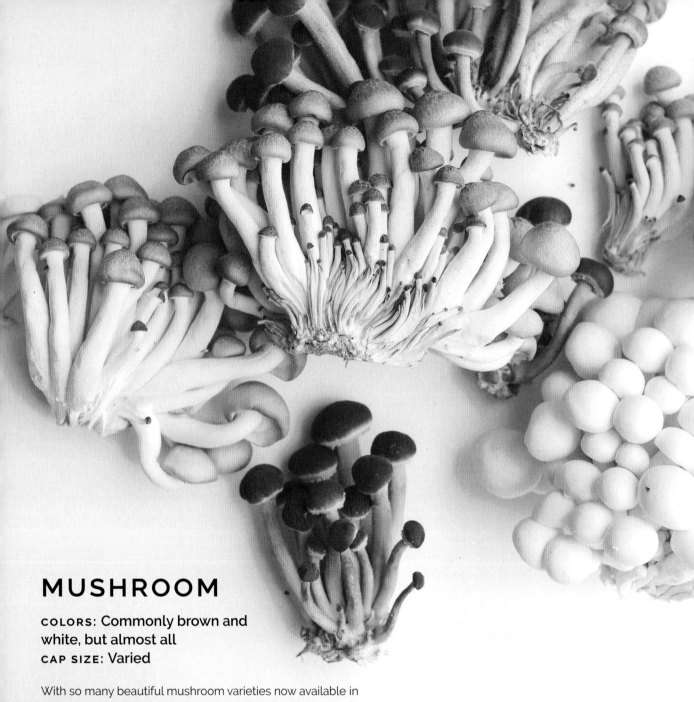

MUSHROOM

COLORS: Commonly brown and
white, but almost all
CAP SIZE: Varied

With so many beautiful mushroom varieties now available in
grow-your-own kits and at farmers' markets and specialty farms,
look beyond the white button to add an unexpected wow factor
in your designs. Beech and pioppino (used in the projects that
follow) grow in clusters, which makes it easy to break off a
small clump of assorted sizes or an individual shroom. Fungi
will get mushy if they sit in water, so they are best used with
dried ingredients or positioned just above a water source (on a
pin frog, a skewer, or chicken wire) in fresh arrangements.

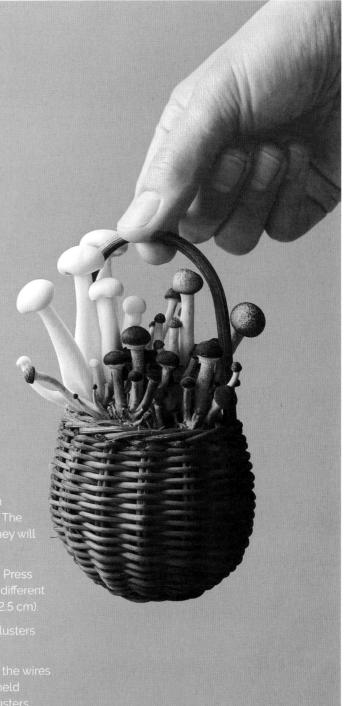

RECIPE 1
ON ITS OWN

INGREDIENTS

4 assorted mushroom clusters

VESSEL & SUPPLIES

Dried moss

5-inch-tall (13 cm) woven basket

Medium-gauge wire

From pinhead to pinky nail, the range of mushroom cap sizes makes this basket particularly endearing. The mushrooms don't require water; after a few days, they will dry to an even smaller size!

1. Tightly pack moss into the bottom of the basket. Press four 3-inch (7.5 cm) pieces of wire into the moss in different areas, leaving the ends sticking up about an inch (2.5 cm).

2. Remove a few individual mushrooms from the clusters and reserve for the last step.

3. Gently press one mushroom cluster onto one of the wires until the base is hidden under the basket rim and held upright by the wire. Repeat with the other three clusters.

4. Tuck the reserved mushrooms around the basket rim to fill in holes.

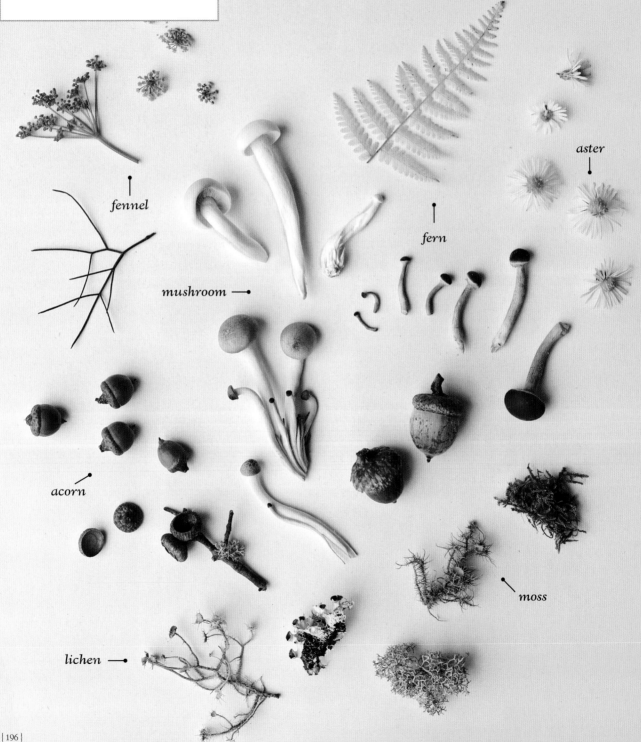

RECIPES 2–4

INGREDIENTS

This foraged collection has all the components of a texturally rich forest floor (minus the gnomes). The exquisite details of the mushroom gills and spongy lichen encourage close observation, while golden ferns, fennel, and asters add a sunny glow to the otherwise neutral palette.

fennel

aster

fern

mushroom

acorn

moss

lichen

MUSHROOM

RECIPE 2
MICRO ARRANGEMENT

INGREDIENTS

3 acorns

1 lichen puff

1 mushroom cluster

4 fern sprigs

4 aster blooms

2 fennel stems

VESSEL & SUPPLIES

Floral glue

Pin frog

1¾-inch-diameter (4.5 cm)
low ceramic vase

Use a pin frog in a low vase to keep the mushrooms propped up out of the water while letting the asters, ferns, and fennel have a drink.

1. Using floral glue, attach the acorns on top of the lichen and set aside to dry.

2. Place the pin frog in the vase and fill halfway with water. Press the mushroom cluster into the pin frog so it stands upright and is not touching the water. Nestle the lichen puff onto the pin frog in the front so the acorns spill over the rim.

3. Add three fern sprigs, the aster blooms, and a fennel floret leaning out at various heights around the mushrooms, making sure the stems reach the water. Finish by tucking the remaining fern and fennel floret under the acorns to conceal the vase rim.

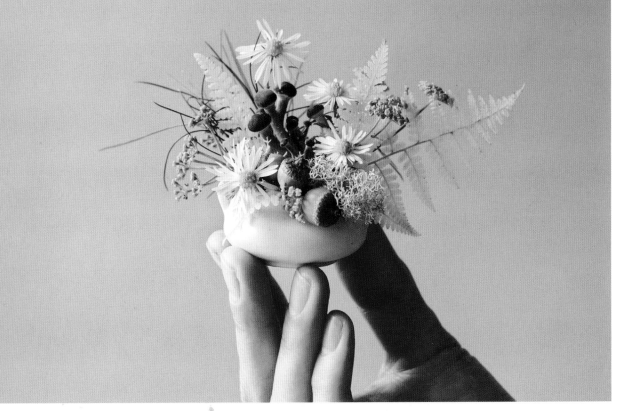

MUSHROOM

RECIPE 3
TABLESCAPE

INGREDIENTS

9 fern sprigs

12 aster sprigs

12 mushroom clusters

9 lichen puffs

10 acorns

VESSELS & SUPPLIES

Three 5-inch (13 cm) squares of chicken wire

Floral tape

Three 4-inch-diameter (10 cm)
glass petri dishes

Three 8-inch (20 cm) squares of sheet moss

1 Make a rounded shape with one square of chicken wire and use floral tape to secure it in a petri dish. Add water.

2 Place a square of sheet moss on top of the chicken wire frame to make a "hill," leaving a small opening at the top. Position three fern sprigs and four asters to lean out at various heights from the moss, making sure the stems reach the water.

3 Nestle four mushroom clusters down into the chicken wire opening so they are held upright. Lean one of the four clusters at the base of the moss hill and use three lichen puffs to fill any empty spaces. Repeat steps 1 through 3 to make two more hills. Group the dishes together to create a larger centerpiece; finish by scattering acorns around the base.

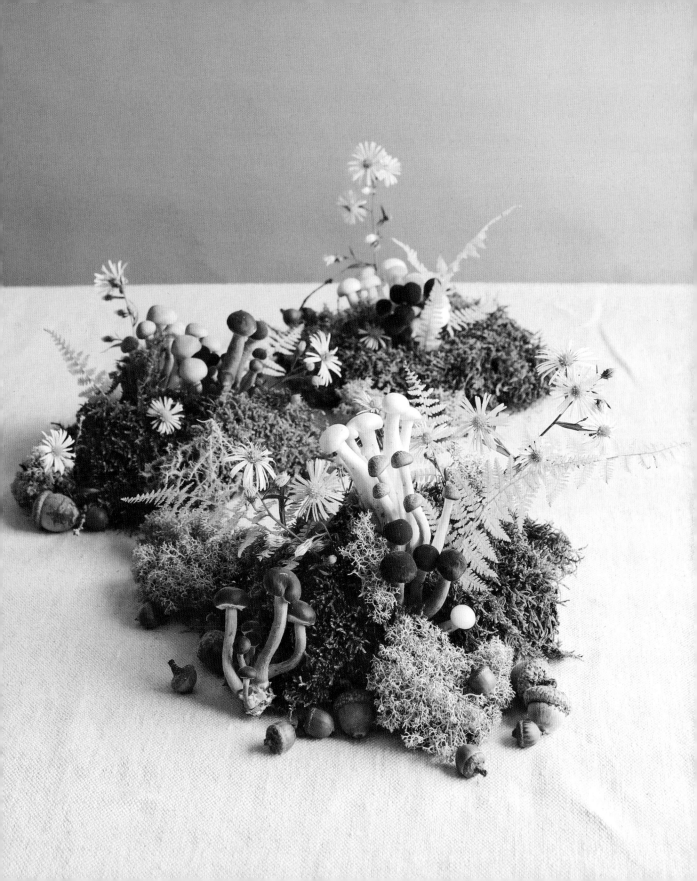

RECIPE 4
BRANCH DECOR

INGREDIENTS

Lichen-covered branch

4 mushroom clusters

2 lichen puffs

5 fern sprigs

SUPPLIES

Floral glue

Hunt down the perfect branch to create this tiny log sculpture seemingly plucked from the forest floor. The mushrooms and ferns will both dry, so this arrangement can be displayed long-term as a treasure in a glass box or under a cloche.

1. Squeeze a small amount of floral glue onto the branch in four spots. Press a mushroom cluster onto each glue spot and hold in place until they are securely adhered. Add another spot of glue and press one lichen puff onto it until attached.

2. To attach the fern sprigs, dip the stems into a small amount of glue, then press onto the branch. Attach the three smallest fern sprigs at the base of three mushroom clusters and place the two larger ferns at the base of the lichen puff.

3. Tear tiny pieces from the remaining lichen puff and press them onto the branch to conceal any exposed glue.

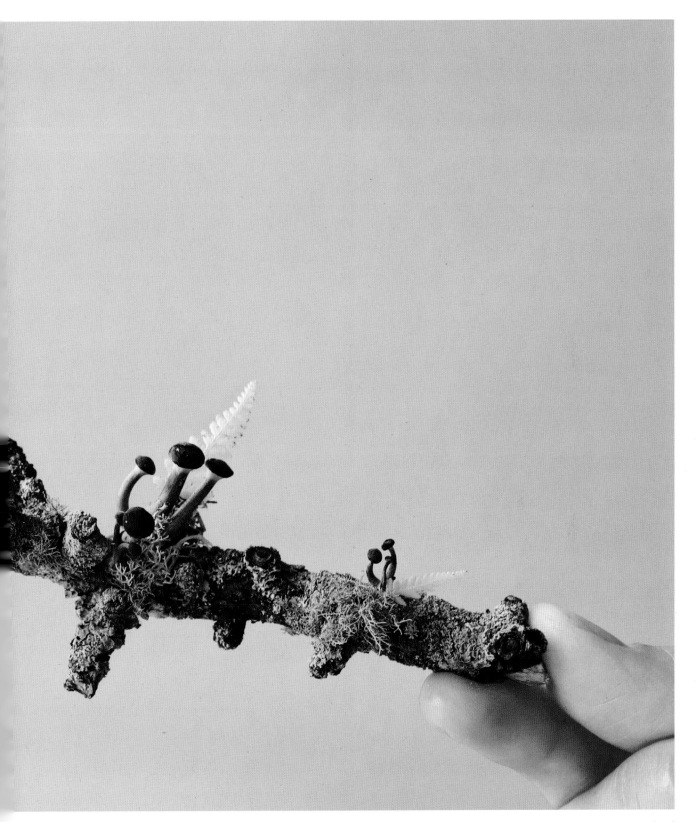

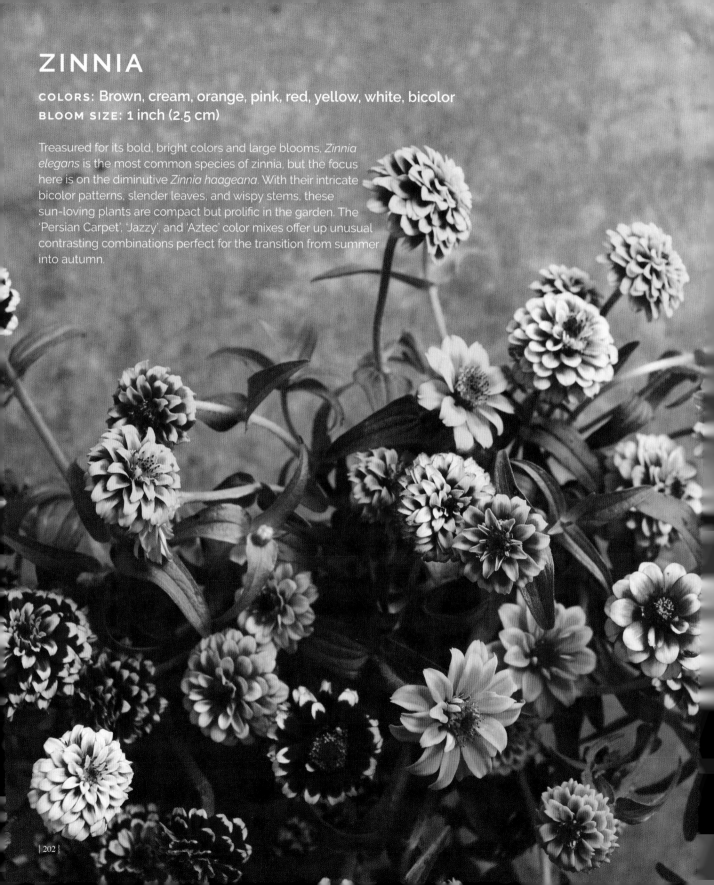

ZINNIA

COLORS: Brown, cream, orange, pink, red, yellow, white, bicolor
BLOOM SIZE: 1 inch (2.5 cm)

Treasured for its bold, bright colors and large blooms, *Zinnia elegans* is the most common species of zinnia, but the focus here is on the diminutive *Zinnia haageana*. With their intricate bicolor patterns, slender leaves, and wispy stems, these sun-loving plants are compact but prolific in the garden. The 'Persian Carpet', 'Jazzy', and 'Aztec' color mixes offer up unusual contrasting combinations perfect for the transition from summer into autumn.

ZINNIA

RECIPE 1
ON ITS OWN

INGREDIENTS

15 zinnia blooms

VESSEL

1¾-inch-tall (4.5 cm) coffee mug

Rich mahogany blooms tinged with cream and pale yellow are playfully arranged in this "coffee with cream"–themed design. Remove the foliage so that all the focus is on the intricate petals.

1. Place five zinnia blooms leaning out over the mug rim on all sides. Create a second layer with five more blooms, leaving their stems a little longer so the blossoms rise above the first grouping.

2. Fill in holes at the top of the arrangement with the remaining blooms to create a rounded shape.

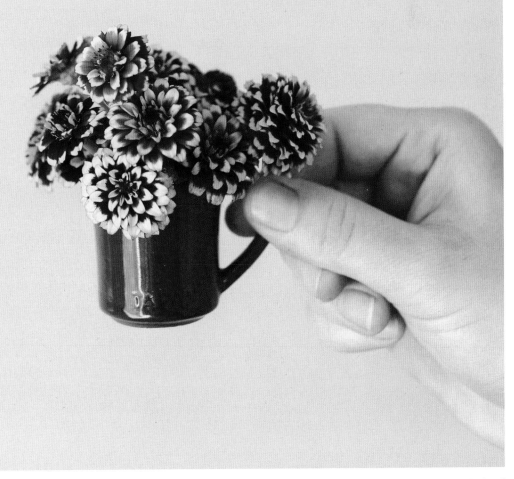

RECIPES 2–4
INGREDIENTS

This warm collection is at once bright and muted: the blended tones in the maple samaras, abelia foliage, and cotoneaster berries echo the unique bicoloration of the zinnias. Wispy spirea leaves add a vivid green pop that brings freshness to an autumnal look. Shrub roses produce small blooms from spring until the frost, making them an excellent resource for clippings across the seasons.

zinnia

abelia

maple samara

spirea

rose

cotoneaster

RECIPE 2
MICRO ARRANGEMENT

INGREDIENTS

2 cotoneaster sprigs

2 abelia sprigs

3 zinnia stems, assorted colors

1 maple samara sprig

1 rosebud

1 spirea sprig

VESSEL

2¼-inch-tall (5.5 cm) ceramic
bud vase

Abelia sepals have the appearance of tiny bloom clusters once their tubular pink flowers fall off. Combined with cotoneaster berries, they make the perfect bed to layer delicate zinnia stems into. A tall-necked vase invites wispy, long stems, so don't be afraid to let some ingredients get leggy.

1. Set a cotoneaster sprig on the left and an abelia sprig on the right along the rim. Place a longer sprig of abelia leaning out at the left and cotoneaster at the right.

2. Add the zinnia stems in the center of the arrangement at varying heights.

3. Place the maple samara and rosebud at the front rim. Finish by leaning the spirea sprig out on the left side, curving upward.

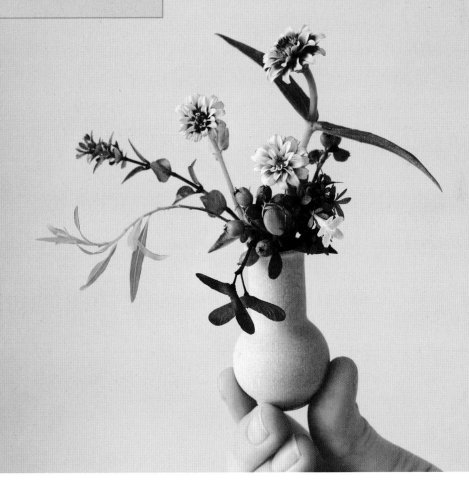

ZINNIA

RECIPE 3
MINI ARRANGEMENT

INGREDIENTS

4 abelia sprigs

2 maple samara sprigs

2 cotoneaster sprigs

2 rose blooms

5 zinnia blooms

3 spirea sprigs

VESSEL & SUPPLIES

Pin frog

3-inch-tall (7.5 cm) ceramic vase

1 Place the pin frog in the vase and press the abelia sprigs into it so the lower leaves rest at the center rim. Add the maple samara sprigs leaning down on the left and right sides.

2 Press one cotoneaster sprig into the pin frog so it angles upward to the left. Nestle the other next to the abelia on the right. Layer the roses, with the blooms facing upward, left and center.

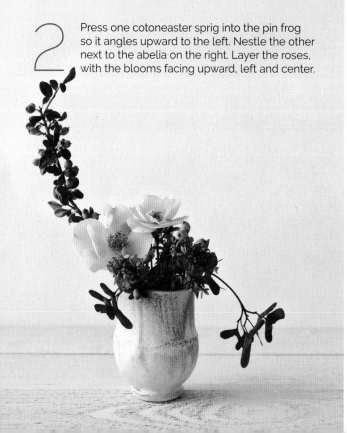

3 Layer four zinnias on top of the other ingredients close to the rim, and position the fifth zinnia higher on the right. Place one spirea sprig at the back left and one to the upper right. Finish by leaning the third to the right so its length balances the tall cotoneaster.

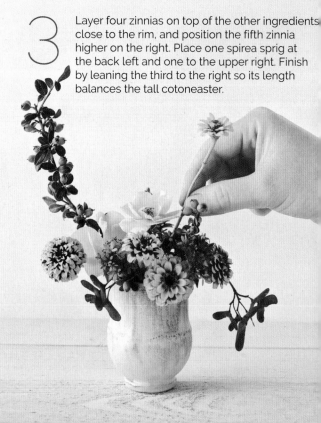

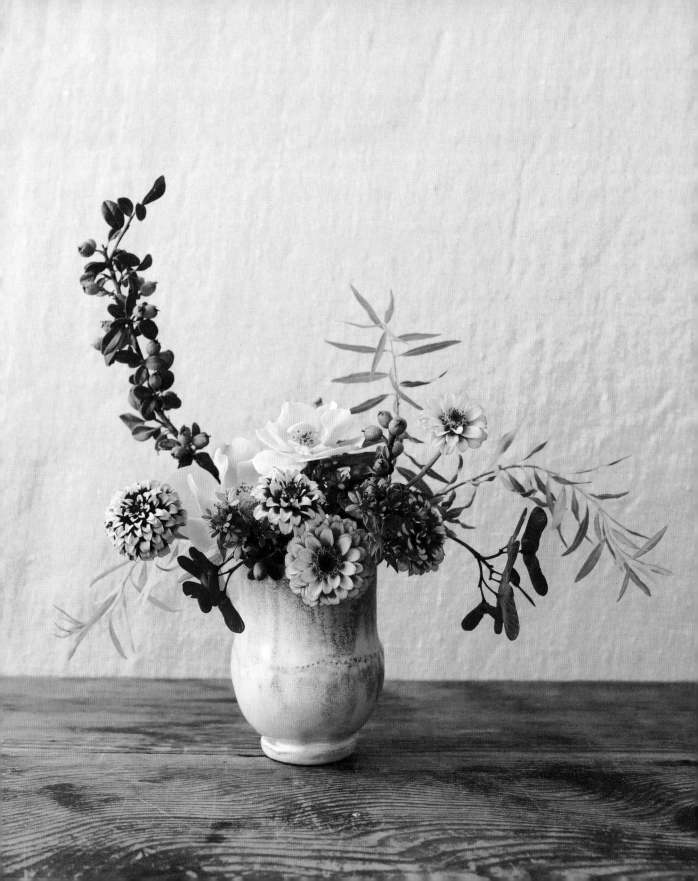

ZINNIA

RECIPE 4
WREATH

INGREDIENTS

One 12-inch (30.5 cm) cotoneaster stem

5 abelia sprigs

5 zinnia heads

SUPPLIES

Bind wire

Floral glue

1 Create the frame by twisting the cotoneaster stem into a round shape and securing the ends with bind wire. Place a small amount of glue on each abelia sprig and press them onto the frame, holding in place until they feel secure.

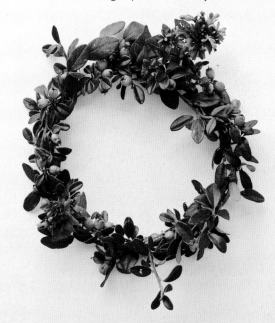

2 Add a small amount of glue to the frame next to one abelia sprig and press a zinnia head onto the glue until it adheres well.

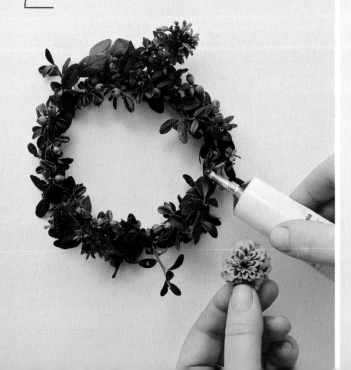

3 Repeat with the additional zinnias. Hang vertically as wall or door decor, or lay flat to create candle flair for a votive or small pillar. The zinnias should last for a day out of water.

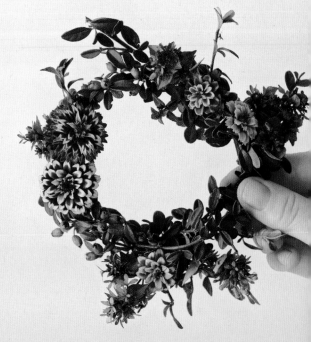

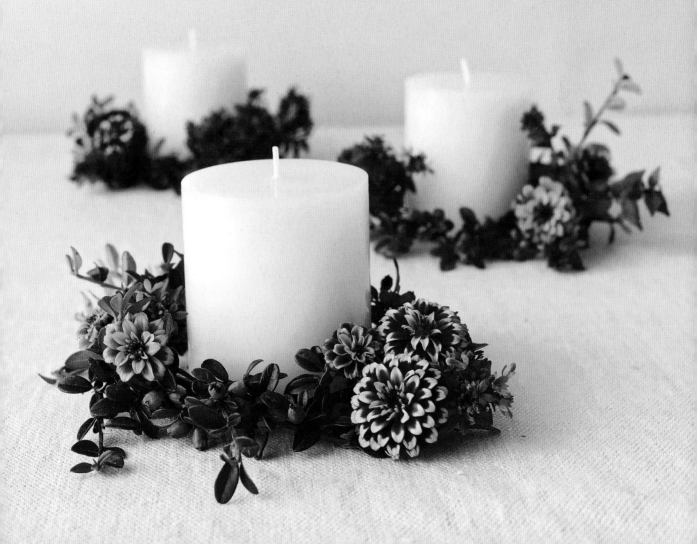

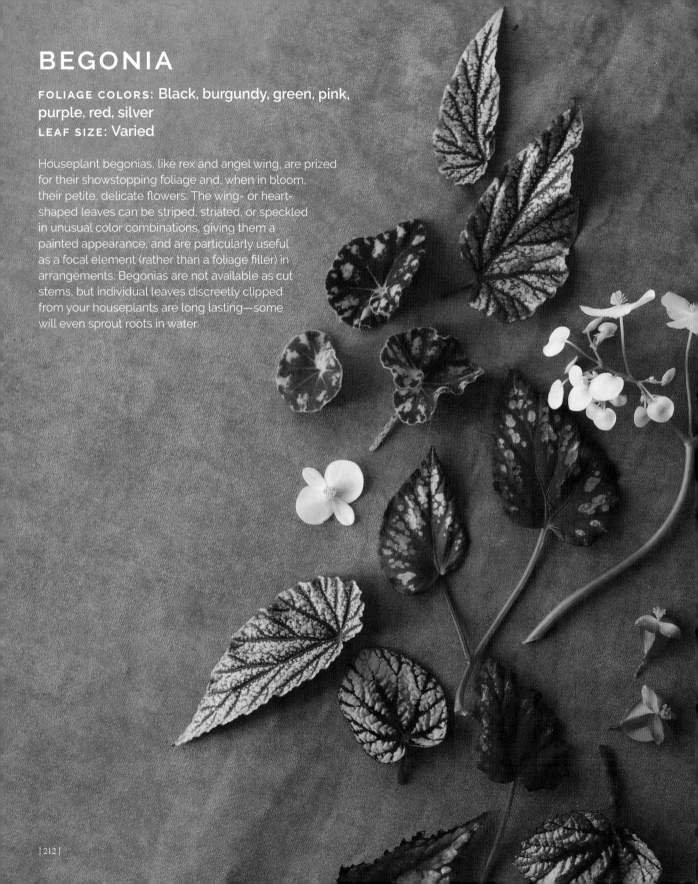

BEGONIA

FOLIAGE COLORS: Black, burgundy, green, pink, purple, red, silver
LEAF SIZE: Varied

Houseplant begonias, like rex and angel wing, are prized for their showstopping foliage and, when in bloom, their petite, delicate flowers. The wing- or heart-shaped leaves can be striped, striated, or speckled in unusual color combinations, giving them a painted appearance, and are particularly useful as a focal element (rather than a foliage filler) in arrangements. Begonias are not available as cut stems, but individual leaves discreetly clipped from your houseplants are long lasting—some will even sprout roots in water.

BEGONIA

RECIPE 1
ON ITS OWN

INGREDIENTS

1 begonia stem, with leaves and blooms

4 begonia leaves, assorted varieties

1 begonia bloom sprig

VESSEL & SUPPLIES

Pin frog

1½-inch-tall (4 cm) ceramic vase

The begonia's unique foliage takes center stage here, with each leaf displayed as a tiny work of art. Let the simple, natural gesture of the stems dictate the shape of the arrangement.

1. Place the pin frog in the vase and press the largest begonia stem (with multiple leaves and flowers) into it so that the stem leans out on the right side and the tip of the bottom leaf grazes the table surface.

2. Add three individual leaves curving out at varied heights on the left side and back, and rest the remaining leaf on the center rim.

3. Finish by placing the begonia bloom sprig in the center of the composition above the other ingredients.

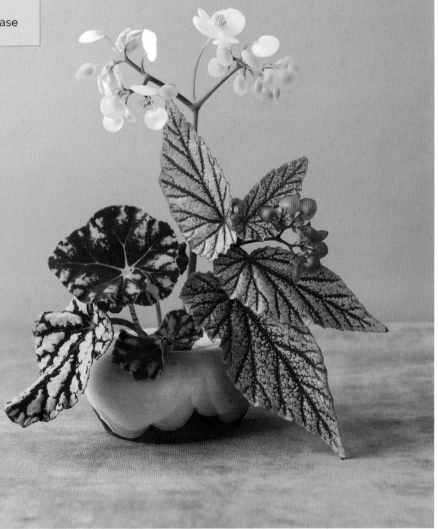

BEGONIA

RECIPES 2–4
INGREDIENTS

This wintry collection celebrates the amazing detail of begonias— even the undersides of the leaves are special, with coloration and texture that differ from those of the tops. The tiny flowers of fragrant jasmine vines and draping pieris provide delicate contrast to the graphic begonia leaves. One of the first flowering branches available in winter, quince are long lasting, and their sprigs will continue to leaf out in the vase.

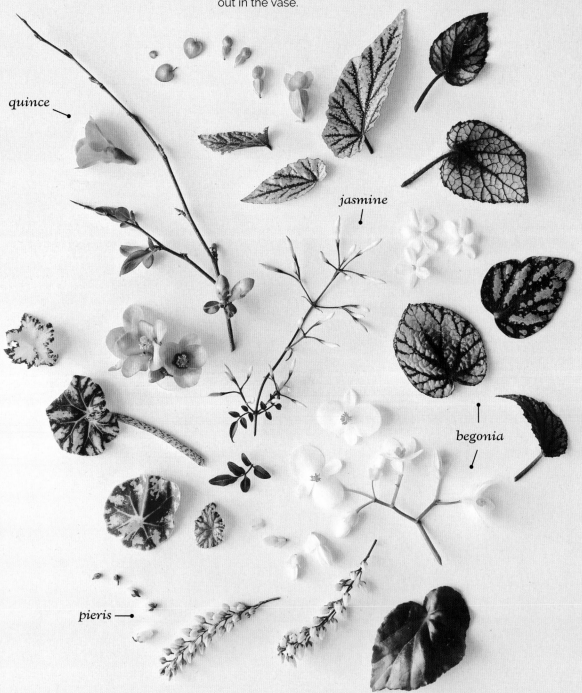

quince

jasmine

begonia

pieris

RECIPE 2
MICRO ARRANGEMENT

INGREDIENTS

2 begonia leaves

1 pieris sprig

1 jasmine sprig

1 quince sprig

VESSEL & SUPPLIES

1½-inch-tall (4 cm)
wooden bud vase

Double-sided glue tab (optional)

It can be tricky to combine straight and curved stems in a small composition, but by giving each ingredient room to breathe, the negative space becomes part of the design. Tiny details like the minuscule spots on the begonia stem are also accentuated in airy arrangements.

1. Place one begonia leaf along the front rim and lean the other out on the left side.

2. Set the pieris and jasmine sprigs on the right side at similar heights, with the pieris curving inward and the jasmine leaning out.

3. Finish by placing the quince sprig straight up in the center of the composition. If desired, add a glue tab to the surface where you wish to place the vase, to help stabilize the arrangement.

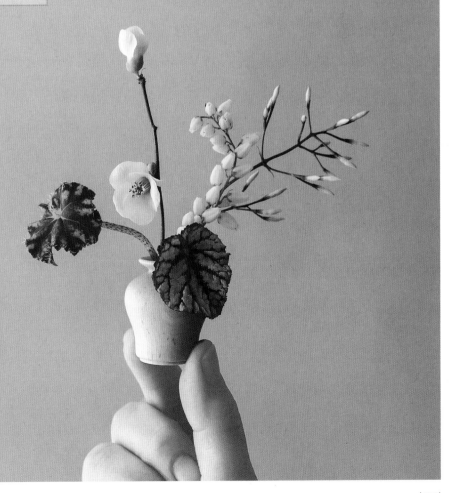

BEGONIA

RECIPE 3
MINI ARRANGEMENT

INGREDIENTS

1 pieris sprig

1 begonia leaf sprig

2 quince sprigs

2 jasmine sprigs

2 begonia leaves

2 begonia bloom sprigs

VESSEL

3-inch-tall (7.5 cm) petite blown glass cup

1 Insert the pieris sprig leaning out the left side of the cup and layer the begonia leaf sprig on top of it.

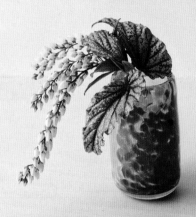

2 Place the quince sprigs leaning out on the right so the lowest blooms rest along the rim.

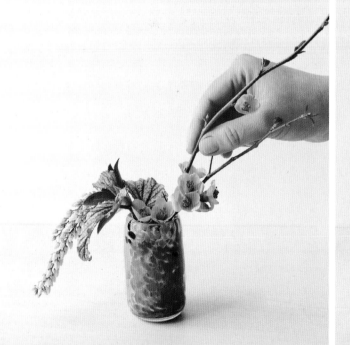

3 Nestle one jasmine sprig curving down under the quince on the right and set the other on the left, arching upward and resting on the begonia leaves. Tuck one begonia leaf under the quince at the right rim and the other leaf in front of the jasmine on the left. Finish by nestling one begonia bloom sprig into the center and positioning the other to cascade down at the left rim.

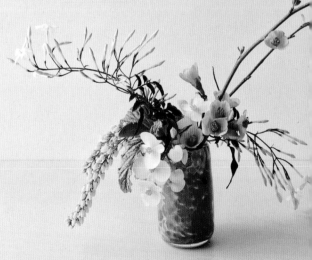

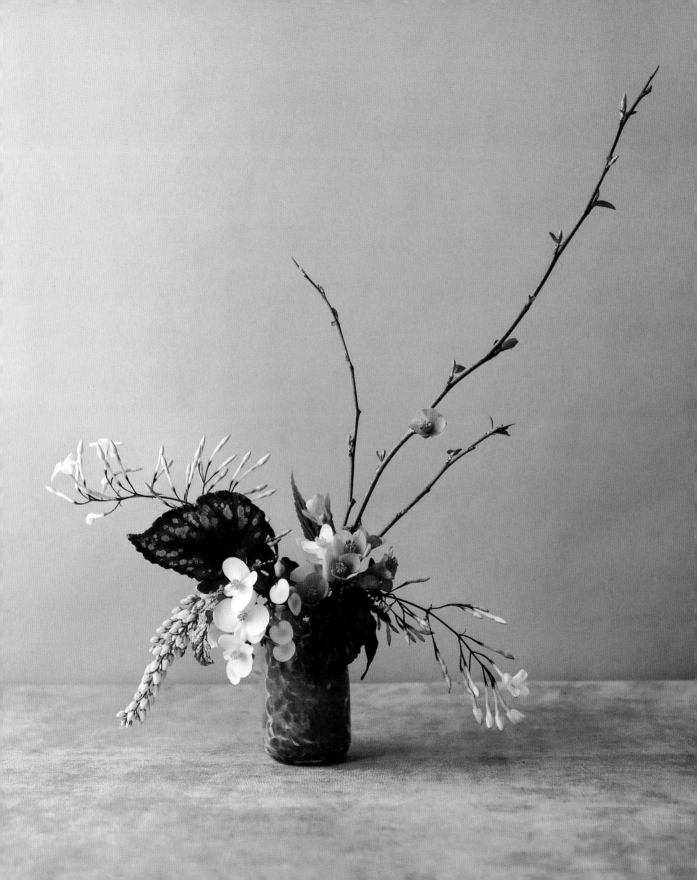

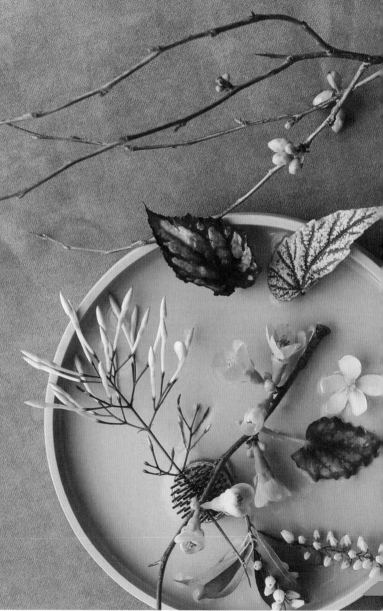

BEGONIA

RECIPE 4
TABLESCAPE

INGREDIENTS

4 quince branch tips

3 jasmine sprigs

9 begonia leaves,
assorted varieties

2 pieris sprigs

6 begonia florets

VESSELS & SUPPLIES

Two 7½-inch-diameter (19 cm)
rimmed porcelain plates

One 4½-inch-diameter (11.5 cm)
low porcelain bowl

3 pin frogs

This unconventional and airy tablescape creates the look of floral-printed dishware and is easy to make by floating ingredients in a grouping of rimmed plates and low bowl.

1. Fill the vessels with water. Use pin frogs to anchor longer quince branch tips and jasmine sprigs in place, with some elements extending beyond the vessels' edges.

2. Rest a few of the begonia leaves with their tips on the rims to hold them in place and float the remaining leaves and blooms in small groupings around the quince and jasmine.

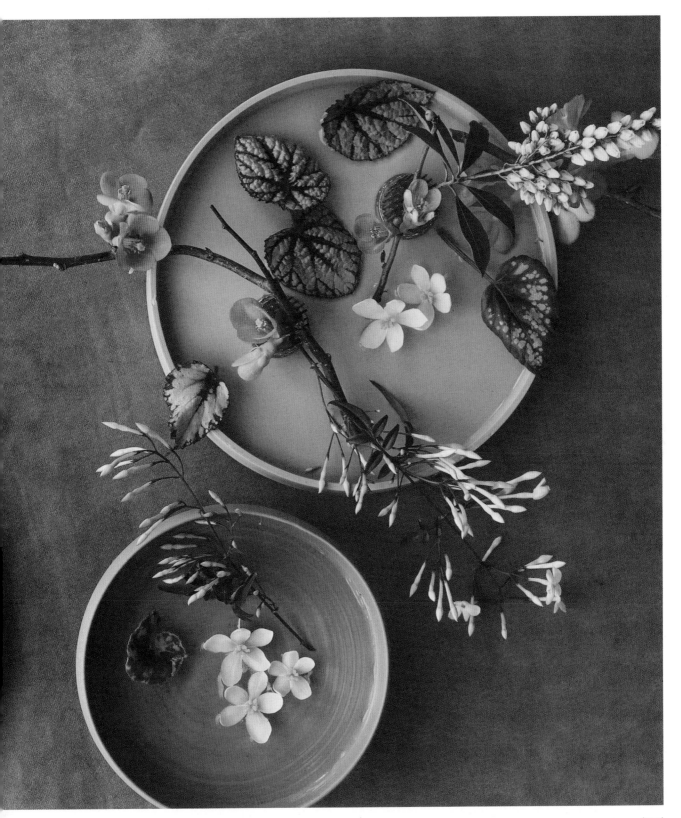

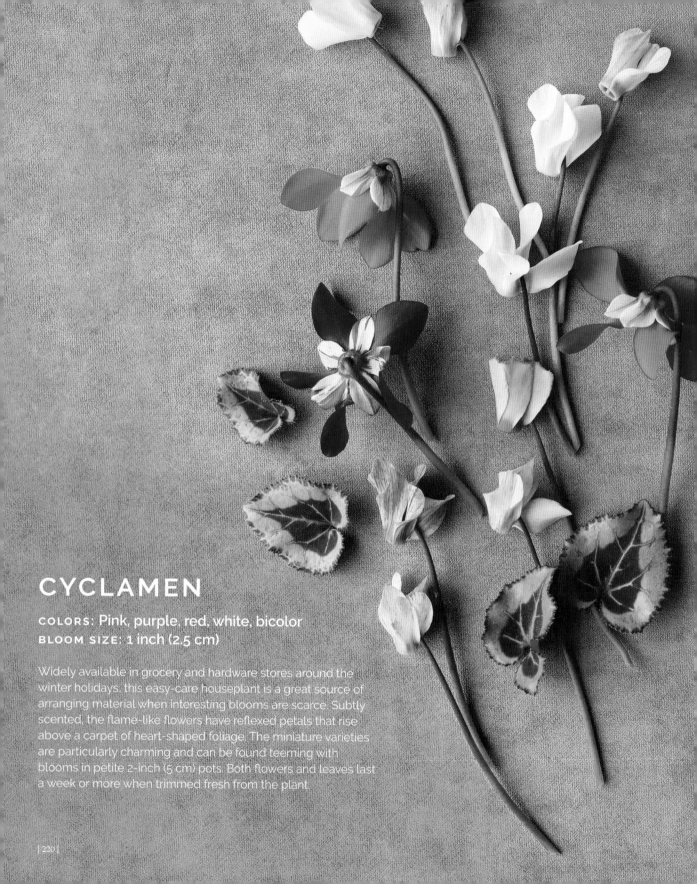

CYCLAMEN

COLORS: Pink, purple, red, white, bicolor
BLOOM SIZE: 1 inch (2.5 cm)

Widely available in grocery and hardware stores around the winter holidays, this easy-care houseplant is a great source of arranging material when interesting blooms are scarce. Subtly scented, the flame-like flowers have reflexed petals that rise above a carpet of heart-shaped foliage. The miniature varieties are particularly charming and can be found teeming with blooms in petite 2-inch (5 cm) pots. Both flowers and leaves last a week or more when trimmed fresh from the plant.

CYCLAMEN

RECIPE 1
ON ITS OWN

INGREDIENTS

One 2-inch (5 cm) potted
cyclamen plant

VESSEL

Straight-sided shot glass

The name cyclamen is derived from the Greek *kyklos*, meaning "circle," after the shape of its perfectly round tuber. Showcase this rarely seen part of the plant outside of the soil in a laboratory-inspired display.

1. Remove the cyclamen plant from its pot and carefully shake off most of the soil. Swirl the tuber and roots in water to remove more of the soil, then rinse under the faucet.

2. Place the plant in the glass, using its leaves to keep it propped up. Add water to just above the tuber, where the leaves start sprouting. The display will last about a week as is, but for longevity, just the roots should be submerged because the tuber will rot.

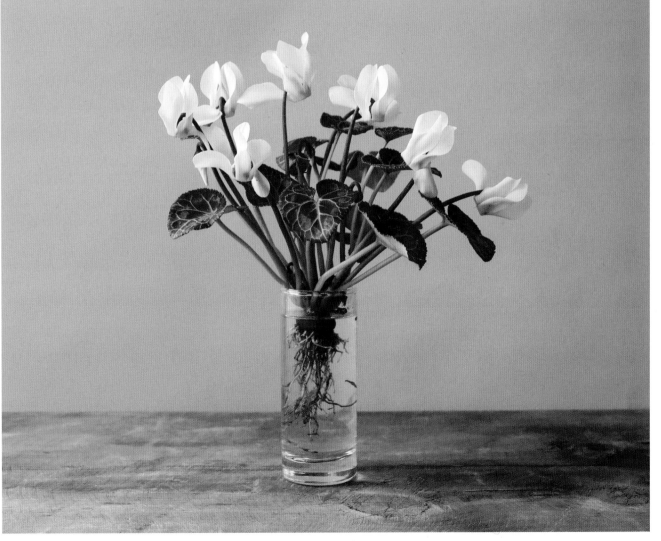

CYCLAMEN

RECIPES 2–4
INGREDIENTS

Golden pops of myrtle and cypress foliage along with whimsical yellow mimosa blooms brighten this wintry palette. The contrast between the dark blue myrtle berries and gray brunia is bridged by the subtle blue tones of the mimosa leaves and cypress. Though the focus is on the cyclamens' flowers, the silver veining and two-tone coloration of their leaves is also quite beautiful.

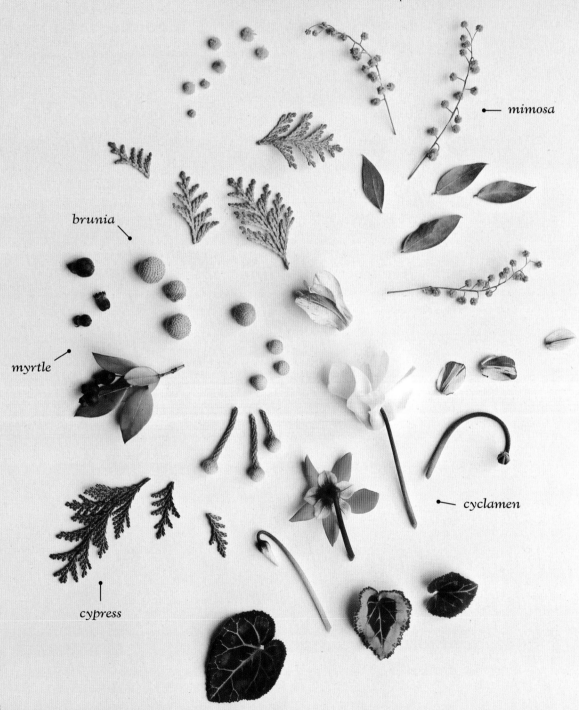

mimosa

brunia

myrtle

cypress

cyclamen

CYCLAMEN

RECIPE 2
MICRO ARRANGEMENT

INGREDIENTS

1 myrtle sprig

1 brunia sprig

2 cypress sprigs

1 cyclamen bloom

1 mimosa sprig

VESSEL & SUPPLIES

1¼-inch-tall (3 cm)
dollhouse vase

Double-sided glue tab (optional)

The focal point of this composition, a showy white cyclamen bloom, is set off by the playful rounded shapes of brunia, myrtle berries, and mimosa.

1. Create a bunch in hand with the myrtle, brunia, and cypress sprigs, lining up the lowest level of foliage. Trim and slip the bunch into the vase.

2. Tuck the cyclamen bloom and mimosa sprig into the vase on opposite sides, curving out at a similar width. If desired, add a glue tab to the surface where you wish to place the vase, to help stabilize the arrangement.

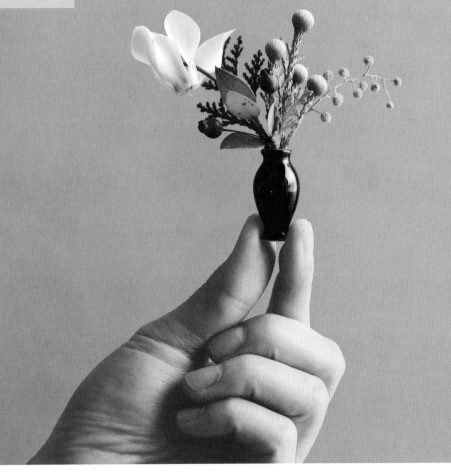

RECIPE 3
MINI ARRANGEMENT

INGREDIENTS

1 mimosa sprig

2 cypress sprigs

1 brunia sprig

1 myrtle sprig

2 cyclamen blooms

VESSEL

3-inch-tall (7.5 cm) ceramic bud vase

1 Lean the mimosa sprig out the left side of the vase, with the lowest level of leaves at the rim.

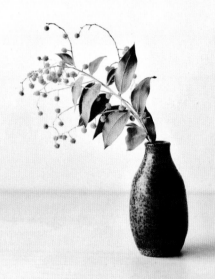

2 Place one cypress sprig leaning out at the right and the other upright in the center. Add the brunia sprig in the front.

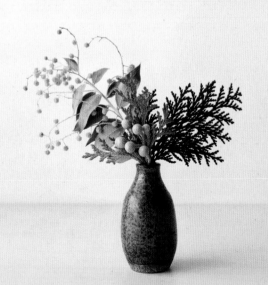

3 Nestle the myrtle sprig into the center of the arrangement so the berries rest along the rim. Place one cyclamen bloom high in the center with the bloom curving forward. Finish by adding the last cyclamen bloom to the right, with the bloom curving forward.

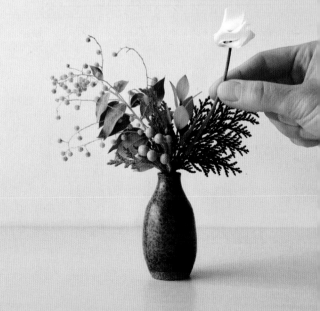

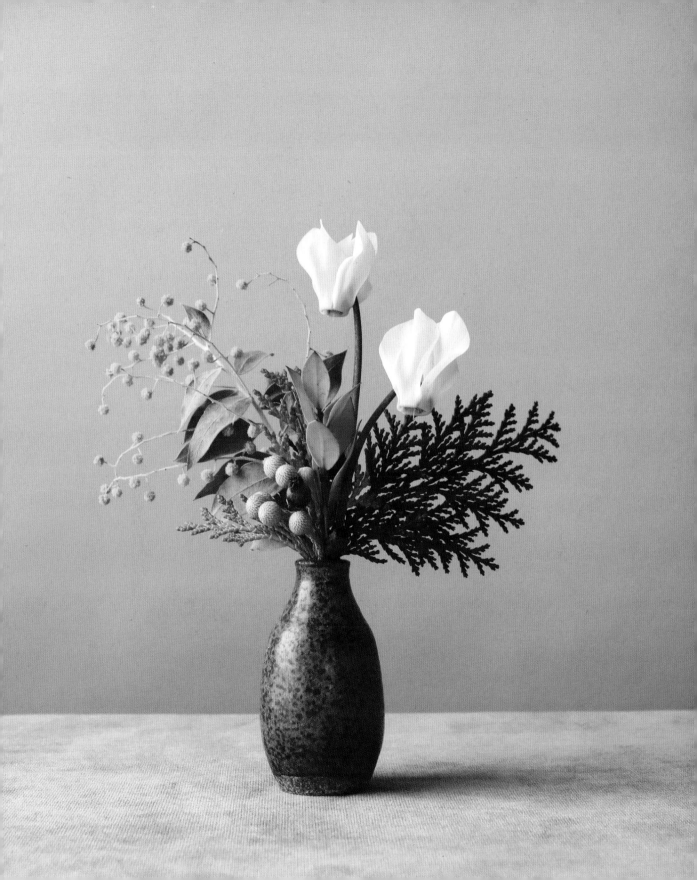

RECIPE 4
WREATHS

The selection of foliage on page 222 holds up well out of water and dries beautifully (with the exception of the cyclamen blooms, which can be plucked out once they fade), making these materials ideal components for festive wreaths. With the help of a few different construction methods, elements can be combined for a mixed look or styled on their own for a simple and elegant feel.

The wreath on this page was made by creating small bunches, securing each with wire, then attaching them to a grapevine frame. This method is great for beginners as well as for those craving a more controlled bunch design. Opposite, small sprigs of brunia (top left) and mimosa (bottom left) were individually wired onto a grapevine frame using the continuous wrap technique (see page 265), cypress sprigs (top right) were tucked into a grapevine frame; and a flexible myrtle branch (bottom right) was twisted around itself into a circular shape and wired in a few places to secure.

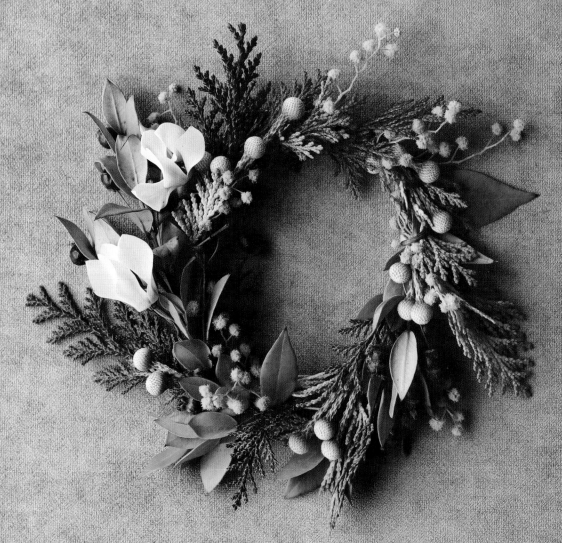

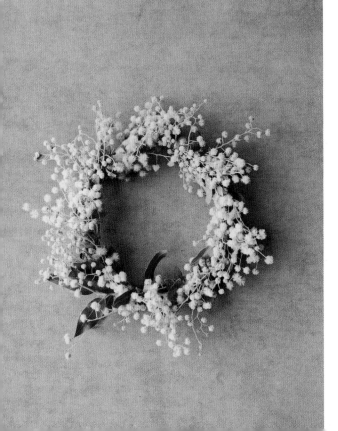
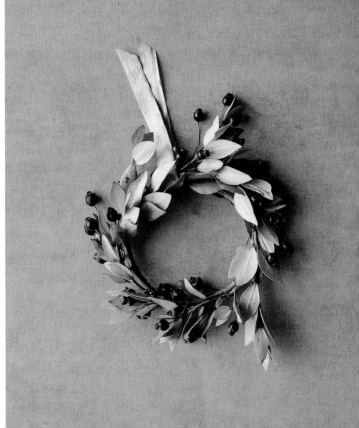

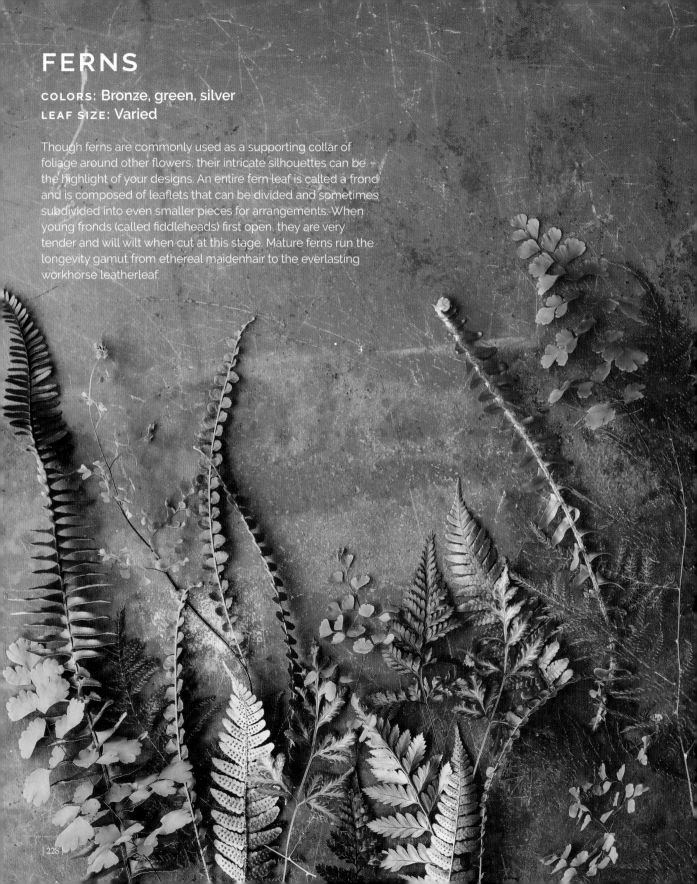

FERNS

COLORS: Bronze, green, silver
LEAF SIZE: Varied

Though ferns are commonly used as a supporting collar of foliage around other flowers, their intricate silhouettes can be the highlight of your designs. An entire fern leaf is called a frond and is composed of leaflets that can be divided and sometimes subdivided into even smaller pieces for arrangements. When young fronds (called fiddleheads) first open, they are very tender and will wilt when cut at this stage. Mature ferns run the longevity gamut from ethereal maidenhair to the everlasting workhorse leatherleaf.

RECIPE 1
MICRO ARRANGEMENTS

INGREDIENTS

20 fern fronds, assorted varieties
(see page 230 for suggestions)

VESSELS

Five 2-inch-tall (5 cm) glass vials

Showcase the varied shape and texture of ferns by mixing them together in tiny clear glass vials. Turn some of the leaflets to expose the intricate dotted pattern of their spores, normally hidden on the underside.

1. Trim the leaflets from the lower part of the fronds to create short stems. Reserve five of the tallest fronds for the last step.

2. Place three fronds in each vial, creating a different combination of varieties in each.

3. Finish by adding the reserved tall fronds, curving them up in different directions for wispy gestures.

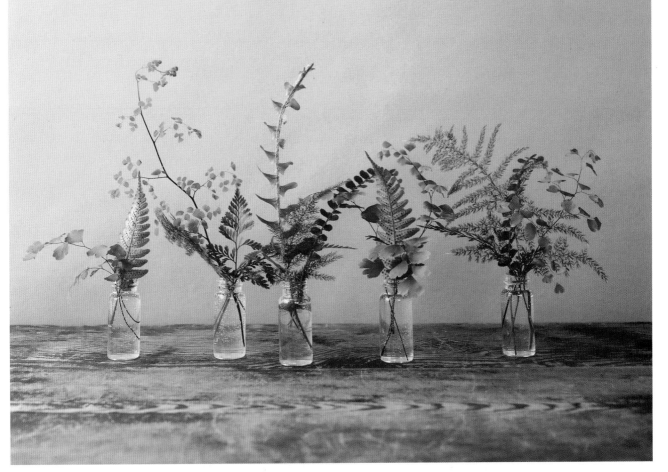

RECIPES 1–5
INGREDIENTS

Whether snipped from a houseplant or pulled from a rose bouquet, ferns provide a welcome bit of green in the home in any season. The monochromatic color scheme of this collection puts the focus on the beautiful combinations that can be created using different textures and leaf shapes. Though plumosa ferns have fern-like foliage, they are actually in the asparagus family.

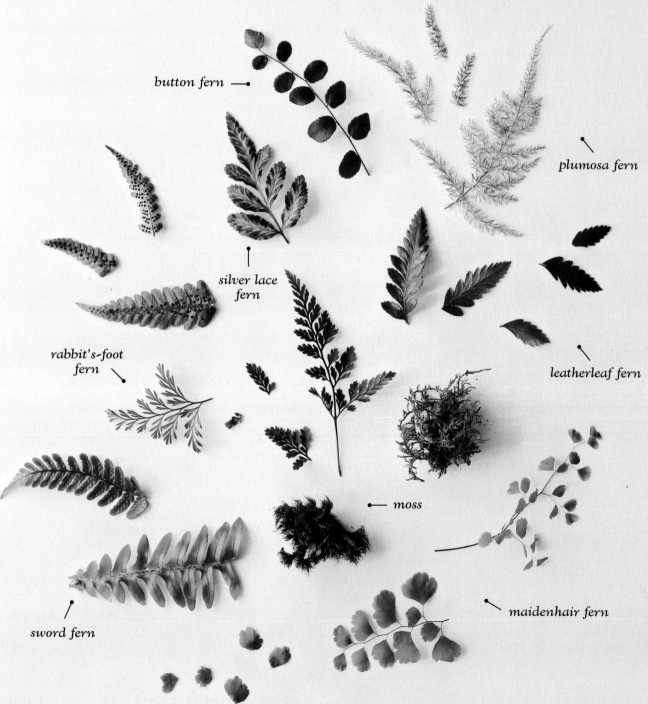

button fern

plumosa fern

silver lace fern

rabbit's-foot fern

leatherleaf fern

moss

sword fern

maidenhair fern

RECIPE 2
MICRO ARRANGEMENT

INGREDIENTS

6 fern fronds, assorted varieties
(see opposite for suggestions)

VESSEL & SUPPLIES

1¼-inch-tall (3 cm) ceramic
bud vase

Double-sided glue tab (optional)

No blooms are necessary to make this sweet assortment of greenery complete.

1. Create a bunch in hand with the assorted fronds, lining up the lowest leaflets and varying the heights. Place fronds with curving stems on the outside edges of the composition and straighter stems in the center.

2. Trim and place the bunch in the vase, making small adjustments to height or stem position if necessary. If desired, add a glue tab to the surface where you wish to place the vase, to help stabilize the arrangement.

FERNS

RECIPE 3
PLANTED CLOCHE

INGREDIENTS

4 fern plants in 2-inch (5 cm) pots

2 fern fronds

VESSEL & SUPPLIES

Pebbles

4½-inch-diameter (11.5 cm)
terra-cotta saucer

4-inch square of moss

6-inch-tall (15 cm) glass cloche

1 Pour a layer of pebbles into the saucer for drainage, and soak the moss in water to moisten it.

2 Remove two ferns from their pots, shake off excess dirt without disturbing the roots, and place them in the center of the saucer on top of the pebbles.

3 Repeat with the remaining two potted ferns, nestling them next to the two in the saucer. Use the excess soil to fill in around all the ferns, covering the pebbles. Place the cut fern fronds in the center of the planting to add height to the composition. (These can be removed later when they dry out.) Layer the moss on top of the soil, carefully tucking it in under the fern fronds. Finish by placing the cloche over the planting.

Note: If you keep the soil and moss moist and out of direct sunlight, the plants should last several weeks before they need to be moved to a larger container.

RECIPE 4
TWIG GARLAND

INGREDIENTS

Twig with lichen

11 fern fronds, assorted varieties
(see page 230 for suggestions)

SUPPLIES

12-inch (30.5 cm) piece of twine

Bind wire

Floral glue

1 Tie the twine to opposite ends of the twig. Hold the twine from the center to see where the twig balances naturally, then lay the twig on your work surface in the same position.

2 Create a bunch in hand with three fern fronds; secure together with a twist of bind wire, leaving the wire ends long enough to attach the bundle to the twig. Repeat to make two more bundles, reserving two fronds. With the bind wire, attach two bundles onto the twig next to each other with the tips pointing up and to the right, then attach the third in the opposite direction. Glue the remaining two fern fronds over the place where the stems cross and the wire is exposed.

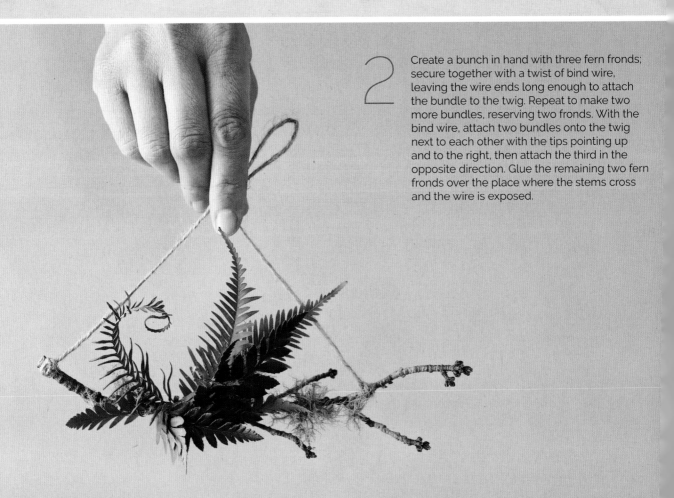

RECIPE 5
PRESSING

INGREDIENTS

75 assorted fern fronds and
leaflets, dried and pressed
(see page 15)

SUPPLIES

4-by-9-inch (10 by 23 cm)
cardstock

4-by-9-inch (10 by 23 cm)
floating glass frame

Superglue

Tweezers (optional)

6-inch (15 cm) piece of ribbon

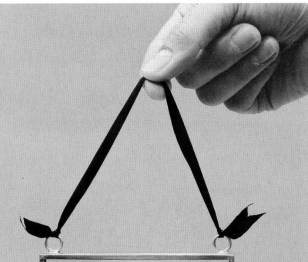

This is a longer-term project than most in this book because the fern pieces must be pressed and dried before being placed in the frame. Once all your ingredients have finished drying, go to town creating a wild and plentiful composition. You can also combine the ferns with violas or other pressed blooms.

1. Start creating the design by lining up a row of assorted leaflets with their tips pointing up along the bottom edge of the cardstock.

2. In the next row, flip a few leaflets to point downward. Don't overlap the ferns—leave a bit of space between each one and its neighbor. Add ferns until the paper is filled and you are pleased with the composition.

3. Transfer the ferns onto the glass in the same way they are composed on the paper. First add a tiny dot of glue to the glass in the area you will place the fern, then pick up the leaflet (using tweezers, if necessary) and lay it on the glue dot. Continue gluing and transferring until the frame is complete. Close the frame and add ribbon to hang.

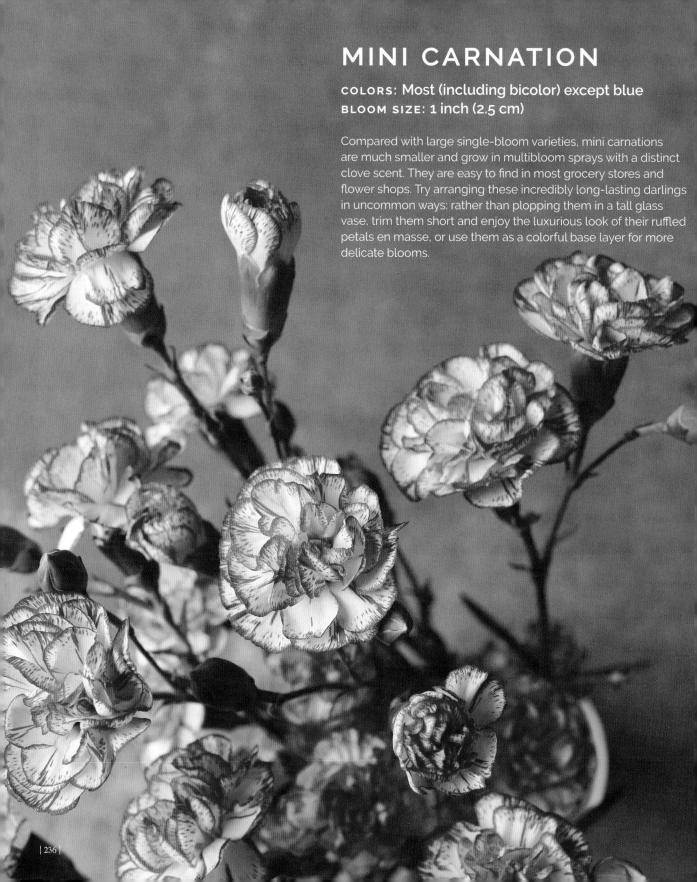

MINI CARNATION

COLORS: Most (including bicolor) except blue
BLOOM SIZE: 1 inch (2.5 cm)

Compared with large single-bloom varieties, mini carnations are much smaller and grow in multibloom sprays with a distinct clove scent. They are easy to find in most grocery stores and flower shops. Try arranging these incredibly long-lasting darlings in uncommon ways: rather than plopping them in a tall glass vase, trim them short and enjoy the luxurious look of their ruffled petals en masse, or use them as a colorful base layer for more delicate blooms.

MINI CARNATION

RECIPE 1
ON ITS OWN

INGREDIENTS

20 mini-carnation heads, red,
dark red, and bicolor

VESSELS

Two 4½-inch-diameter (11.5 cm)
low ceramic bowls

Show off a mass of intricate, ruffled petals with mounded bowls of mini-carnation heads. Trim the blooms from their stems just below the receptacle so they don't fall apart (see page 20), and create a display that will last for weeks.

1. Fill the bowls with water and sort the mini-carnation heads by color. You will create small color groupings in the bowls rather than alternating the three colors across the compositions.

2. Place the first few heads into a bowl, leaning them against the outer edge and working inward until there are no spaces between them. Repeat with the second bowl.

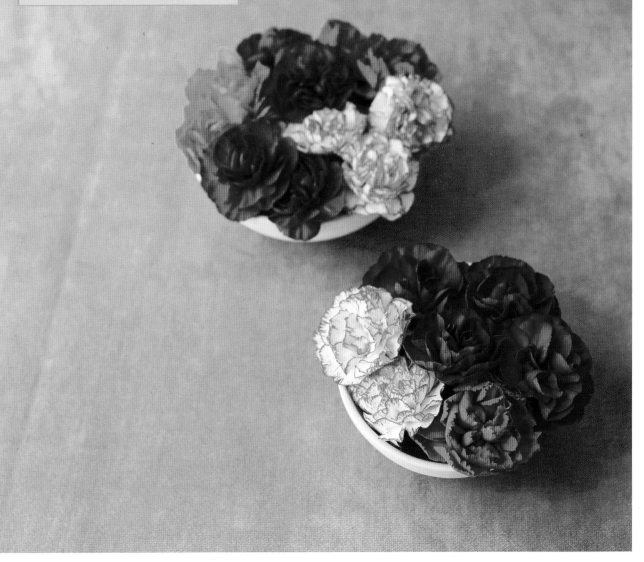

RECIPES 2–4

INGREDIENTS

Bright red and orange pair well with cheerful peppermint mini carnations in this vibrant holiday collection. Fragrant rosemary and gold-edged holly add touches of festive greenery to the leafless flower stems. Nerine lilies and miniature amaryllis both belong to the amaryllis family and share a similar clustered bloom structure, useful either as trimmed florets or multiheaded stems.

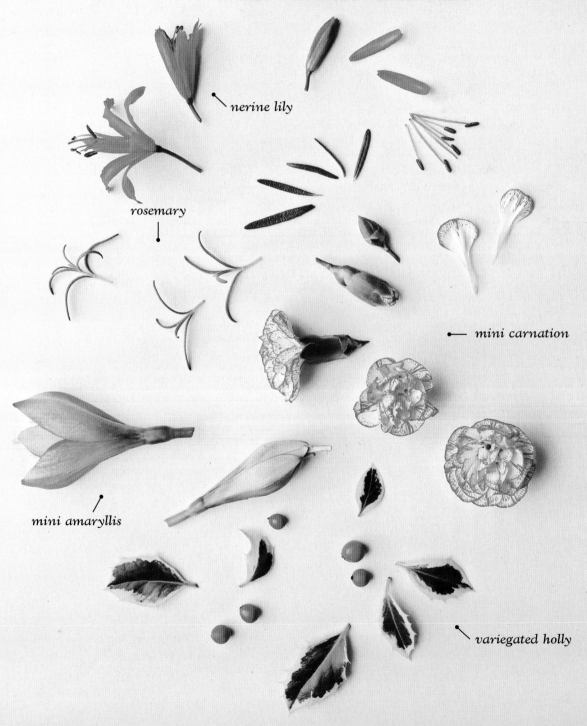

nerine lily

rosemary

mini carnation

mini amaryllis

variegated holly

MINI CARNATION

RECIPE 2
MINI ARRANGEMENT

INGREDIENTS

3 holly sprigs with berries

6 mini-carnation blooms

2 nerine lily stems

1 mini-amaryllis stem

3 rosemary sprigs

VESSEL & SUPPLIES

Pin frog

2¾-inch-tall (7 cm) ceramic cup

Trumpet-shaped nerine and amaryllis florets spring up from a stripy base layer of mini carnations. Spindly sprigs of rosemary add a touch of wildness, without encroaching too much on the negative space you want to allow around them.

1. Place the pin frog in the cup and press the holly sprigs into it, with the lowest level of leaves at the rim, placing one sprig on the right, one on the left, and one in back. Nestle five of the mini-carnation blooms around the holly and set the remaining bloom a little higher on the right in back.

2. Nestle one nerine lily stem into the base layer on the right and lean the other out wide to the left, giving the florets room to open. Place the mini-amaryllis stem on the right side so the florets have room to open, too.

3. Tuck in one rosemary sprig along the left rim so it curves down to touch the table and another at the back right. Finish by placing the third rosemary sprig curving up and inward at the back.

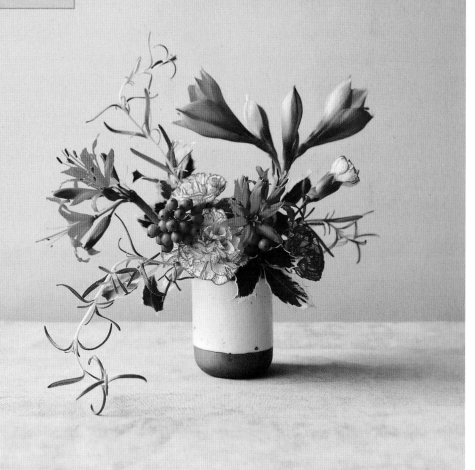

MINI CARNATION

RECIPE 3
MINI POMANDER

INGREDIENTS

50 mini-carnation blooms

SUPPLIES

Excelsior wood shavings

Bind wire

12-inch (30.5 cm) piece of ribbon

Floral glue

1 Trim the mini carnations, leaving about ½ inch (1 cm) of stem beneath the receptacles to insert into the excelsior.

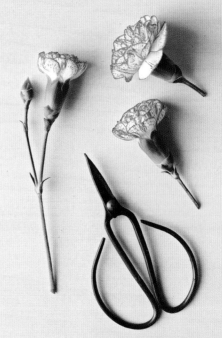

2 Form a tennis ball–size sphere of excelsior and wrap a piece of bind wire around the circumference, twisting at the top to secure. Repeat with another piece of bind wire, partitioning the ball into quarters. Loop the ribbon around both pieces of bind wire where they cross at the top.

3 Dab a small amount of floral glue onto a mini-carnation stem and the lower part of the receptacle. Repeat with five more heads, letting the glue dry for a few seconds before inserting the stems into the excelsior. Pack the heads together closely and angle the blooms slightly, following the curve of the sphere. Continue the process, gluing and adding six blooms at a time, until the ball is filled in.

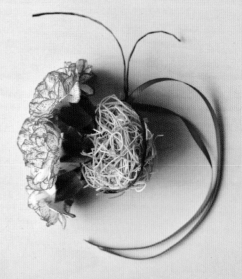

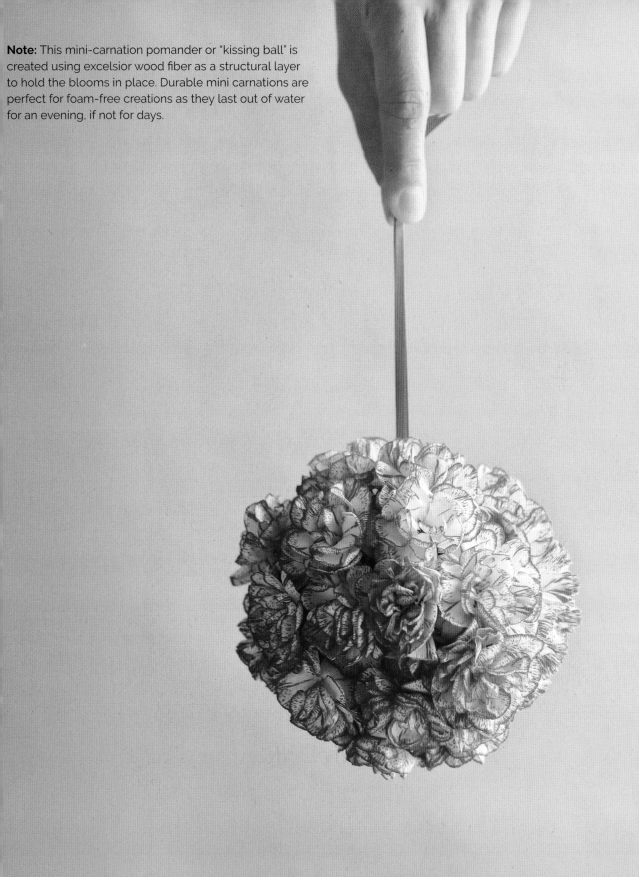

Note: This mini-carnation pomander or "kissing ball" is created using excelsior wood fiber as a structural layer to hold the blooms in place. Durable mini carnations are perfect for foam-free creations as they last out of water for an evening, if not for days.

RECIPE 4
TABLESCAPE

INGREDIENTS

4 holly sprigs with berries

8 mini-carnation blooms

2 nerine lily stems

2 mini-amaryllis stems

4 rosemary sprigs

VESSELS

10 ceramic vases in assorted
sizes from 1½ inches (4 cm) to
4½ inches (11.5 cm) tall

A collection of ceramic bud vases in delightfully varying shapes unifies this assortment of single-ingredient arrangements. A sprig here, a floret there: the handmade vases make each arrangement feel unique but cohesive. Clustered mini carnations are mirrored by a group of nerine lilies, and in a similar relationship, a single mini-carnation bloom and two nerine florets sit opposite each other. The combinations are limited only by the quantity of vases!

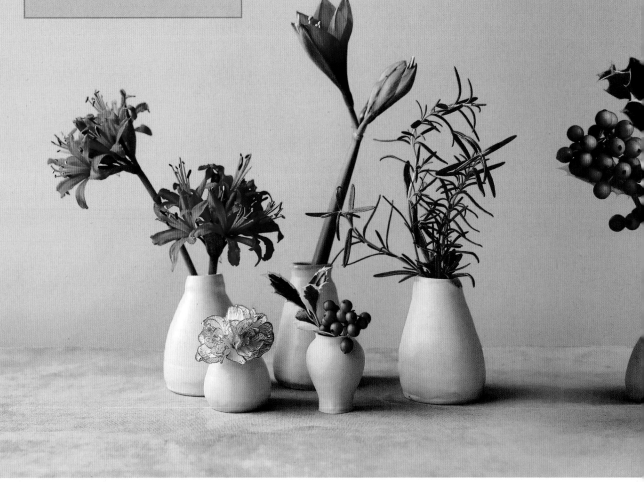

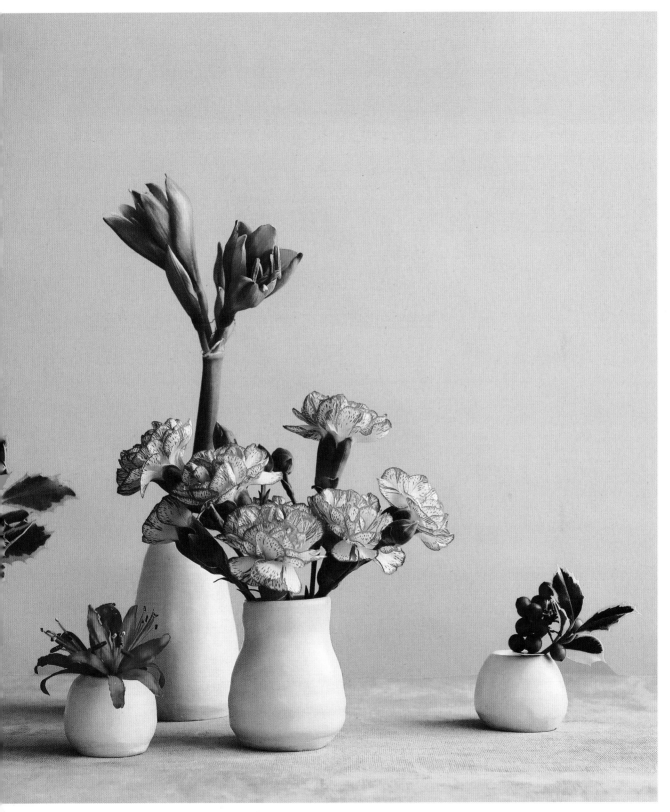

PAPERWHITE

COLOR: White
BLOOM SIZE: 1 inch (2.5 cm)

When new growth is scarce in winter months, shoots of green can be coaxed up early by forcing paperwhite bulbs, a variety of narcissus, to bloom indoors. Their delicate clusters of six-petaled, star-shaped flowers with tiny, cupped centers have a divisively strong fragrance; some people love it, and for others it is headache-inducing. Regardless of how the fragrance affects you, the beautiful white flowers are a welcome sign of the new growth to come. Like all daffodils and narcissi, paperwhites secrete a sap poisonous to other flowers when cut, so let them sit in water by themselves for a few hours before arranging.

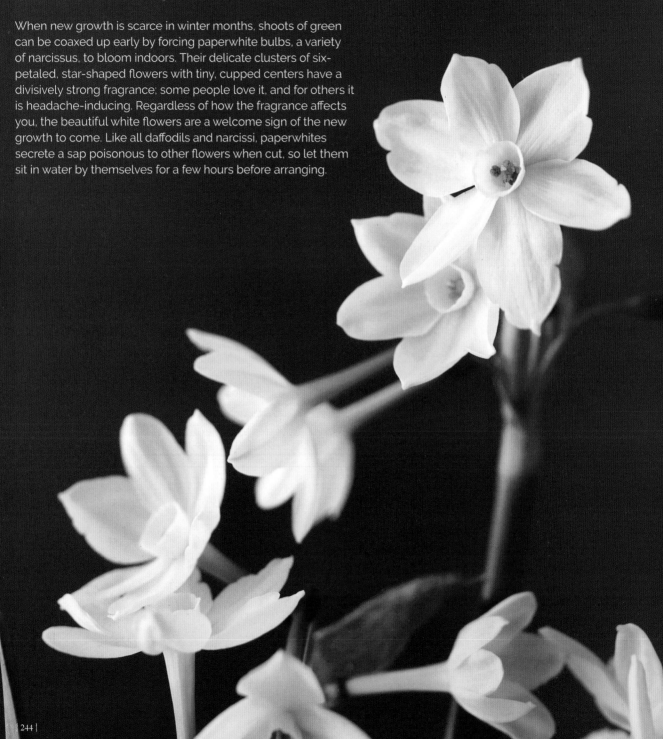

PAPERWHITE

RECIPE 1
ON ITS OWN

INGREDIENTS

40 paperwhite stems

VESSEL & SUPPLIES

Straight-sided shot glass

Floral glue

The smooth, straight, leafless stems and clustered blooms of paperwhites are ideal for creating a tiny, architectural flower tower (this also works with similarly shaped blooms like calla lilies). If the arrangement starts to get too crowded at the top, you can cheat by adding headless stems.

1. Trim the paperwhite stems to a length a few inches (7.5 cm) taller than the height of the glass and thoroughly dry them. Coat a small section of the outer glass with a thin layer of floral glue, being sure to cover all the way to the top and bottom edges. Let the glue dry for a few seconds.

2. Lay the first stem vertically on the glass so the blooms sit a little higher than the rim. Hold the stem firmly in place for a few seconds, until it feels secure. Attach a second paperwhite next to the first, carefully lining up the bloom height and keeping the stems vertically straight. Add stems until you fill the area where the glue was applied.

3. Continue adding glue and stems until the glass is fully covered. Trim the stems straight across at the bottom. You may wish to set the glass on a shallow dish of water for longevity.

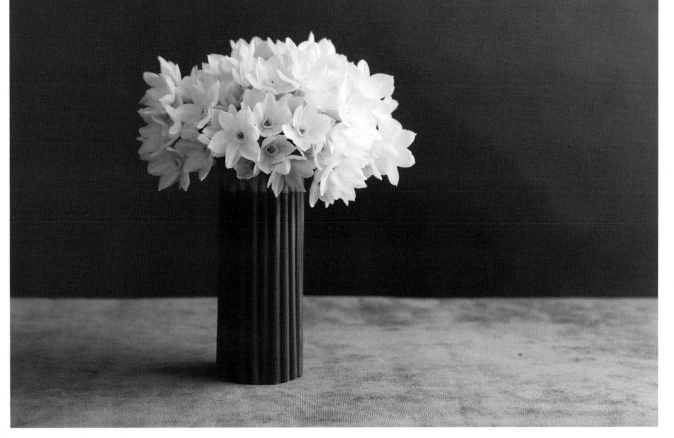

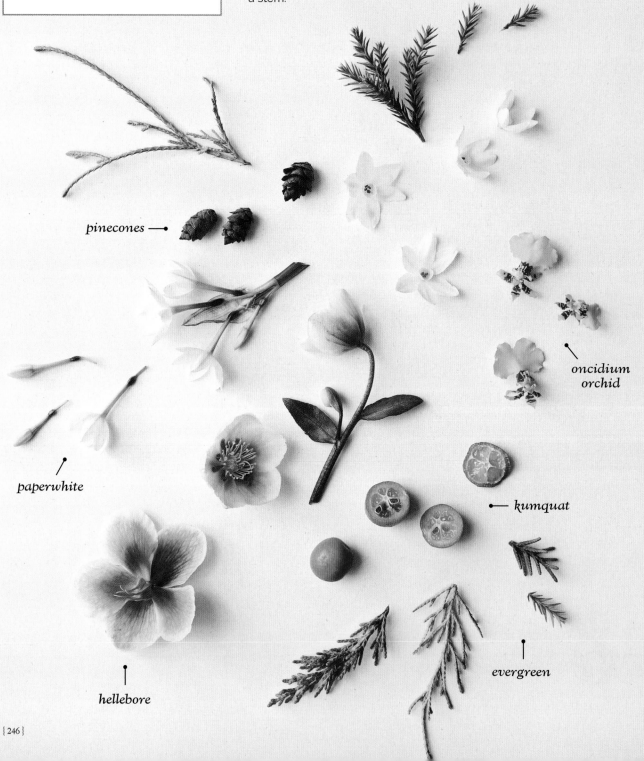

PAPERWHITE

RECIPES 2–5
INGREDIENTS

Tiny kumquats and bright yellow orchids add an unexpected citrus palette to this classic winter mix of fragrant evergreens, hellebore (specifically the early-blooming 'Winterbells' variety), and paperwhites. If you can't find kumquats on the branch, skewer the fruit to create a stem.

pinecones ◄

oncidium orchid

paperwhite

kumquat

hellebore

evergreen

RECIPE 2
MICRO ARRANGEMENT

INGREDIENTS

3 evergreen sprigs

3 paperwhite florets

1 kumquat sprig

1 hellebore bud

1 hellebore bloom

1 oncidium orchid sprig

2 pinecones

VESSEL & SUPPLIES

1¾-inch-tall (4.5 cm) ceramic vase

Floral glue

Most of the time Mother Nature doesn't need assistance with her amazing ingredients, but a dab of floral glue here helps position these teensy pinecones in exactly the right spot.

1. Place the evergreens in the middle of the vase and leaning out the left side. Set two paperwhite florets along the right rim and slip in the third above them, weaving it through the evergreens.

2. Tuck in the kumquat sprig behind the paperwhites so the fruit dangles over the rim, and insert the hellebore bud nodding down just above it. Layer the blooming hellebore on the left, supported by the evergreens and facing out.

3. Lean the orchid out high on the right. Finish by attaching the two pinecones to the evergreens at the front of the vase with a small amount of floral glue.

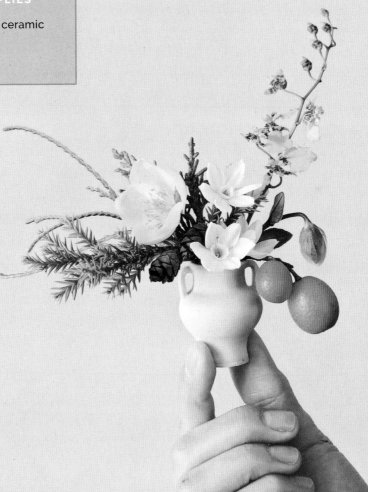

PAPERWHITE

RECIPE 3
MINI ARRANGEMENT

INGREDIENTS

6 evergreen sprigs

2 kumquat sprigs

2 paperwhite stems

3 hellebore blooms

2 oncidium orchid sprigs

1 evergreen sprig with cones

VESSEL & SUPPLIES

Pin frog

2½-inch-tall (6.5 cm) ceramic cup

1 Place the pin frog in the cup and press the evergreens into it, filling in around the rim on all sides and in the center. Cluster the kumquat sprigs so they're dangling over the right rim.

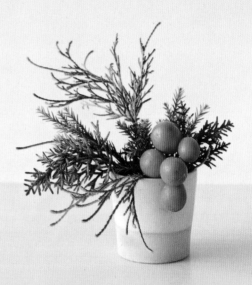

2 Add one paperwhite at the front rim of the cup and lean the other out a few inches (7.5 cm) taller than the kumquats on the right.

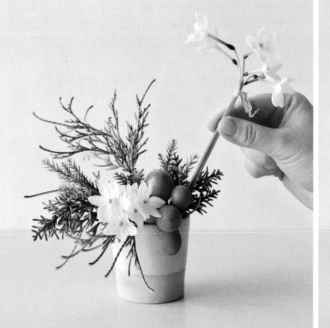

3 Tuck in one hellebore bloom behind the paperwhites in the front, and set the other two facing inward at varied heights. Place one orchid sprig next to the kumquats so it curves out at the rim and set the other slightly higher on the opposite side. Finish by nestling the evergreen cone sprig on the right.

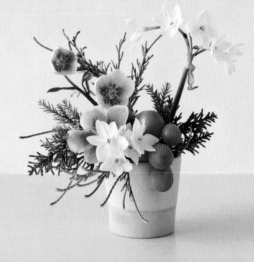

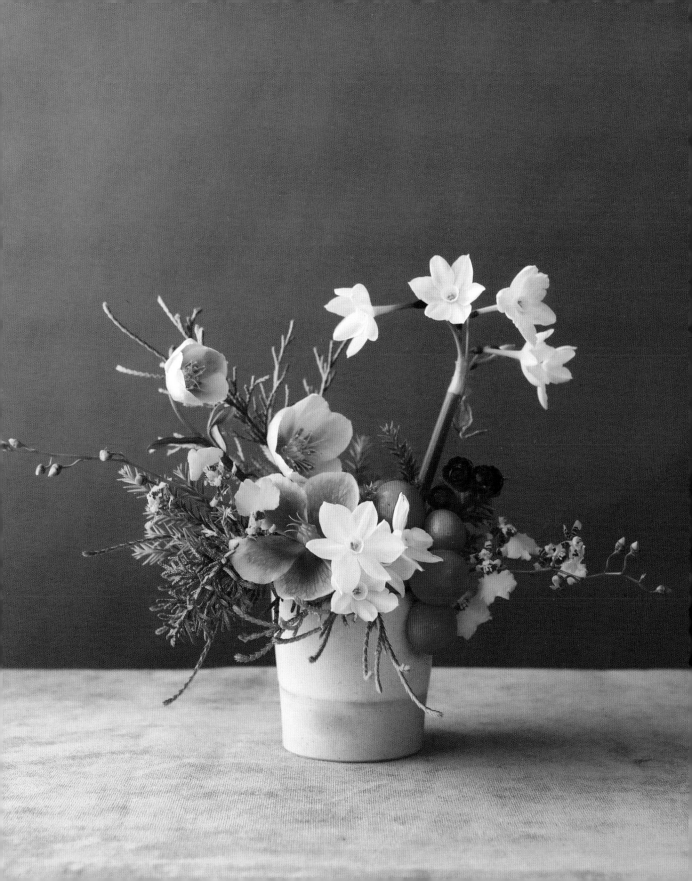

RECIPE 4
BOUTONNIERE

INGREDIENTS

2 paperwhite stems

8 evergreen sprigs

1 hellebore stem

2 oncidium orchid sprigs

2 kumquats

1 pinecone

1 dried kumquat slice

SUPPLIES

Floral glue (optional)

Floral tape

Ribbon

1 Trim the ingredients to a height of about 4 inches (10 cm), then remove the foliage from the bottom inch (2.5 cm) of the stems. Create a bunch in hand, lining up the lowest level of leaves or blooms and placing sturdy foliage toward the back and flowers in the front. Floral glue is useful to attach small decorative elements lacking stems, like pinecones and citrus fruit.

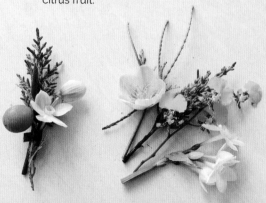

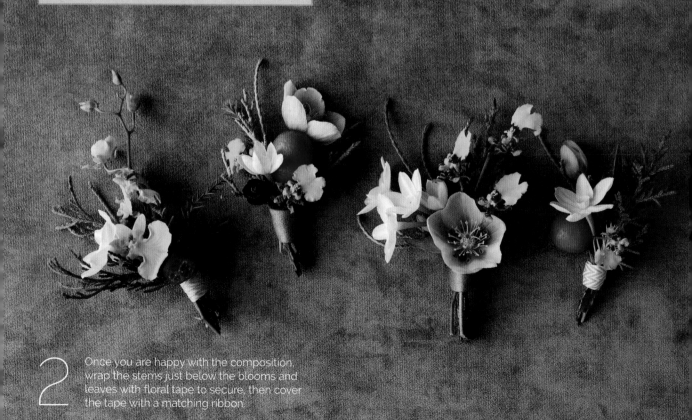

2 Once you are happy with the composition, wrap the stems just below the blooms and leaves with floral tape to secure, then cover the tape with a matching ribbon.

RECIPE 5
WREATH

INGREDIENTS

10 evergreen stems,
assorted varieties

7 pinecones

7 dried kumquat slices

SUPPLIES

4-inch (10 cm) grapevine
wreath frame

Bind wire

Floral glue

6-inch (15 cm) piece of ribbon

Kumquats are the smallest of all citrus fruits, and they retain their bright yellow-orange color beautifully when dry. Prepare kumquats or other citrus fruit for wreaths by cutting them into thin slices and drying in the oven on low (200°F/93°C) for about two hours, until the moisture is removed but they are not browned.

1. Make a fragrant mixed-evergreen sprig wreath using the continuous-wrap method (see page 265).

2. Adorn by gluing on tiny pinecones and dried kumquat slices, and a loop of ribbon to hang.

WAXFLOWER

COLORS: Cream, pink, purple, white
BLOOM SIZE: ½ inch (1 cm)

Often categorized as a long-lasting "filler," waxflower blooms can take center stage when trimmed low and clustered or used in combination with other petite blossoms. The tiny, five-petaled blooms grow on brown woody stems in a branching spray formation, making them ideal for snipping and using in small arrangements. While removing the lower leaves for stem cleaning, you'll observe that the pine-needle-shaped leaves and the flowers are rich in a lemony scented oil that is released when they are crushed: the oil gives them a waxy appearance. The glossy brownish centers even look like tiny votive candles with a wick poking up!

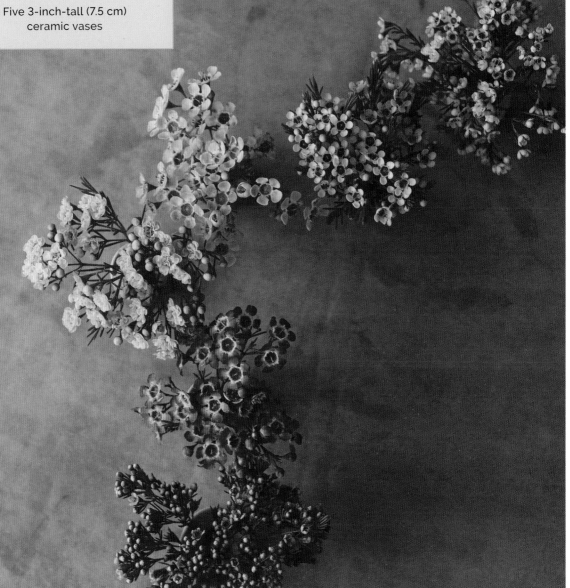

WAXFLOWER

RECIPE 1
ON ITS OWN

INGREDIENTS

5 sprigs each of five different
waxflower varieties (25 total)

VESSELS

Five 3-inch-tall (7.5 cm)
ceramic vases

Compare the subtly different hues and sizes of waxflower
blooms side by side in this bud vase display.

1. Create a rounded cluster in hand with one variety of
waxflower, then trim the stems together and place the bunch in
a vase. Repeat with the four other waxflower varieties.

2. Arrange the vases in a row, in a gentle gradient lineup from
dark to light.

RECIPES 2–4
INGREDIENTS

This collection pays homage to the backup singers of the floral world, those fluffy "extra" stems used to bulk up bouquets . . . the filler flowers. Most are long lasting and dry well, and possess some of the smallest blossoms out there. With the largest bloom size in this collection of tinies, waxflower plays the leading role.

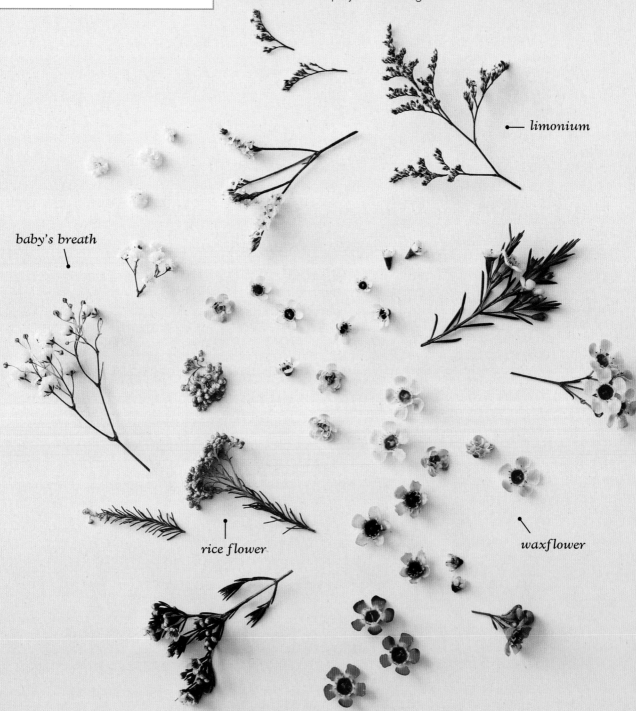

limonium

baby's breath

rice flower

waxflower

WAXFLOWER

RECIPE 2
MICRO ARRANGEMENT

INGREDIENTS

4 waxflower sprigs,
assorted colors

1 baby's breath sprig

1 limonium sprig

2 rice flower sprigs

VESSEL & SUPPLIES

3-inch-tall (7.5 cm)
floral-patterned bud vase

Double-sided glue tab (optional)

When bushy sprays of filler flowers are trimmed apart and given room to breathe, the hidden structure of their blooms is quite remarkable.

1. Cluster three sprigs of waxflower at the vase rim.

2. Above the waxflower, place the baby's breath leaning out to the left. Set the remaining waxflower sprig on the right, curving outward. Add the limonium in the center back.

3. Finish by placing one of the rice flower sprigs jutting out on the right and the other curving upward. If desired, add a glue tab to the surface where you wish to place the vase, to help stabilize the arrangement.

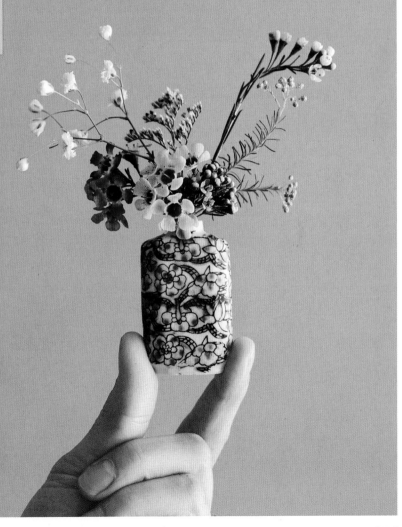

WAXFLOWER

RECIPE 3
MINI ARRANGEMENT

INGREDIENTS

8 waxflower sprigs, assorted colors

2 baby's breath sprigs

5 limonium sprigs

3 rice flower sprigs

VESSEL

3-inch-tall (7.5 cm) ceramic vase

1 Cluster the waxflower sprigs in a loosely mounded shape along the vase rim.

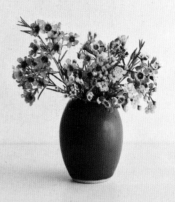

2 Place the baby's breath sprigs on the right to lean out above the waxflower base layer.

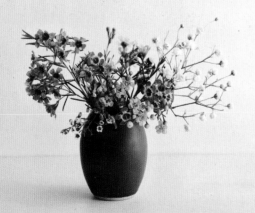

3 Add the limonium sprigs leaning out at varying heights throughout the composition. Nestle one rice flower sprig at the left rim and set another on the right among the waxflowers. Place the last one above the other flowers, creating a high point on the right side to balance the width of the arrangement.

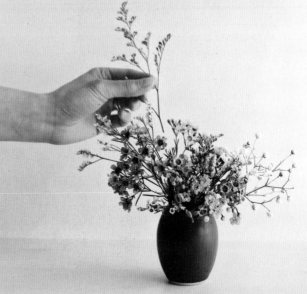

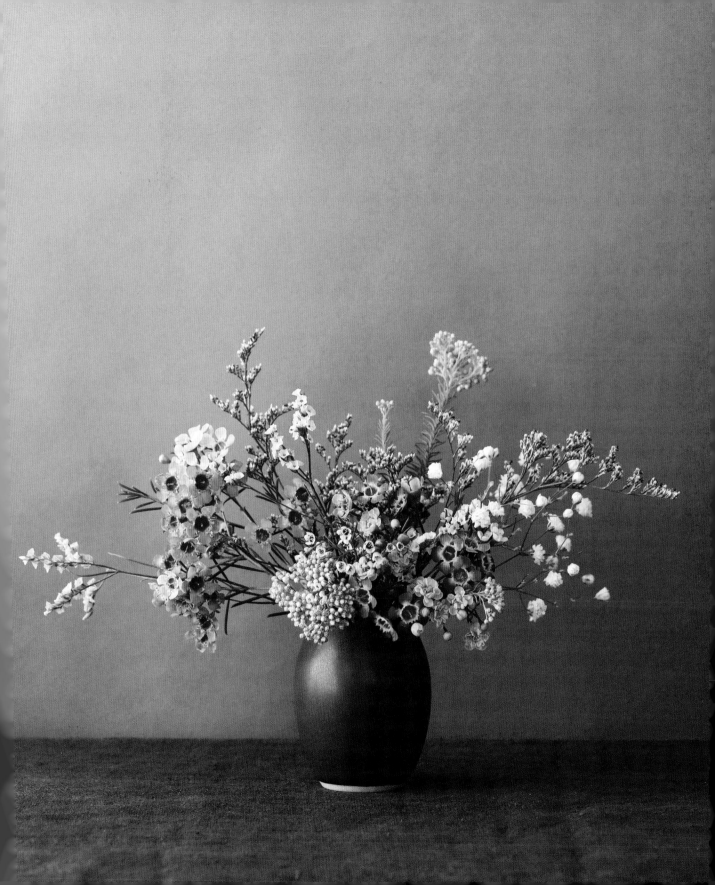

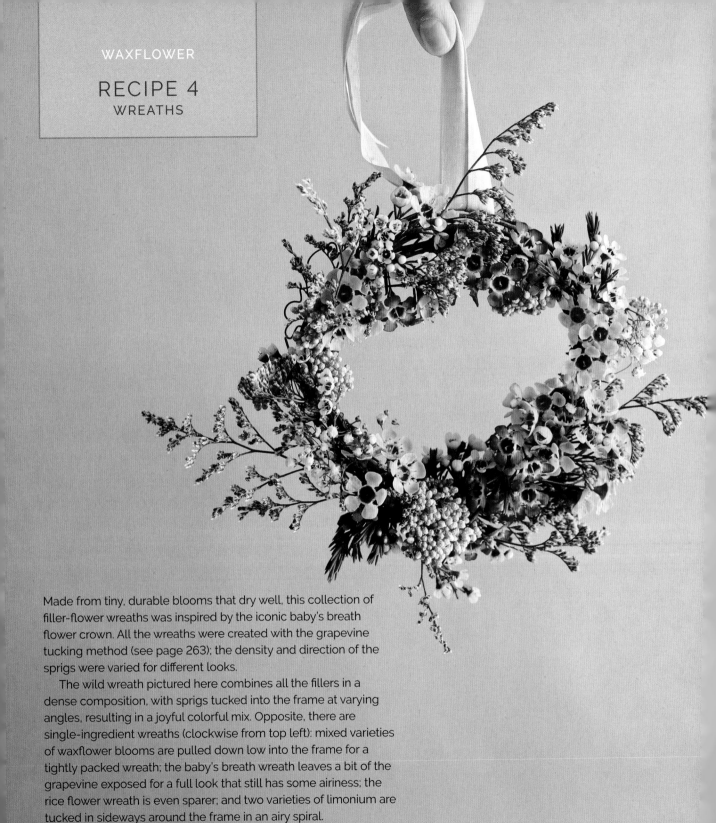

RECIPE 4
WREATHS

Made from tiny, durable blooms that dry well, this collection of filler-flower wreaths was inspired by the iconic baby's breath flower crown. All the wreaths were created with the grapevine tucking method (see page 263); the density and direction of the sprigs were varied for different looks.

 The wild wreath pictured here combines all the fillers in a dense composition, with sprigs tucked into the frame at varying angles, resulting in a joyful colorful mix. Opposite, there are single-ingredient wreaths (clockwise from top left): mixed varieties of waxflower blooms are pulled down low into the frame for a tightly packed wreath; the baby's breath wreath leaves a bit of the grapevine exposed for a full look that still has some airiness; the rice flower wreath is even sparer; and two varieties of limonium are tucked in sideways around the frame in an airy spiral.

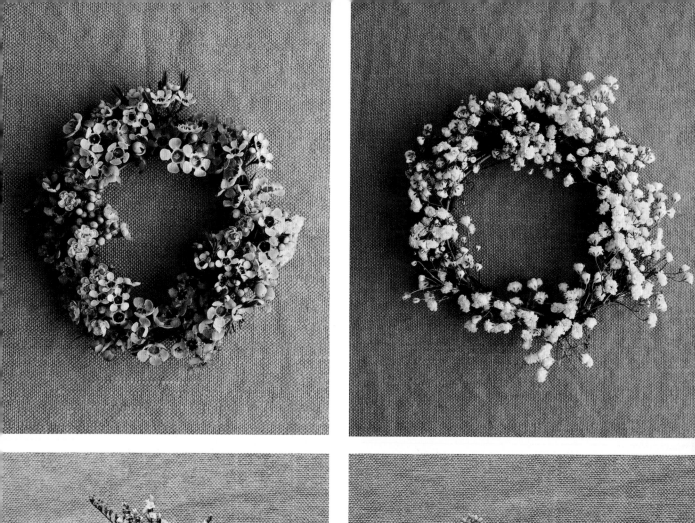

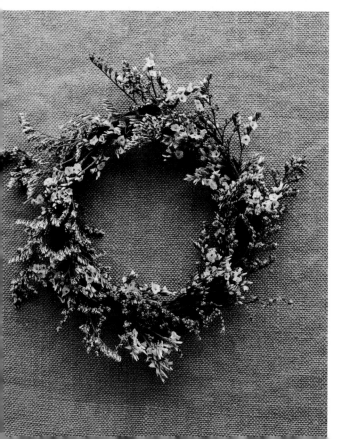

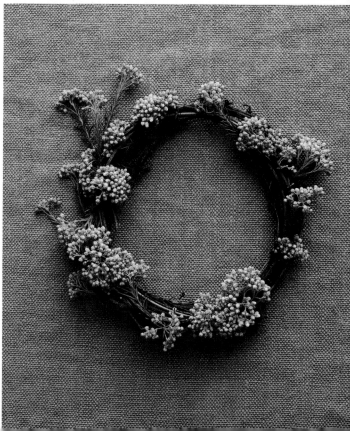

SPECIAL TECHNIQUES

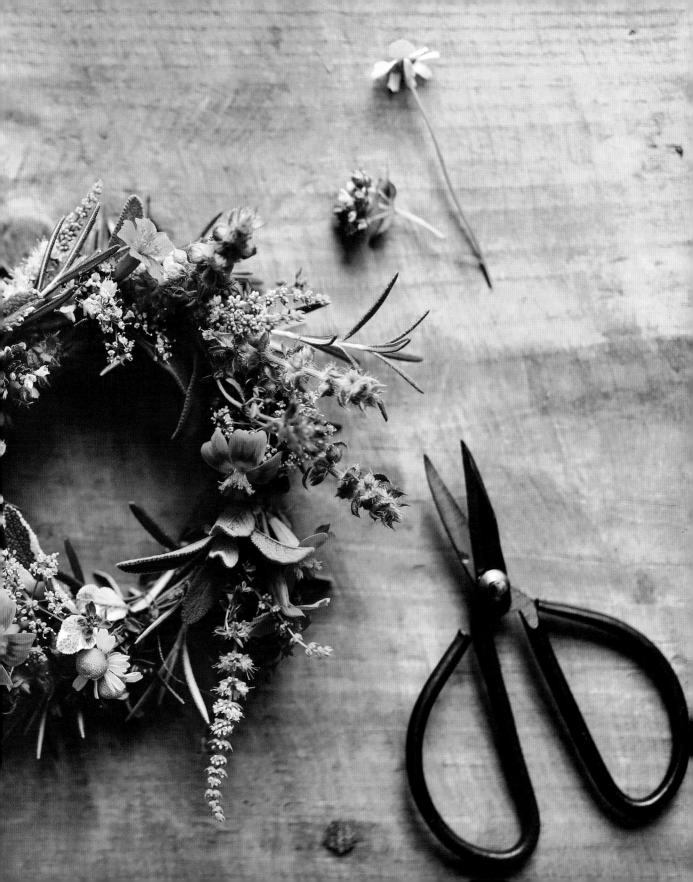

BUILDING A WREATH

There are many different ways to create wreaths. Depending on the materials you use, one technique might be better suited than another to achieve the desired look. The tucked-sprig method is fast and simple and works well for asymmetrical designs where the grapevine frame is visible. Wreaths made with a continuous-wrap method are usually the opposite: full and fluffy with the frame completely covered by the ingredients. This type of wreath is more difficult because the positioning and wiring happen in one step, but once you get the hang of the technique, you can attach the bunches very quickly. The wired-bunch method provides a little more control over composition and placement than the continuous wrap, so it's good for beginners.

WREATH FRAMES & BASES

Both wire and grapevine-wreath frames can be found at most craft supply stores, but those with a diameter of less than 6 inches (15 cm) can be harder to locate. Luckily the materials adorning them are small and lightweight, so miniature wreath frames can be fashioned from almost anything.

Grapevine. Grapevine wreaths are the most common, readily available at most craft stores. These frames are sturdy, look good when left exposed, and are great for tucking in stems. Grapevine can also be purchased in rolls that can be cut apart and used to make frames of any size (as shown here). Honeysuckle vine is a similarly flexible substitution.

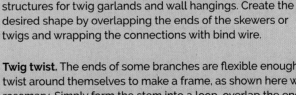

Skewers and twigs. These materials can be used to create triangular or square frames for wreaths, as well as base structures for twig garlands and wall hangings. Create the desired shape by overlapping the ends of the skewers or twigs and wrapping the connections with bind wire.

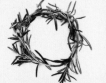

Twig twist. The ends of some branches are flexible enough to twist around themselves to make a frame, as shown here with rosemary. Simply form the stem into a loop, overlap the ends, and secure with thread or wire. Heavy-gauge wire can also be bent into a circle or a piece of cardboard cut to the desired shape for gluing (see page 160).

TECHNIQUE 1: TUCKED SPRIGS

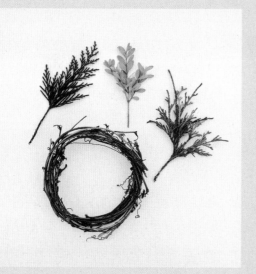

1. Prepare three sprigs to insert into a grapevine frame by removing the foliage from the lower part of the stems.

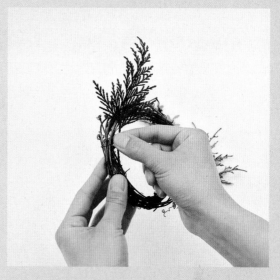

2. Insert the first sprig at an angle by feeding the stem between the grapevines. Pull it through until the foliage sits flat against the frame.

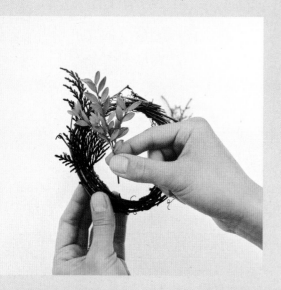

3. Repeat with the second sprig, so the foliage is slightly layered over the first. Repeat with the final sprig, leaving most of the frame exposed.

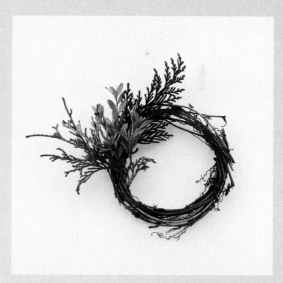

4. Finish by tucking the ends of the stems into the back of the frame if they are hanging out.

TECHNIQUE 2: WIRED BUNCHES

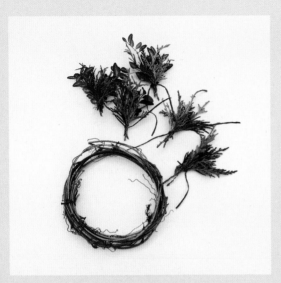

1. Create five bunches in hand with a few different ingredients and secure each one together with a piece of bind wire.

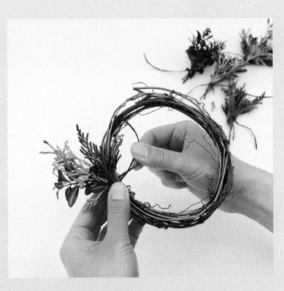

2. Hold the first bunch against the frame and attach it by wrapping the wire around the frame and twisting it closed at the front.

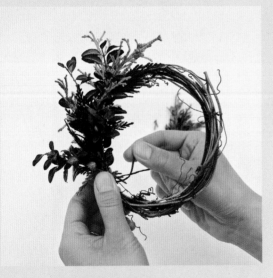

3. Attach the second bunch, using the foliage to cover the stems of the first one. Repeat with the third and fourth bunches.

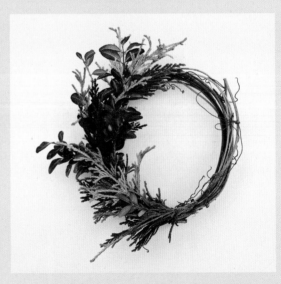

4. Attach the last bunch, leaving half of the frame exposed for an asymmetrical look. Finish by trimming and tucking the ends of the wires into the frame.

TECHNIQUE 3: CONTINUOUS WRAP

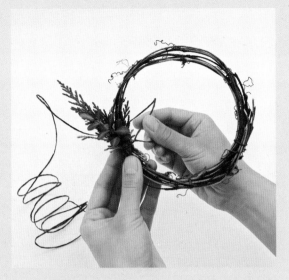

1. Create a mixed bunch in hand. Attach it to the frame by wrapping bind wire around both bunch and frame and twisting it closed at the front.

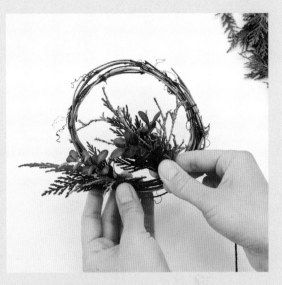

2. Press and hold a second bunch over the stems of the first. Wrap the wire around the stems and frame several times to attach.

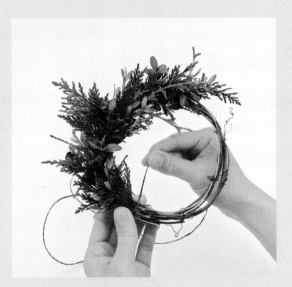

3. Continue making and attaching bunches, moving down the frame and using the same long piece of wire.

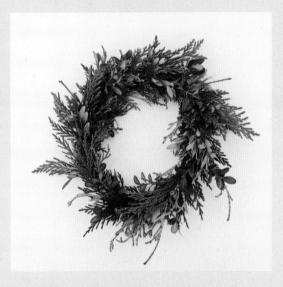

4. Tuck the stems of the last bunch under the foliage of the first and attach with the wire. Trim and tuck the end of the wire into the frame. Fluff and prune to achieve the desired shape.

CREATING A TWIG GARLAND

Twigs provide the perfect natural base for both hanging garlands and those resting on a surface. The twig can be completely covered with material or left visible in sections to reveal interesting bark texture.

1. Create three bunches in hand with a few different ingredients and secure each with a piece of bind wire, leaving the ends long to attach to the frame. Attach twine to a twig at both ends and hold up from the center point to find the balance. Lay the twig on the work surface in the same position you were holding it to attach the bunches.

2. Hold the first bunch against the twig with the foliage hanging off the end and attach it by wrapping the wire around the frame and twisting it closed at the front.

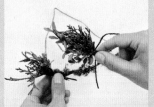

3. Attach the second bunch, using the foliage to cover the stems of the first one.

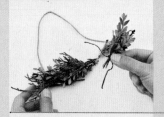

4. Attach the third bunch facing the opposite direction, with the stems overlapping the stems of the previous bunch.

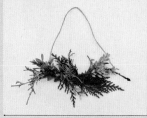

5. Use floral glue to attach a few sprigs on top of the stems to conceal the bind wire.

GLUING

Floral glue can adhere natural material to almost any surface, so it is useful for all kinds of projects. It works best if you apply and let it dry for a few seconds before pressing the surfaces together. Use in a well-ventilated area.

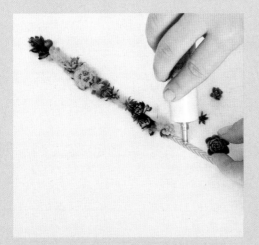

Run glue along a piece of ribbon and press succulents and dried ingredients onto it for a long-lasting green gift topper.

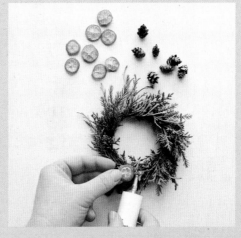

Apply dots of glue around a simple evergreen wreath to add flair.

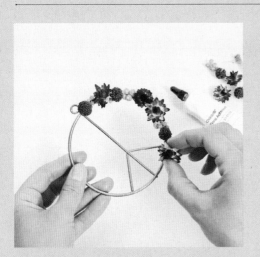

A ring of dried blooms glued onto a brass peace sign makes a lovely all-season ornament.

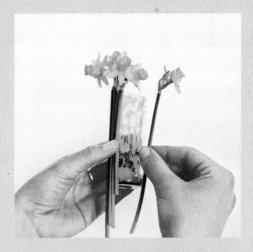

Coat a straight-sided shot glass with a thin layer of glue and press vertical stems onto it for a modern mini flower tower.

WIRING & STRINGING

Graphic strung garlands and wreaths are fast and simple to create on a small scale. Experiment with them for all sorts of uses like gift toppers, napkin rings, wall decor, and more.

CREATING WIRE STEMS
Use medium-gauge wire to give a succulent, piece of fruit, or mushroom a longer stem for arranging. Push the wire into the ingredient at the spot where it would sprout from the ground or from a stem, taking care to not push the wire all the way through. For extra hold, add a dab of floral glue before inserting the wire.

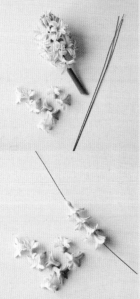

WIRING FLOWER HEADS
Pierce a row of flower heads (hyacinth is shown here) with wire to create a simple and easy garland, wall hanging, or wreath. Trim the open florets from the flower stem.

Insert a piece of wire through the face of a floret and out the other side, pulling it down the length of the wire. Thread another floret onto the wire facing in the same direction, and pull it down close to the first so they nest slightly. Repeat until the desired length is reached, then curve into the desired shape.

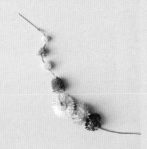

THREADING FLOWER HEADS
An alternative to the wiring method described above, here strawflowers were strung using a needle and thread. Thread a needle with embroidery floss and cut it to the desired length. Pierce the center of the heads with the needle and pull them down onto the thread, spacing them apart as desired.

MAKING PAPER CONES

Easy to make and with endless pattern possibilities, paper cones are versatile vessels for flower confetti, dried bouquets, and bagged blooms.

1. Cut a piece of patterned (or plain) paper into a small square. Gently hold the bottom corner and curve one edge inward to form a cone shape.

2. Apply glue along the bottom edge and continue rolling to complete the cone.

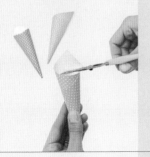

3. Leave the back pointed corner on the cone if using the cone for a petal toss, or trim the corner flat for hanging or carrying.

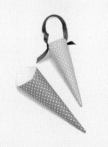

4. Attach a ribbon, if desired.

GLOSSARY

PLANT ANATOMY

bloom. A single flower on a stem with no leaves or buds.

bract. A small leaf-like or petal-like structure that is neither leaf nor flower but can look like either.

bud. An immature bloom on a stem.

collar. Bracts or leaves surrounding a bloom.

floret. One of the very small individual flowers that make up a larger bloom.

foliage. A grouping of leaves.

head. A bloom that has been cut from the stem and used for floating or stringing.

leaf. A flat structure attached to a plant stem that can have a simple or compound shape.

leaflet. A section of a compound leaf.

node. A point on a stem where buds and leaves emerge.

receptacle. The part of a flower stalk where the head of the flower is attached.

spike. A pointed flower made up of a group of florets.

spikelet. A secondary miniature spike on a stem or a sprig from a larger spike flower.

sprig. A small section of a stem that may contain blooms, leaves, and buds.

stem. A full-size flower with blooms, leaves, and buds.

twig. A small piece of a branch.

umbel. A flower formation where multiple florets grow from a common center point.

DESIGN TERMS

base layer. A foundation of foliage or blooms used to provide support for other ingredients.

bunch. A bouquet made in hand where the stems aren't secured with ribbon, tape, or wire.

posy. A bouquet made in hand where the stems are secured with ribbon or tape in the final design.

strand. A length of thread strung with flower heads.

TECHNIQUES

cluster. To group multiple ingredients in the same place to create a larger bloom or dense area.

feed. To add a stem through the florets of another flower or base layer to anchor the stem in place.

layer. To add one object just above another, barely touching or with a little space between.

mound. To create a clustered, rounded composition.

nestle. To add an ingredient between other items that are already in the composition.

string. To add heads onto a wire or thread.

ACKNOWLEDGMENTS

Huge hugs and gratitude to all the amazing people who made this book possible: Maaike, Erik, and Harper Bernstrom; my number one cutter, Nicolette Owen; the best hands in the biz, Fay Andrada; dream team Victoria Canel and Brooke Ferris; my goodest boy, Sammy; John O'Connor; the Pilotte family; the LSFC team; Brigid Finn and the BFFG crew, including hand model Nola Haynes; and Lesley Unruh and Anna Beckman, who helped source some very special tiny vases.

Thanks to the OG *Flower Recipe* cocreators, Alethea Harampolis and Paige Green. And to Katherine Cowles and the Artisan team: Lia Ronnen, Bridget Monroe Itkin, Elise Ramsbottom, Nina Simoneaux, Suet Chong, Sibylle Kazeroid, Paula Brisco, Nancy Murray, Donna G. Brown, Allison McGeehon, Theresa Collier, Amy Kattan Michelson, and Patrick Thedinga.

I couldn't do what I do without my partnership with Anna Jane Kocon of Little State Flower Company. Additional big thanks for tiny materials to Tea Lane Farm and all the orphans, the Dahlia Shed, Weatherlow Farms, Pistil and Stamen, Charles Little and Co., Three Porch Farm, the Floral Reserve, RJ Carbone, Fall River Florist Supply, Dutch Flower Line, and Peckham's Greenhouse.

Special thanks to Julie Ahn of Object and Totem for creating a collection of over forty tiny vases, featured on the cover and throughout the book (on pages 23, 29, 65, 101, 125, 133, 145, 149, 175, 197, 205, and 247). Other makers whose beautiful work is featured in the book include Caroline Unruh (pages 5, 131, and 207), Yuta Segawa (page 27), Martha Beckman (page 31), Little Tomato Glass (pages 35 and 104), Tiny Pottery Studio (pages 37, 59, and 231), Middle Kingdom (pages 47 and 218), Peaches (pages 53 and 87), Mud and Maker (page 54), East Fork Pottery (pages 112 and 239), Heath Ceramics (page 119), Sarah Kersten (pages 139 and 257), Notary Ceramics (pages 144 and 213), Plant and Vessel (page 159), VO ceramics (page 169), Mokun (page 191), Linda Fahey (page 217), Katherine Moes (page 225), and Karen Jenkins (page 242).

JILL RIZZO is the owner of the floral design company Wild Season Florals, which she opened in Rhode Island in 2015. Previously, she was a cofounder of Studio Choo in San Francisco. With her Studio Choo partner, Alethea Harampolis, she is a coauthor of the bestselling *Flower Recipe Book* and *Branches & Blooms*. Follow her on Instagram at @wildseasonflorals.